HIDE AND SEEK

The Architecture of
Cabins and Hide-Outs

gestalten

Preface

4

Index/Imprint

252/256

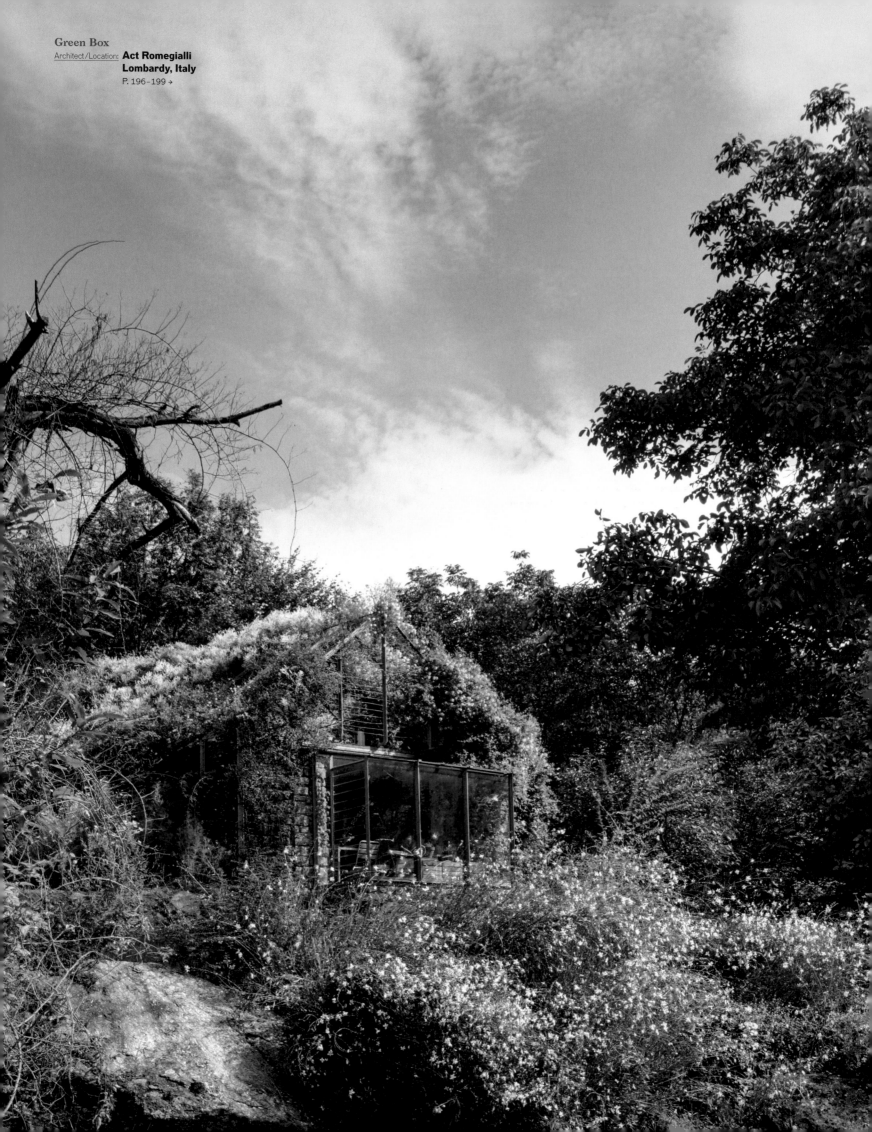

Wild Things: Natural Uprisings in Contemporary Architecture

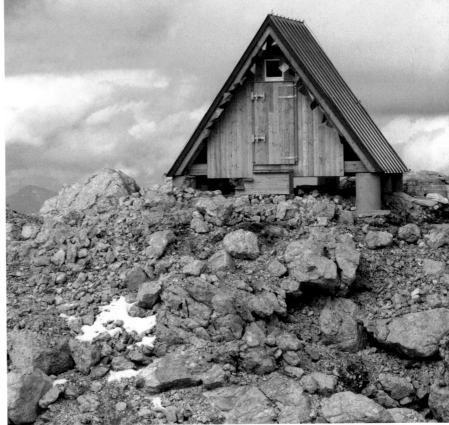

"That very night in Max's room a forest grew and grew—and grew until his ceiling hung with vines and the walls became the world all around."
Quote: **Where the Wild Things Are, Maurice Sendak**

Haven't you ever wanted to run away? Book a one-way flight to an exotic place where no one knows your name? Pull the covers up over your head? Our need to escape, even for a short time, represents a primal feeling we all share. This desire for solace and hunger for the natural world is something we learn as children, with each fort we build and treehouse we occupy. However, as we grow older, our visceral longing for retreat and spaces that foster creativity gradually gets conditioned away. With fewer and fewer opportunities for true respite and privacy, our lives become ever more public. In the midst of this high visibility and interconnectedness, some chose to disconnect and return to the wild. These pilgrimages back to nature take many forms, ranging from the archetypal primitive hut to more contemporary examples of summer homes and chalets in remote locations. Whether floating on a mountaintop or nestled into a lakeside clearing, the resurgence of the cabin stands as the adult manifestation of our beloved childhood hiding places—a personal haven for prospect and refuge.

Our innate quest for both prospect and refuge coincides with the language of the nature retreat. The successful hideout not only pulls on our heart strings and conjures an instinctual feeling of longing, but also helps us reclaim our sense of wonder toward the world around us. By finding new ways to balance protection and outlook, even the most understated and rudimentary shelters can elicit these emotional responses. *Hide and Seek* explores a range of such cabins, shelters, hideouts, and sanctuaries that tap into our human desire for escape and tranquility.

The more our refuges embed themselves in the land, the more opportunities for outlook arise. This relationship between safety and vista is a key component in introducing mystery back into our daily lives. Relating to this idea, the English romantic poet John Keats coined the term *negative capability*—

Bivacco Luca Vuerich
Architect/Location: **Giovanni Pesamosca Architetto Friuli-Venezia Giulia, Italy**
P. 66–69 →

a concept that investigates our intrinsic ability to react to nature and defy preconceptions in the face of contextual constraints. Keats writes about the importance of keeping an open and unburdened mind that remains, "capable of being in uncertainties, Mysteries, doubts, without any irritable reaching after fact & reason."[1] This poignant statement underlines the importance of finding places that defy the mundane and foster a sense of awe away from fact and reason. From the rugged citadel to the delicate hermitage, the varied forms of living with and learning from nature result in highly personal spaces that court such negative capability. These architectural acts invite us to revel in the raw, mysterious, and sensorial qualities of nature.

Historically, when we came across uncharted territories, our first instinct was to tame them. Theorist Edmund Burke's influential work, *A Philosophical Enquiry*, summarizes this tendency towards subduing nature as he writes:

> Therefore having observed, that their dwellings were most commodious…they transferred their ideas to their gardens; they turned their trees into pillars, pyramids, and obelisks; they formed their hedges into so many green walls, and fashioned walks into squares, triangles, and other mathematical figures … they thought if they were not imitating, they were at least improving nature, and teaching her to know her business.[2]

Interspersed between these periods of preening the natural world and industrial expansion, counter movements that privileged invigorating and unmediated relationships with the outdoors emerged. The rise of the eighteenth century English garden, which reconstructed picturesque pastoral landscapes found in nature, rejected the formal and rigid gardening style made famous by the French throughout the seventeenth century. These lush, lightly styled grounds typically mixed verdant green meadows with idyllic lakes, mimicking the experience of walking in a pristine yet curated swatch of nature. As a reaction to the Industrial Revolution, Romanticism further expanded this more emotional way of engaging with the wilderness. This period, which continued through much of the 19th century, argued for intense, authentic, and sublime connections to nature that extended through all forms of creative practice.

This dialectic and cyclical urge between wanting to control nature and letting it break through informs the latest resurgence of the primitive shelter. Once again, the contemporary cabin invites the wild back in. The reversal from repressing to embracing the natural landscape speaks to the importance of re-awakening the wild part in us all. As nature returns to the spotlight and architecture retreats to the background, an interesting interplay between indoor/outdoor living ensues. Such hideouts offer room for reflection and creativity, a space to see without being seen.

Understanding that a meaningful and experiential connection to nature does not happen over a hedge or behind a wall, the new retreat opens up to the landscape and adopts a more submissive role toward the outdoors. While some examples wind around trees or perch in their branches, others simply invite the garden up and over their structures. These shelters not only tread lightly on the land, but also gradually dissolve into ephemeral extensions of the nature that surrounds them. Green Box (P. 196-199 →) by Act Romegialli exemplifies this willingness to return to the wild. Here, the repurposed dwelling features a pitched roof structure specifically designed as a supporting trellis where native vines, wild flowers, and plant life can cluster. Enveloped in nature, the modest shelter hides behind this protective cloak of organic and evolving camouflage. The mysterious allure of this country residence grows alongside the thickness of the vines that envelope it. Nearly invisible to the wandering eye, this secretive lair frames an authentic, shifting, and tactile experience of nature for its occupants.

The successful hideout not only pulls on our heart strings and conjures an instinctual feeling of longing, but also helps us reclaim our sense of wonder toward the world around us.

Sledge-Project
Architect/Location: **Rob Sweere**
Qaasuitsup, Greenland
P. 32-33 →

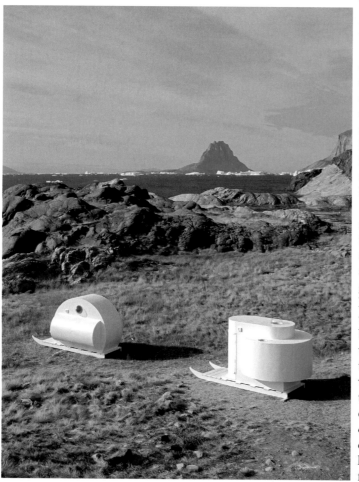

The fleeting aspects of nature motivate many new shelters to introduce the concept of mobility into their design. These mobile hideouts take on an adaptive approach to the outdoors, allowing for a level of flexibility that can readily respond not only to shifts in weather but also to the sentiments of its inhabitants. Providing the rare freedom to move from place to place, these nomadic structures redefine our typically fixed relationship to a given setting. The Sledge-Project (P. 32-33 →) by Robert Sweere fluidly navigates Greenland's formidable ice formations. Mounted on sleds, the two iconic micro shelters transport local hunters and school children across a remote island to master the ways of the wild. The pure white hideouts fade into the snow that covers the rugged landscape throughout most of the year. Portable House ÁPH80 (P. 126-129 →) by Ábaton serves as yet another example of the mobile cabin movement. True to its name, the preassembled dwelling can be erected in a single day and later transported from one location to another. While engaging a classic gabled roof silhouette, the rest of the residence proves extremely progressive in its foresight and ability to acclimate to a wide spectrum of climates and terrains.

In addition to concepts of mobility and camouflage, the contemporary cabin seeks out unfettered access to nature's elements. Direct connections to water, earth, air, and even fire enhance the power and sense of discovery present within the rural refuge. *Hide and Seek* organizes an exceptional selection of retreats according to their experiential location in nature. The book begins at water's edge with the chapter Where Land Meets Water, showcasing a variety of sanctuaries overlooking serene lakes, ponds, oceans, and bays. Zielturm Rotsee (P. 16-19 →) by Andreas Fuhrimann Gabrielle Hächler Architekten and The Pierre (P. 34-37 →) by Olson Kundig Architects both embody the exhilarating and emotional aspects of life lived framed by water. From here, the projects ascend into the mountaintops with Sky High to explore an assortment of ultimate outlooks. Beginning with Bivacco Luca Vuerich (P. 66-69→) by Giovanni Pesamosca Architetto, the striking and precariously perched A-frame shelter for mountain climbers in the Julian Alps, this section also uncovers a collection of enticing alpine retreats that bewitch the senses. The next section of the book, Open Range, takes us out into the wide open meadows where romantic pastoral landscapes abound. Here we come across the idyllic contemporary country residence Casa 4 Estaciones (P. 182-183 →) by Churtichaga+Quadra-Salcedo arquitectos and the endearing micro habitat NOA Cabin (P. 166-167 →) by Jaanus Orgusaar. Concluding in the heart of the forest, In this Neck of the Woods uncovers imaginative tree houses and rustic huts hidden behind layers of rich foliage. Examples such as the whimsical mirrored Lake Cottage (P. 222-227 →) by UUfie or the understated and atmospheric wooden sanctuary known as Waldsetzkasten (P. 208-211 →) by Bernd Riegger reflect a common need both for refuge and the ability to touch and be touched by nature. These shelters, no matter how small or experimental, maintain an underlying pragmatism that provides them with universal appeal.

Refreshing, and in some ways rebellious, these shelters push back against the contemporary tendency to over share and over consume within the public eye. The new cabin forges connections to nature that brim with sensation and ephemerality. In his hauntingly beautiful poem "To Autumn," Keats notes our inherent ability to craft romantic experiences in nature as he muses:

> Where are the songs of spring? Ay, Where are they? Think not of them, thou hast thy music too, —[3]

Keats' words here return to the concept of negative capability and the importance of relating to the world with spirited delight, which the creative minds behind these architectural endeavors have aspired to do. Lyrical, protective, and contemplative, these sanctuaries from the urban condition reignite our primitive instincts in the wild. Whether tucked under the blankets or between the leaves, such sacred spaces become the physical embodiments of what we all hide from and what we all seek.

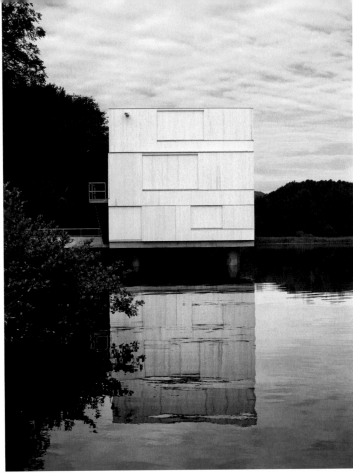

Zielturm Rotsee /
Finish Tower Rotsee
Architect/Location: **Andreas Fuhrimann Gabrielle Hächler Architekten**
Lucerne, Switzerland
P. 16-19 →

This dialectic and cyclical urge between wanting to control nature and letting it break through informs the latest resurgence of the primitive shelter.

1 Keats, John. *The Complete Poetical Works and Letters of John Keats,* Cambridge Edition, Mifflin and Company (Houghton, 1899), 277.
2 Burke, Edmund. *A Philosophical Enquiry,* Oxford University Press (New York, 1757), 92.
3 Keats, John. *To Autumn,* (1819).

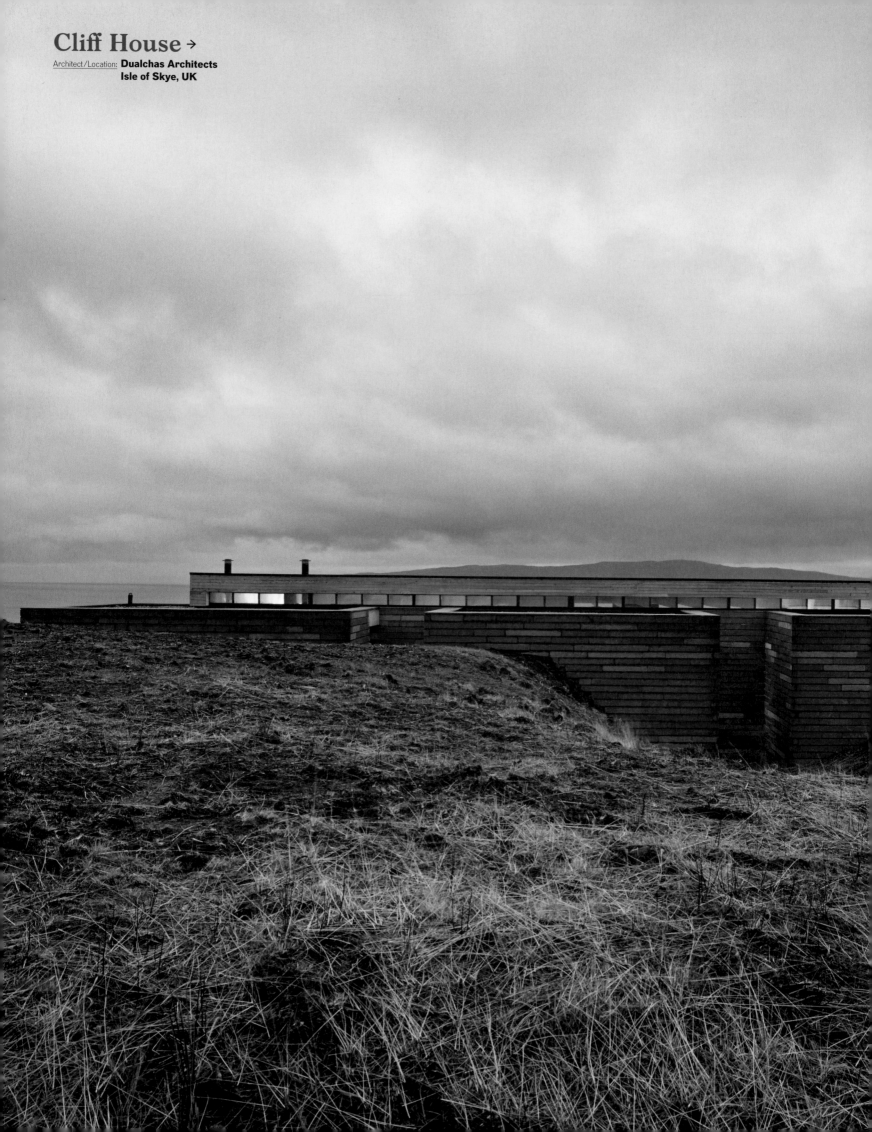

Cliff House →

Architect/Location: **Dualchas Architects**
Isle of Skye, UK

Chapter 1

WHERE LAND MEETS WATER

P. 8–65

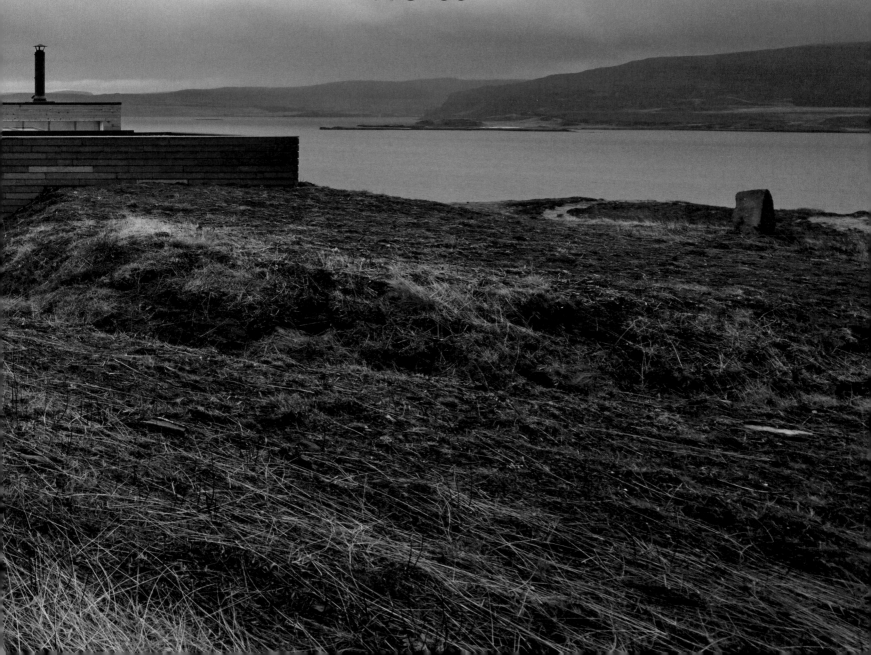

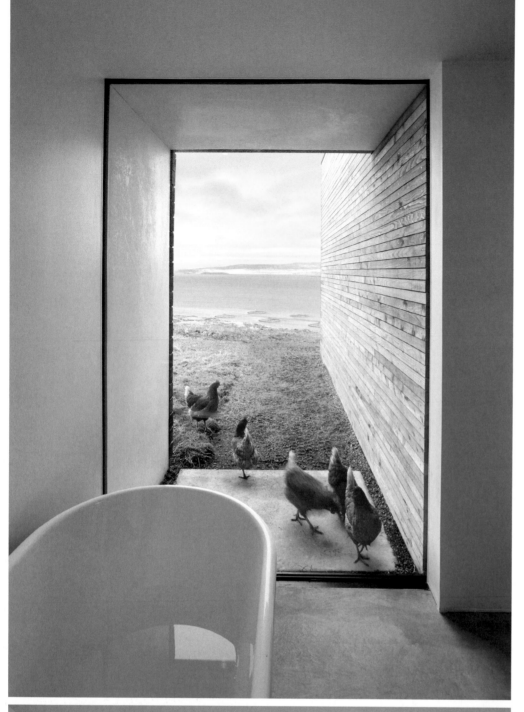
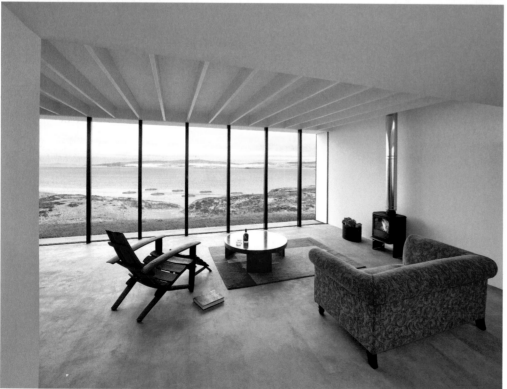

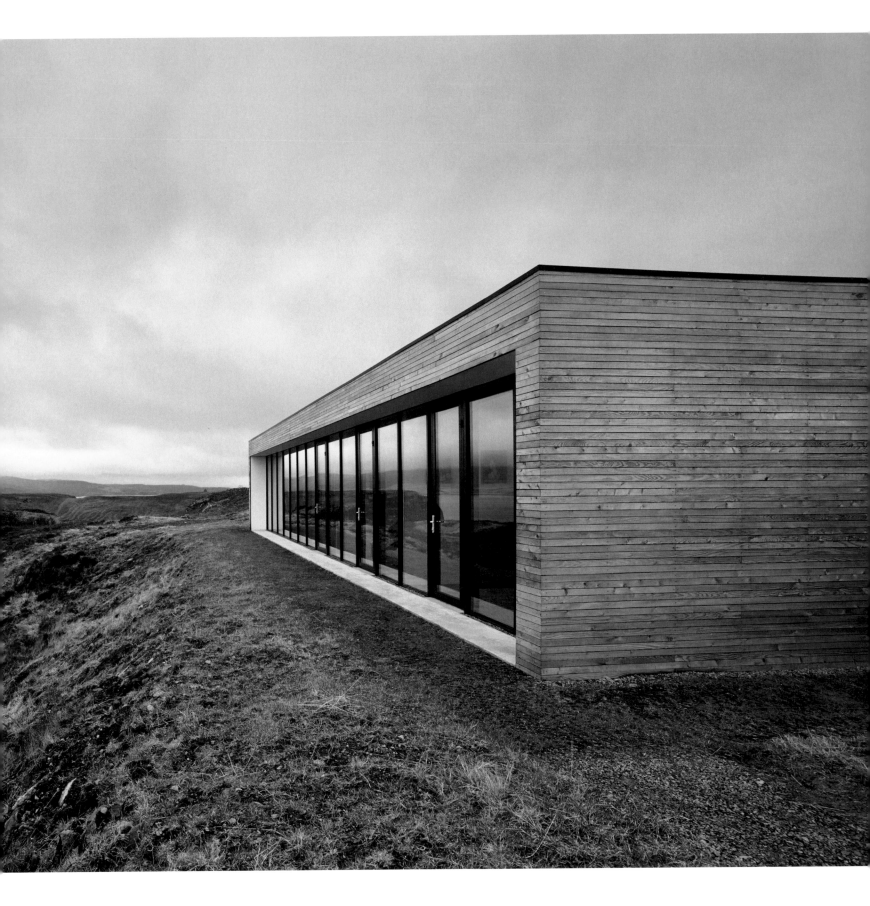

Cliff House

Architect / Location: **Dualchas Architects**
Isle of Skye, UK

A partially buried refuge overlooks Loch Dunvegan. Accentuated by a constant horizon, the dwelling sidles up to the cliff's edge high above the water. The building consists of two volumes: one closed, the other open. This first volume contains all serving functions to support the main open rooms. Together, the two areas provide shelter and privacy while maintaining a constant focus on the surroundings. One wall of the open volume is made entirely of glass, allowing visitors to marvel at the exhilarating cliff top vista and blustery landscape. While the typology of the building proves specific to its surroundings, the house develops a timeless way of relating to the outdoors. A bathroom with a large floor-to-ceiling window frames a majestic panorama out to sea and enables guests to tranquilly soak in the tub while observing the home's family of chickens as they gather under the eaves. The seaside residence invites nature to gradually reclaim the site — a protective envelope brimming with mystery and atmosphere.

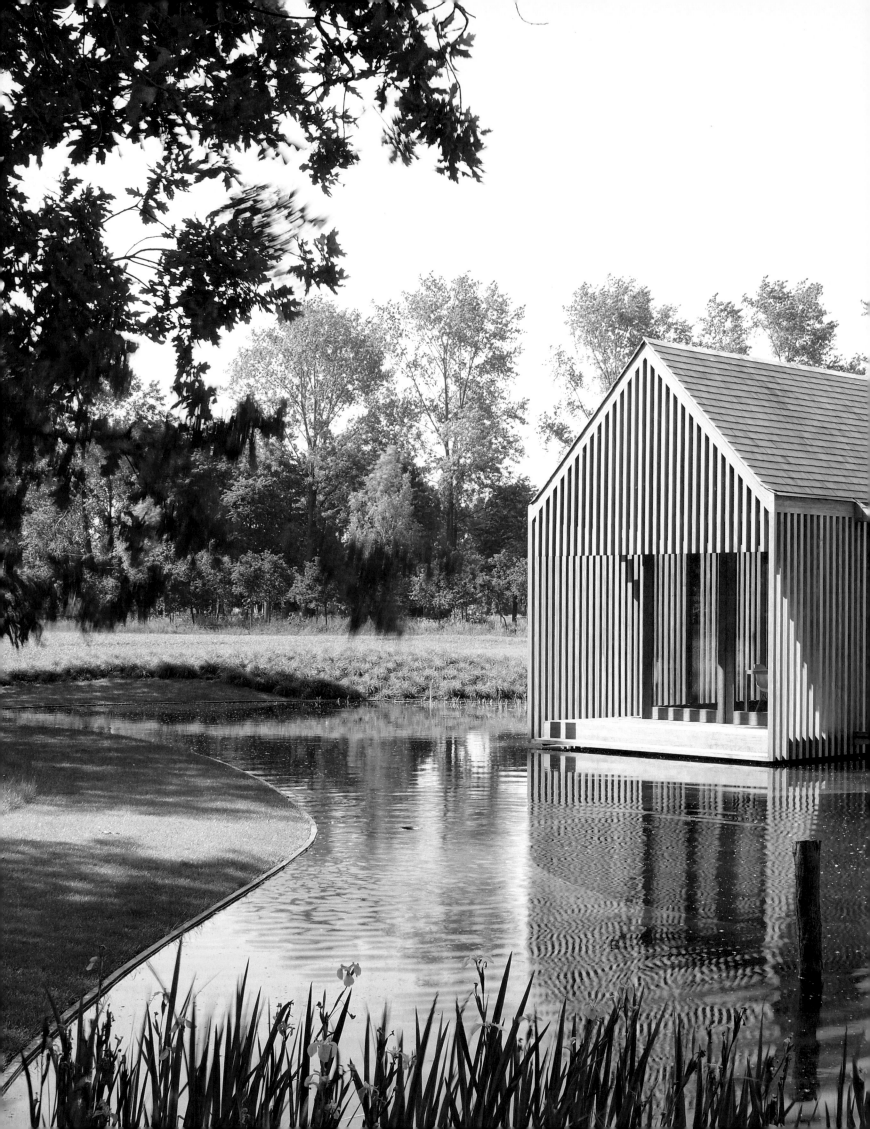

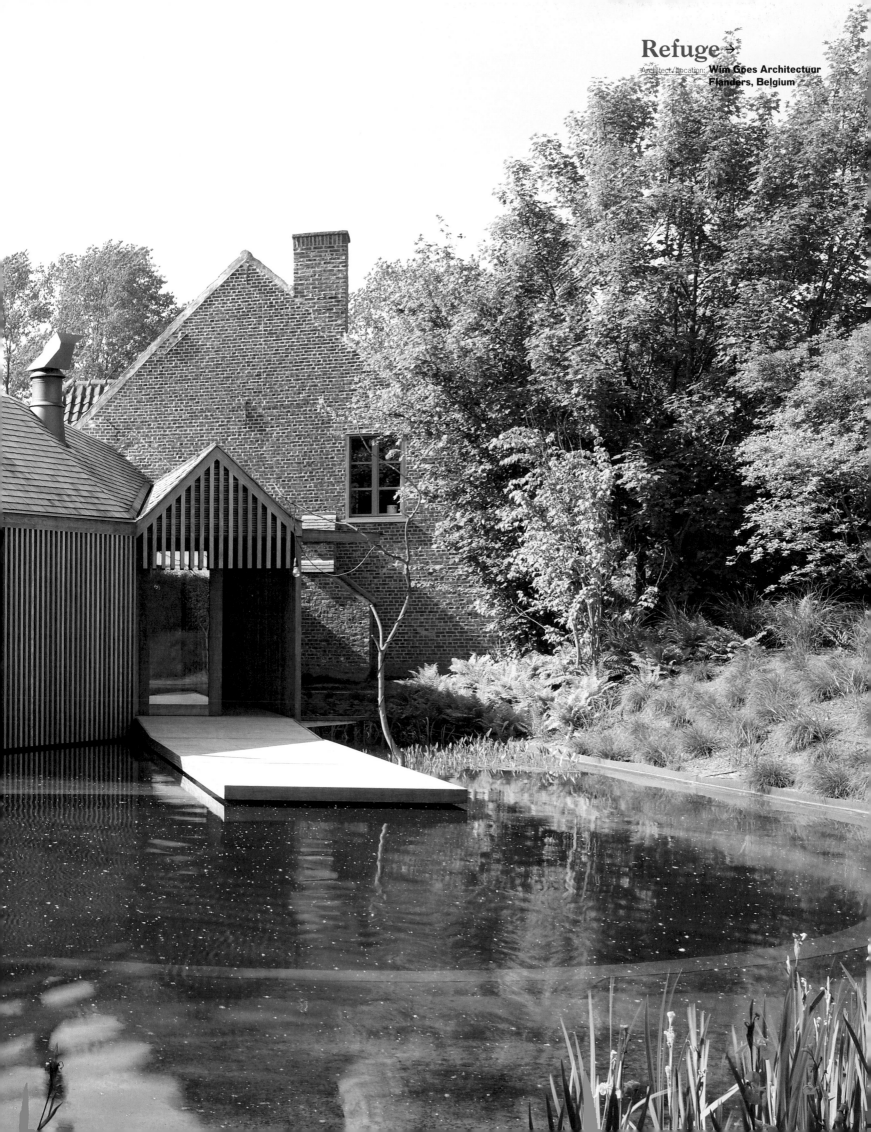

Refuge

Architect/Location: **Wim Goes Architectuur**
Flanders, Belgium

In the Flemish countryside, on a parcel fringed with willows and swamps, a southern-oriented farmhouse appears. The wooden refuge, honest and simple, stands as a delicate link between landscape and architecture. Sliding doors protect a meditative interior space from high winds, temperature shifts, and sound. The small refuge effortlessly adapts to the changes of nature. During warmer times of year, the cabin opens up to its serene setting and interacts with the small pond at its doorstep via a cantilevered wooden pier. On the roof, red wood shingles lead the rain to red copper spouts, returning the water to the pond surrounding the pavilion. Similar to the wood, the red copper takes on a mature patina over time. The inviting hideout demonstrates that living with nature transcends aesthetics and formal behaviors to instead become an alluring state of mind.

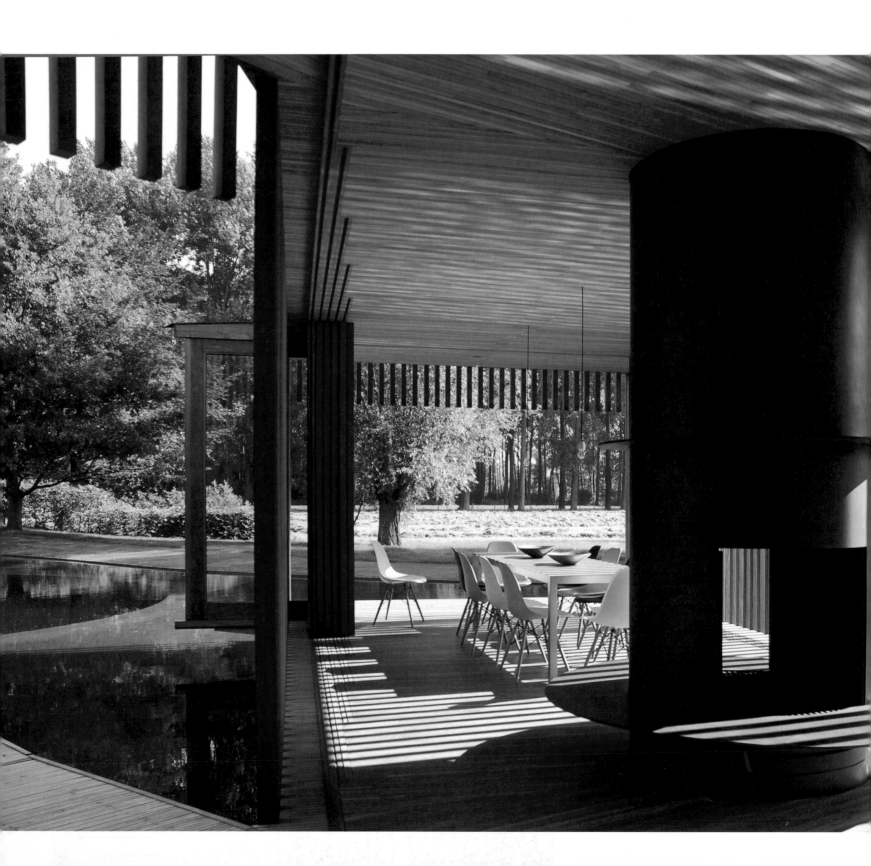

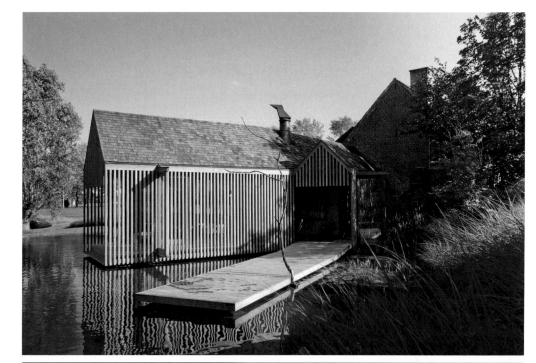

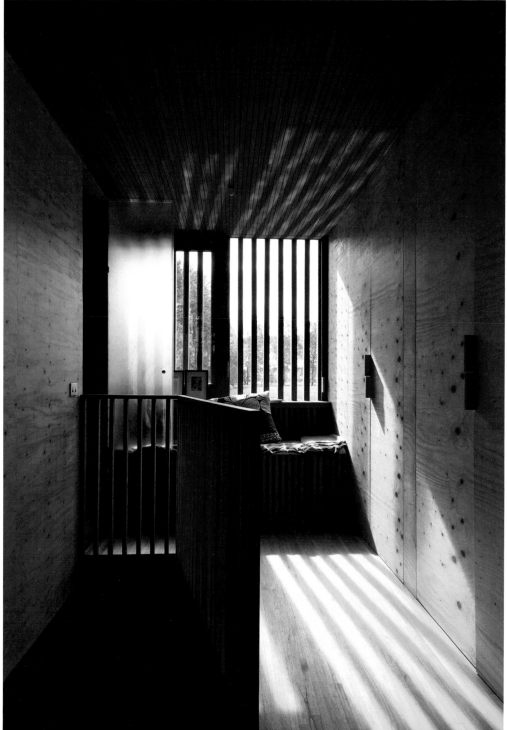

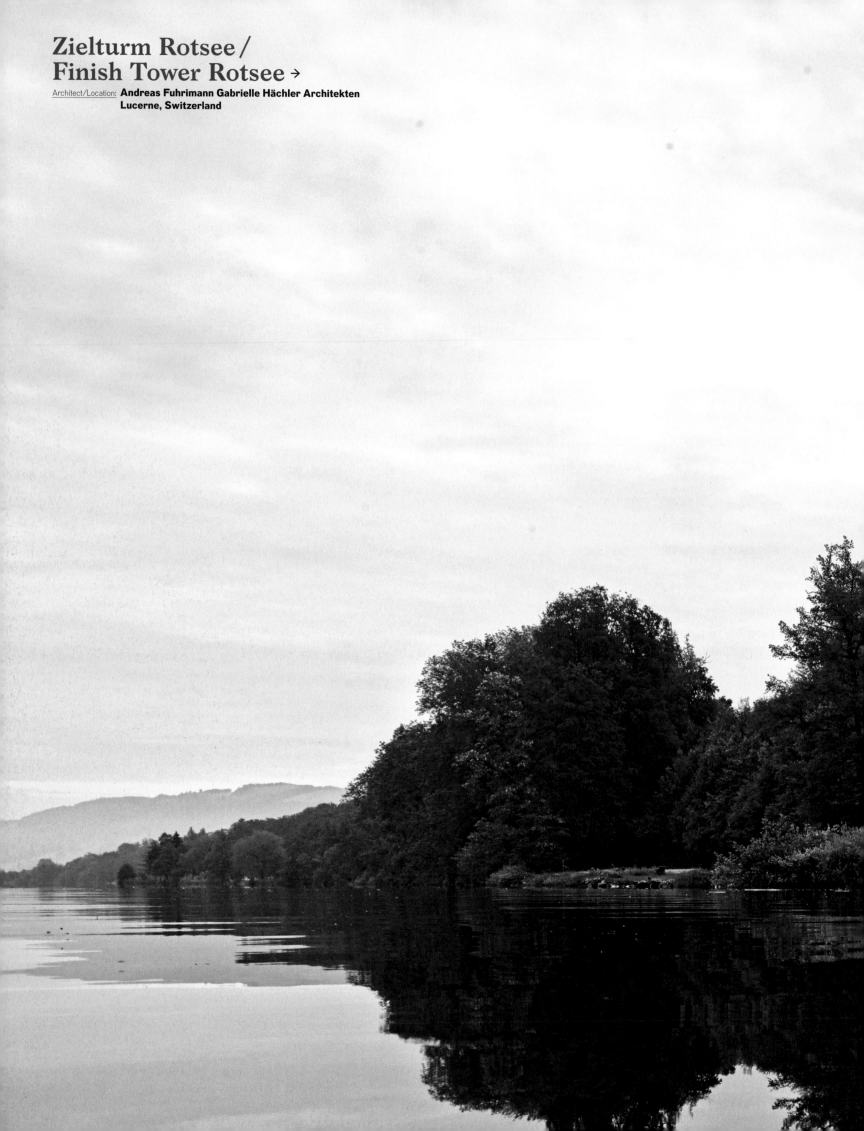

Zielturm Rotsee /
Finish Tower Rotsee →

Architect/Location: **Andreas Fuhrimann Gabrielle Hächler Architekten**
Lucerne, Switzerland

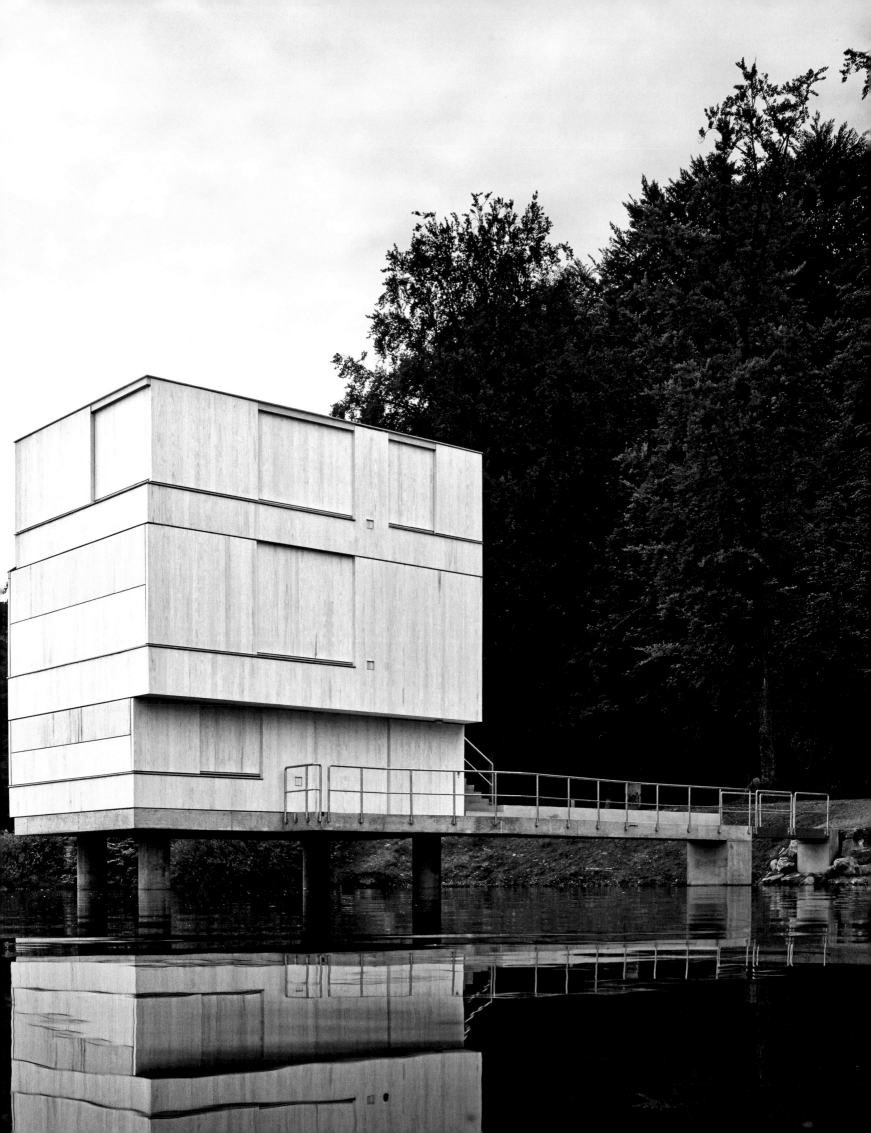

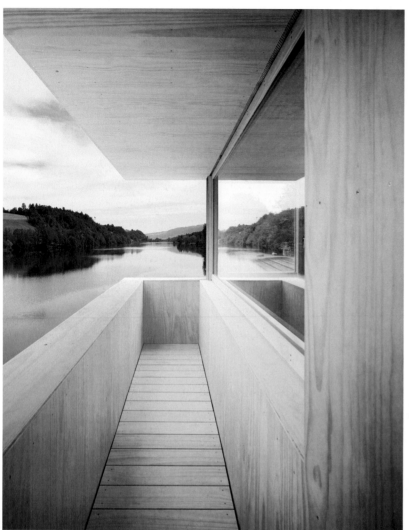

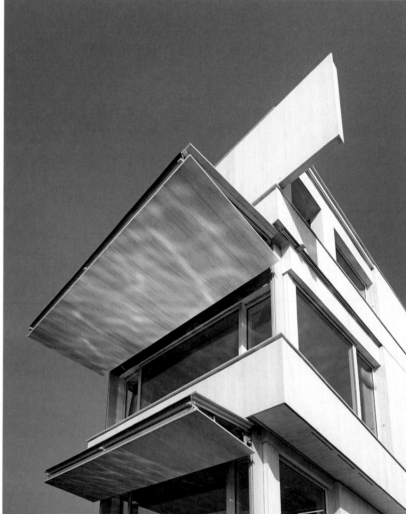

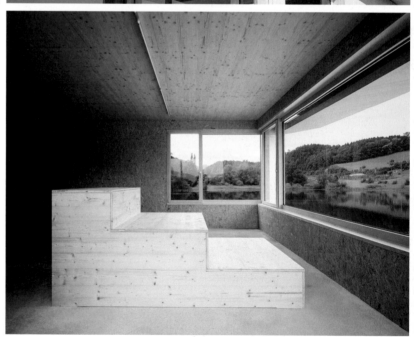

Zielturm Rotsee /
Finish Tower Rotsee

Architect/Location: **Andreas Fuhrimann Gabrielle Hächler Architekten**
Lucerne, Switzerland

Raised over a body of water nicknamed the "Lake of Gods," a pine wood tower accommodates the officials of the annual rowing regatta. The structure, occupied just three weeks each summer, stacks the spatial units in a vertical volume. Acting as a point of reference on the horizontal lake, the subtle offsets of the three levels make the durable shelter seem fragile and delicate. A long platform provides access to the tower from both water and shore. Pragmatic and sculptural, large shutters slide closed to protect the building during its periods of vacancy. The aesthetic impression of this visual and spatial metamorphosis grows stronger once the building closes up for the year and the sliding shutters return the open levels back into a solid mass. Casting long reflections over the water, the structure blends into the pristine landscape and responds to the constantly changing seasons. The abstract form retains a strong recognition value, conveying a lasting identity for the rowing sport.

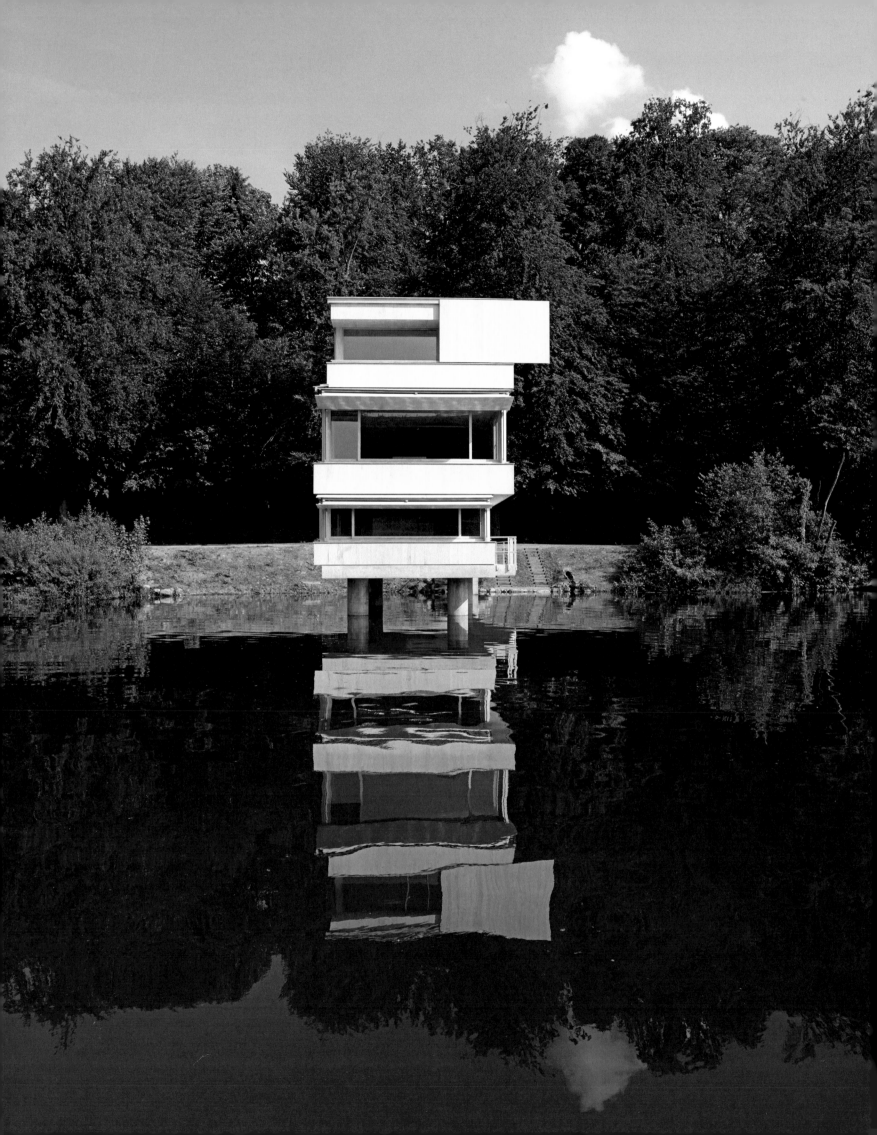

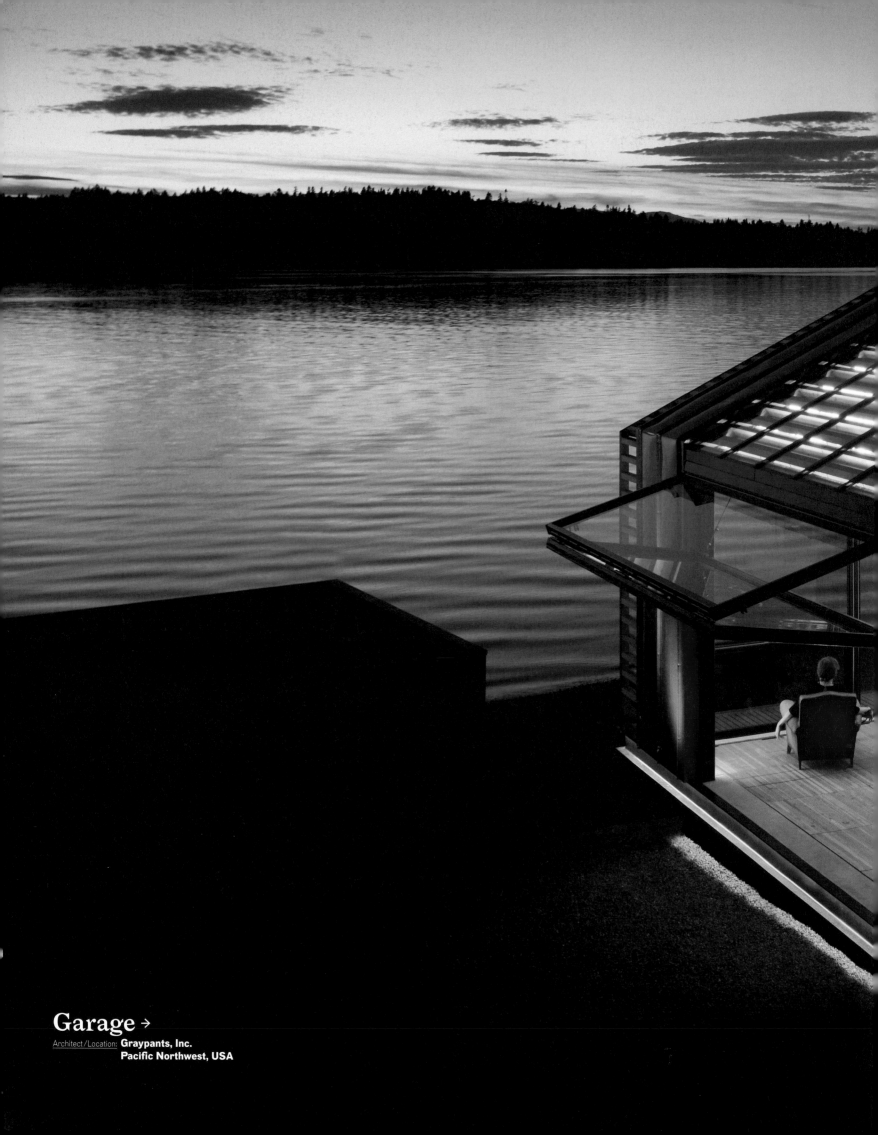

Garage →

Architect/Location: **Graypants, Inc.**
Pacific Northwest, USA

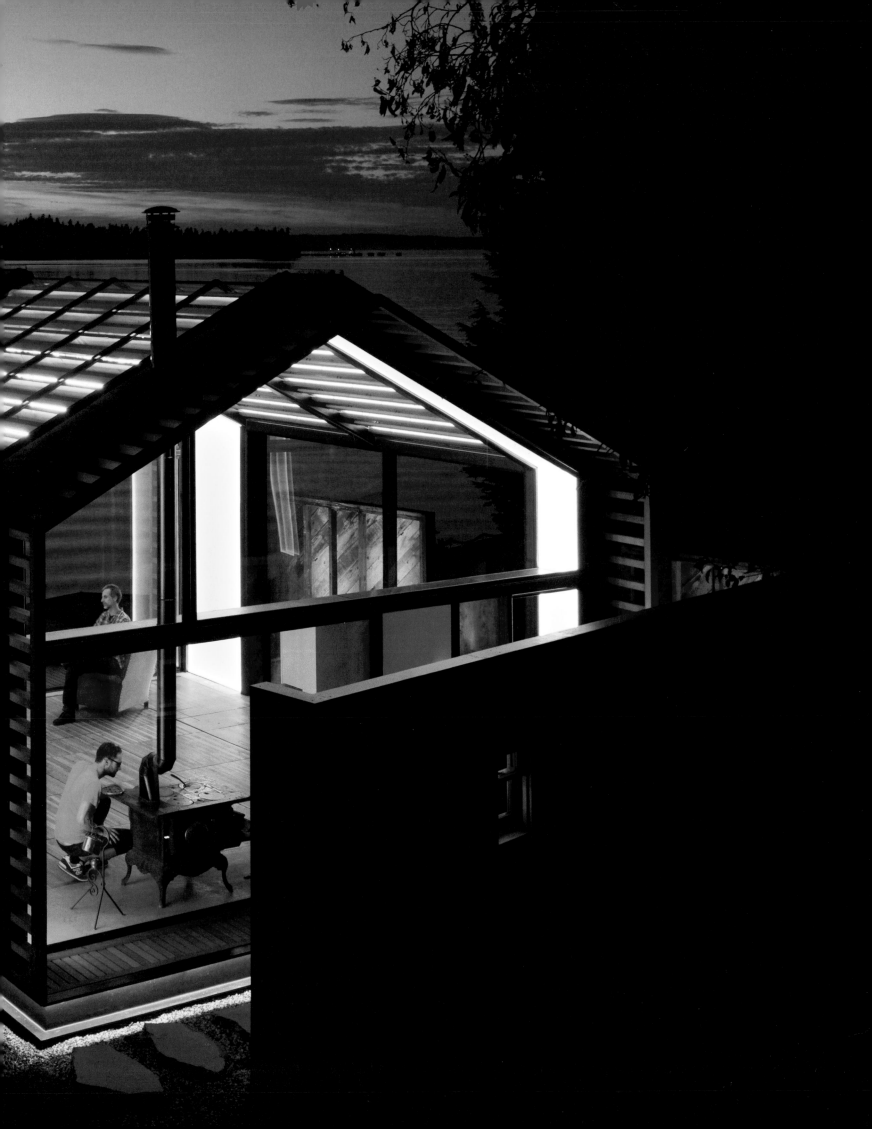

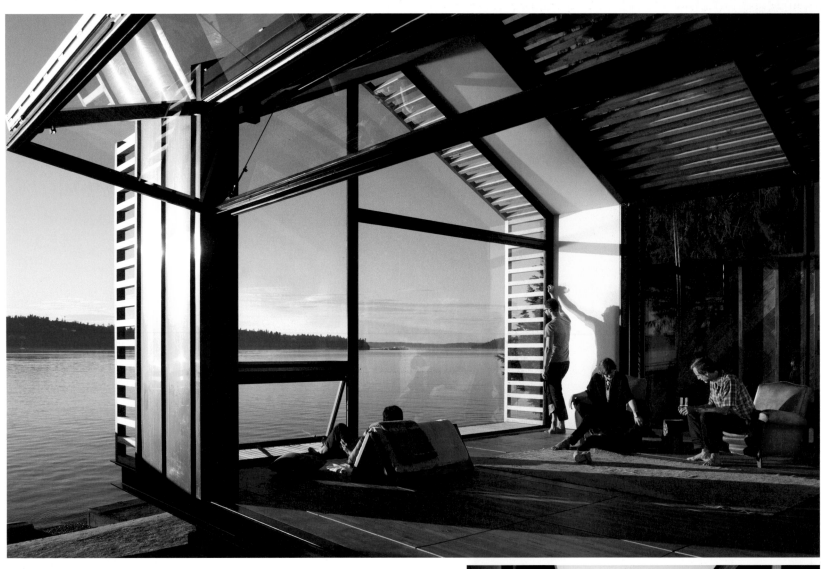

Garage

Architect/Location: **Graypants, Inc.**
Pacific Northwest, USA

Situated on the Puget Sound, this captivating shelter addresses themes of mystery, memory, poetry, and light. The luminous glass structure reinvigorates a tired and forgotten post-World War II garage. Rich with stories of past impressions and family life, the archetypal yet contemporary project joyously recombines materials and imparts them with new meaning. Scratched boards become a textured backdrop defining new functions, while the remaining structure dismantles into flooring, concealing beds and lounges beneath. Reclaimed pine, a discarded basin, and a century-old stove introduce the memories of others — a remix of the familiar and the novel, the past and the future. The pitched roof garage at water's edge integrates foldable glass panels to seamlessly link inside and out. Providing a charming medley of old and new, ordinary and extraordinary, the iconic hut acts as a glowing beacon and private theater for nature's majestic cycles to unfold.

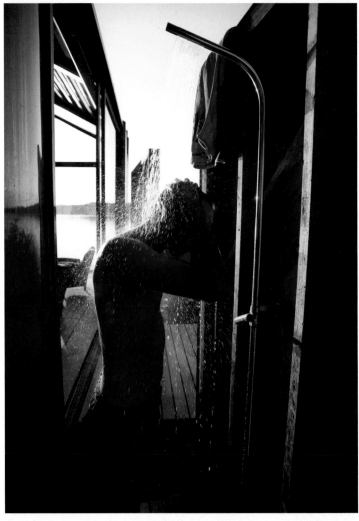

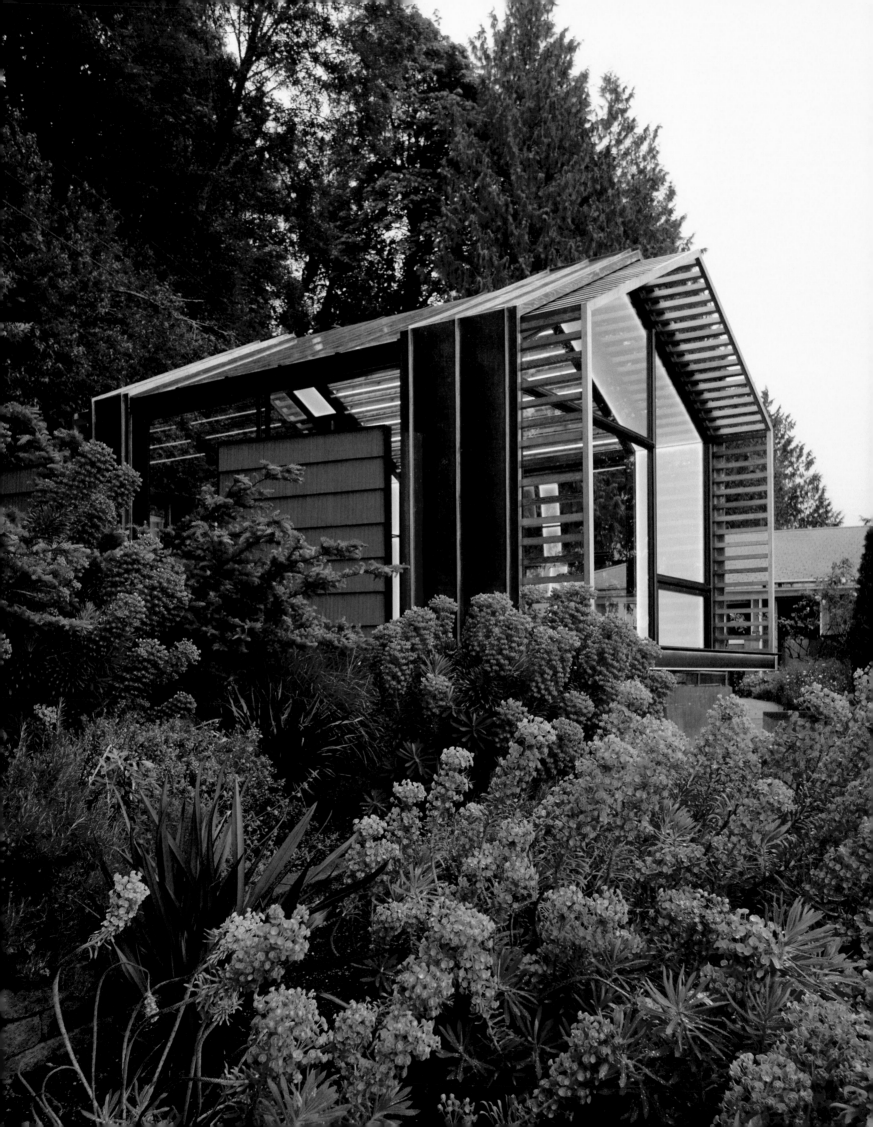

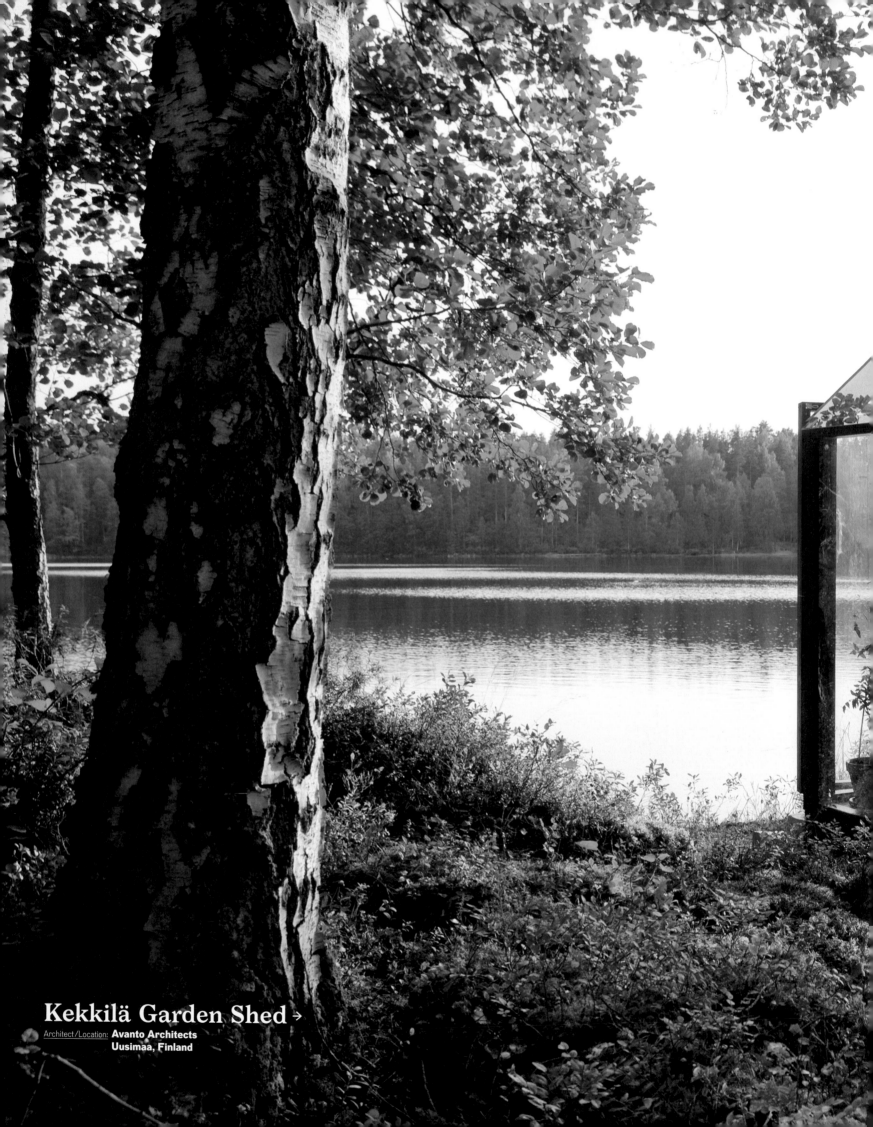

Kekkilä Garden Shed →

Architect/Location: **Avanto Architects**
Uusimaa, Finland

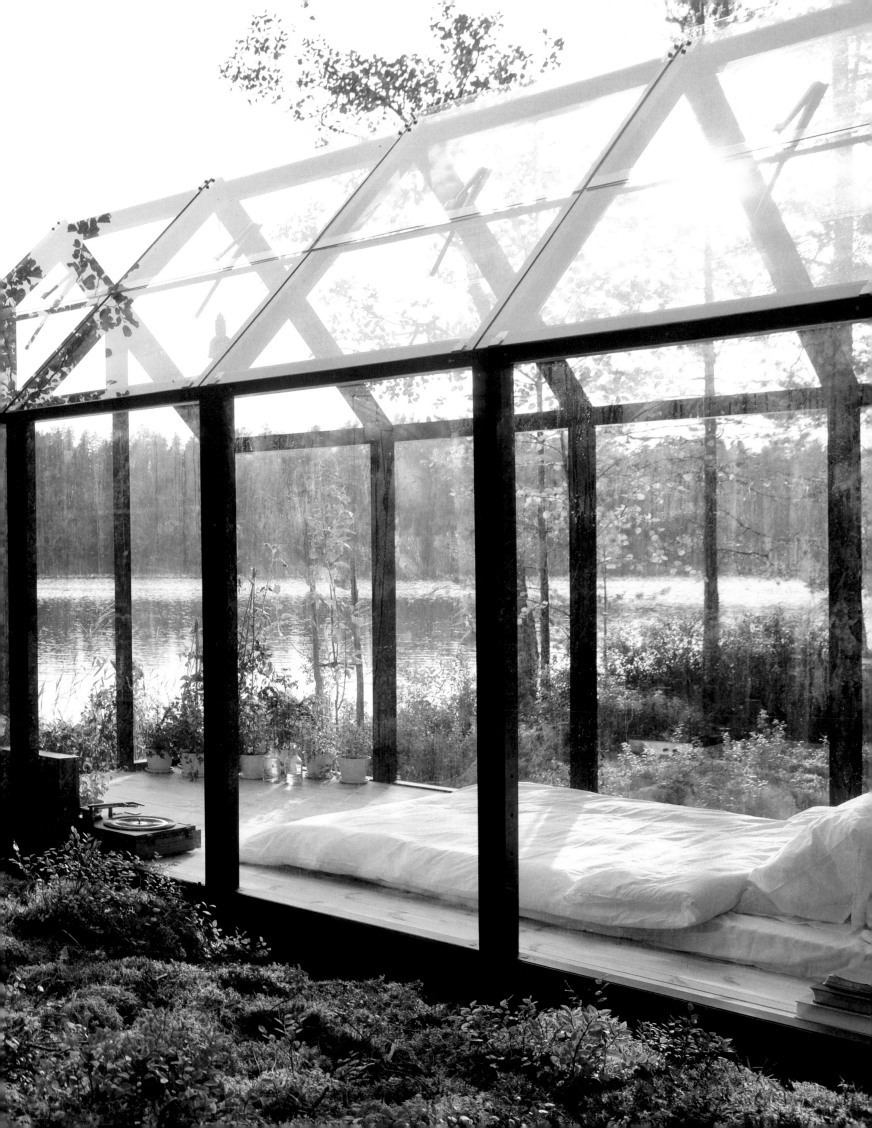

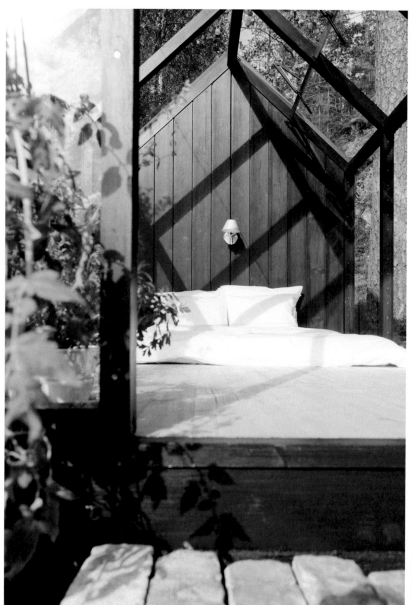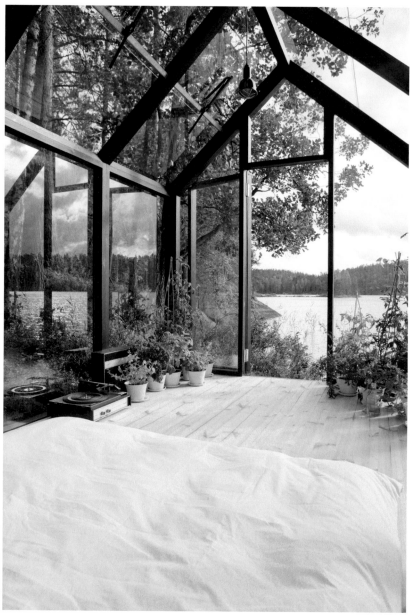

Kekkilä Garden Shed

Architect/Location: **Avanto Architects**
Uusimaa, Finland

Reviving the archetype of the primitive hut, this modular pitched roof structure uniquely combines a garden shed with a greenhouse. Four different sheds—infused with Scandinavian elegance and designed to suit all gardening dreams and garden types—can be built from the various shed modules.

This model, equipped for resting and relaxation, features a glass pergola between the shed and greenhouse. Easy to assemble and highly durable, the restful and restorative design represents the perfect choice for those who enjoy taking time out from gardening to relax with a cup of tea and admire the surroundings.

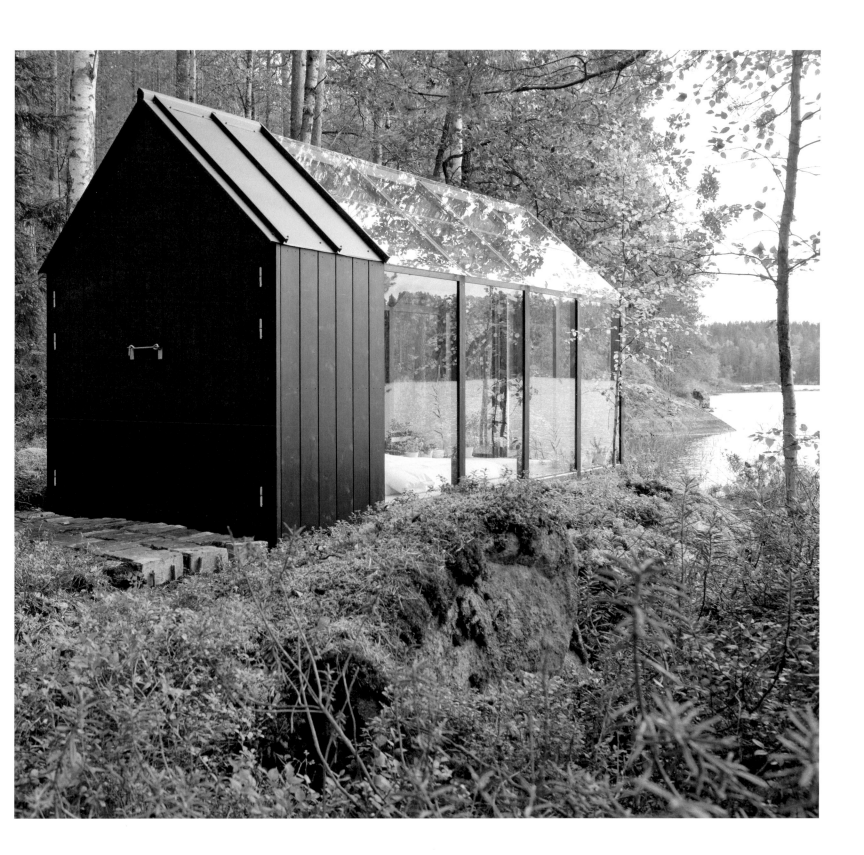

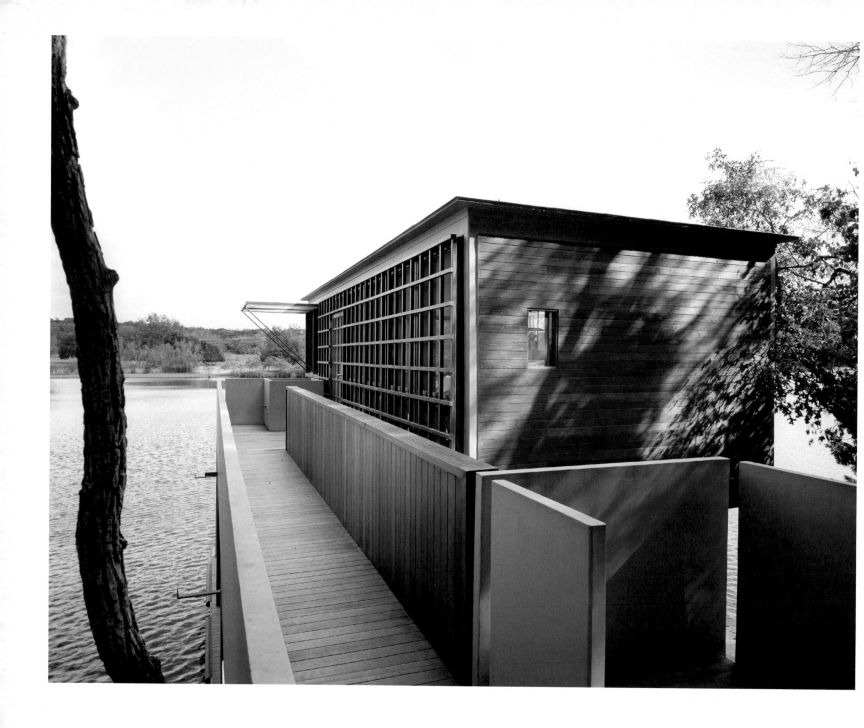

Lake House

Architect/Location: **Andersson-Wise Architects**
Southwest, USA

An inviting elevated cabin, located on the steeply sloped bank of Lake Austin, is designed as a haven for leisure. A nearly mile-long path leads visitors down the hill, over a suspension bridge spanning a ravine, and finally to the boat house. The simple, elegant, and off-grid dwelling rises above the water, resting delicately on the surface and minimally impacting its surroundings. Anchored into the rock beneath the water, the steel structure was barged to site and completed by a floating carpenter shop from the water side. The wind and lake provide natural cooling for the structure while encouraging fresh breezes to flow through the living spaces. On the north and east faces, the lower screens swing out, forming full-height openings for impromptu diving platforms. The humble boat-house offers respite from the exhaustion of the summer heat and the exertion of swimming while actively reminding its occupants of their proximity to the water.

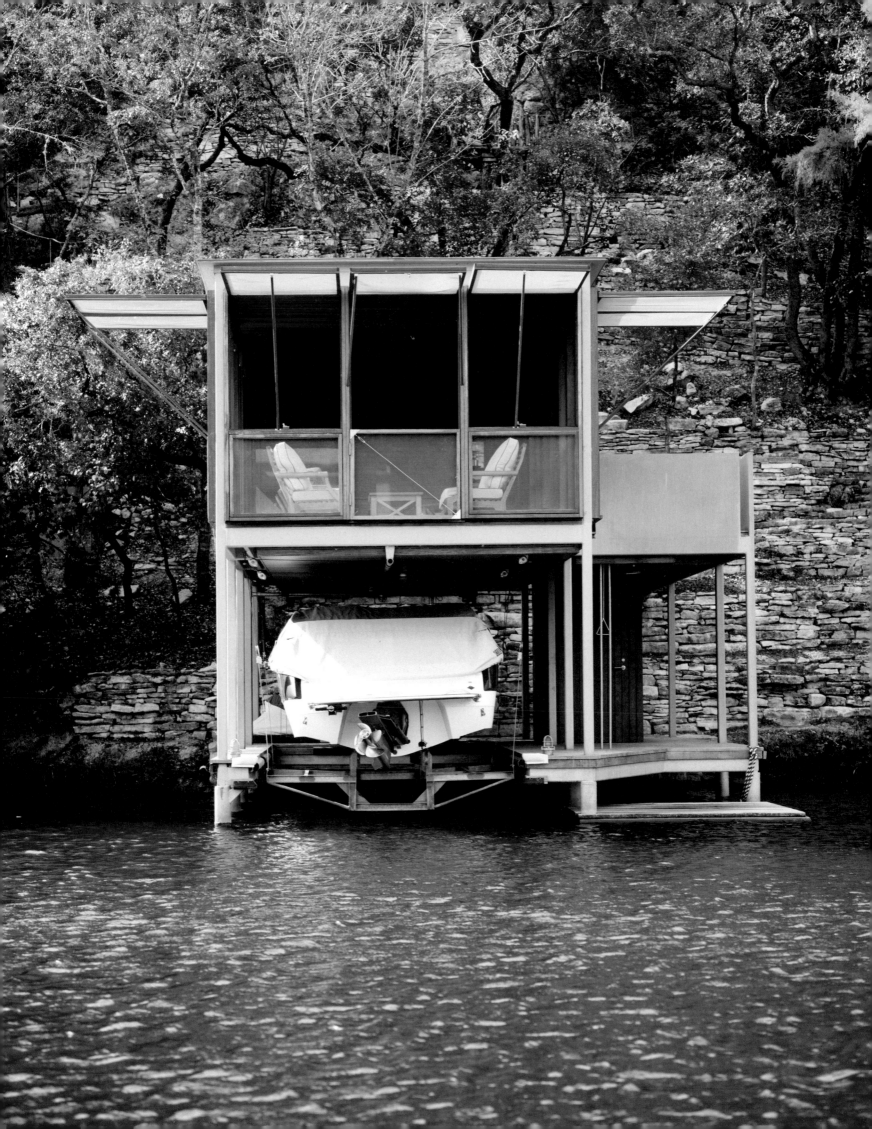

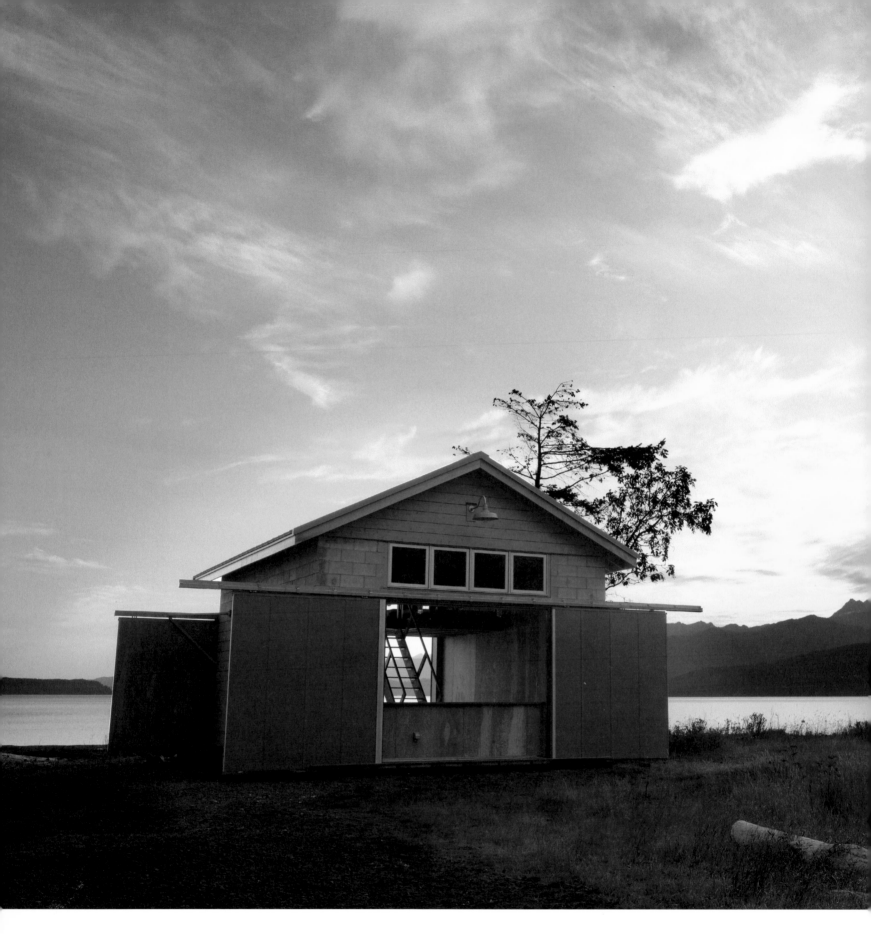

Hood Canal Boathouse

Architect/Location: **Bosworth Hoedemaker**
Pacific Northwest, USA

Beginning with an uninspired, dark, and utilitarian building, an existing boathouse from the 1950s transforms into a timeless and ethereal dwelling. As a new construction was not possible within the shoreline's setback, the re-imagined concrete boathouse serves as a fresh hub for beach activities, boat storage, and accommodating extra guests. Without altering the height or building footprint, a completely new structure grows from within. The updated shelter breathes new life and purpose into the building. Movable features crafted in local and natural materials create a series of flexible interior spaces. Oversized sliding doors connect the house to the shore, revealing the warmth of the marine plywood walls just inside. These doors form two outdoor areas on either side of the structure: one which captures the morning light and off shore breezes, and a second that revels in the rich sunsets and cool night air.

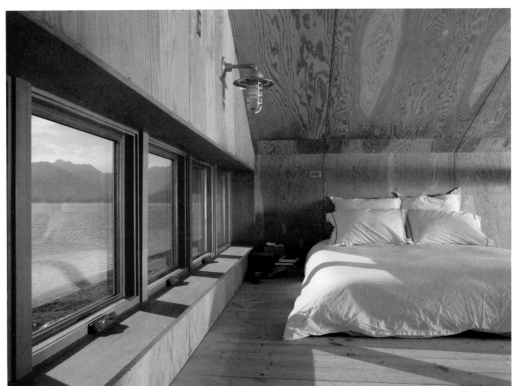
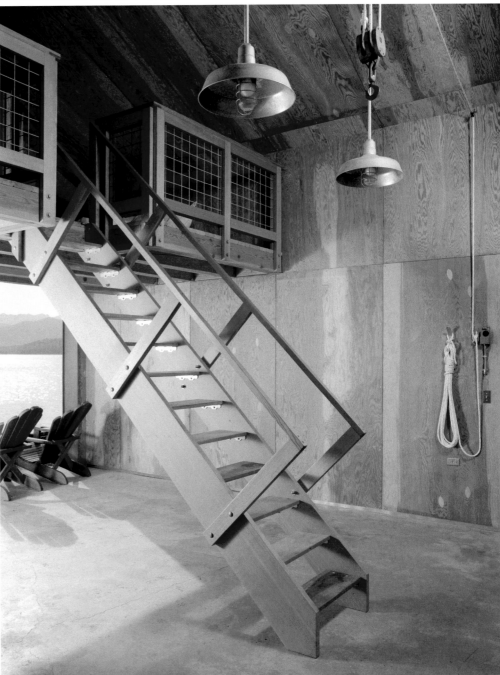

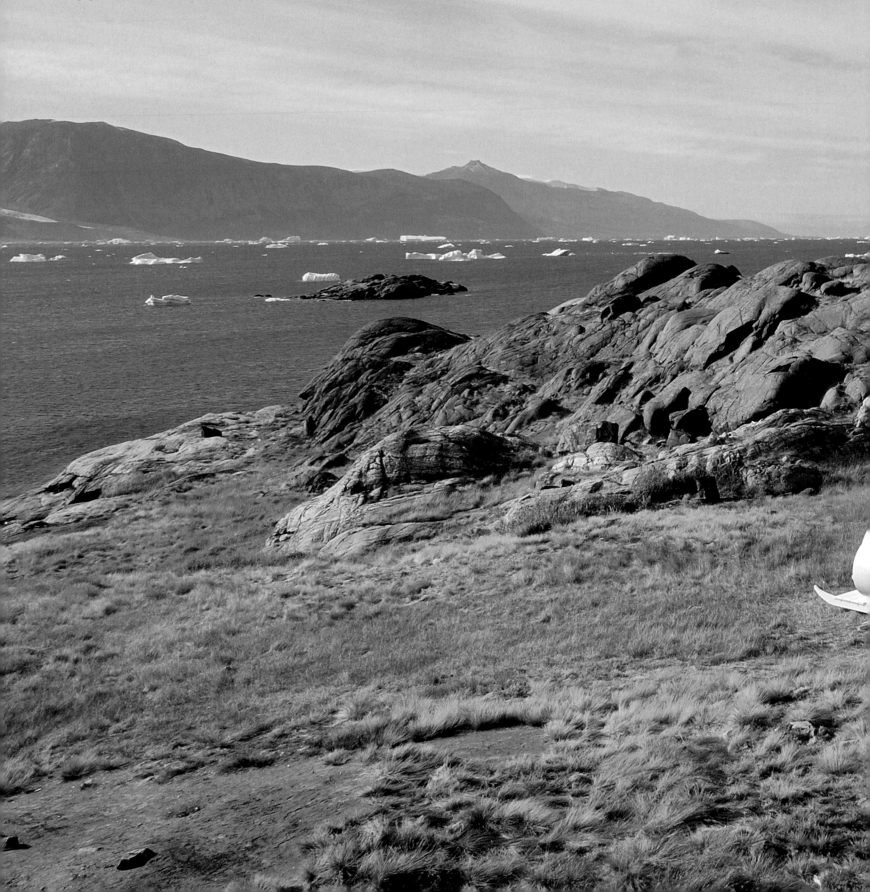

Sledge-Project

Architect/Location: **Rob Sweere**
Qaasuitsup, Greenland

Two futuristic dwellings on sleds navigate the formidable climate of a remote island in Greenland. Built for an organization that offers therapeutic rehabilitation for troubled children by pairing them with local hunters for short periods to learn the ways of the wild, the mobile and imaginative shelters can be towed with dogs or snowmobiles over sea and ice. Each hideout accommodates up to six guests. A collaborative effort between the architect, the hunters, and the children, the intimate lodgings provide cozy spaces for cooking, sleeping, and socializing. With no access to electricity and all water foraged from the ancient glaciers surrounding the island, these iconic retreats capture the local Viking spirit and answer its call to the wild.

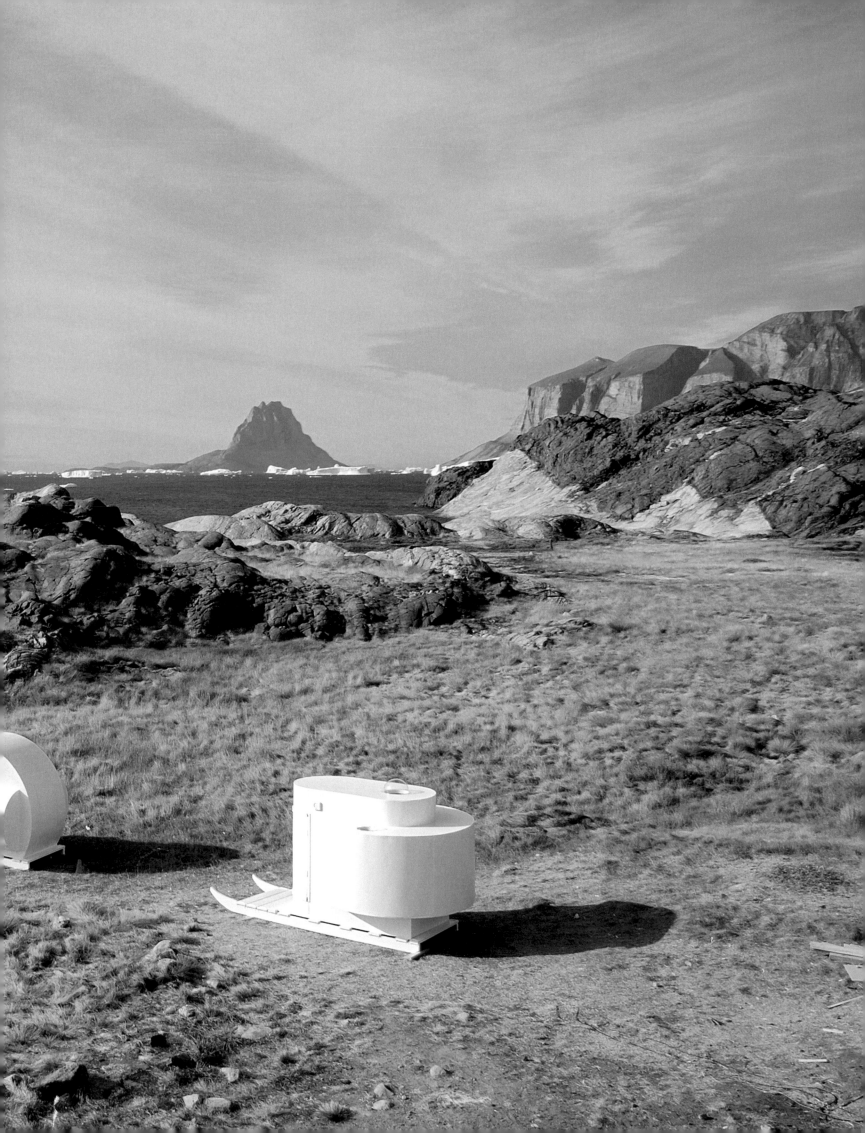

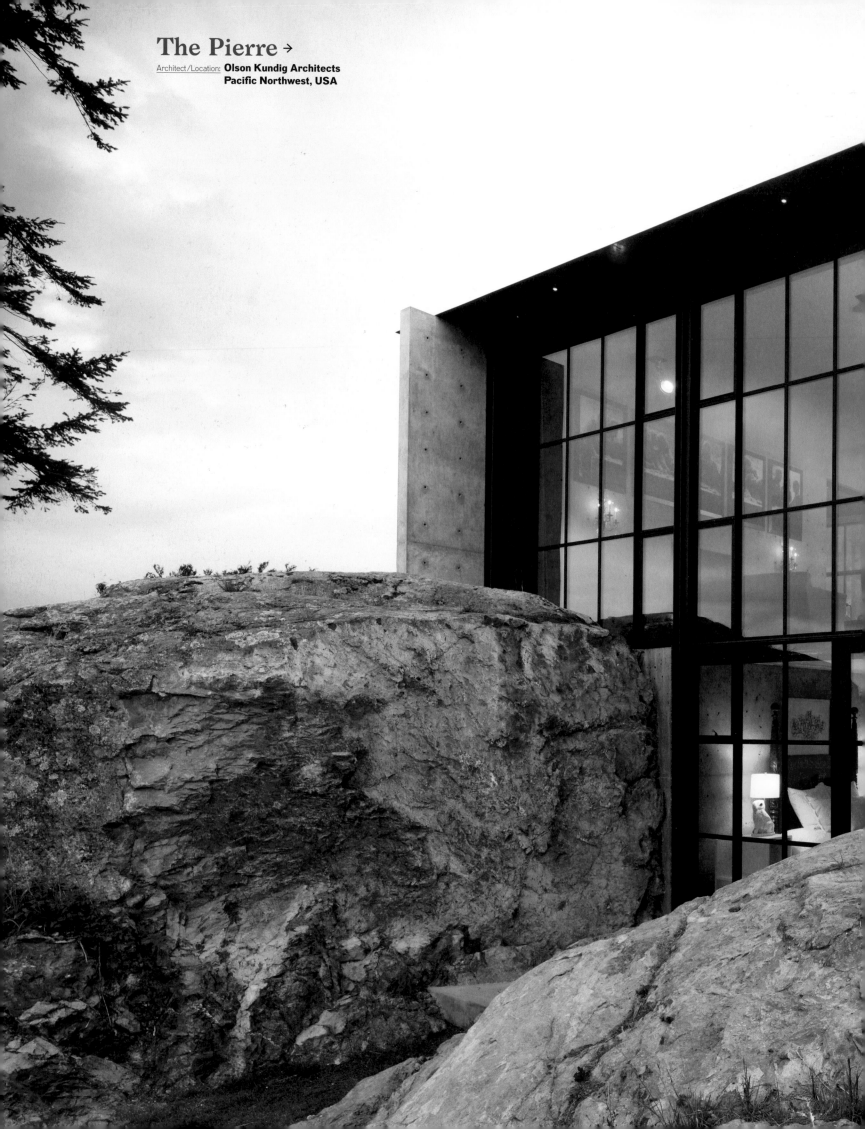

The Pierre →

Architect/Location: **Olson Kundig Architects**
Pacific Northwest, USA

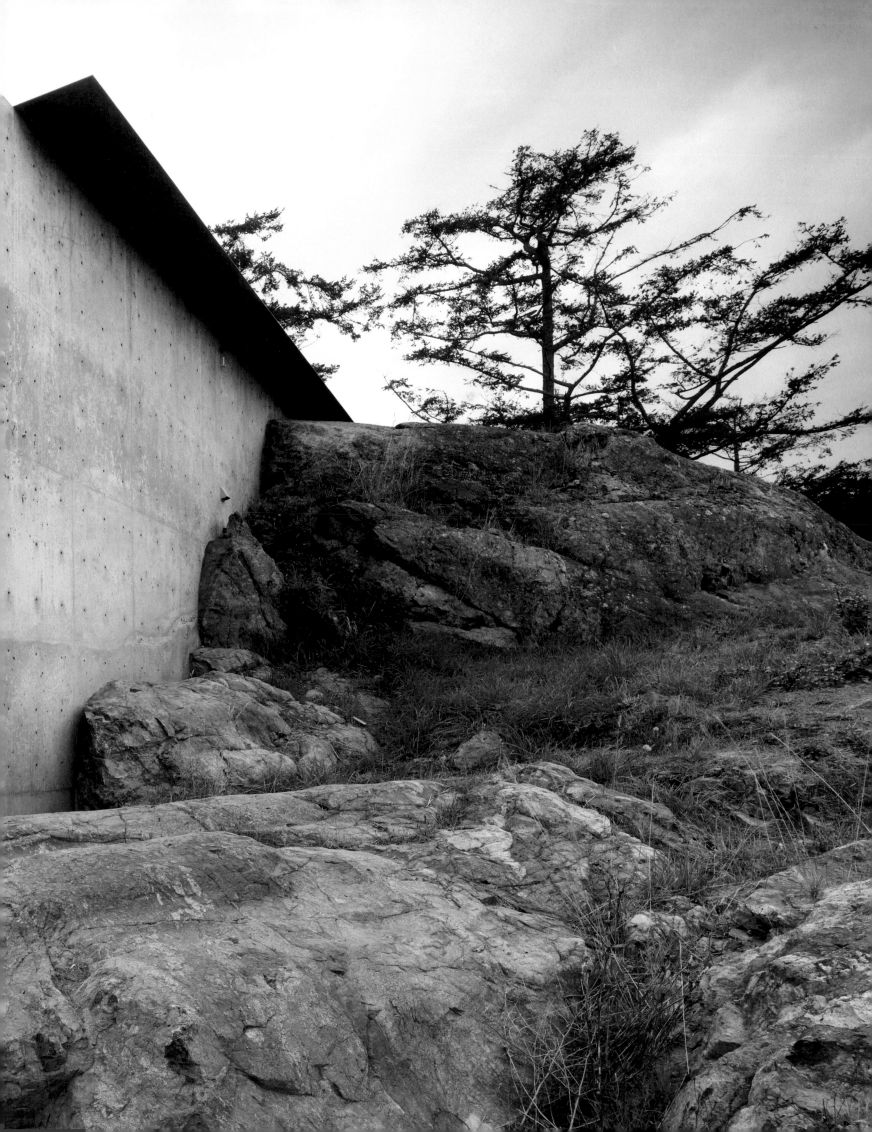

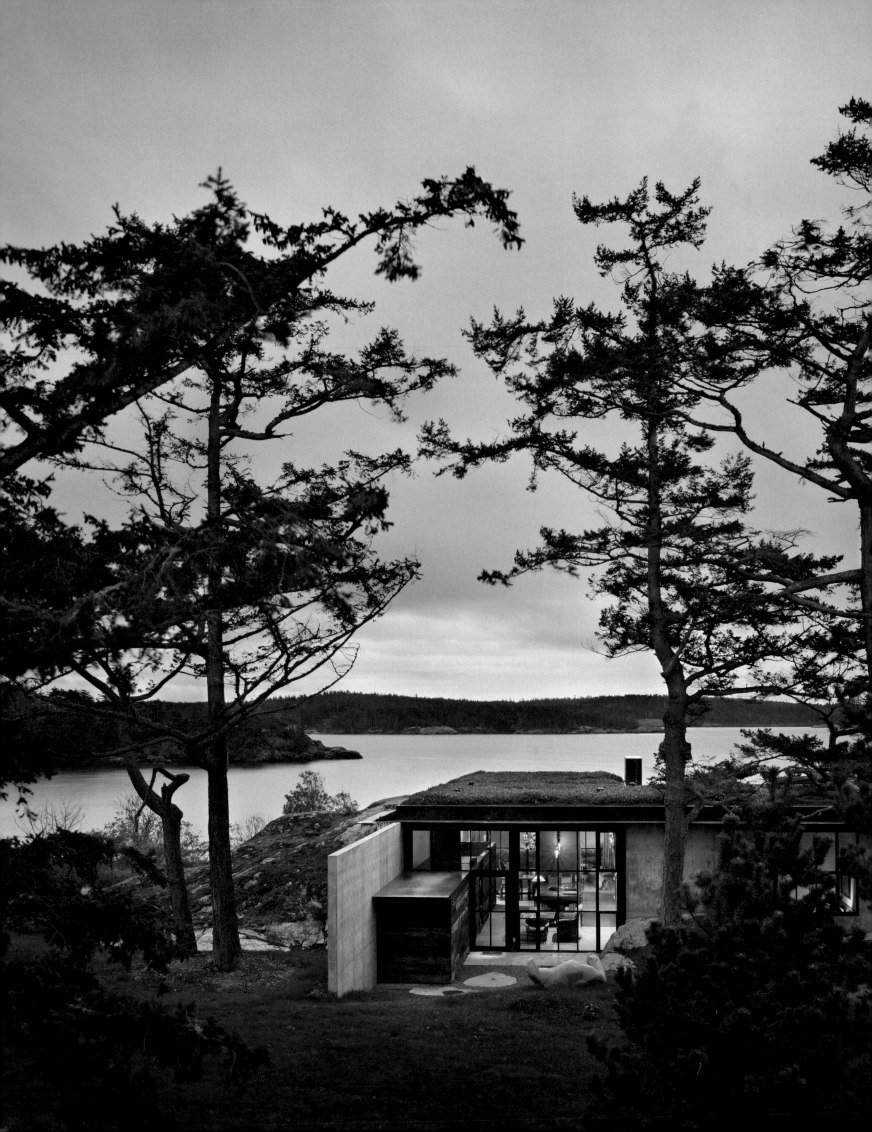

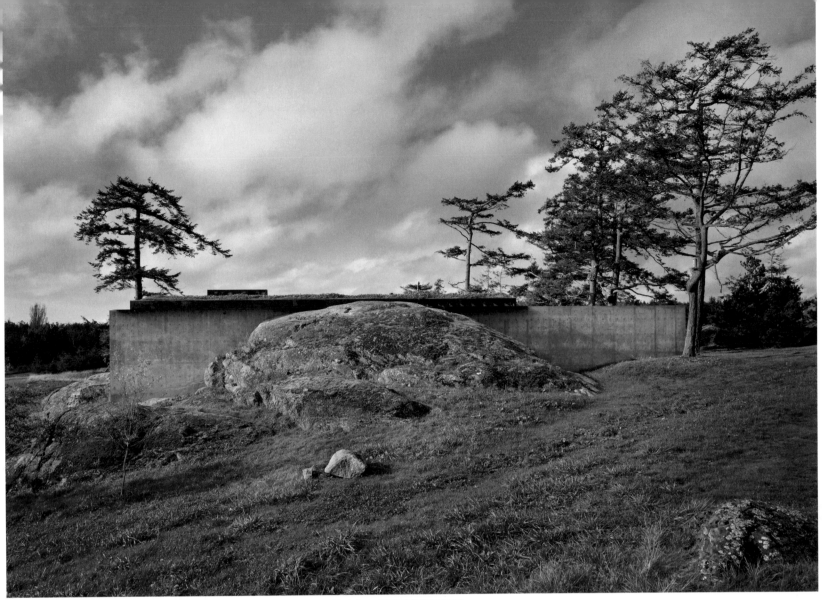

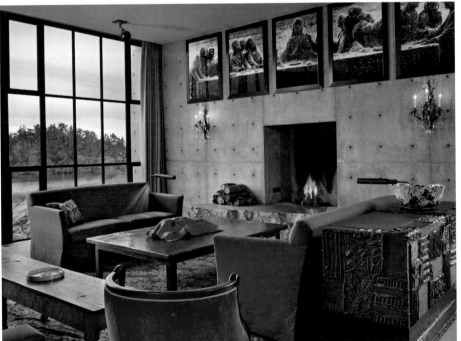

The Pierre

Architect/Location: **Olson Kundig Architects**
Pacific Northwest, USA

Conceived as a house nestled into the rock, The Pierre—French for stone—celebrates the materiality of the site and the owner's affection for a stone outcropping on her property. With its rough materiality, the house disappears into the land from certain angles. To embed the home deep into the site, portions of the rock outcropping were carefully excavated and reused as accentuating features throughout the indoor and outdoor spaces. With the exception of a separate guest suite, the retreat spreads over one main level, with an open plan kitchen, dining, and living room. Throughout the house, rock extrudes into the space, contrasting with luxurious interior textures and furnishings. Interior and exterior hearths are excavated from existing stone and left raw—much like the master bathroom sink and powder room, which are fully carved out of the rock. Exuding a stoic and captivating power, the residence represents an evolving negotiation between architecture and nature.

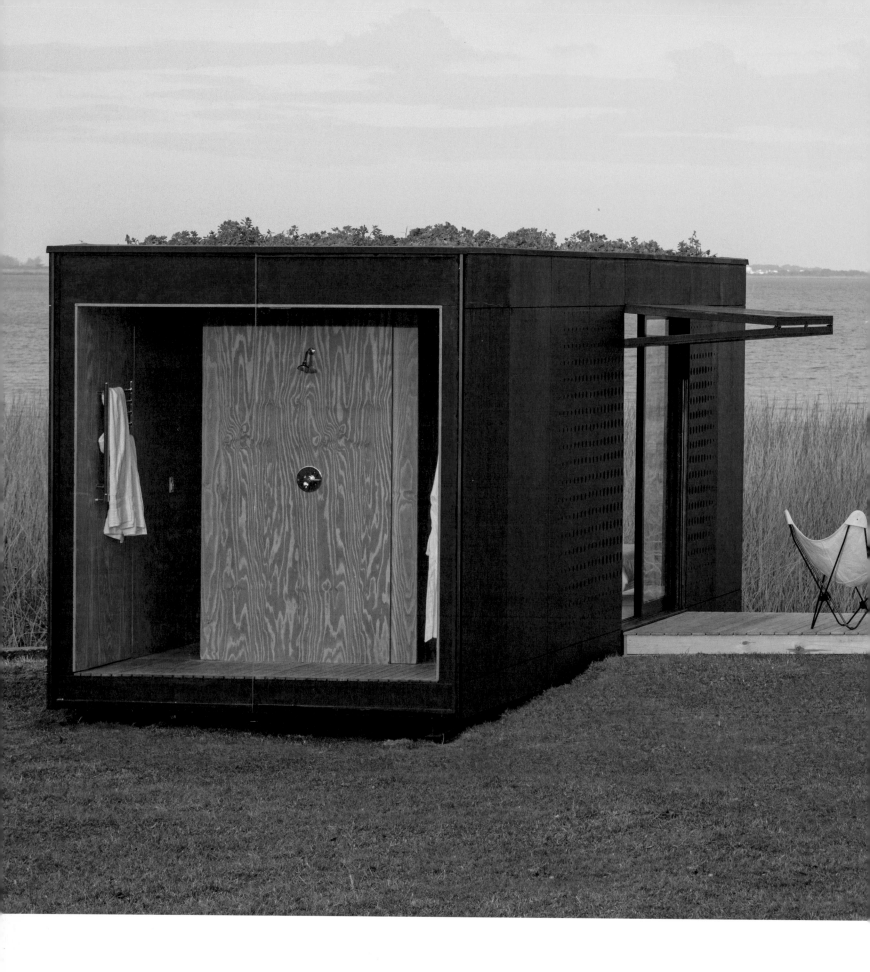

Minimod – A modular weekend cabin

Architect/Location: **MAPA Architects**
Maquiné, Brazil

A prefab modular cabin transports its occupants into the great outdoors. With the flexibility to relocate when the mood strikes, this compact hideout can comfortably host a single occupant or couple for a memorable retreat into the heart of the Brazilian wilderness. With sliding glass doors on two faces and fixed glass windows doubling as each end wall, the modest layout achieves an expansive feeling as it frames the scenic panorama on all four of its sides. The mobile and expandable cabin, complete with a green roof, consists of an open kitchen, living, and sleeping space with a bathroom and shower tucked behind. Granting the sensation of bathing outdoors, a single pane of glass is all that separates the shower from the meadow and grazing sheep just beyond. The two sliding doors open onto a covered entry on one side and a gracious sun deck on the other. Intertwining elegant comfort with nature and economy, this flexible shelter enjoys the freedom to go where the wind takes it.

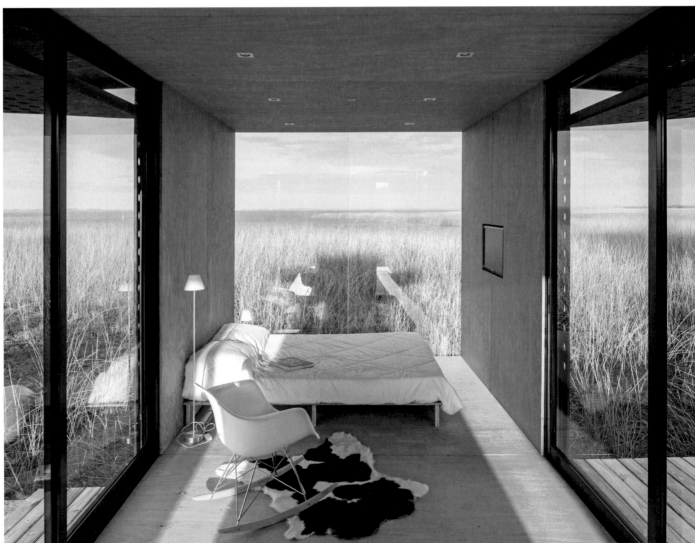

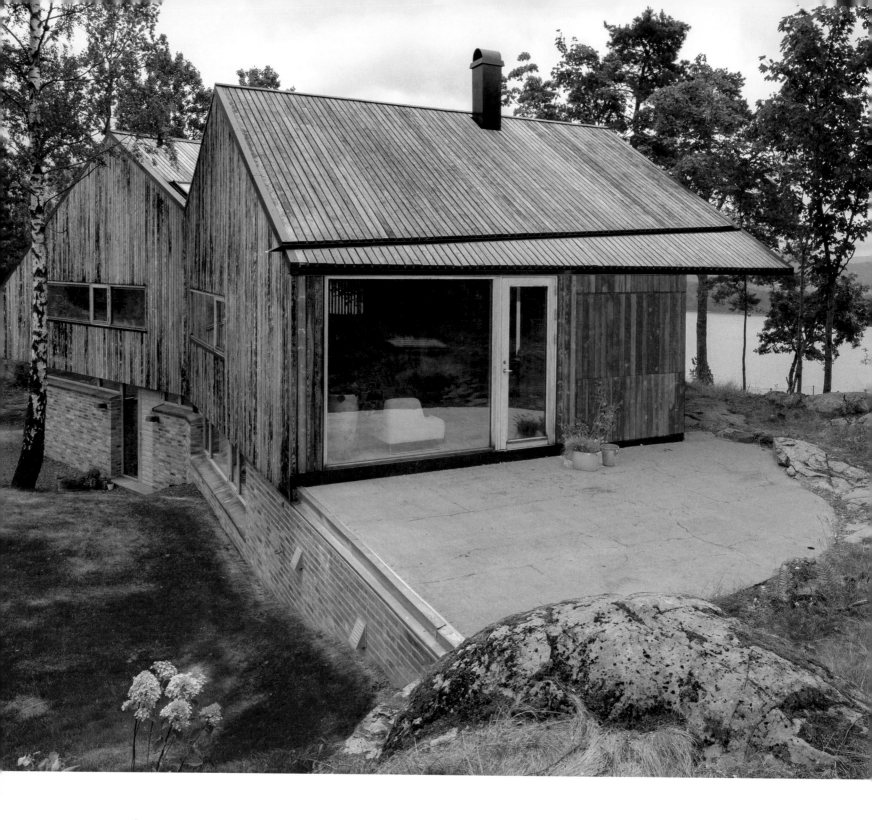

House Off / Ramberg

Architect/Location: **Schjelderup Trondahl architects**
Oslofjord, Norway

A single-family house in Southeast Norway hovers on the edge of a prominent cliff, overlooking a small city and the majestic fjords. The site features a spectacular 180 degree view towards the sea to the east and an open cultural landscape to the west. Masterfully switching between distant and close vistas, the double-gabled residence offers striking glimpses of nature that brim with sunlight and subtle reflections. The house merges with the terrain with the least possible intervention. Outfitted in hearty materials that will gracefully weather with time, the volume embraces its distinct duality as it moves from east to west. Rough but refined, the retreat's shifting façades and intersecting spaces choreograph a unique and meaningful enclosure for contemplating nature's untamed, visceral presence.

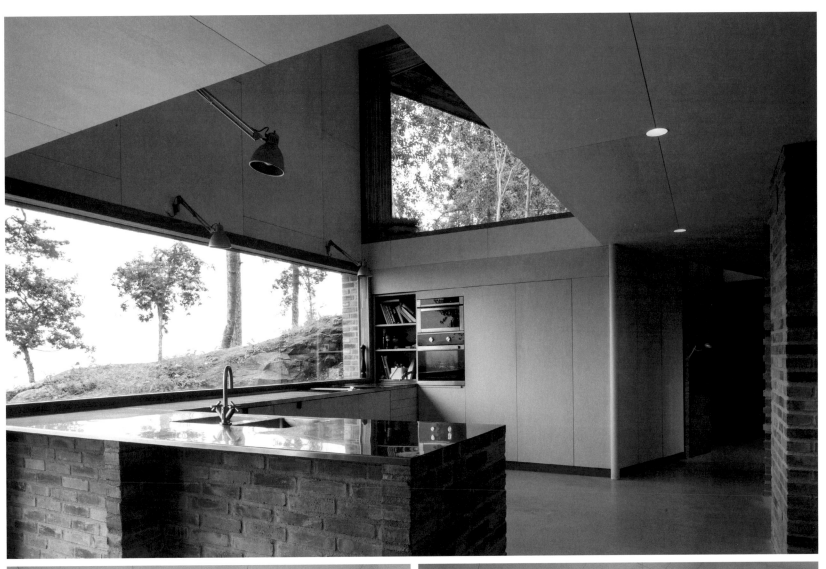

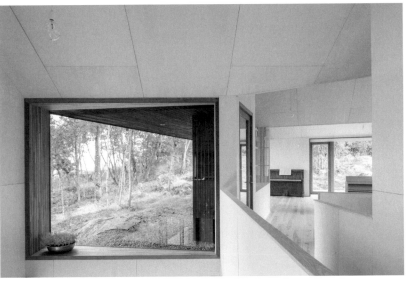

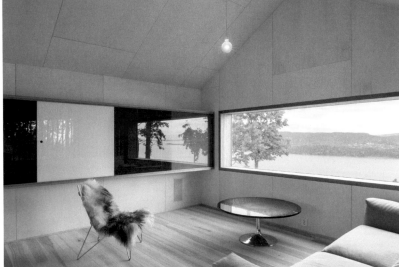

Villa Lóla

Architect/Location: **Arkís Arkitektar**
Akureyri, Iceland

Drawing inspiration from Swiss mountain cabins, a sea ranch in Northern California, and Japanese solutions for spatial efficiency, the design of this contemplative dwelling represents a close dialogue between client and architect. The low-maintenance wood house, set on a serene and expansive fjord, frames breathtaking views of the local scenery. Divided into three distinctive peaks that point towards the sky, the tilting form of the building references the qualities of the surrounding mountains, valleys, and fjord. Inside these three apartments, the layout can be enlarged or reduced as needed. The house faces the bay with unrestricted mountain vistas to the north and south. Strongly rooted in the environment, the hideout builds on the raw dignity and unique appearance of the landscape. The weathered grey larch wood structure elevates the natural gradations of the site, where natural light and arresting color combinations move through the grasses and birch wood trees.

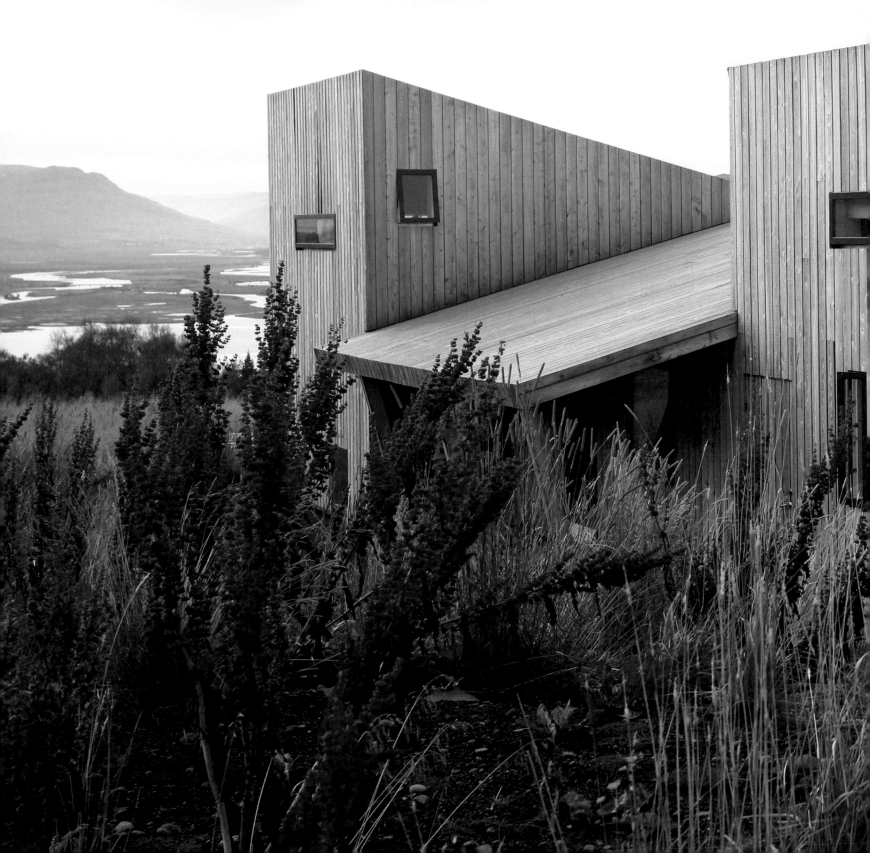

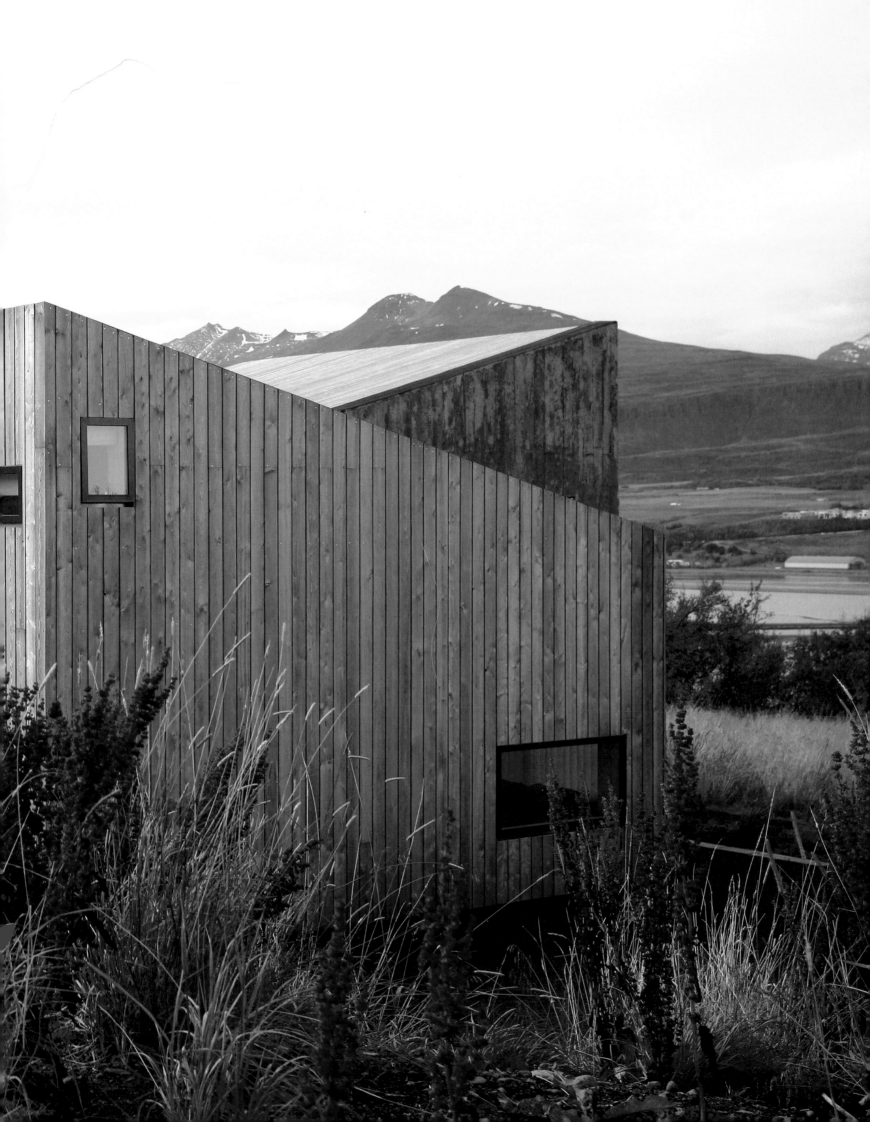

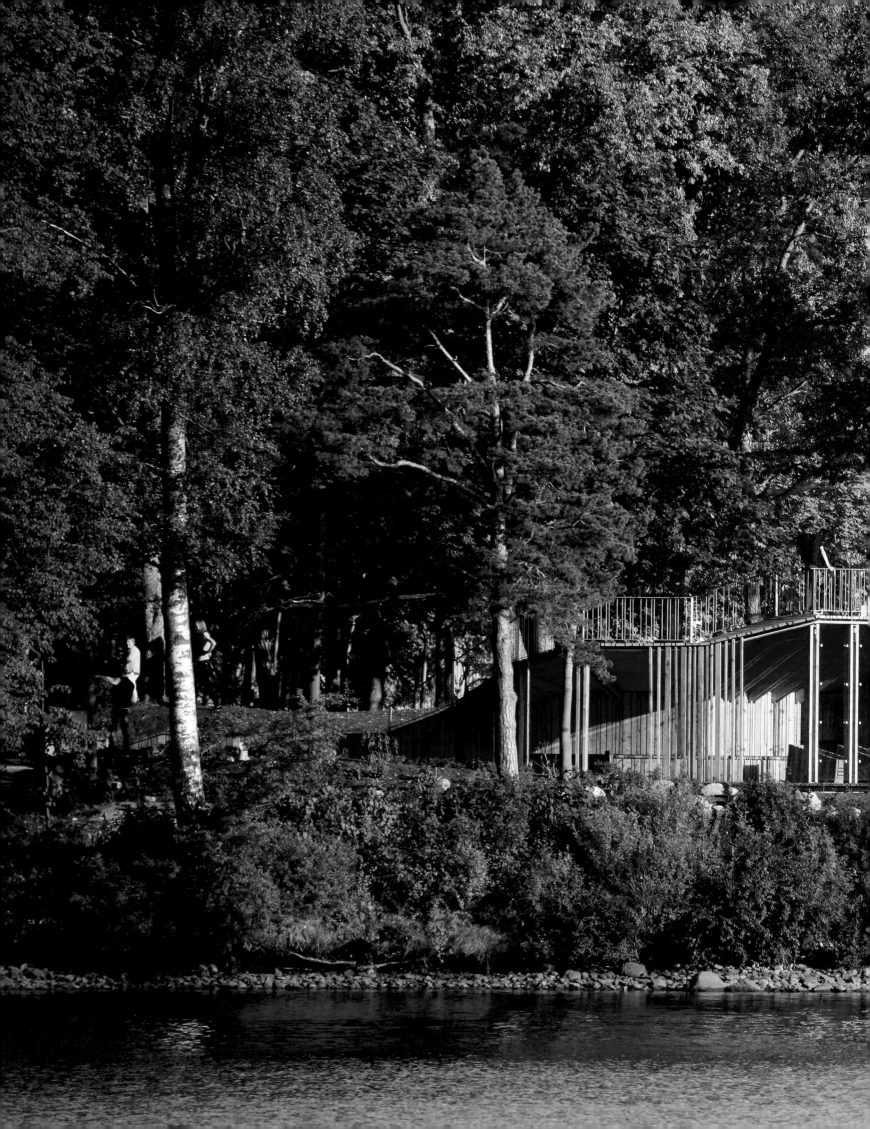

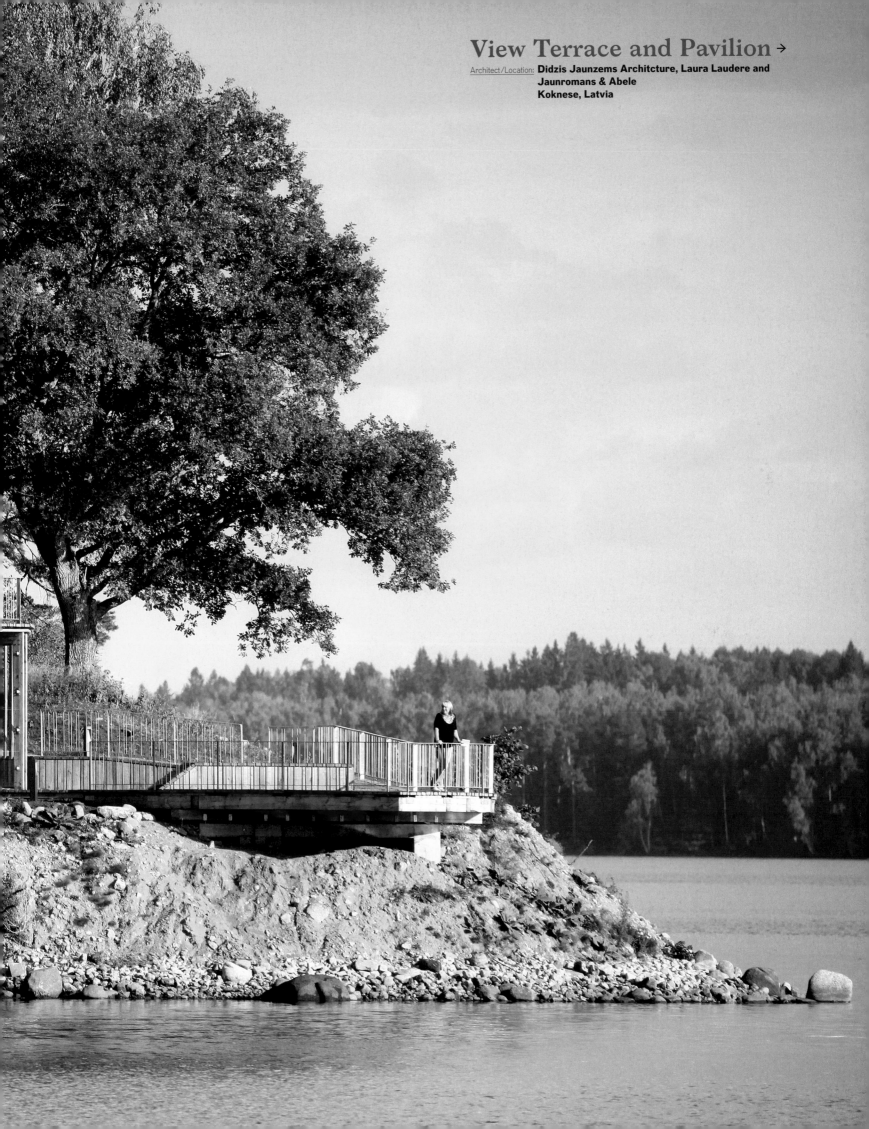

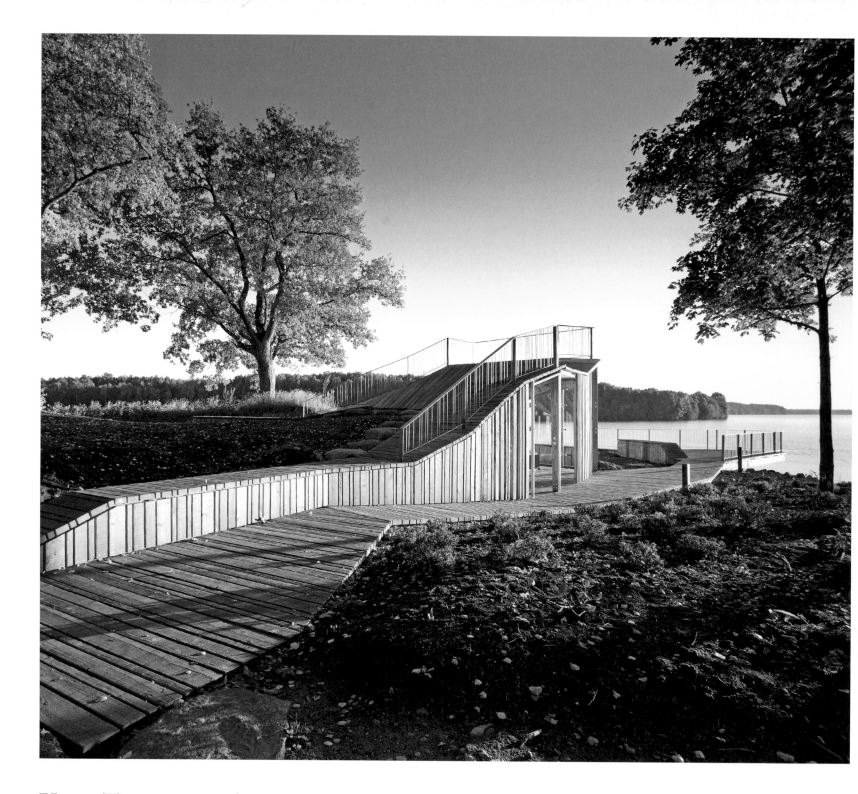

View Terrace and Pavilion

Architect/Location: **Didzis Jaunzems, Laura Laudere and Jaunromans & Abele**
Koknese, Latvia

This noble viewing terrace and pavilion appears in a public memorial garden. The shelter and outdoor walkway stage a harmonious procession to explore the environment and dream-like horizon over Daugava River. The lookout emphasizes the bond between Latvian people and nature. For those who come to mourn, the larch wood project's strong relationship to the land and water represents a source of comfort. The subtle design, partially sunken into the ground, keeps existing trees and views of the river intact as it gradually transitions from prospect to refuge, outside to inside. Covered spaces and benches act as resting points, strategically placed according to the most experiential views. The multi-purpose sequence empowers guests to choose the level of exposure and activity that emotionally suits them best. Offering year-round protection from and exposure to the elements, the humble structure funded by the people becomes a site of pilgrimage to reflect on history through the lens of nature.

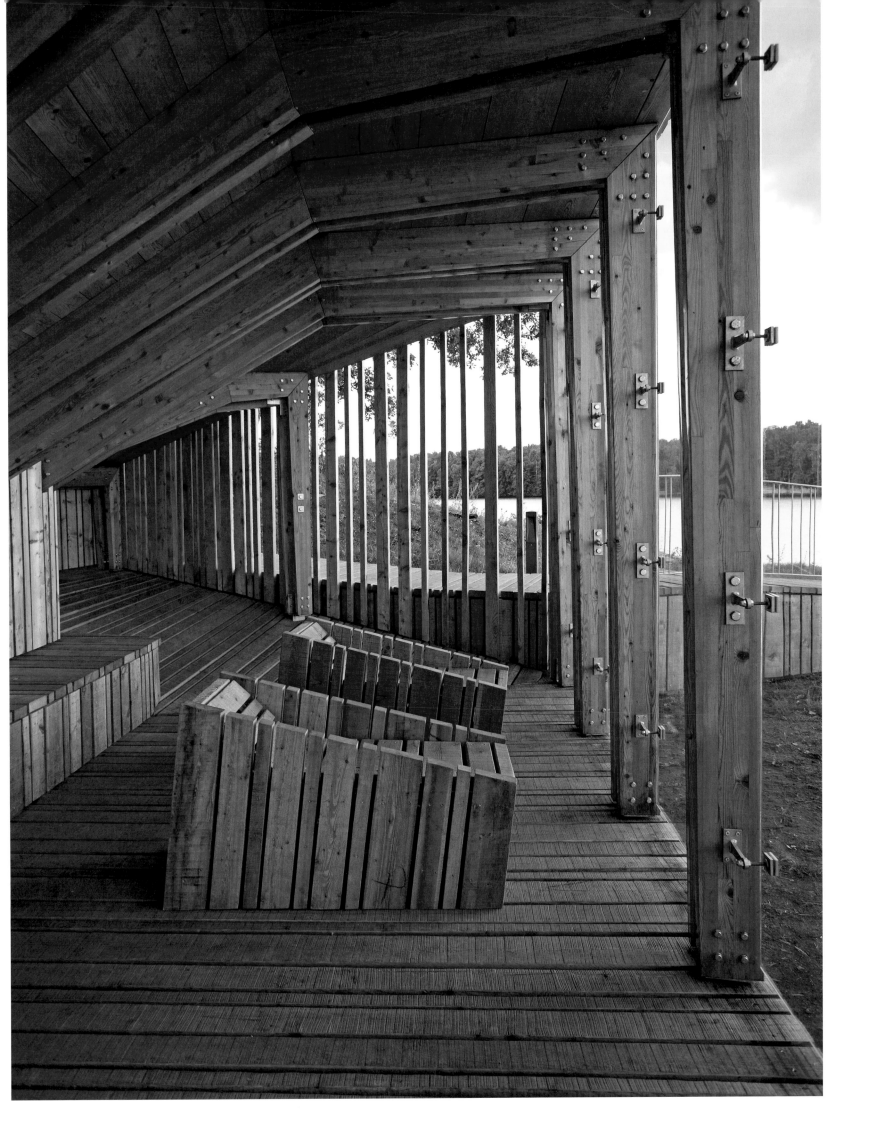

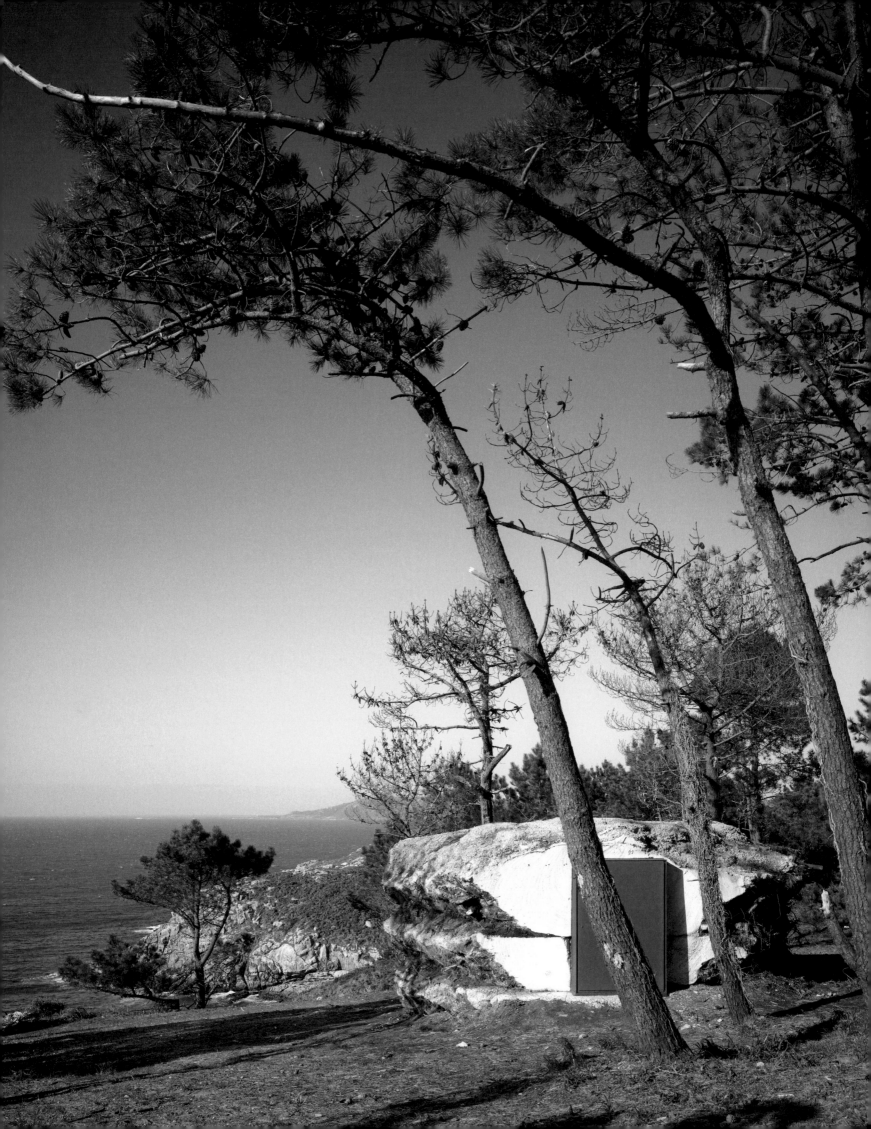

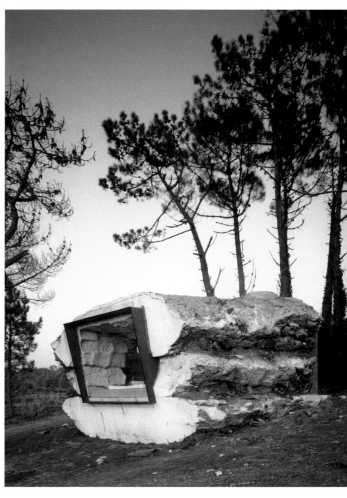

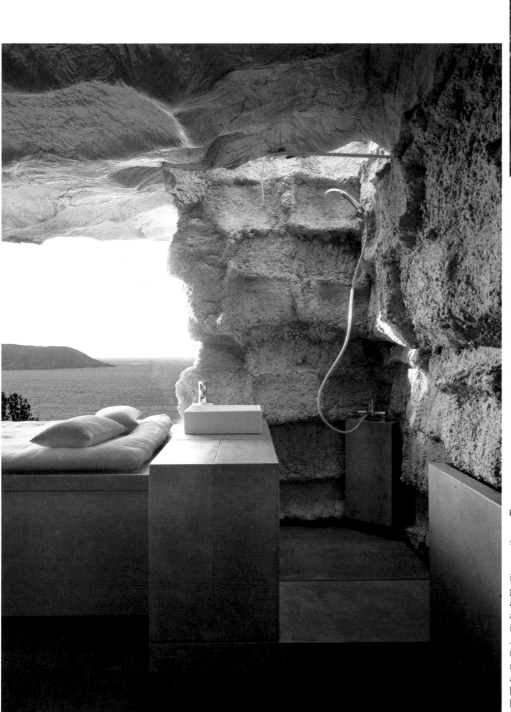

The Truffle

Architect/Location: **Ensamble Studio**
Costa da Morte, Spain

What began as a man-made stone now serves as an imaginal, organic dwelling. After tightly stacking bails of hay into the ground, a mass of concrete was poured around it to form a rugged and protective shell. Once excavated, a few cuts were made into the amorphous stone for Paulina the calf to begin eating away at the hay inside. The more Paulina ate, the more interior space was uncovered. After a year of dining, the final 25 m² interior appeared for the first time, ready for human occupation. Walking the line between the natural and man-made worlds, the fluid expression of the interior and its dense materiality dramatically highlight a sublime view of the horizon over the Atlantic Ocean. A rugged and weighty camouflaged hiding place, the subdued and tranquil shelter becomes a piece of landscape, built with earth and full of air.

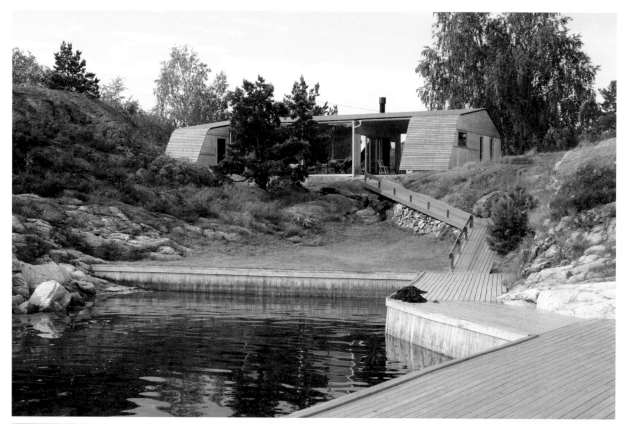

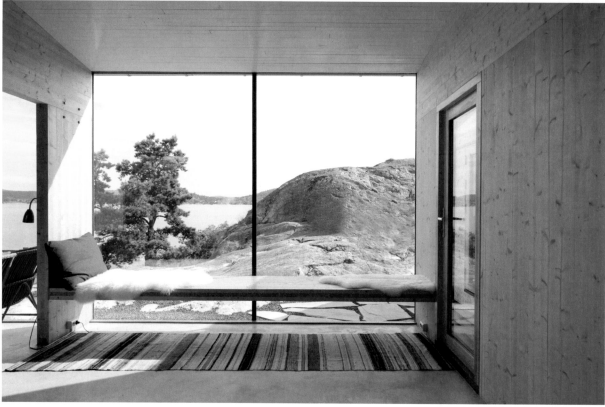

Summer House Grøgaard and Slaattelid

Architect/Location: **Knut Hjeltnes Architects**
Kragerø Archipelago, Norway

A small timber summer house grows out of the rocks and extends down the site to meet the water. Two rounded wooden arms, one shorter and one longer, hold the more private programs and frame an open glass volume in the center that overlooks the sea. Promoting links to the one-of-a-kind outdoor setting, a concrete terrace acts as a welcoming pause in the rugged micro topography. This terrace, partially clad in wood, doubles as the foundation for the entire house and creates a network of interior and exterior rooms. All space are covered by a shared roof that bends down towards the earth. The inside of this tent-like roof is painted in six different colors, a tribute to the traditional timber houses found along the Scandinavian coast.

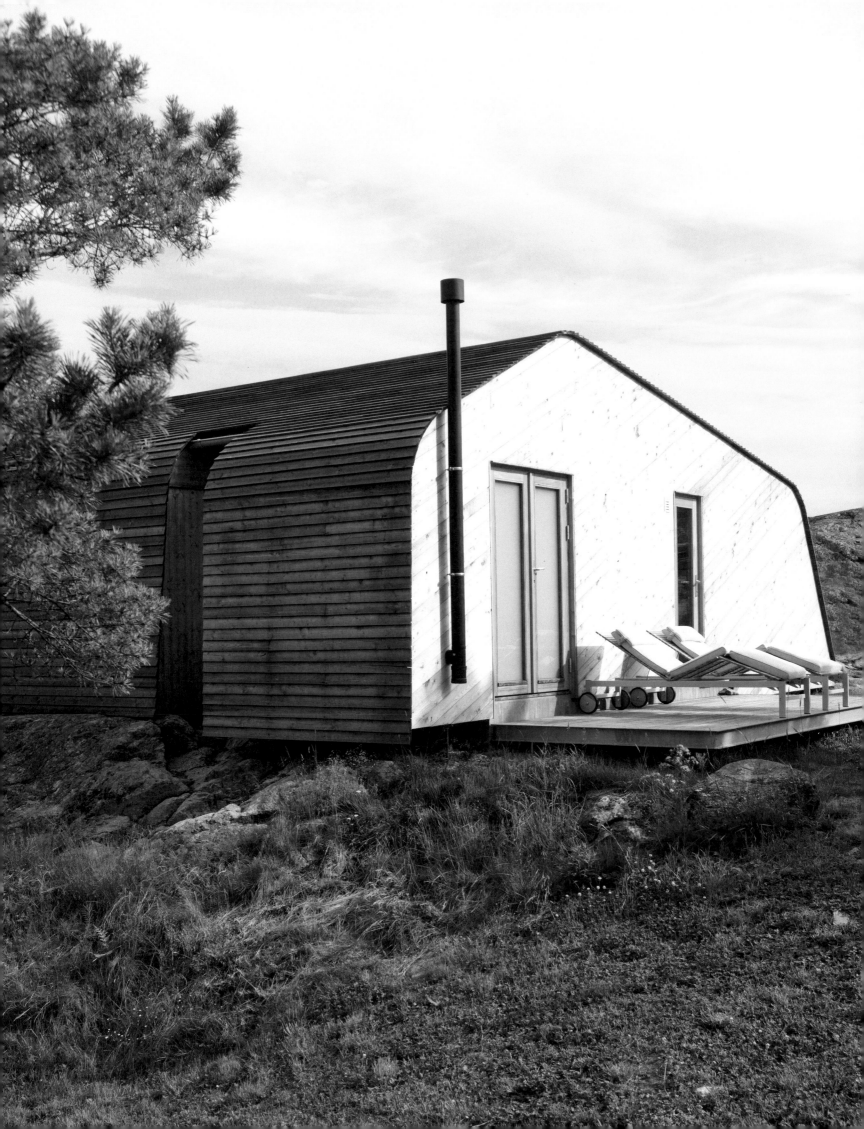

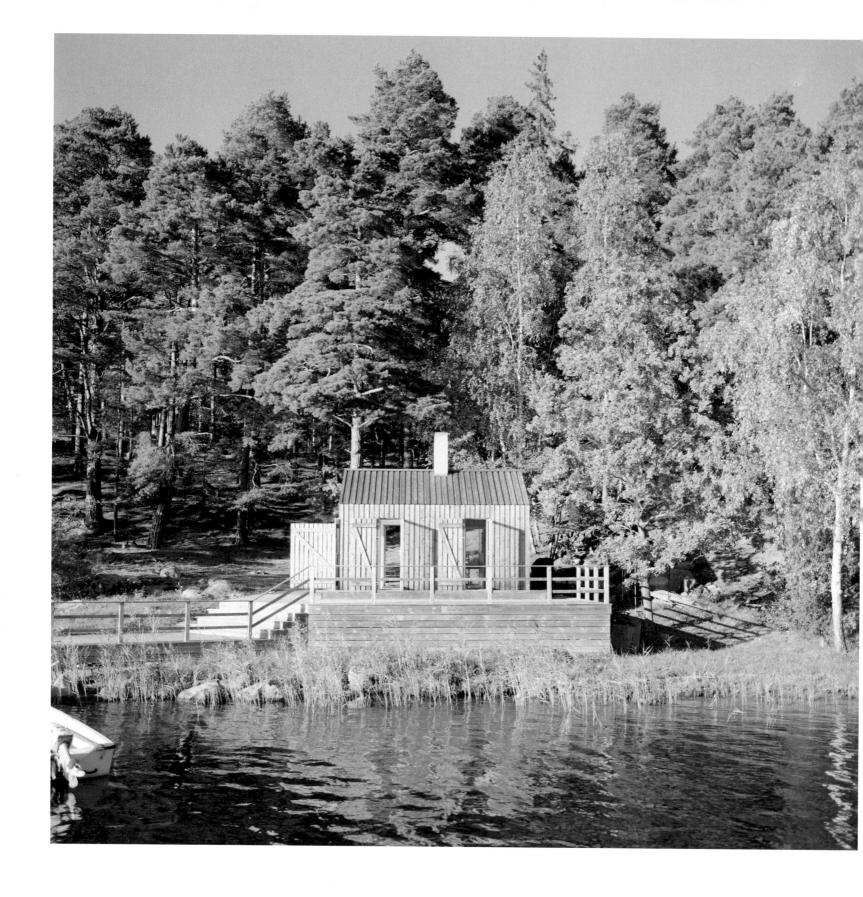

Sauna

Architect/Location: **General Architecture**
Stockholm Archipelago, Sweden

Situated in the pristine archipelago of Stockholm, a small sauna nestles by the water's edge. The classically shaped structure, clad in larch wood panels, reads as a tiny house from a distance. When not in use, the building can be completely closed up. Otherwise, the paneled doors of the façade open out towards the surrounding landscape and a generous sun terrace. The warm, unweathered finish of the larch wood gives the sauna a soothing and organic character. Channeling a timeless Scandinavian design sensibility, the tranquil and bright interior looks out over the water and offers a rejuvenating space for relaxation. An extension of the forest, the unpretentious sauna maintains its distinctive allure throughout the changing seasons.

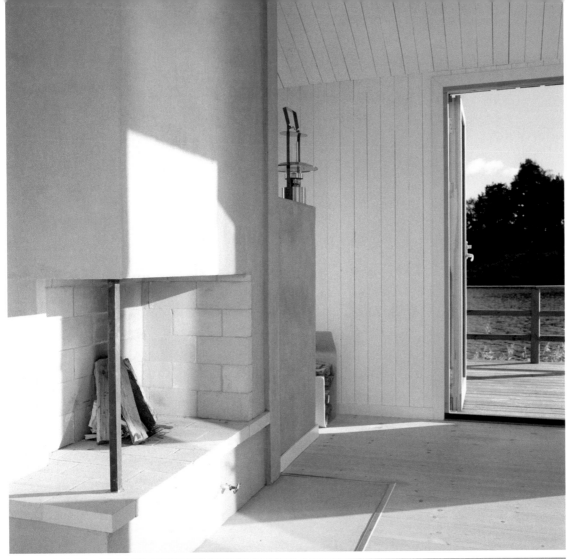

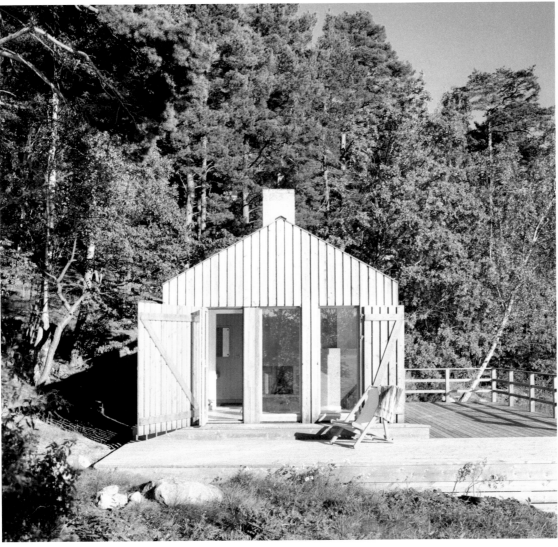

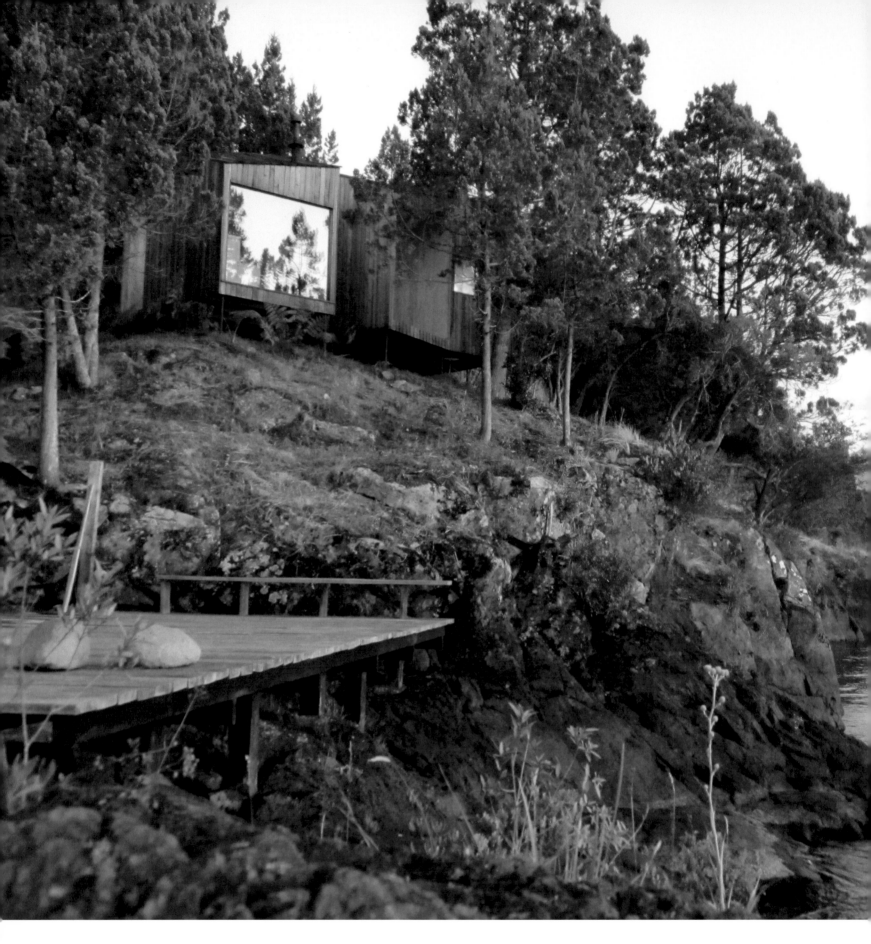

Sauna

Architect/Location: **Panorama**
Los Ríos, Chile

Looking out over a placid lake, an unassuming sauna, terrace, and changing room settle into a dark granite rock at the shore. Each of the three interlocking spaces frame unique views of the picturesque setting. Elevated on stilts and surrounded by cypress trees, the humble structure appears to hover above the earth. Naturally aging oak wood wraps the exterior of the hideout's angular form. Continuing to grey over time in the face of the site's harsh weather conditions, the structure will gradually disappear between the trees. By contrast, the warm and meditative interior uses a brighter cottonwood cladding. Safely protected from the elements, the simple sauna acts as an exhilarating threshold for relaxation and observation.

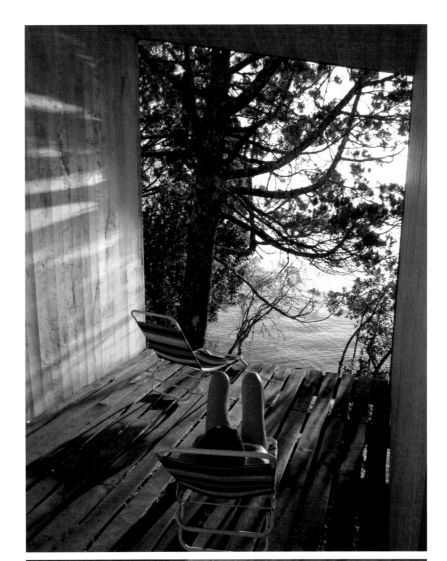
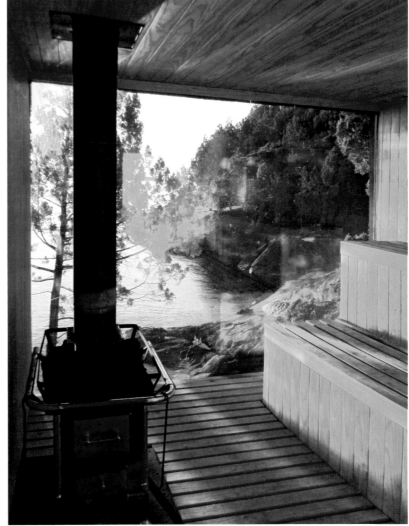

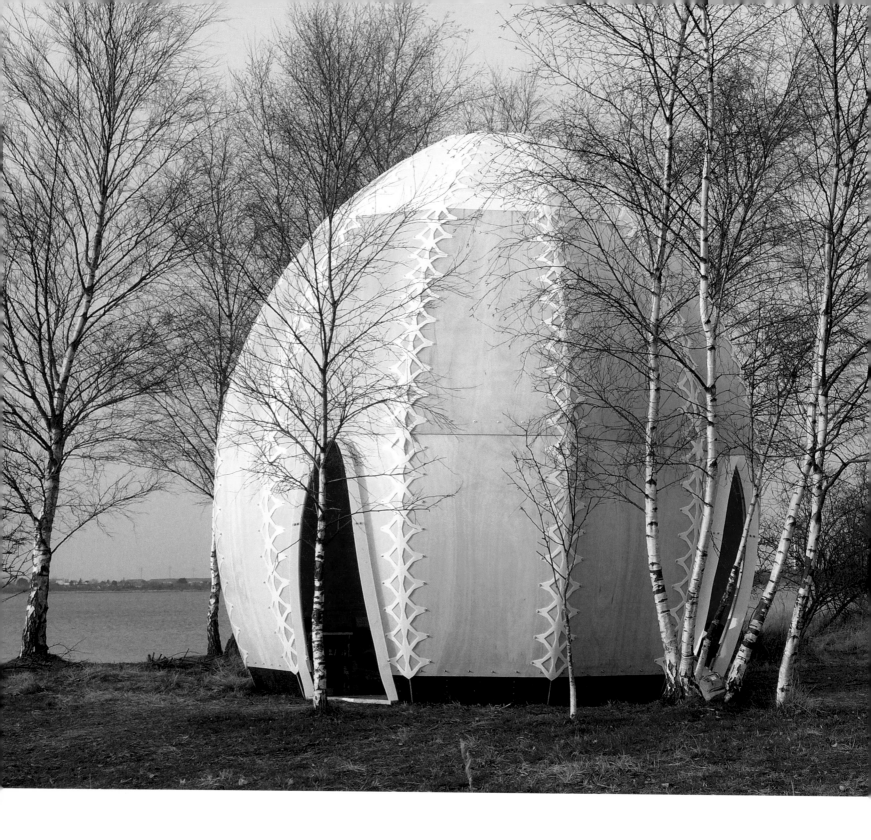

Fire Shelter: 01

Architect/Location: **Simon Hjermind Jensen**
Capital Region of Denmark, Denmark

The egg-like shelter takes inspiration from the architecture of nomadic people. Composed of CNC fabricated plywood stitched together with a polycarbonate structure, the hideout stretches upward towards the sky. The thin and bendable shell, reminiscent of a primitive tepee dwelling, introduces one hole in the top and two circulation openings at the bottom to promote natural ventilation. Inside, a simple bench encircles the perimeter and draws visitors towards the central fire place. White transparent polycarbonate coats the upper part of the shelter, bringing in sunlight during the day and transmitting the warm glow of the fire out into the landscape by night. Intended to stand for a year, the ephemeral shelter serves as a gift to the area and those who wish to use it. A beacon of rebirth on soil once blighted by landfills, this public hideout celebrates the simple pleasures found in the company of good friends as they gather around the fire.

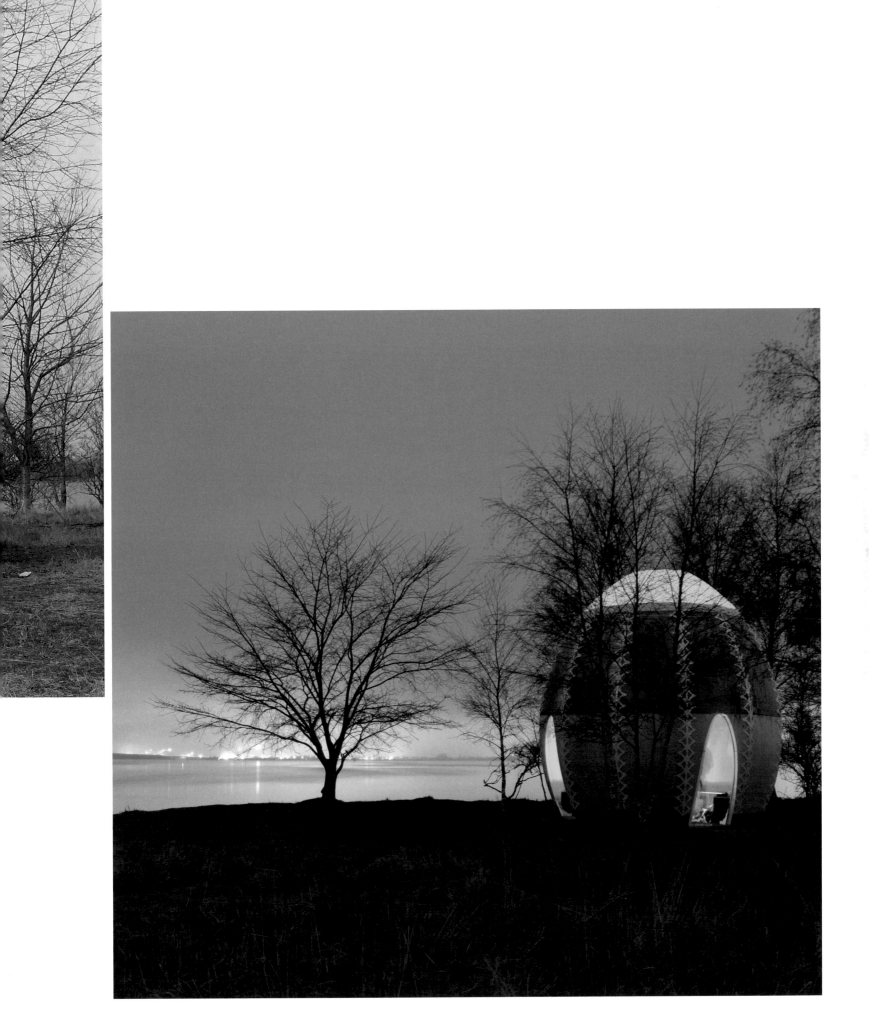

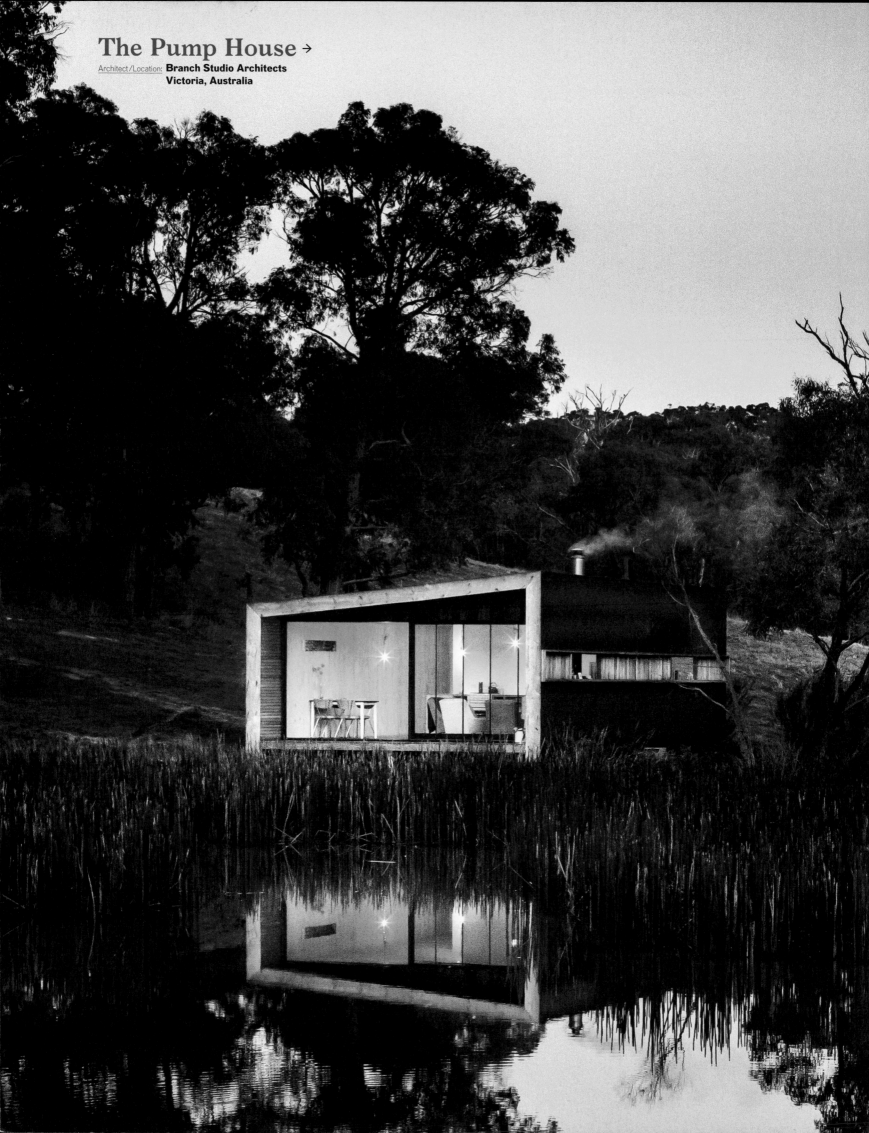

The Pump House →

Architect/Location: **Branch Studio Architects**
Victoria, Australia

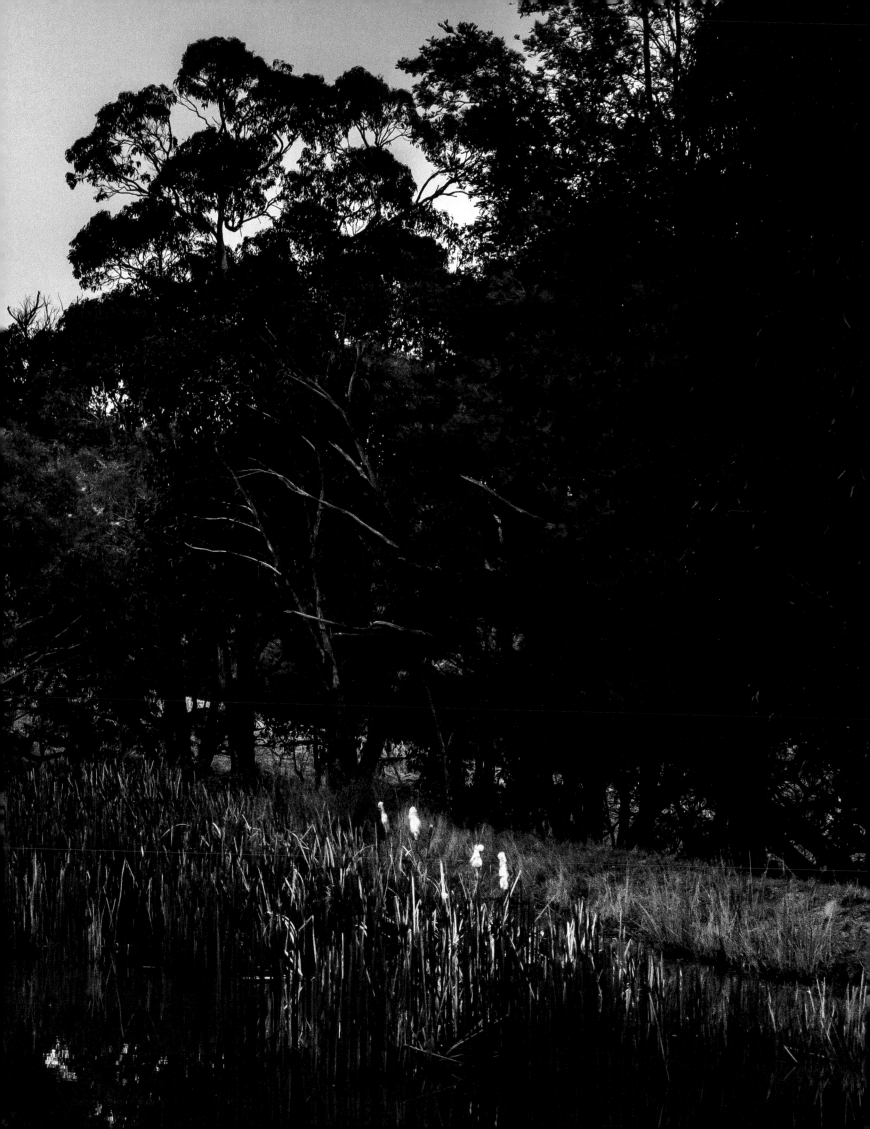

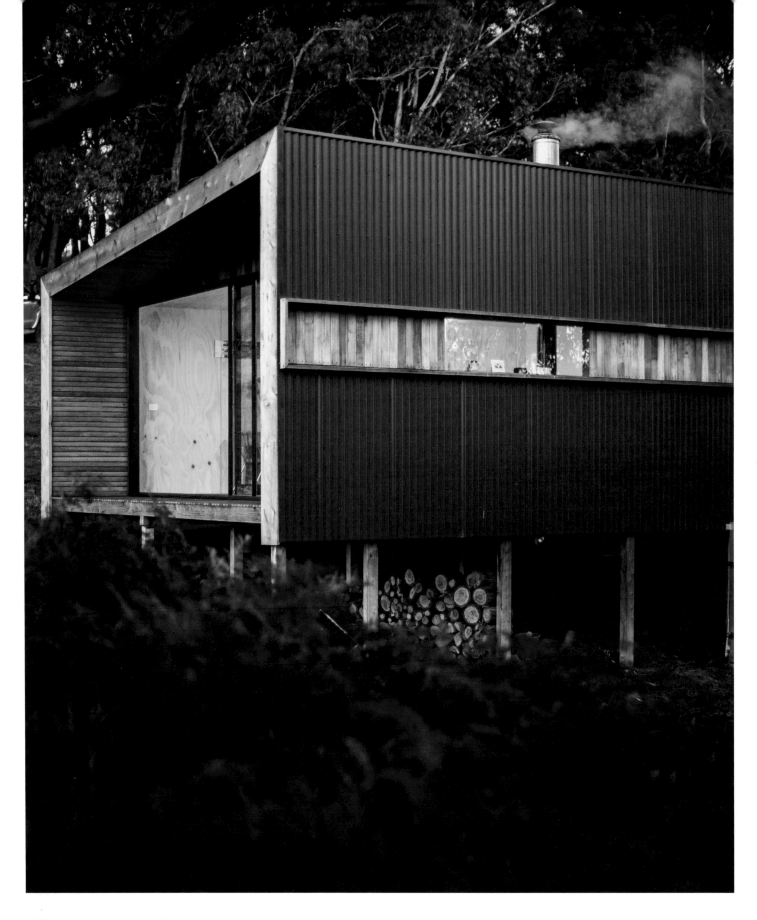

The Pump House

Architect/Location: **Branch Studio Architects**
Victoria, Australia

This transcendent lakeside cabin stands as a compact, re-locatable structure that exudes a casual and meditative atmosphere. The simple retreat lightly perches on stilts between the paddocks and wilderness. Celebrating the ordinary, the small dwelling encourages an uncomplicated life. The semi-permanent off-grid structure combines robust agricultural materials with old-fashioned craftsmanship. Large expanses of glazing allow sunlight and green vistas to pass through, promoting a sense of spaciousness. The black boxy exterior forms a protective cocoon within the landscape, contrasting with the warm, timber-lined internal spaces. Inset into the exterior volume, the interior gains two slender wooden decks for admiring the water and keeping an eye on the family horse. Both a storage space for farm equipment and a splendid haven for weekend relaxation, the ruggedly graceful shelter invites its owners to observe the afternoon light as it filters through the treetops and refracts off the lake.

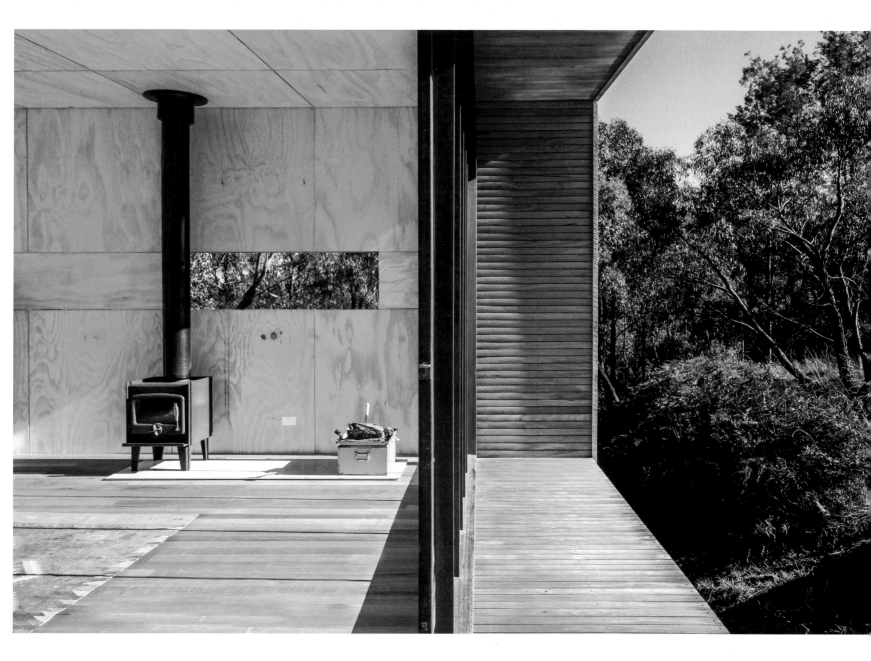

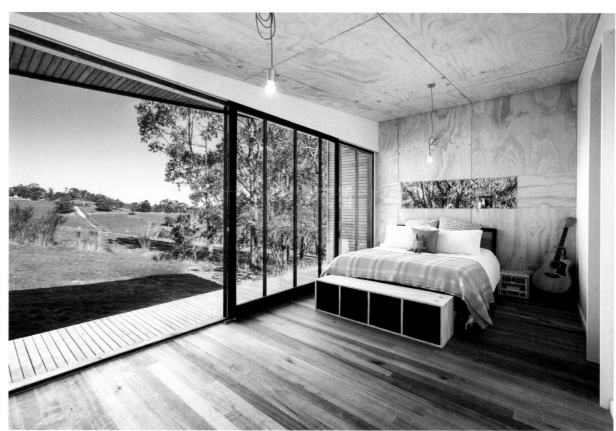

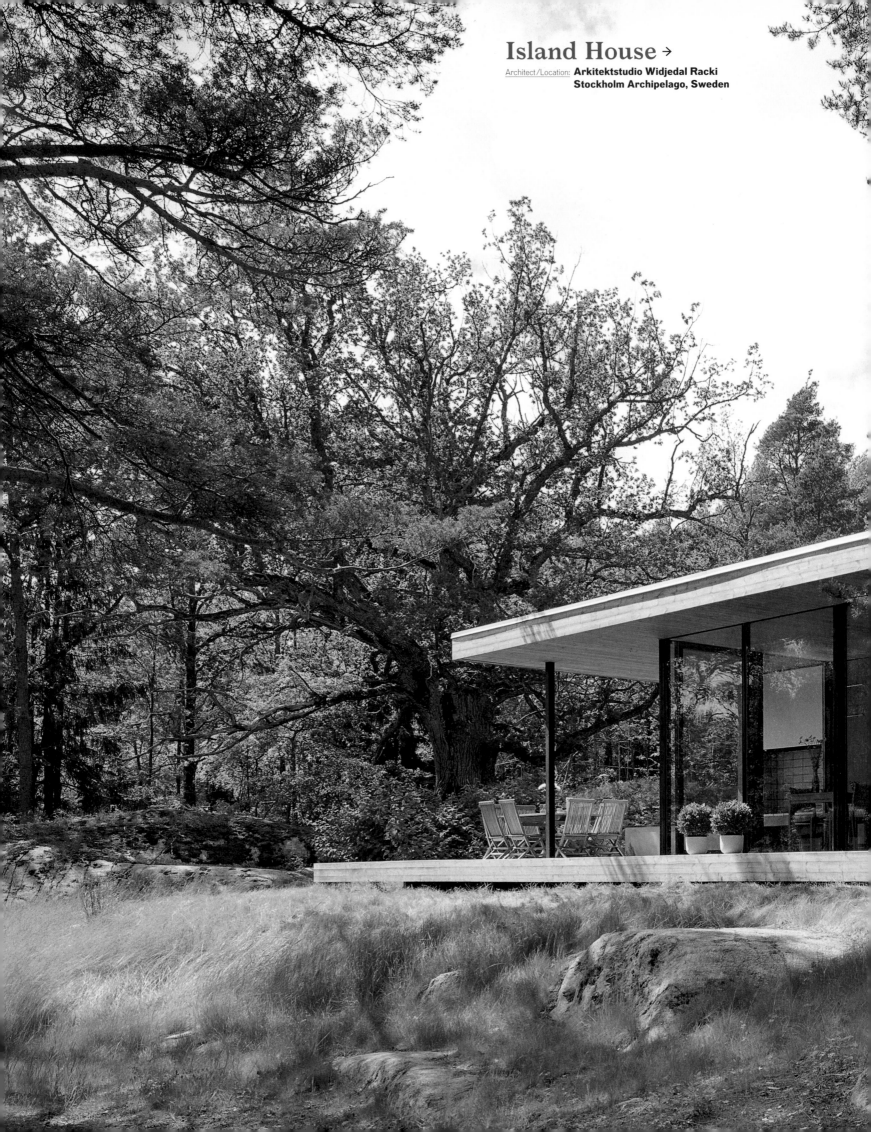

Island House →

<u>Architect/Location:</u> **Arkitektstudio Widjedal Racki**
Stockholm Archipelago, Sweden

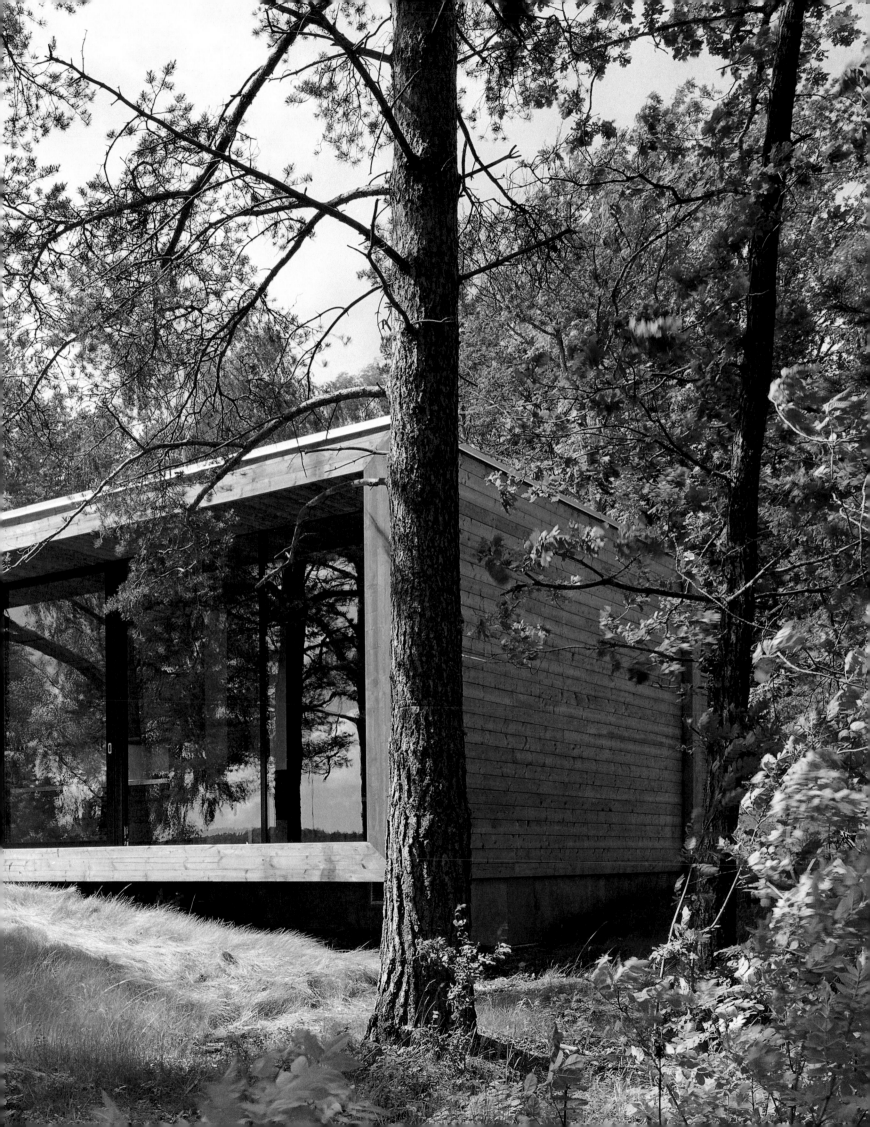

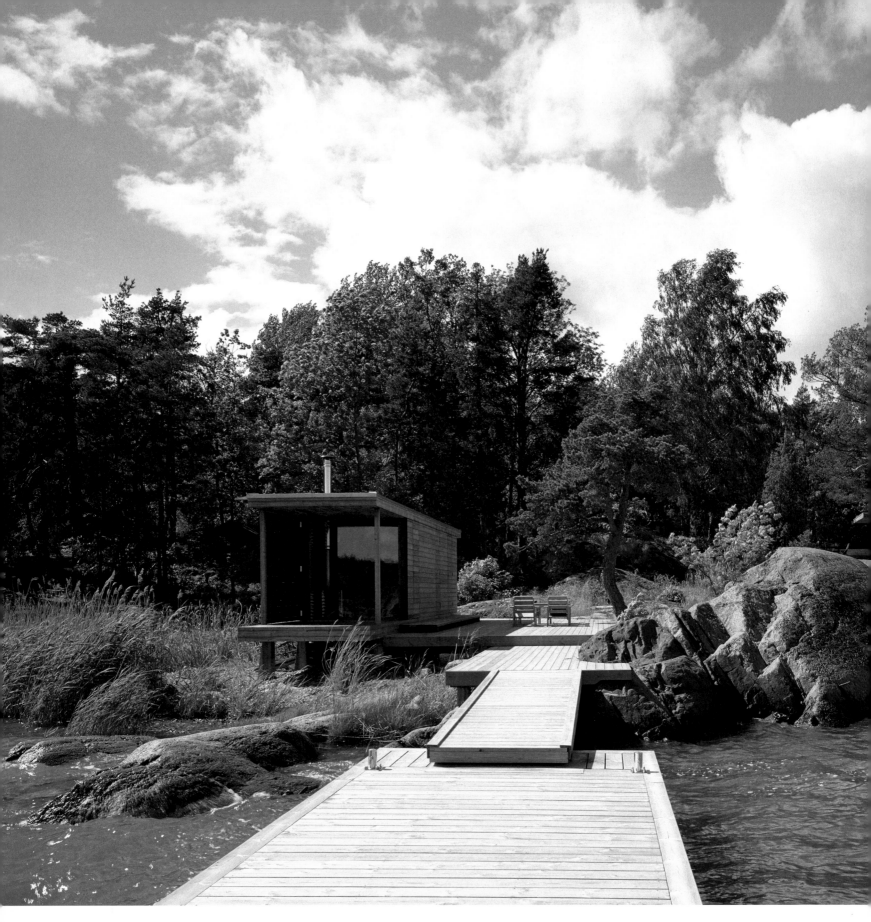

Island House

Architect/Location: **Arkitektstudio Widjedal Racki**
Stockholm Archipelago, Sweden

An enchanting summer house and private cabin on a waterfront property of a Swedish island captures the imagination. Old-growth oaks and pine trees accent the landscape's sculptural rock formations. Built for a young couple with children, the retreat takes full advantage of the scenic ocean view without becoming a dominant feature on the coastline. A place of leisure and respite, the social house behaves as a sanctuary for relaxation and whiling away the warm summer days. The home, slightly elevated from the waterfront, remains half hidden behind the knotty pine trees. A wooden walkway leads down to the waterfront cabin elevated over the rocks. Indoor/outdoor shared living spaces face the ocean. Separated by a fine sliding glass wall, these areas can come together or indistinguishably move apart according to the weather. The private sleeping areas are located in a more enclosed part of the house. These quiet and deeply personal spaces overlook a secluded courtyard encircled by compelling the rock formations and a 500-year-old oak tree.

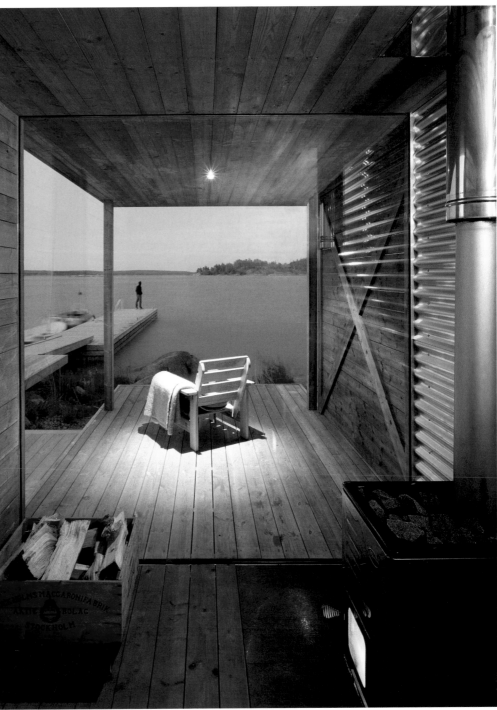

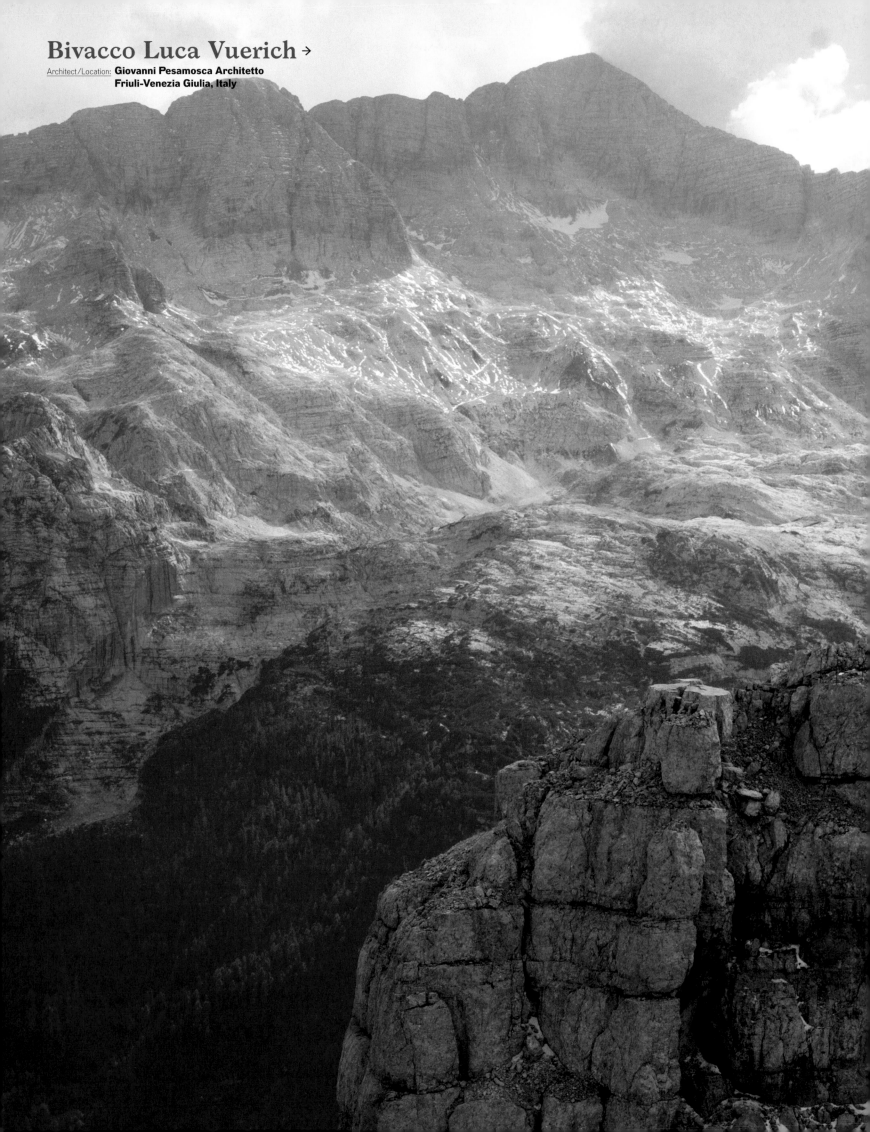

Bivacco Luca Vuerich →

Architect/Location: **Giovanni Pesamosca Architetto**
Friuli-Venezia Giulia, Italy

Chapter 2

SKY HIGH

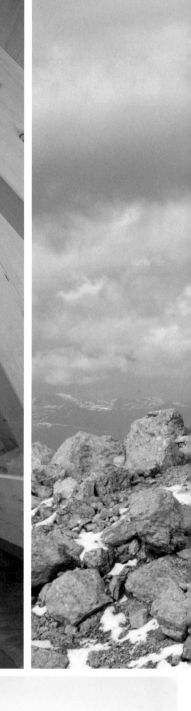
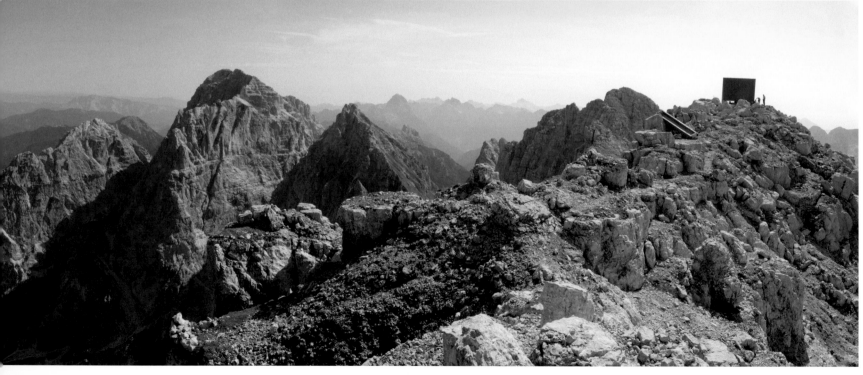

Bivacco Luca Vuerich

Architect/Location: **Giovanni Pesamosca Architetto**
Friuli-Venezia Giulia, Italy

A tiny and stoic A-frame cabin perches atop a rugged, mountainous landscape in the Julian Alps. Named after a deceased climber and built and commissioned by his family, the exhilarating retreat sleeps up to nine guests. The modular wooden cabin situates itself 2,531 meters above sea level. The strategically placed shelter appears along a summit trail, providing refuge to hikers, climbers, visitors, or anyone looking for a rest in the mountains. Built in a single day, the 16 m² hideout protects against the harsh winter and becomes a destination in its own right during the summer. The cabin, elevated on concrete piles, exudes a rare and timeless simplicity where guests can immerse themselves within the silence of the mountains.

Boisset House

Architect/Location: **Savioz Fabrizzi Architectes**
Valais, Switzerland

Originally built for agricultural use, this old wooden structure takes on a second life as a charming Alpine retreat. Renovated from a small existing cabin, the new update stages a comfortable and contemporary holiday home that takes advantage of the mountainous landscape. Leaving the exterior virtually untouched, the renovation focuses on the interior, where new openings improve views to nature. Organized in three levels, the entry and shared living spaces occupy the middle floor. Below, the children's bedroom and bathroom are set into the steep hillside. Half-way embedded into the earth, a window made from the original cattle door frames the space and grants it a rustic sensibility. An upper level holds the master bedroom, with arguably the best views over the valley. The rugged and aged exterior dramatically contrasts with the new larch wood interior. With special attention to craftsmanship, the home exudes a warm and inviting atmosphere—the perfect hideout for a winter getaway.

70

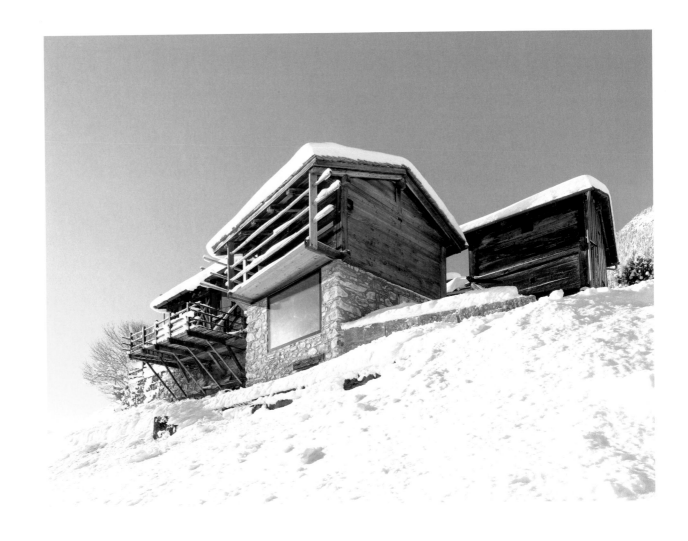
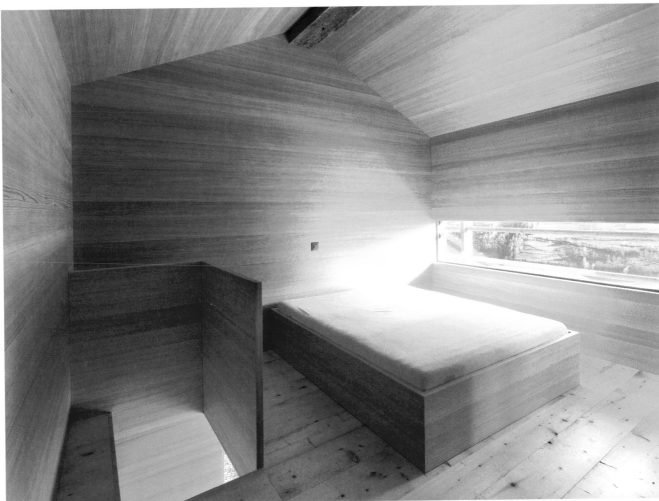

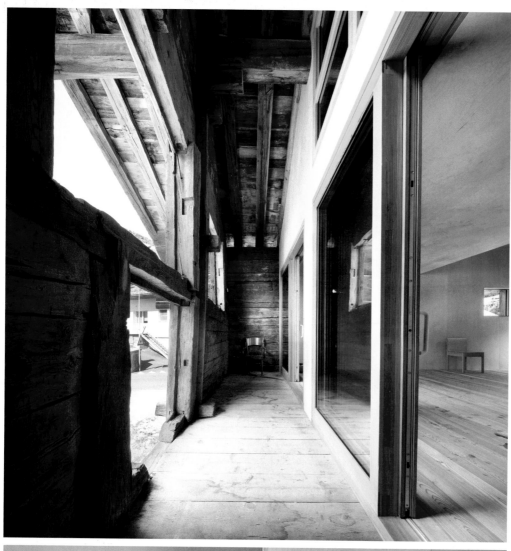

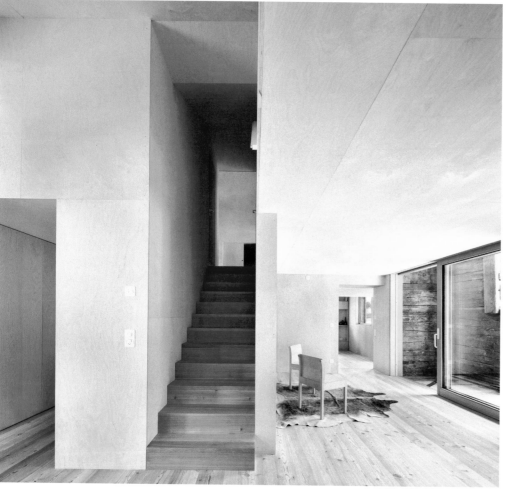

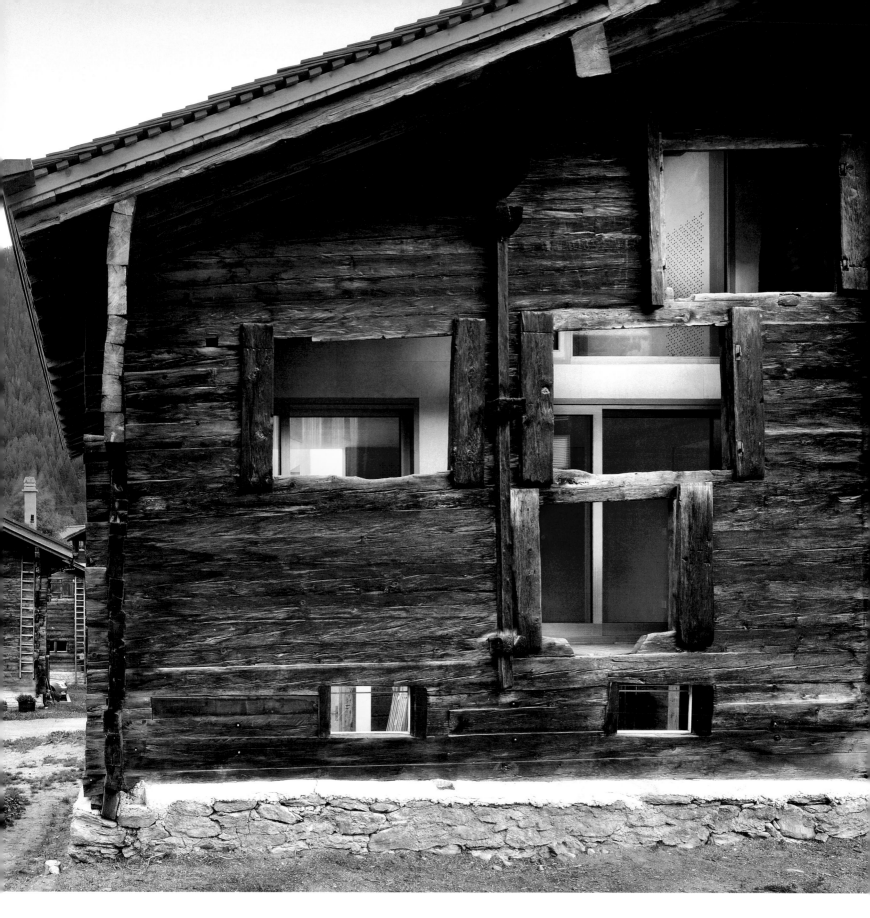

Casa C

Architect/Location: **Camponovo Baumgartner Architekten**
Valais, Switzerland

A 100-year-old refurbished hay barn sits in the center of a historic mountain village. The barn consists of two units that keep the traditional layout intact. Due to the strict local preservation rules, the renovation coverts the extant structure into a charming residence without destroying its outer façade. The new weekend home within resides just behind this rustic shell. This restoration strategy results in two alcove areas that expose the original height and wooden structure of the barn. The first alcove serves as an entry area while the other becomes a loggia for the living room. Generously glazed interior façades enlarge the living room and create an atmospheric connection between the old and new elements of the house. Above, sleeping rooms with impressive alpine views join as niches to the main living space. This house within a house layers bright contemporary spaces behind a dark and rugged façade to form an immersive getaway that only improves with time.

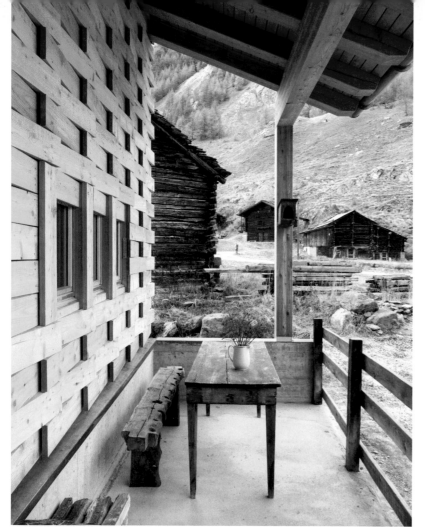

Transformation d'une grange-écurie

Architect/Location: **Galletti & Matter Architectes**
Valais, Switzerland

At the base of a sublime Alpine backdrop, a rugged barn gracefully transitions into a mountain retreat. The charming dwelling, comprised of a partially updated façade made from staggered rows of alternating wood planks, respects the structure's heritage while helping it evolve. Rather than merely replicating the past, the use of hearty and local materials infuses a continuity between the old and new elements of the house. The original part of the building remains in excellent condition, featuring dark and robust timber pieces. Solid and without pretense, this historic detailing artfully merges with the rhythmic renovation, forming an engaging pastiche of country vernacular. The gabled stone roof completes the farmhouse exterior, cantilevering over the main entrance to make room for a covered porch. Inside, the bright larch wood faces contrast against black slate tiles and the older areas of the house. A rich palimpsest of mountain styles, this charming lodge returns the building to its simplest expression as a roof over its inhabitants.

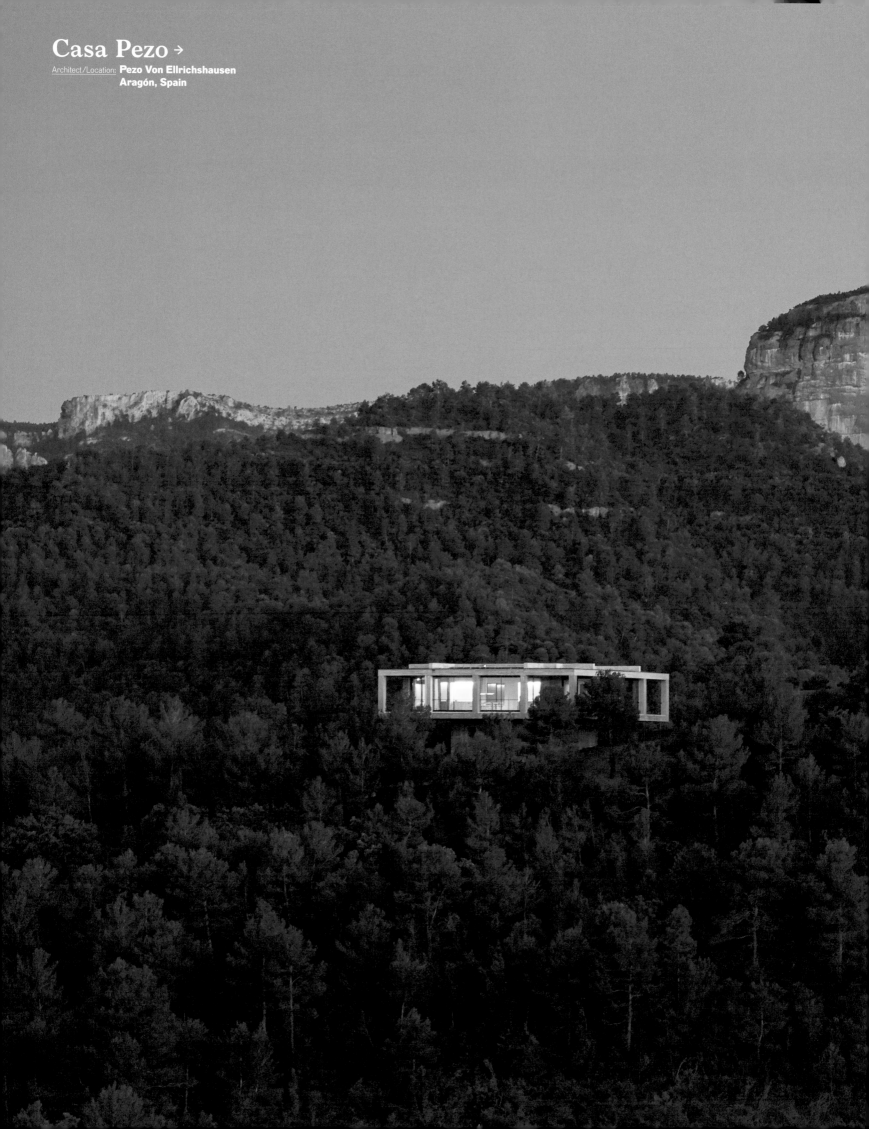

Casa Pezo →

Architect/Location: **Pezo Von Ellrichshausen**
Aragón, Spain

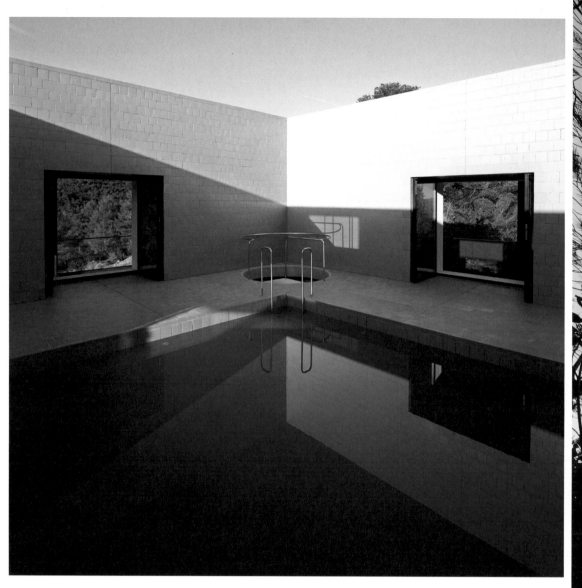

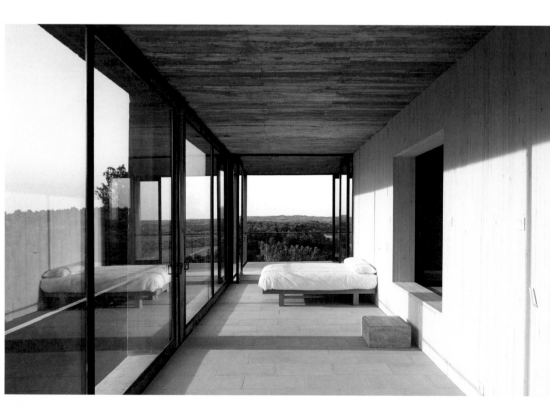

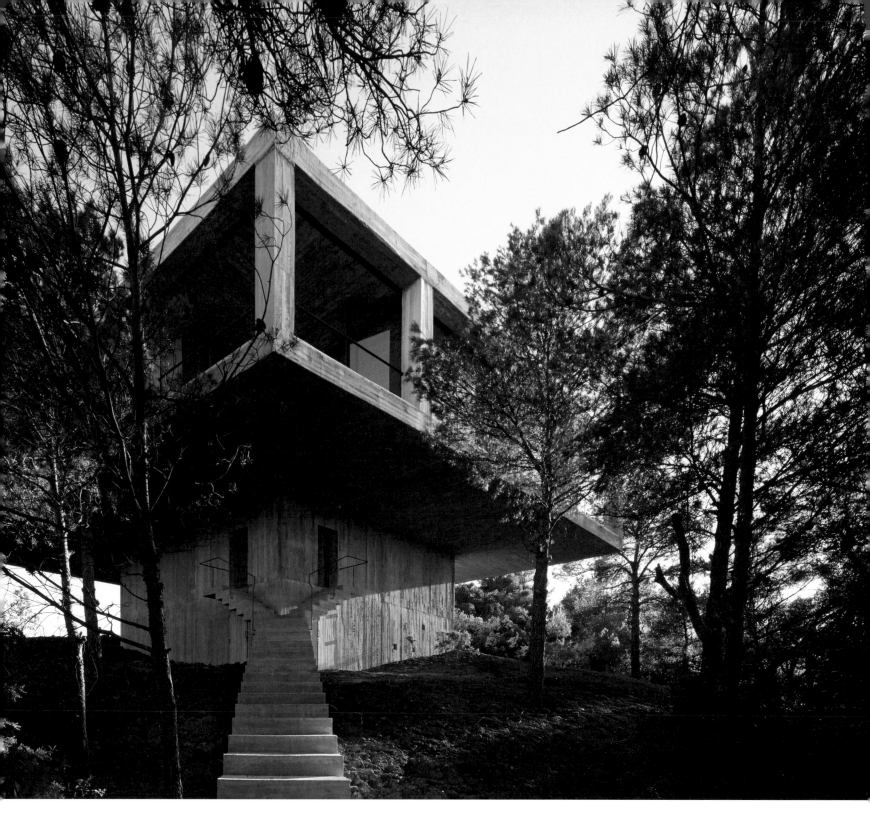

Casa Pezo

Architect/Location: **Pezo Von Ellrichshausen**
Aragón, Spain

Occupying a dominant position in a rural landscape of vineyards and olive groves, a unique concrete and glass residence hovers against a background of medieval villages and rocky outcrops. The bare horizontal volume perches above the ground on a large plinth. Transparent and monolithic, the outline of the balancing building splits between an elevated portion visible from a distance and another that disappears behind the leaves of native plants. The house above introduces a panoramic perimeter ring punctuated by 16 columns and a sequence of flexible rooms. These crystalline, symmetrical living spaces are mutually independent and link together via four open terraces at their corners. Enclosed on all four sides and open to the sky, a private pool acts as a discreet oasis at the center of the residence. With modern lines and 360 degree views of nature, this iconic house presents a lifestyle enriched by its constant and visceral relationship with both land and sky.

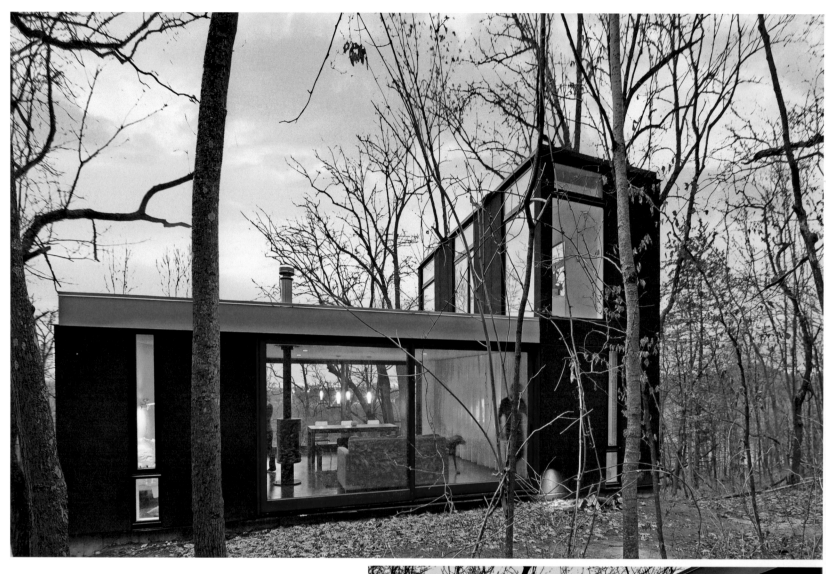

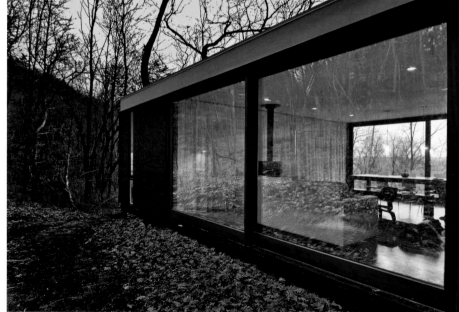

Stacked Cabin

Architect/Location: **Johnsen Schmaling Architects**
Great Lakes, USA

Carefully nestled into a densely wooded hillside, this modest cabin for a young family sits at the end of an old logging road. The compact house reconfigures and vertically stacks the typically horizontal program found in a traditional cabin compound. Stairs lead up to the open living hall centered around a wood-burning stove and bracketed by a kitchen and small sleeping rooms. Tall curtains, whose undulating fabric adds a sensual dimension to the crisp interiors, can be moved to screen the kitchen or offer privacy to the sleeping rooms. Large apertures provide extensive views and access to a hillside terrace. In the summer, the screened openings transform the living hall into an outdoor room. A simple material palette, drawn from the region's farmstead architecture, echoes the muted hues of the surrounding forest and rock formations. White interiors brighten the retreat during the long winter months, providing a quiet foreground against which nature's ever-changing tableau can unfold.

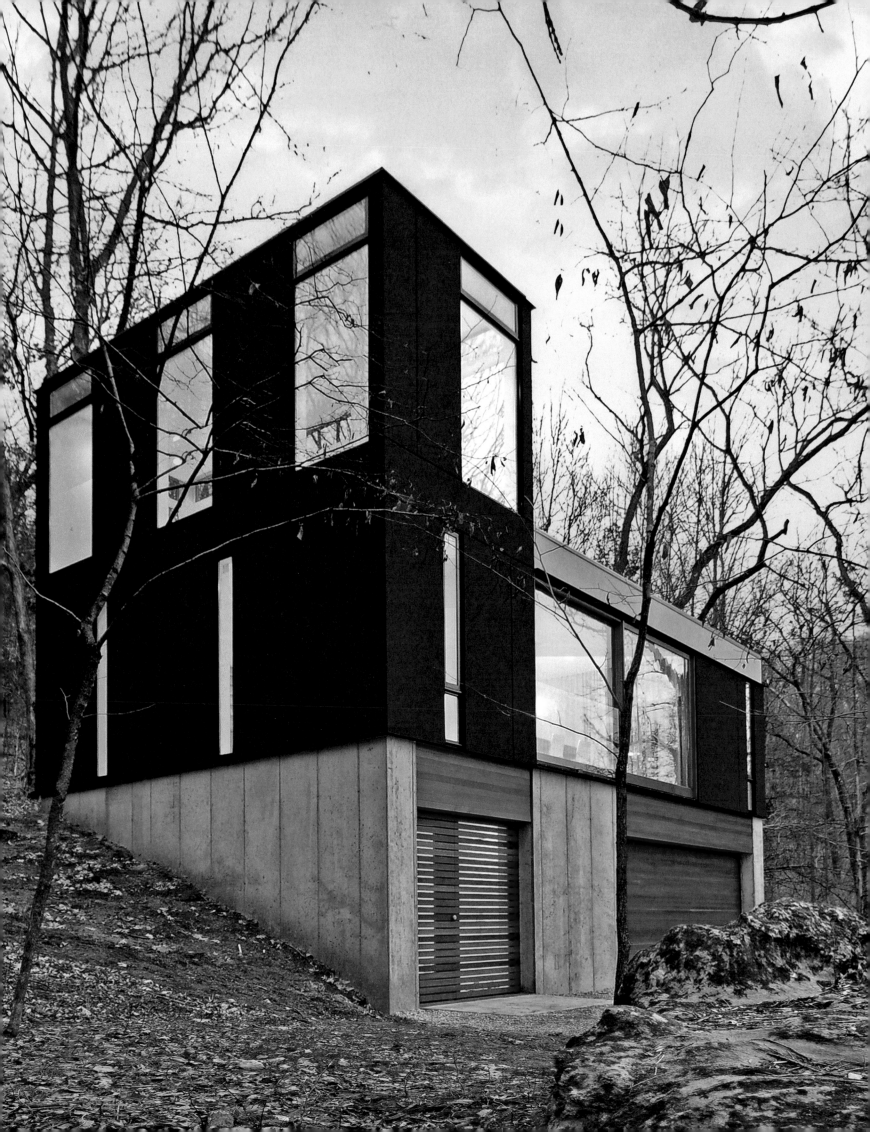

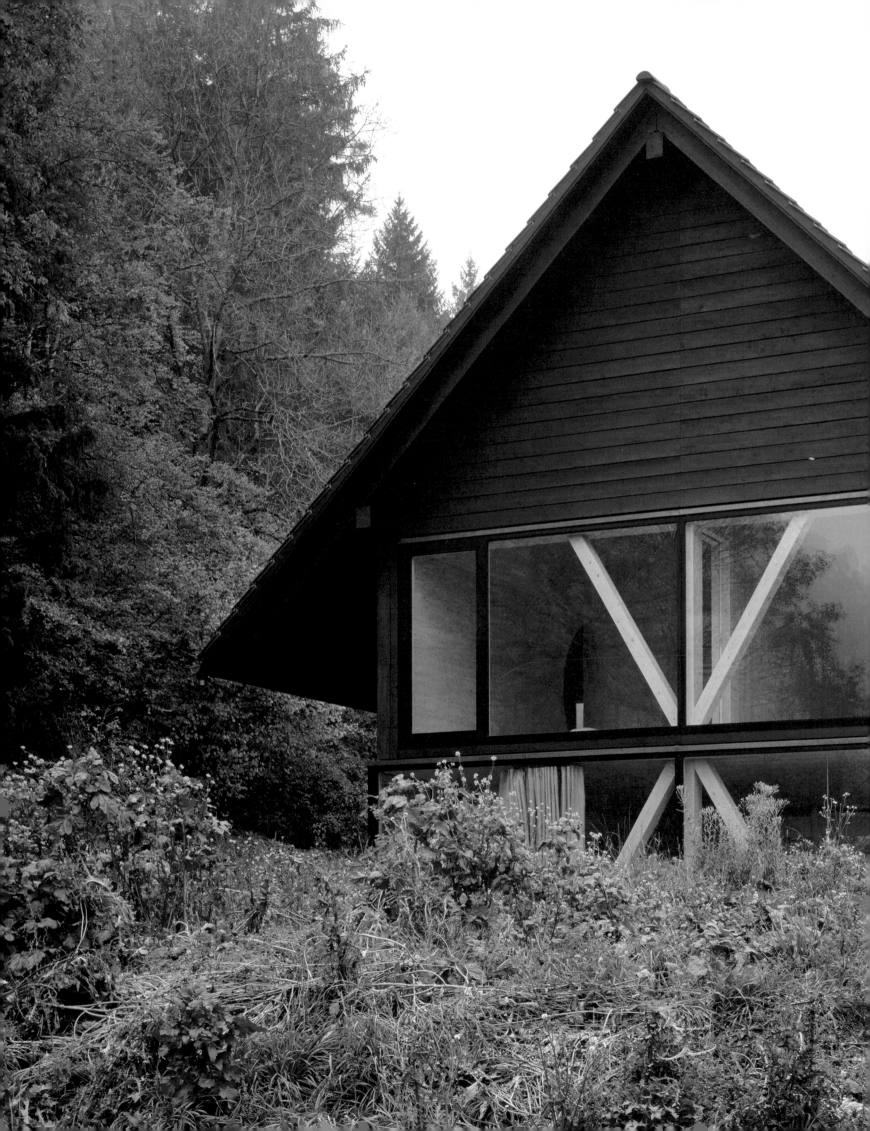

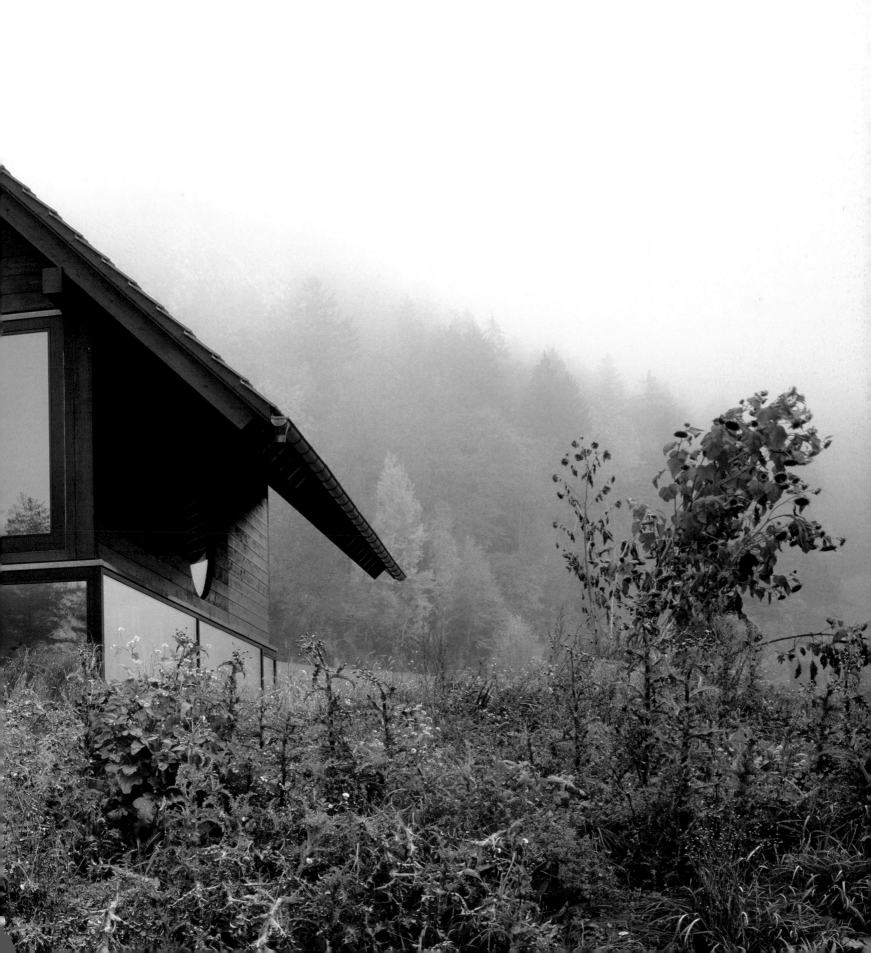

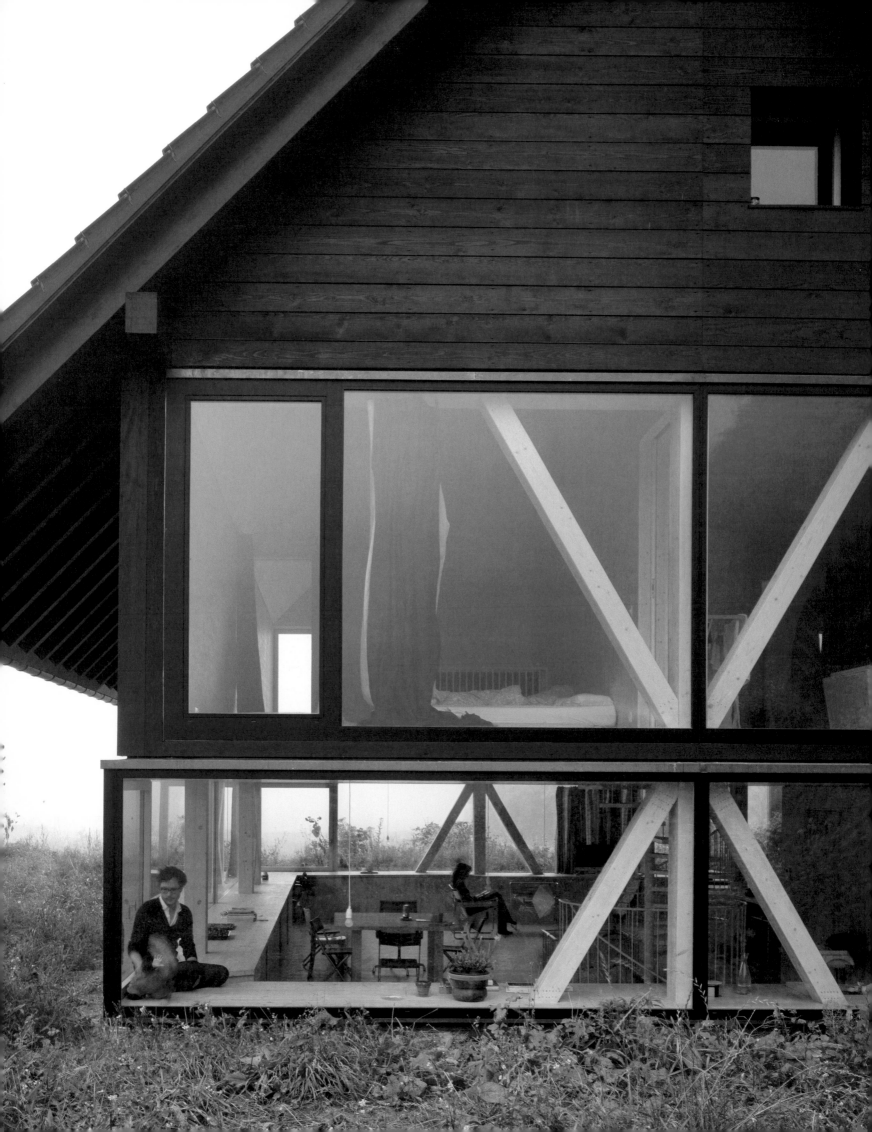

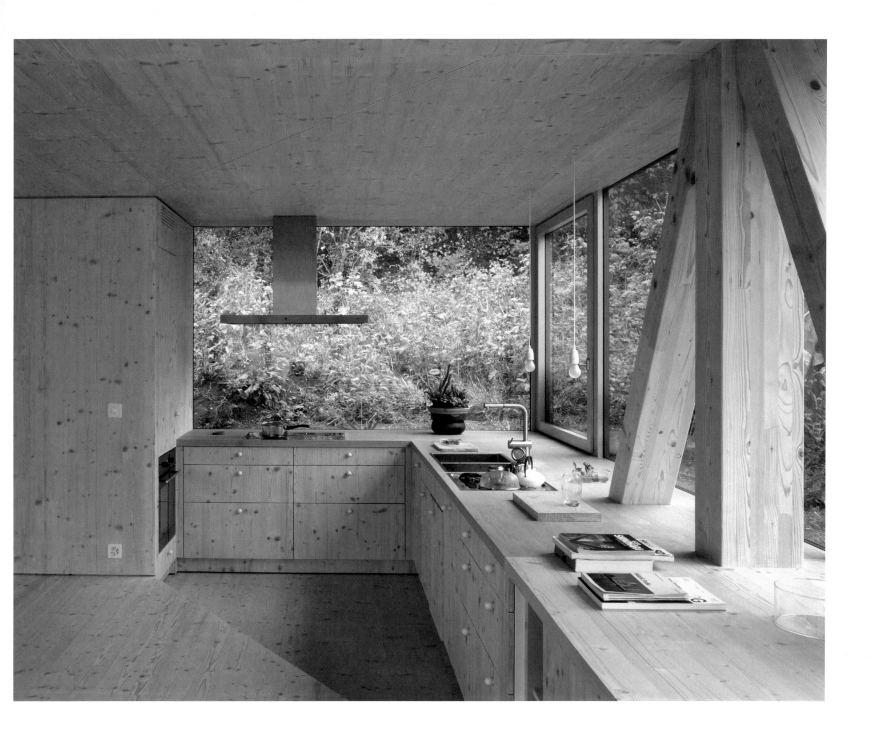

House in Basthal

Architect/Location: **Pascal Flammer**
Solothurn, Switzerland

This archetypal pitched roof timber house choreographs new ways of perceiving the landscape that surrounds it. Comprised of two principal floors, the ground level holds the family room with a noticeably low horizontal ceiling. Continuous windows on this level allow nature to play a key role in defining the communal space. The upper floor, divided into three bedrooms and a bathroom, boasts soaring angled ceilings. These rooms are punctuated by circular and rectangular windows that open up to composed views of the scenic wheat field. While the partially buried lower floor brings the ground up to eye level and forges a visceral connection to nature, the upper story stages a more protected and cerebral vantage point for observing the landscape. Inside the steeply pitched roof structure with pronounced overhangs, the dark residence hosts a bright and surprisingly modern interior. In the evenings, the dwelling casts a rich glow into night sky, adding to its mysterious allure.

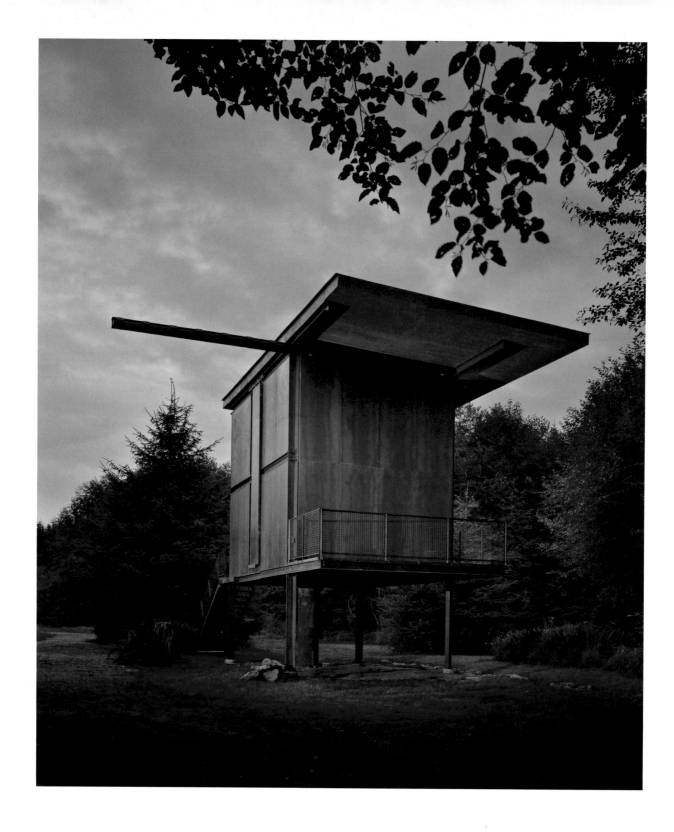

Sol Duc Cabin

Architect/Location: **Olson Kundig Architects**
Pacific Northwest, USA

A striking cabin on stilts responds to the owner's desire for a compact and virtually indestructible home for himself and his wife during fishing expeditions. Composed of two levels, the cabin's entry, dining, and kitchen areas are located on the lower floor while a sleeping loft hovers above. A cantilevered steel deck extends from the lower level, staging unimpeded views of the river. Predominately prefabricated to reduce site disruption, the innovative structure also works with salvaged materials and can be completely shuttered when the owner is away. The cabin's rugged patina and raw materiality respond to the wild setting while its verticality provides a safe haven during occasional floods. A cantilevered roof shades the interior from the summer sun and protects the structure from the strong coastal storms. When in use, the large sliding façade panel sweeps to the side, transforming the cabin into a luminous and modern beacon in the wilderness.

86

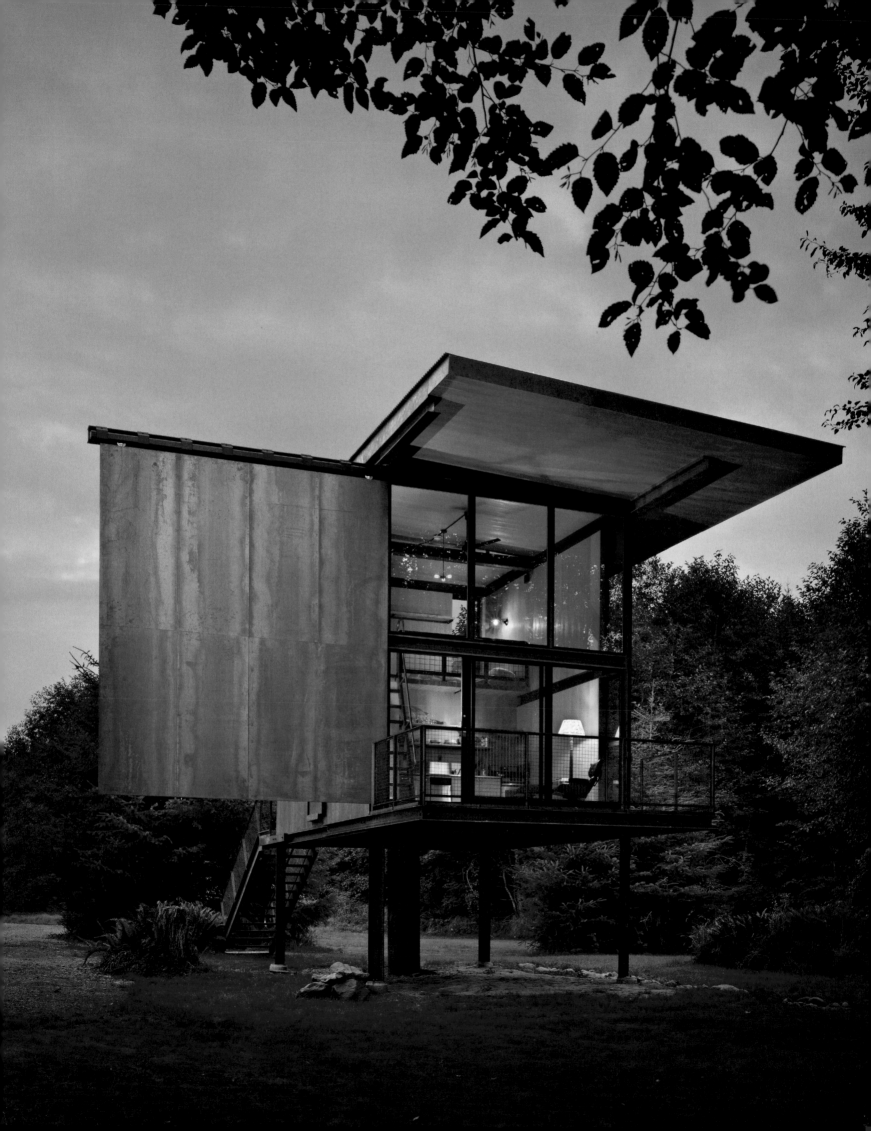

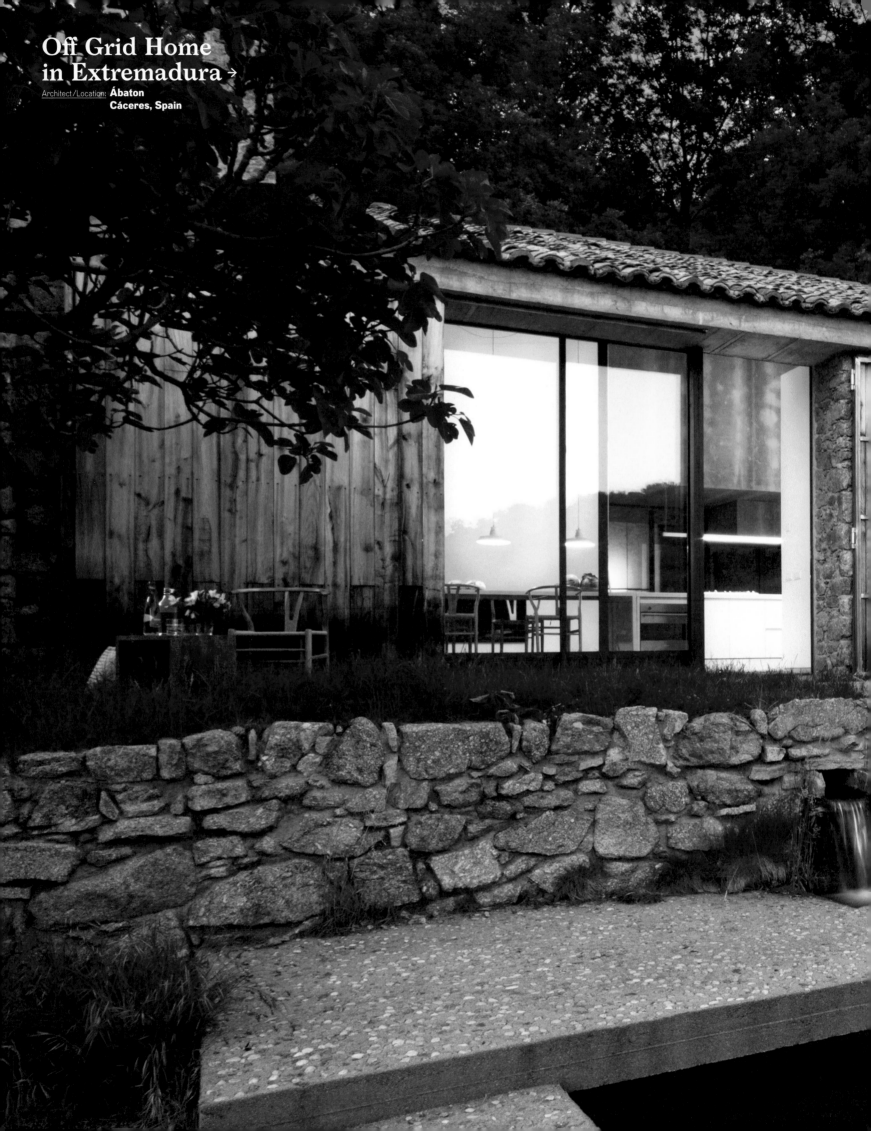

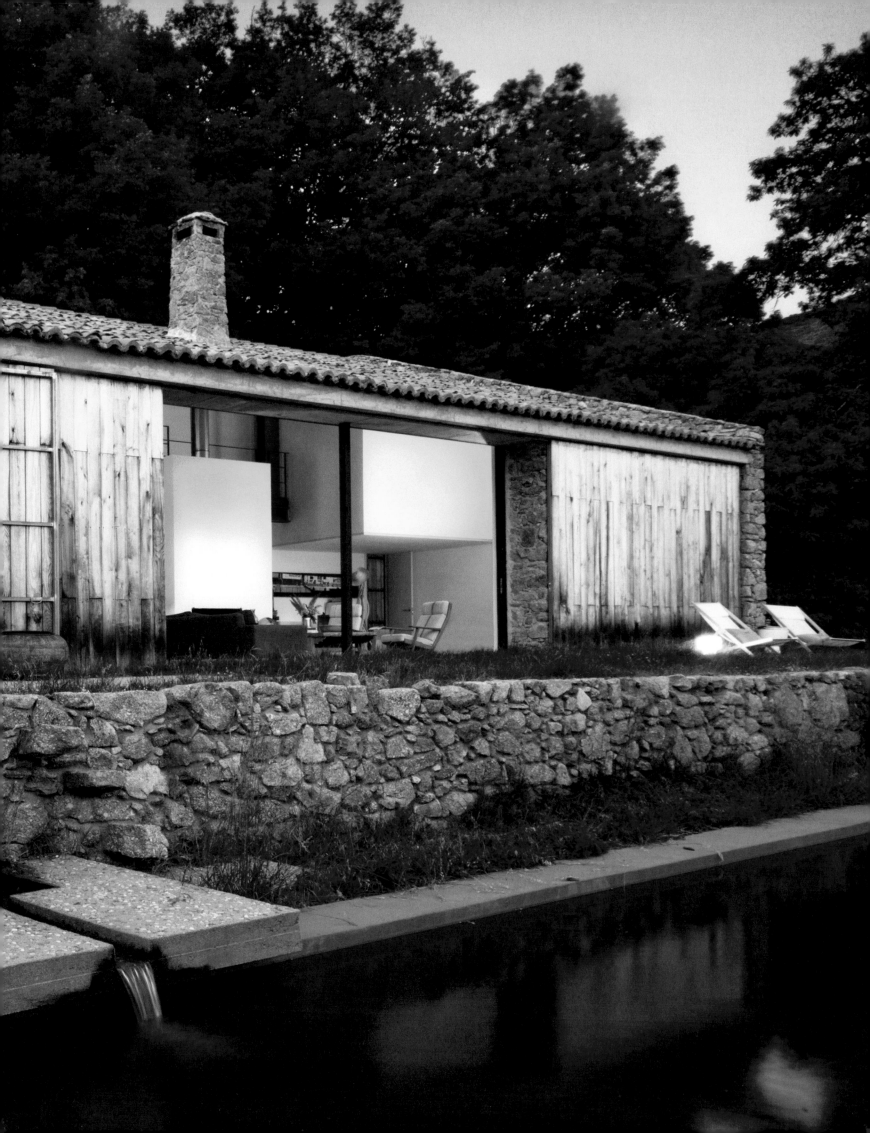

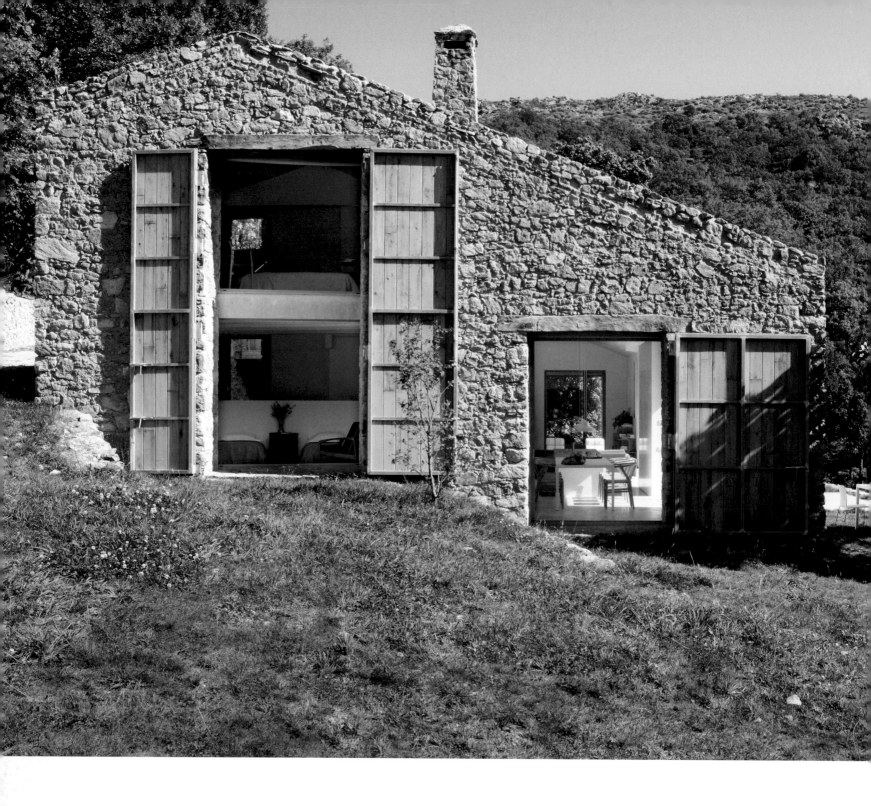

Off Grid Home
in Extremadura

Architect/Location: **Ábaton**
Cáceres, Spain

Set on a sweeping 5-hectare estate, an abandoned stable reinvents itself as an authentic country home. The sensitive renovation remains consistent with and respectful of the farm building's history and the picturesque landscape. Made from recycled local stone and accented by rustically inspired shutters, the two-level house opens onto the sloped terrain. A gracious swimming pool lines the main living space, sending cool breezes flowing through the double-height space. Nature blends into almost every room in the house. In this elegant interior, bathrooms overlook the interior patio and stone water fountain while bedrooms with generous picture windows feature panoramas of the pristine countryside. Rising out of the forest clearing, the house basks in the regal ambiance of the surrounding oak, chestnut, alder, and willow trees.

90

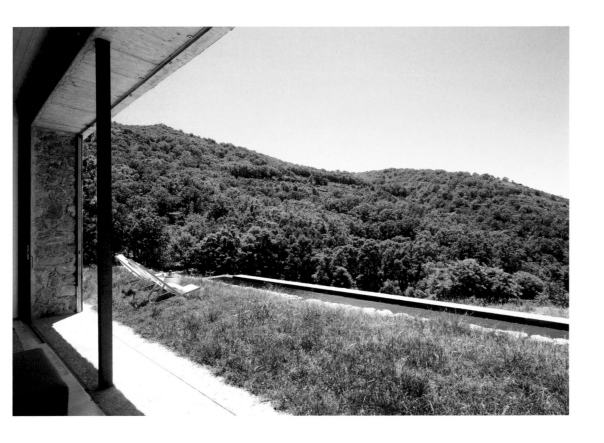

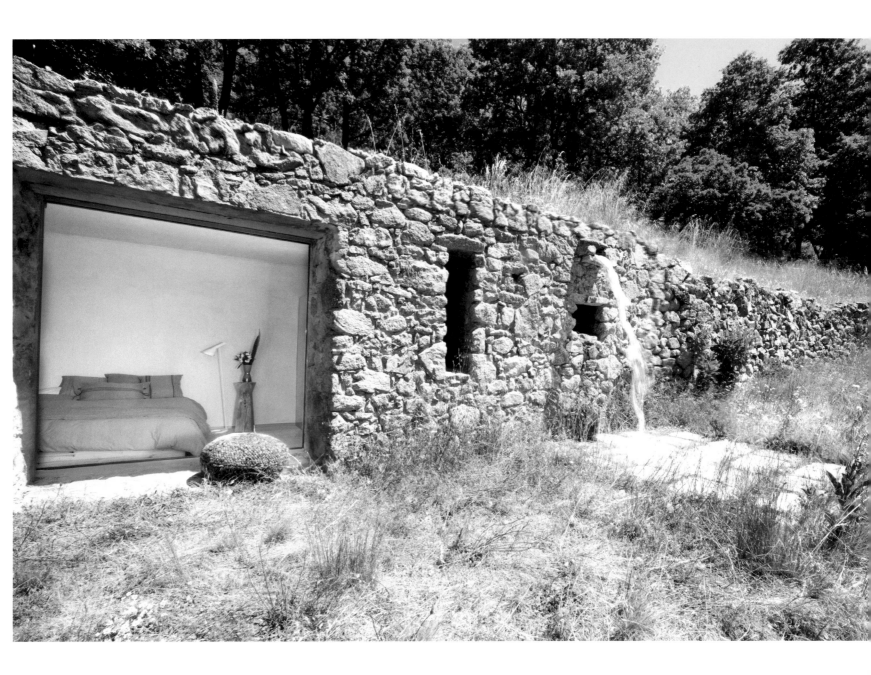

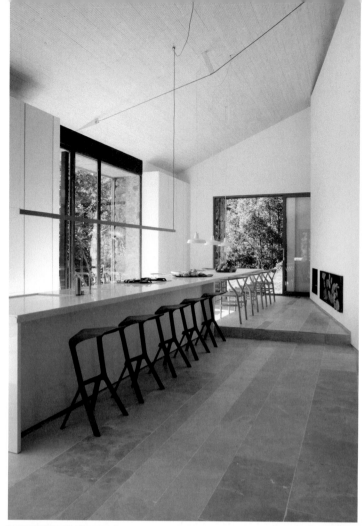

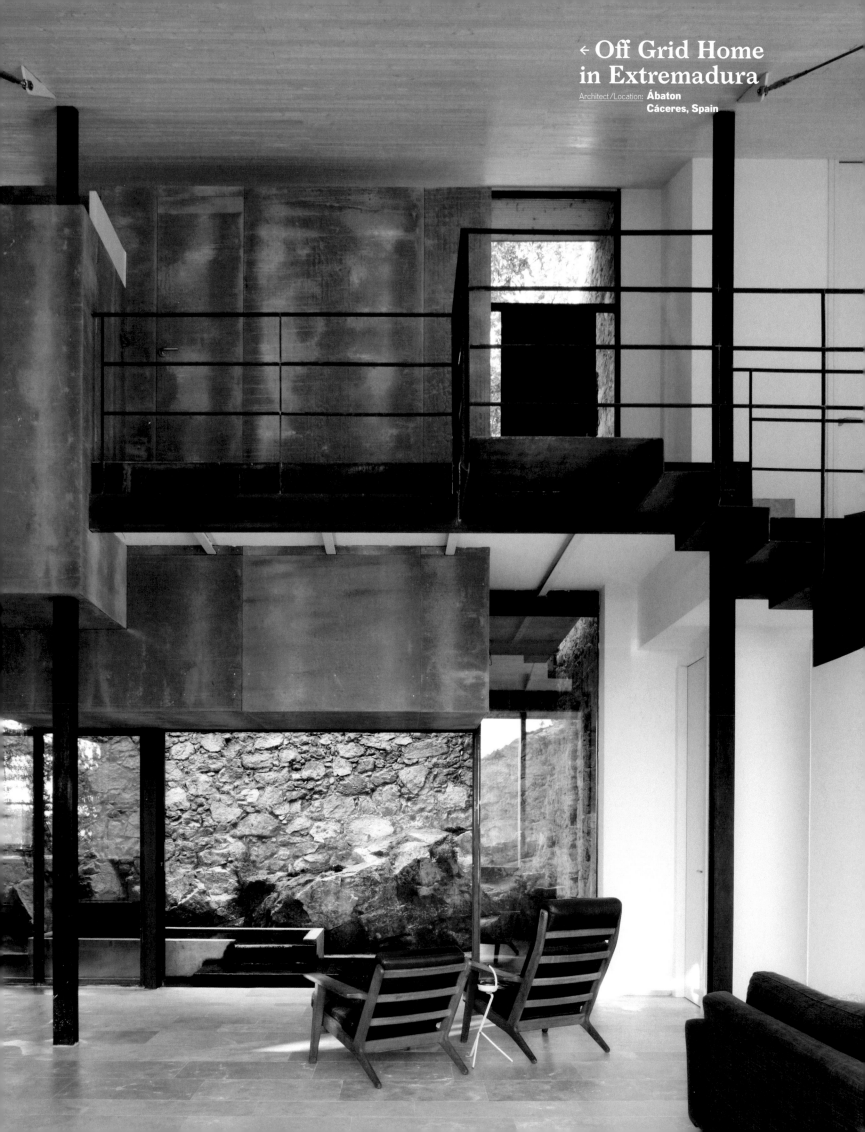

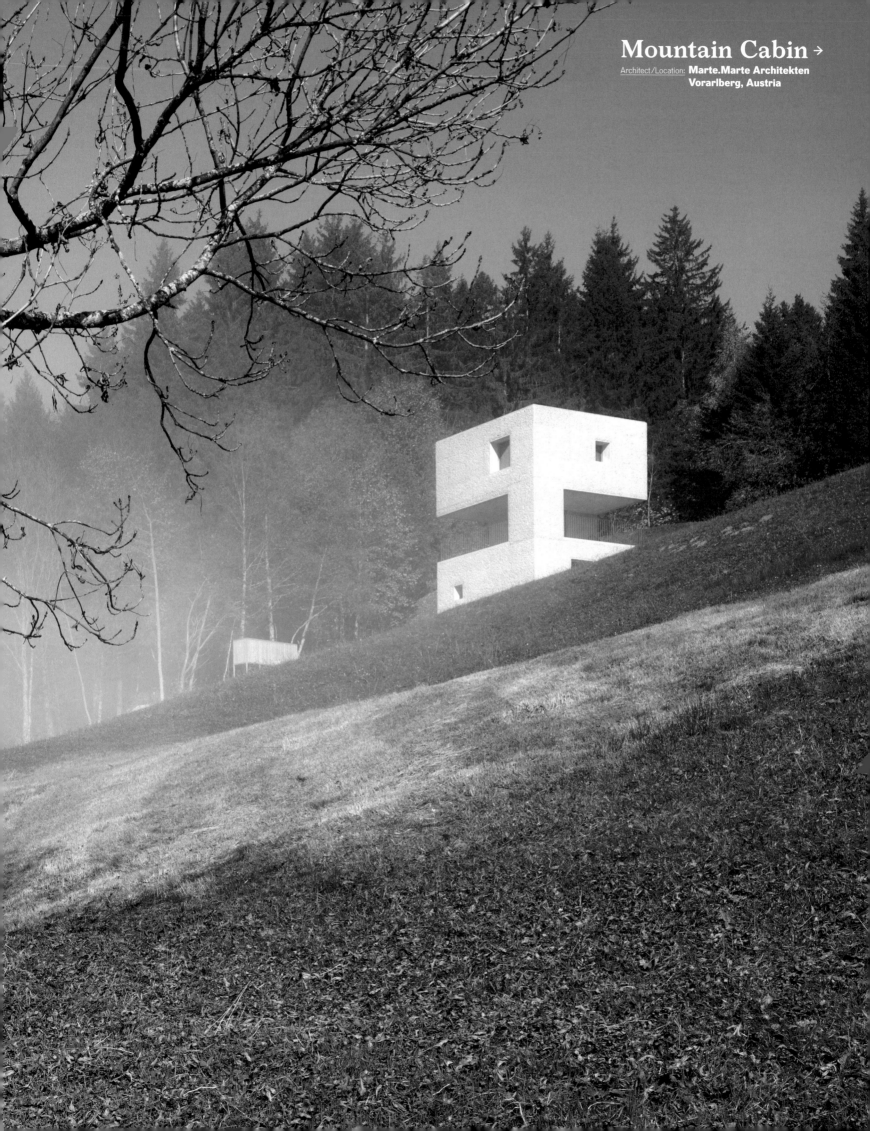

Mountain Cabin

Architect/Location: **Marte.Marte Architekten**
Vorarlberg, Austria

At the edge of a wooded ravine, a small tower rises from the steep hillside. The retreat, carefully hewn from rough concrete, juxtaposes against the meadow's greenery in the summer and blanket of white snow in the winter. Heavy oak front doors blend in with the branches of the surrounding forest trees. As if punched into the walls, square windows of different sizes spread out across the façade. Inside, wide solid oak frames transform these openings into subtly shifting landscape paintings. These framed windows direct the guest's attention to the prominent mountain chain, over the gentle slopes, and through the dense forest grove.

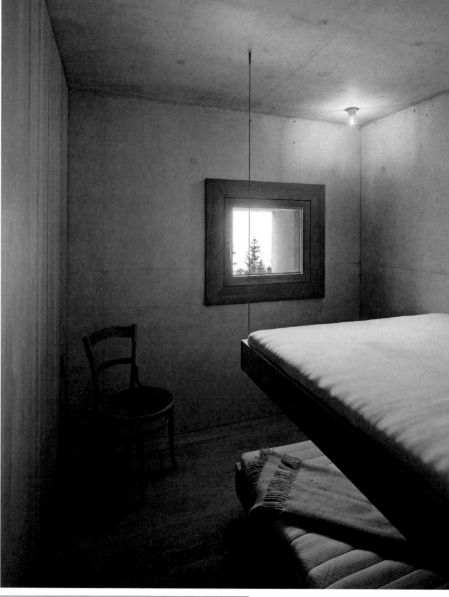

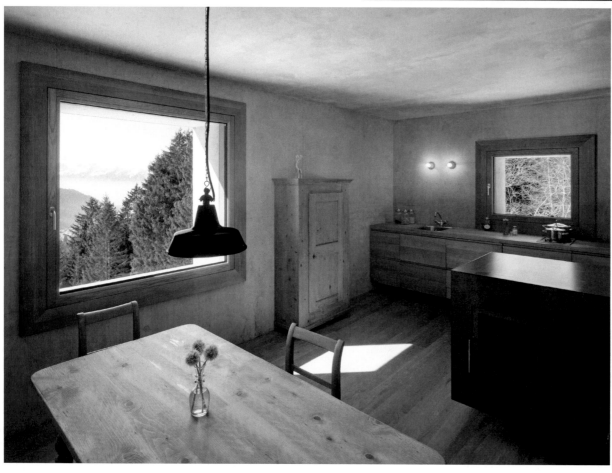

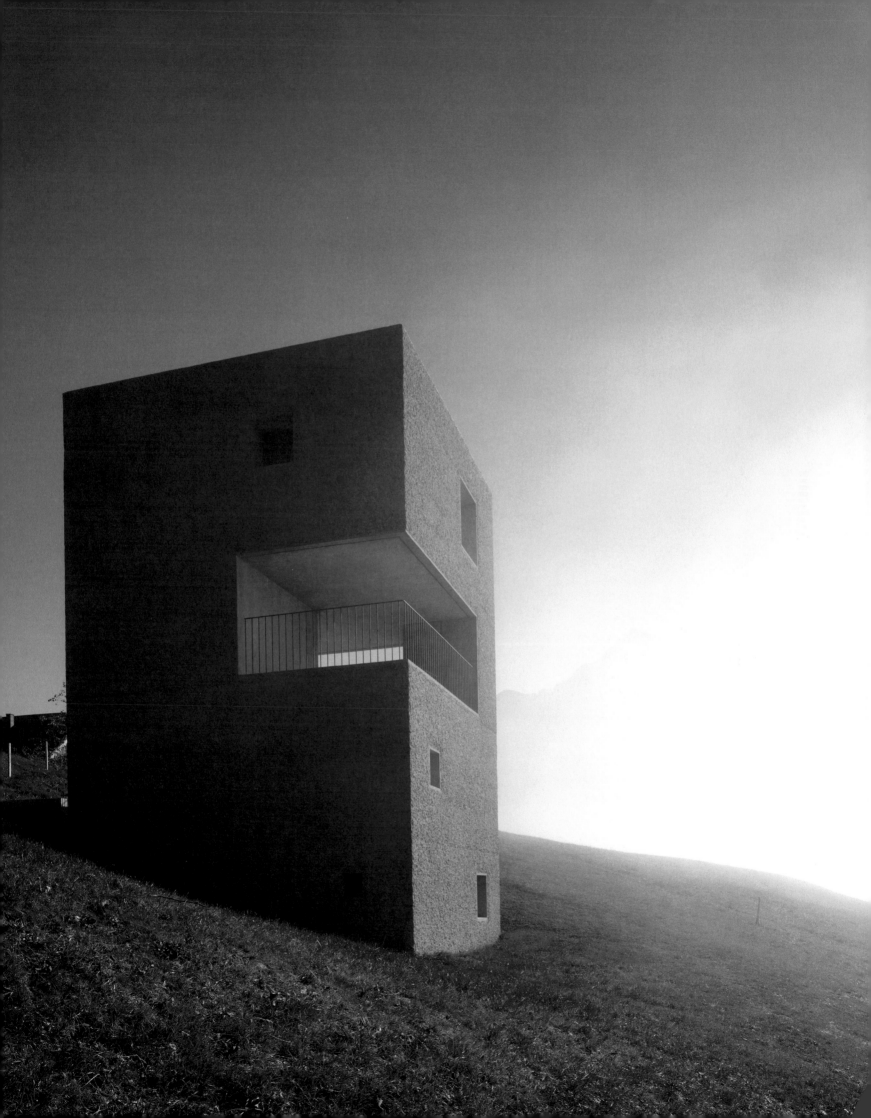

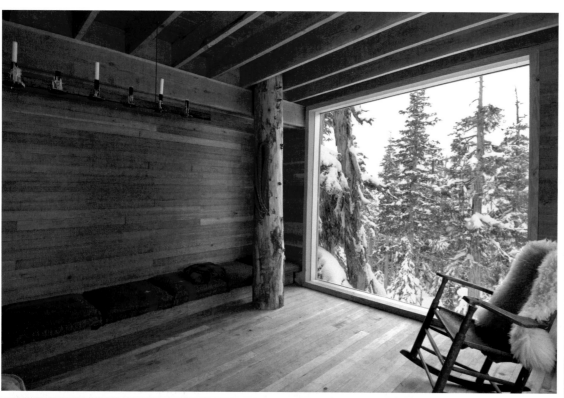

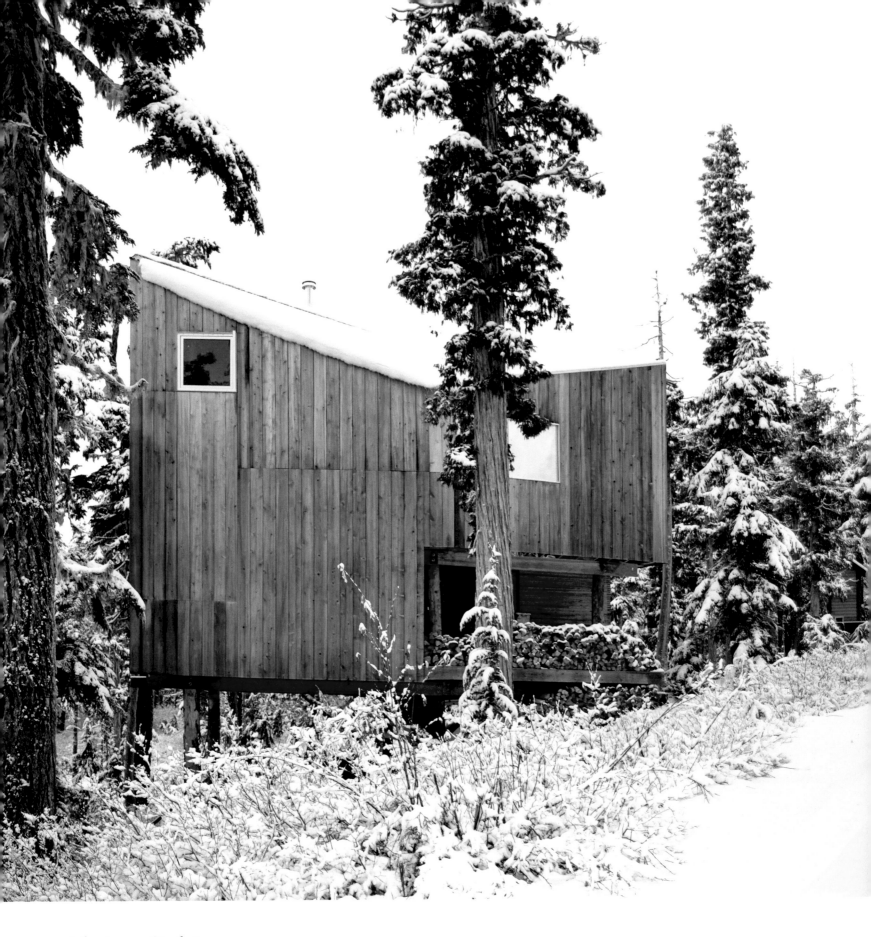

Alpine Cabin

Architect / Location: **Scott & Scott Architects**
British Columbia, Canada

A remote forest cabin captures the challenging setting's adventurous spirit. Accessible via a gravel road five months of the year, the home can be reached by foot or toboggan during the winter season. Built by and designed for the architects, the angular retreat stands as an homage to their love of snowboarding and the freedom such outdoor activities embody. The cabin, designed to withstand the heavy annual snowfall and resist the dominant winds, hovers off the ground to sit above the accumulated snow. Left in their raw forms and finishes, the home's rugged materials will gracefully age with time. The exterior, clad in weathered cedar, helps the structure blend into the surrounding forest. With no electricity and all water collected from a local source and carried in, the dwelling transports its occupants to a simpler time. Heated by a wood stove, the winter shelter crafts a back to basics retreat for an unfettered experience of the wild.

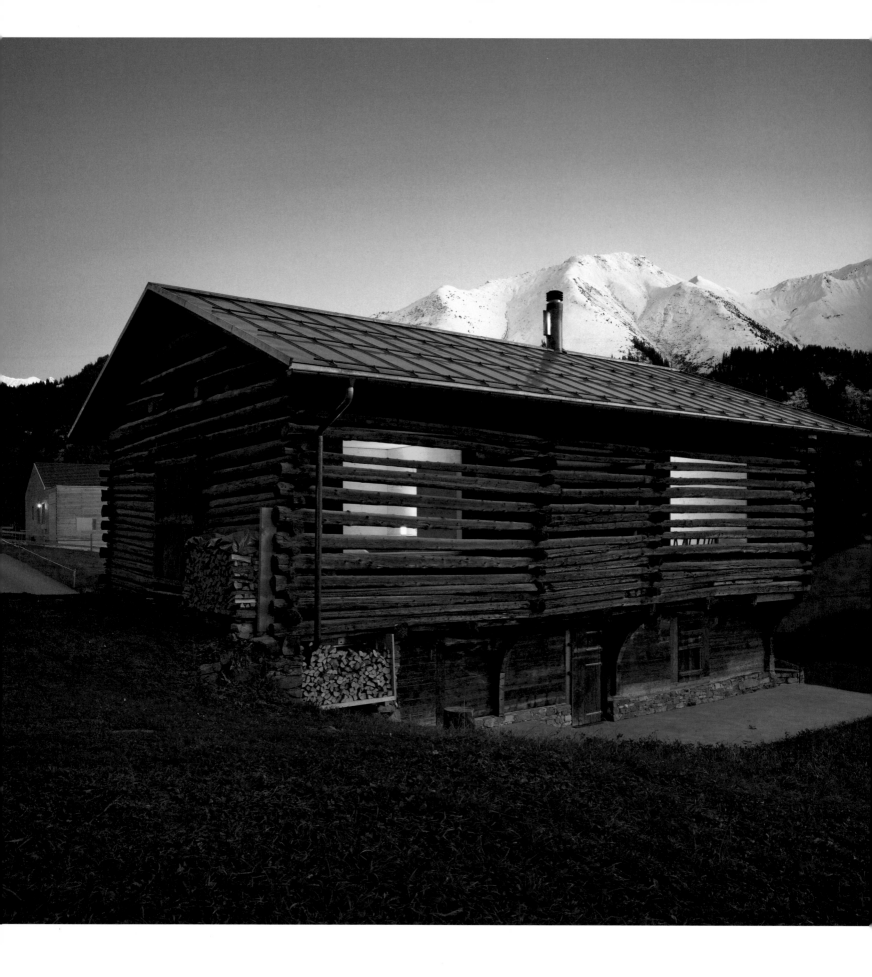

Stall-Haus

Architect/Location: **Morger + Dettli Architekten**
Grisons, Switzerland

Tucked into the hillside of a scenic valley, this remote Alpine retreat choreographs the ultimate blend of rustic charm and modern comfort. The vacation home, converted from a disused cowshed, captures the regional chalet style. Largely gutting the original structure while preserving its weathered façade, the resulting house within a house seamlessly blends into the existing village fabric. Two and a half levels of interior living space combine old and new elements. The extensive renovation, completely hidden from the outside, features refurbished original beams and woodwork juxtaposed by ethereal timber surfaces. Straight out of the pages of a fairy tale, the exterior's historic country style lets in light and views while warding off prying eyes. Complete with a pyramid-shaped fireplace, the relaxing interior introduces large openings that offer glorious views of the valley. Balancing tradition with contemporary desire, the enchanting renovation brings to life a timeless sanctuary.

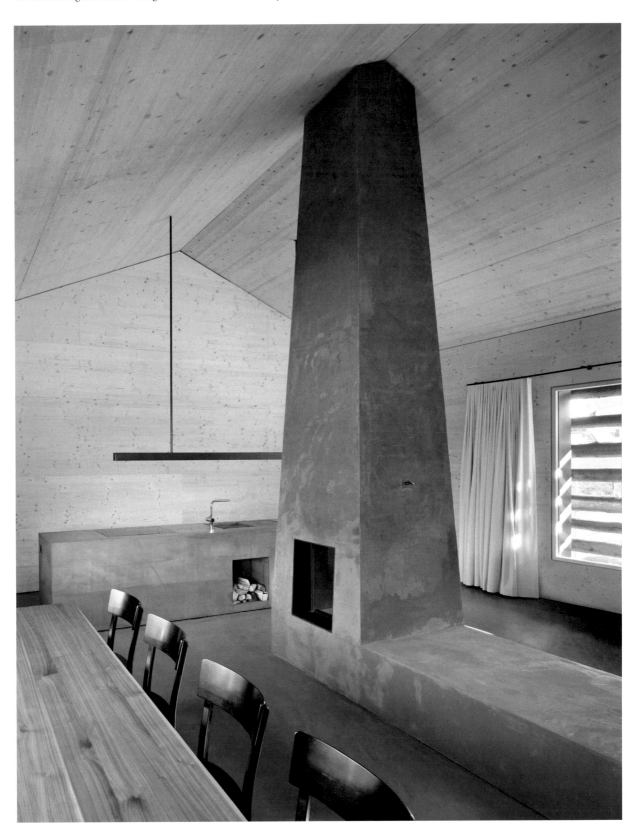

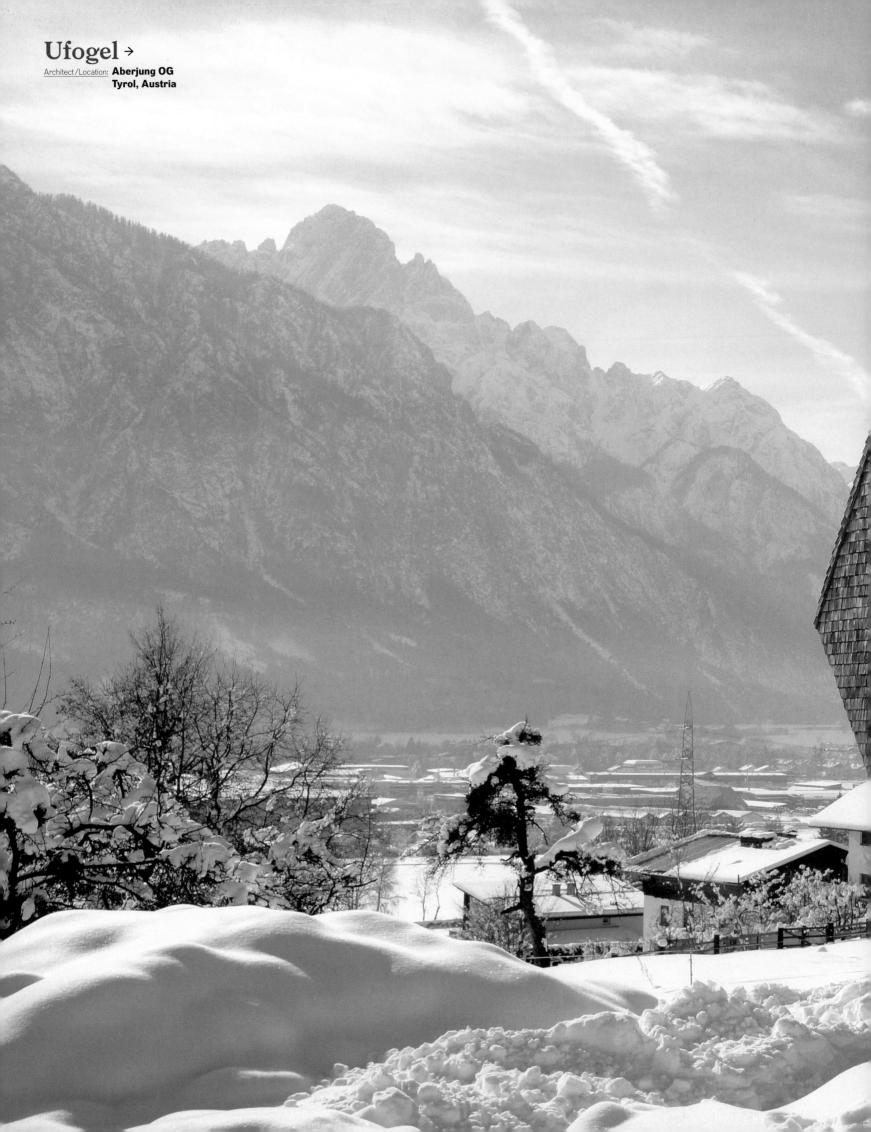

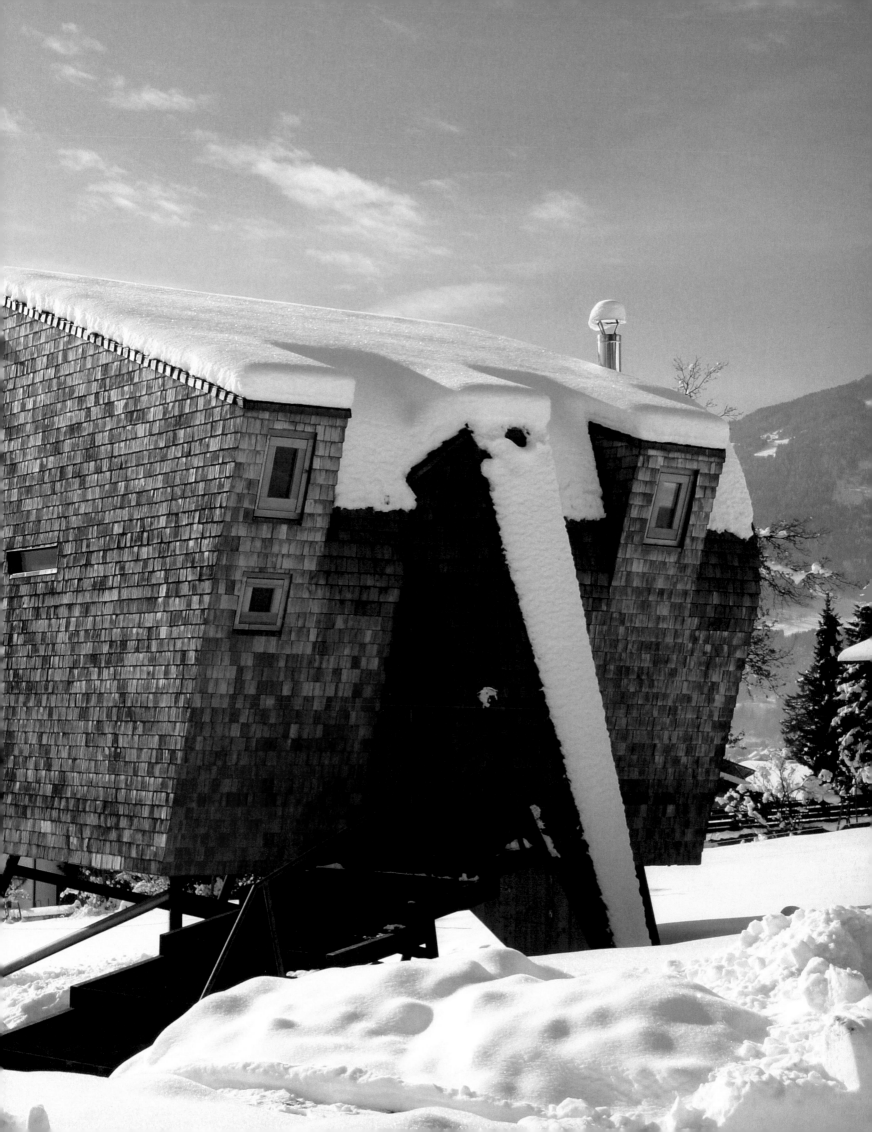

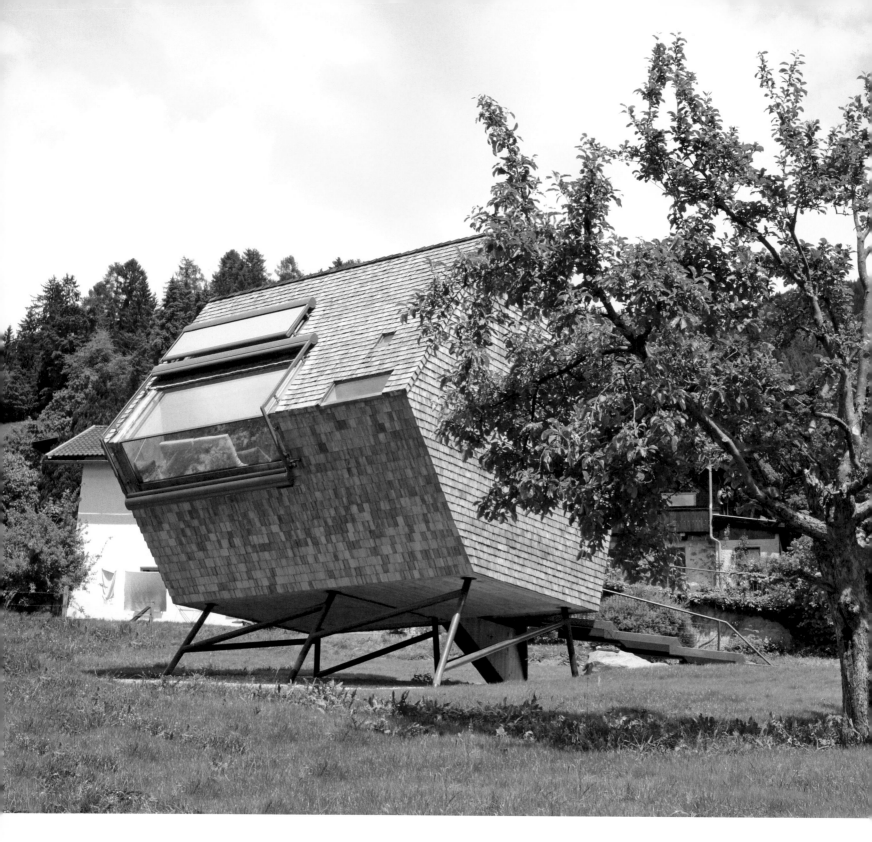

Ufogel

Architect/Location: **Aberjung OG**
Tyrol, Austria

Set in the picturesque world of East Tyrol, a quirky and comfortably appointed hideout floats above a peaceful meadow. The compact cabin's unusual form bears resemblance to a prehistoric bird from certain angles and an extraterrestrial dwelling from others. Built on stilts amidst unspoiled nature, the curious retreat embeds panoramic windows into its larch wood façade. These windows bring the nature indoors, basking in the breathtaking views of the region's impressive mountain peaks. A livable sculpture, the multifunctional interior stands as a spatial wonder nestled inside a curved shell. Covered in traditional shingles, the rustic refuge grants a feeling of warmth and security as it protects its guests from the natural elements. The cozy shelter, available for rent, inspires sound sleep and an ever-present relationship to both trees and sky.

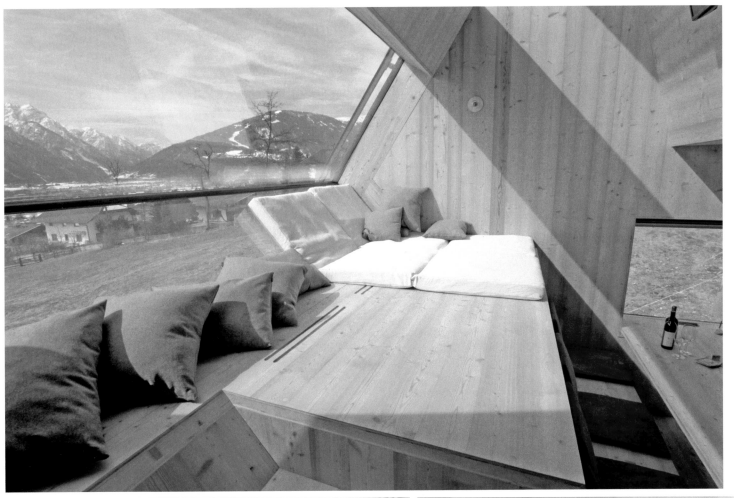

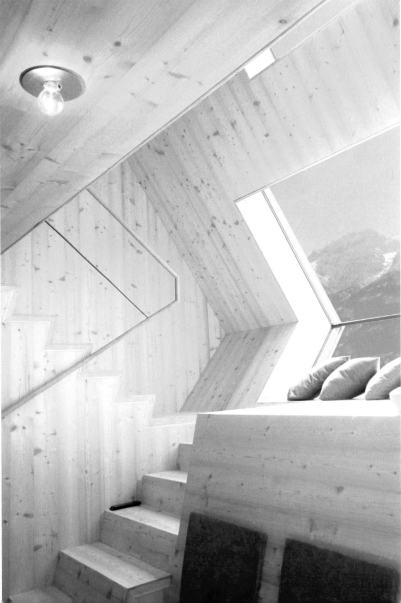

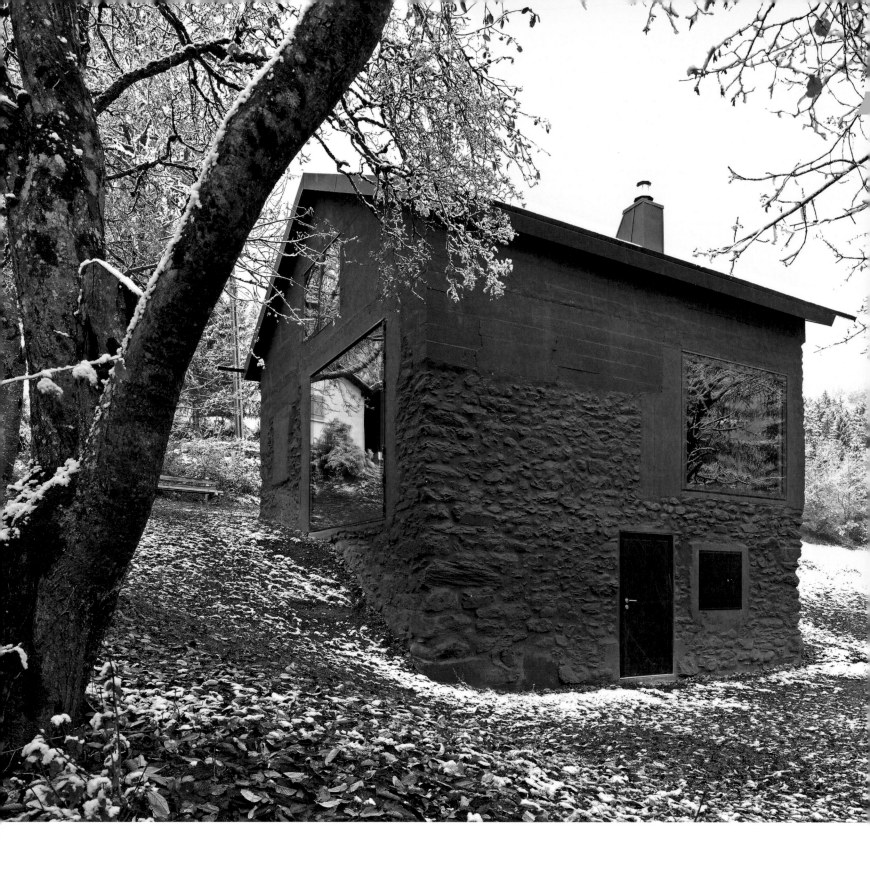

Savioz House

Architect/Location: **Savioz Fabrizzi Architects**
Valais, Switzerland

A barn built in 1882 becomes a charming contemporary holiday home. Set in the middle of picturesque fields, the structure's most recent intervention reveals the history of the building. The striking renovation highlights all the materials used in the façade over the years. Unified beneath a dark painted finish, the original stones, the bricks added in the 1980s, and the contemporary concrete modifications are all disclosed and showcased side by side. Far from the smooth appearance of some holiday chalets, the rugged façade treatment celebrates the functional aspect of the ancient barn. The living room, embraced by fields and forest, opens up to nature. Here, four boxes covered with dark wood emphasize the corners of the space. These boxes are separated with large floor to ceiling widows which can be opened wide, dramatically extending the interior into the outdoors.

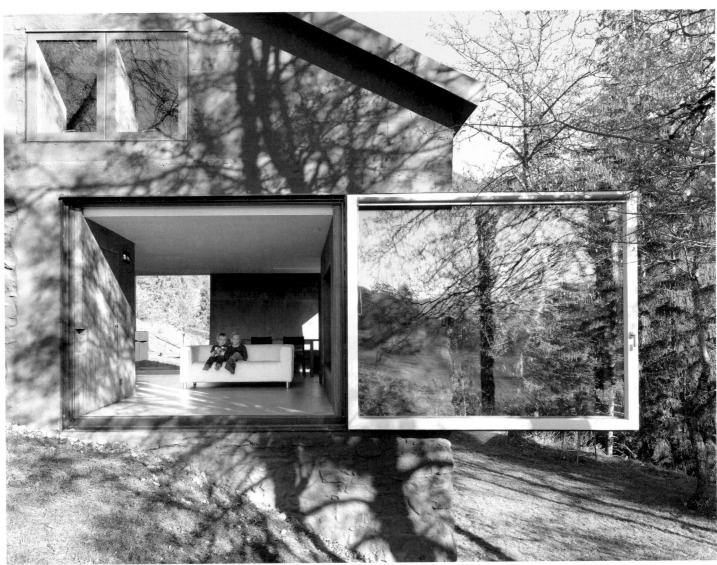

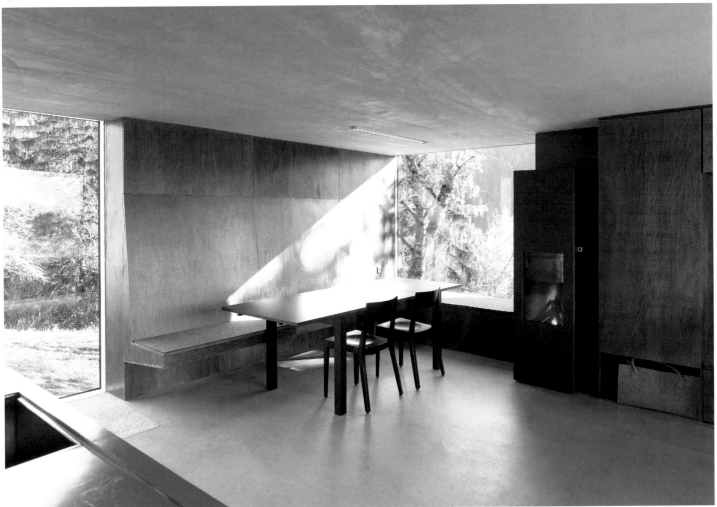

Split View Mountain Lodge →

Architect / Location: **Reiulf Ramstad Arkitekter**
Østlandet, Norway

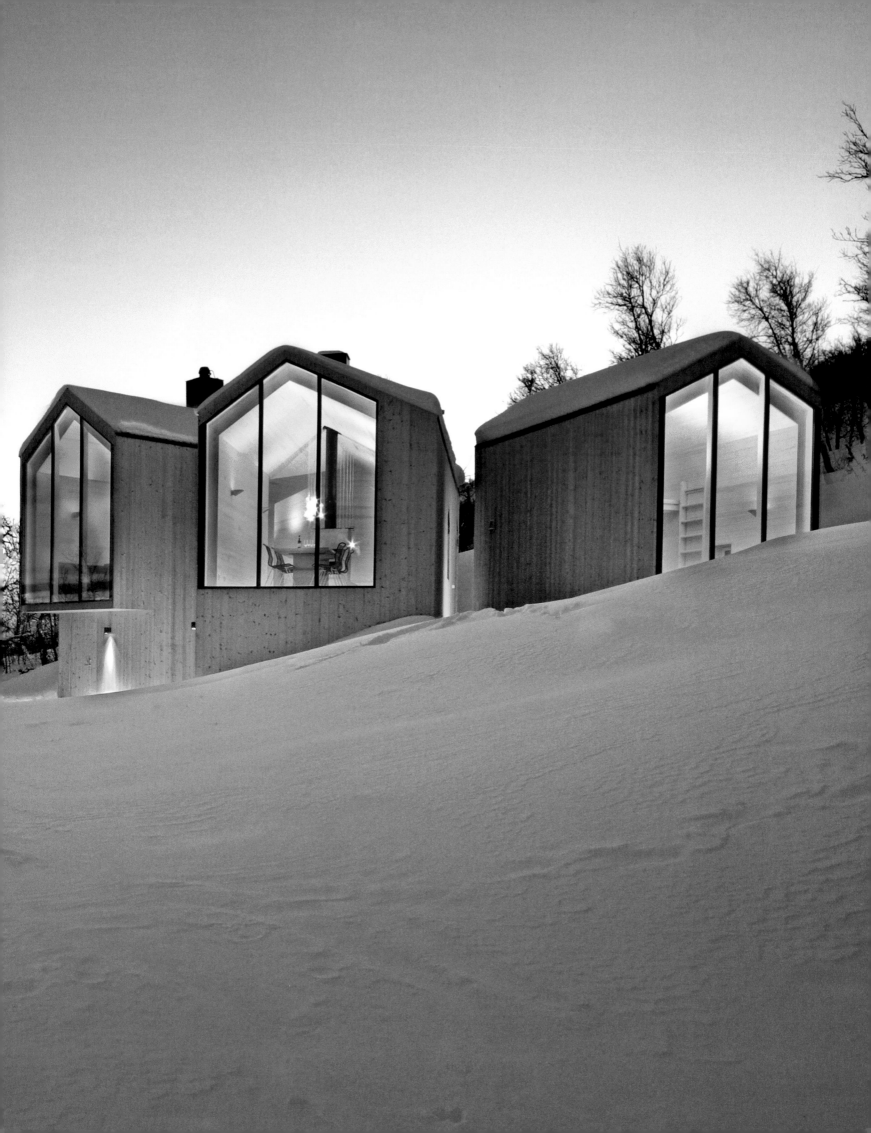

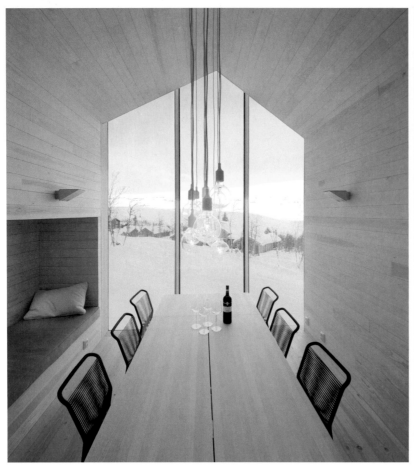
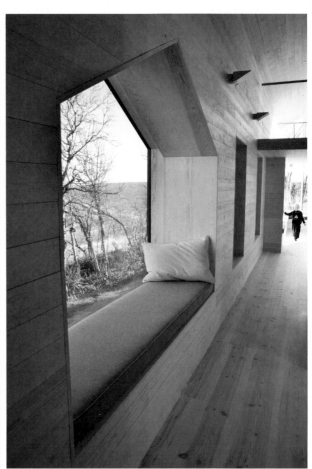
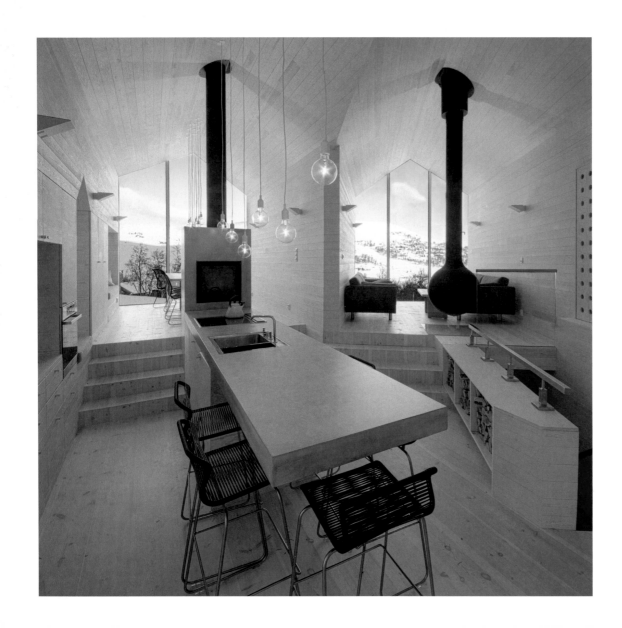

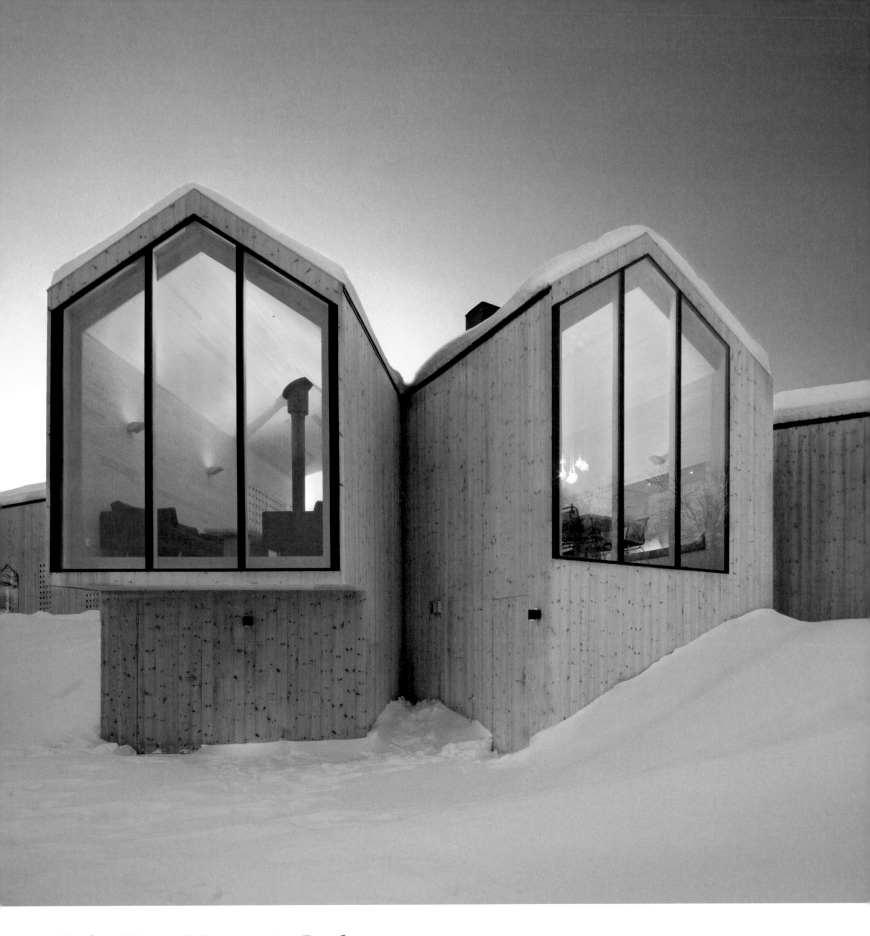

Split View Mountain Lodge

Architect/Location: **Reiulf Ramstad Arkitekter**
Østlandet, Norway

Located on a mountain slope of a popular ski valley, this holiday home reads as a collection of intersecting cabins. Each bay of the three-winged layout culminates in an all glass façade framing breathtaking alpine views. Fluently adapting to the angled terrain, the pitched roof volume's main wing houses the family's four bedrooms. The two adjoining wings work together to form an open, multi-level kitchen, dining, and living area. Connected but separate, the branching layout steps up a level to create an intimate dining space on one side and a peaceful living room on the other. The timber-framed house exudes a Scandinavian sensibility. Mixing a classic cabin silhouette with contemporary finishes and an unconventional floor plan, the playful family lodge reawakens the family's respect for nature and one another.

Contemporary Interpretation of a Traditional Zagorje Cottage

<u>Architect/Location:</u> **PROARH/Davor Mateković**
Hrvatsko Zagorje, Croatia

A splendidly restored traditional cottage situated on the green slopes of a picturesque countryside pays homage to local heritage and vernacular design. Keeping the pre-existing structure intact, a striking glass cube substitutes the original porch. To give the cottage southern exposure, the glass volume slides out from the main house, simultaneously forming an entrance area and cantilevered sun deck. The glass walls tilt open to promote seamless interaction between interior and exterior spaces. An innovative use of straw, considered largely an archaic and forgotten material, appears on both roof and walls. With the sleeping areas nested above, the ground floor hosts the cottage's living, dining, and kitchen spaces that orient around a central hearth. Easily renovated from locally available resources, the indoor/outdoor cottage becomes a timeless classic for the area.

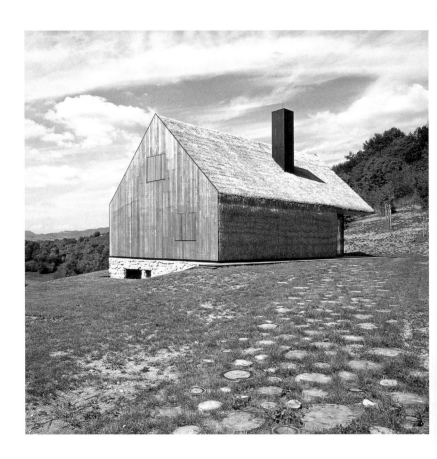

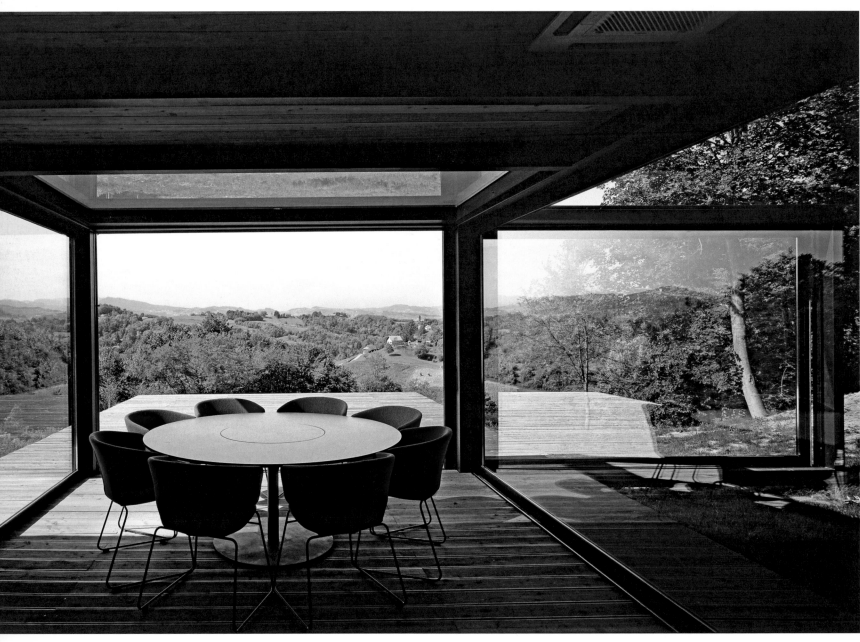

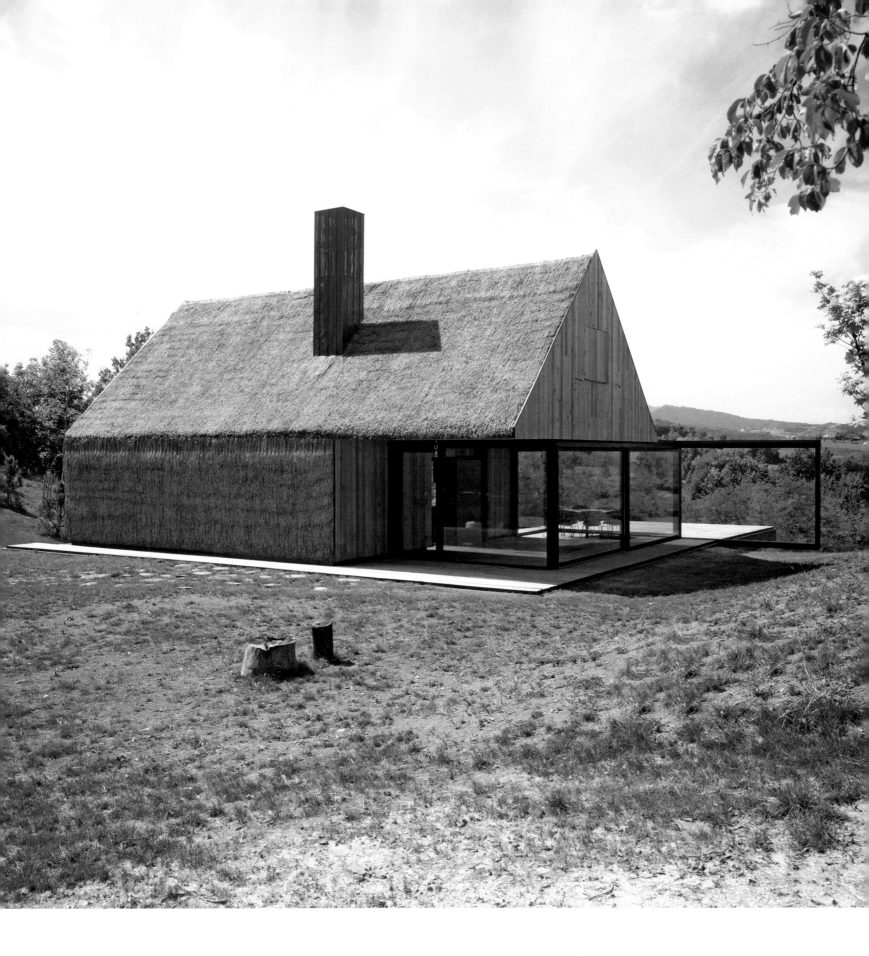

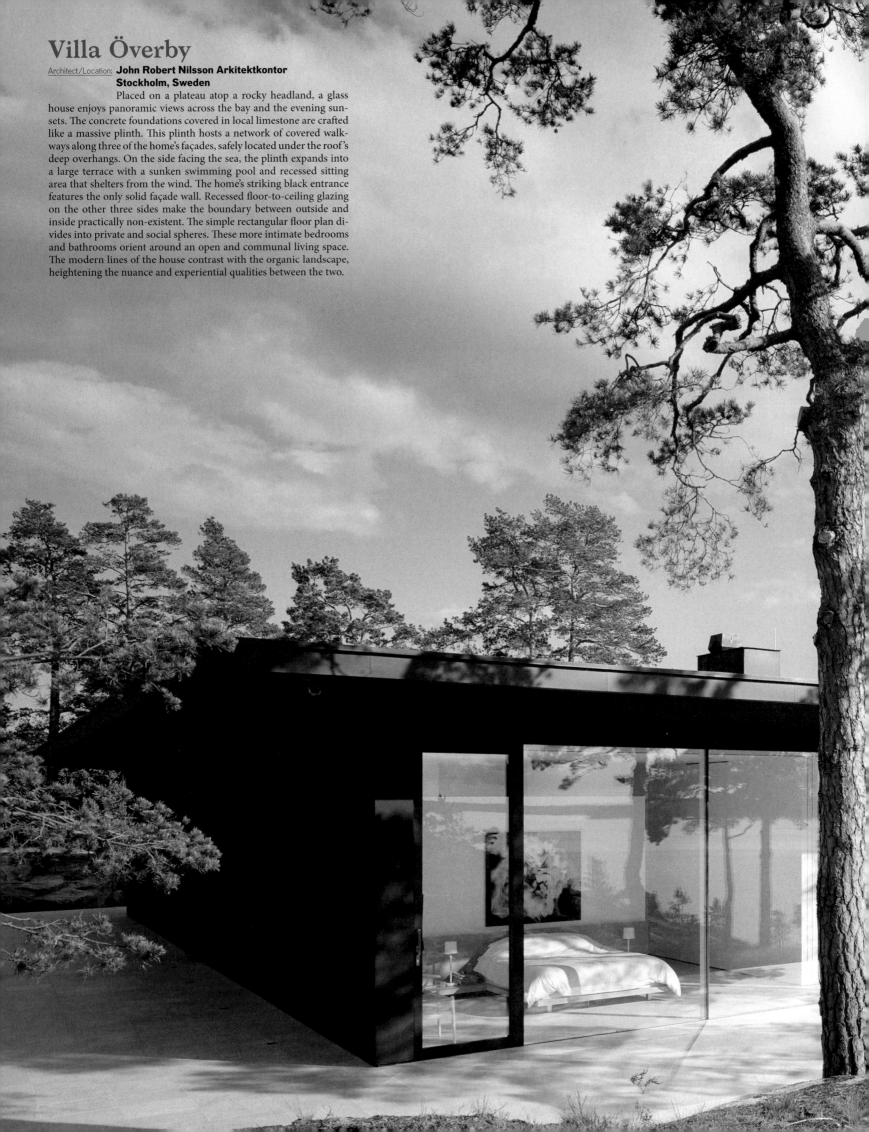

Villa Överby

Architect/Location: **John Robert Nilsson Arkitektkontor**
Stockholm, Sweden

 Placed on a plateau atop a rocky headland, a glass house enjoys panoramic views across the bay and the evening sunsets. The concrete foundations covered in local limestone are crafted like a massive plinth. This plinth hosts a network of covered walkways along three of the home's façades, safely located under the roof's deep overhangs. On the side facing the sea, the plinth expands into a large terrace with a sunken swimming pool and recessed sitting area that shelters from the wind. The home's striking black entrance features the only solid façade wall. Recessed floor-to-ceiling glazing on the other three sides make the boundary between outside and inside practically non-existent. The simple rectangular floor plan divides into private and social spheres. These more intimate bedrooms and bathrooms orient around an open and communal living space. The modern lines of the house contrast with the organic landscape, heightening the nuance and experiential qualities between the two.

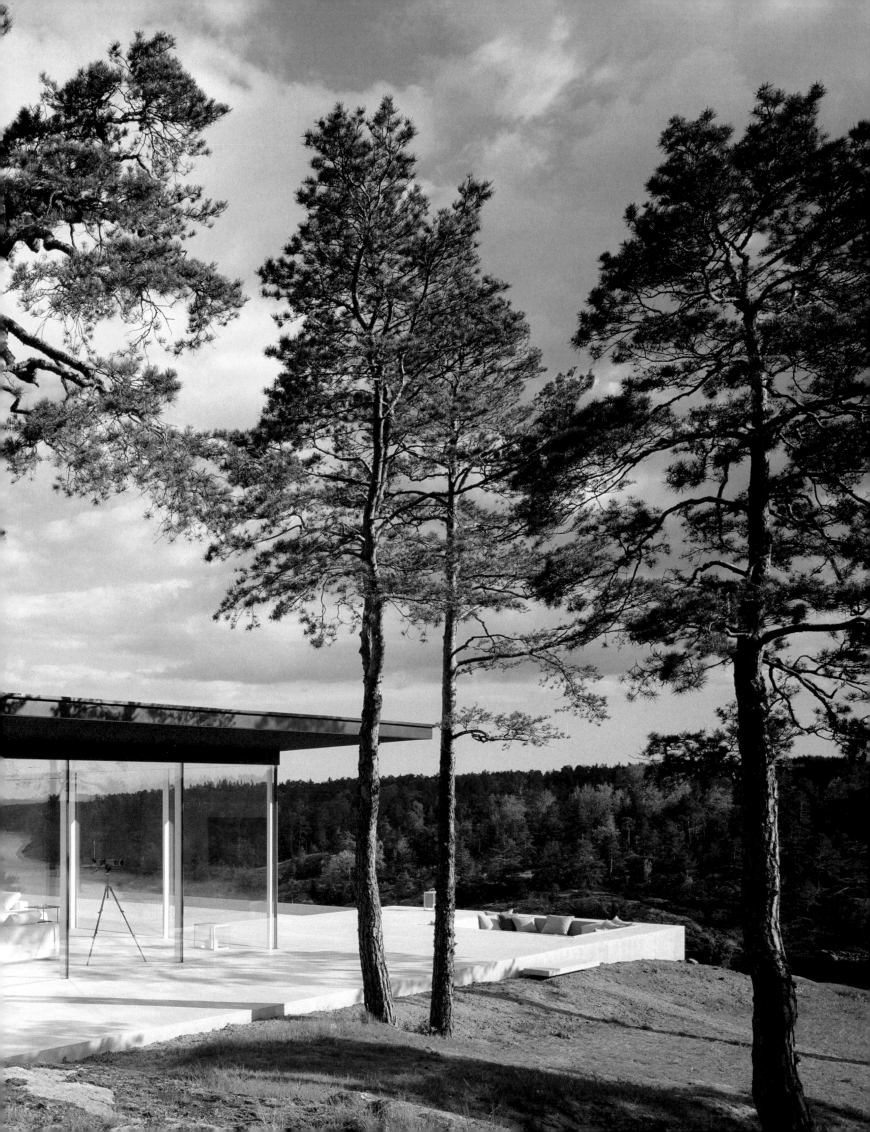

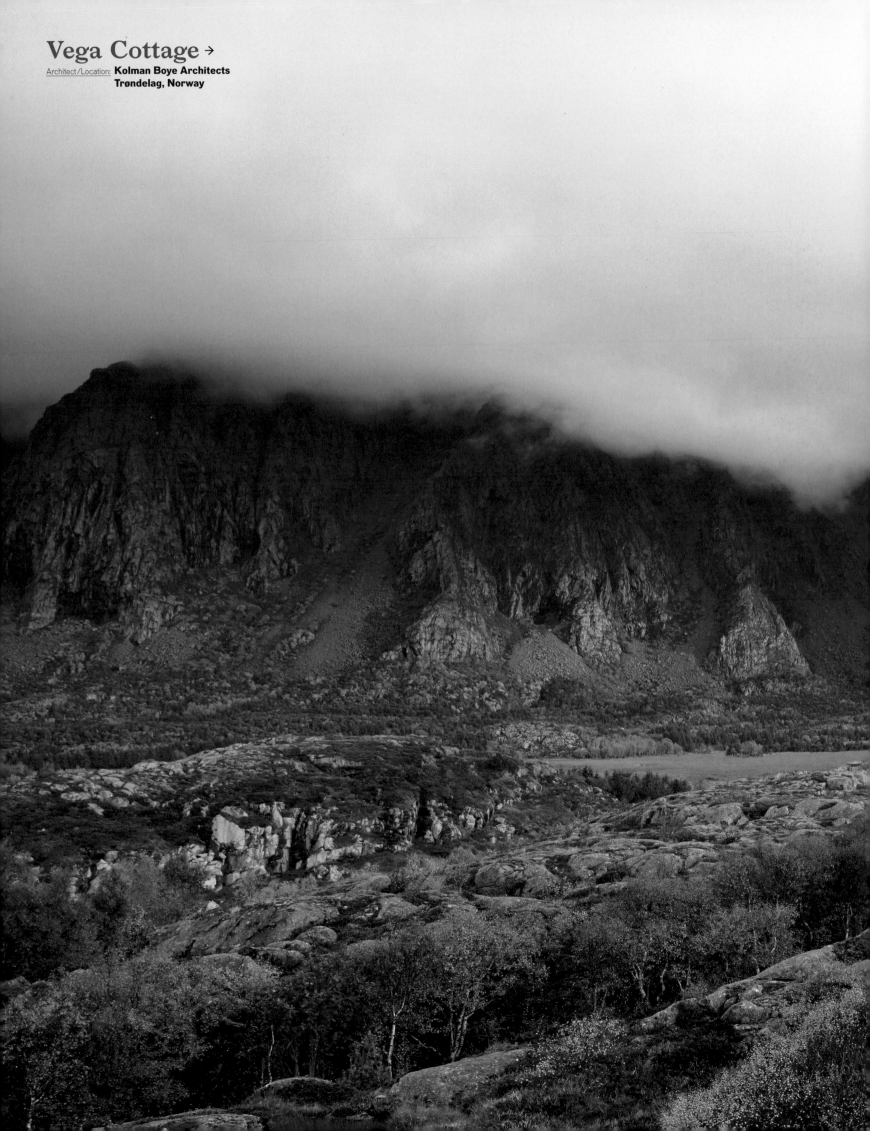

Vega Cottage →
Architect/Location: **Kolman Boye Architects**
Trøndelag, Norway

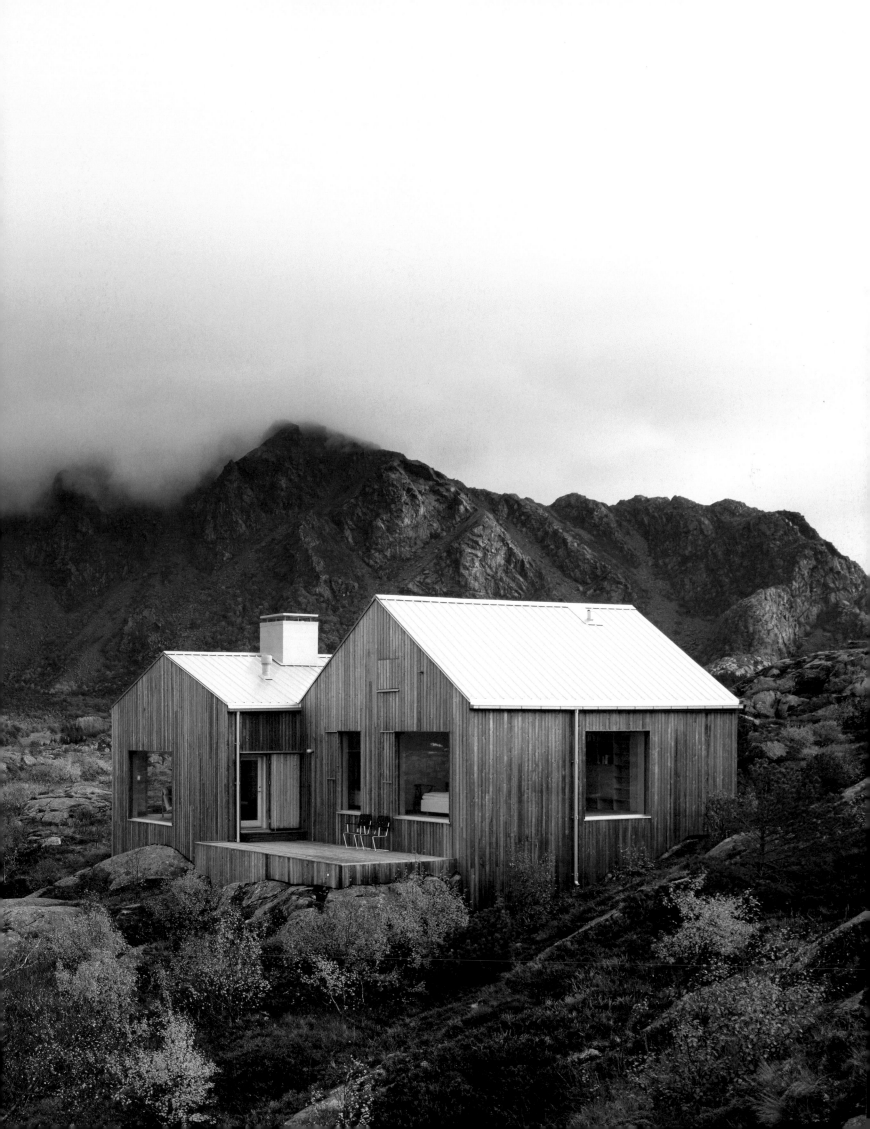

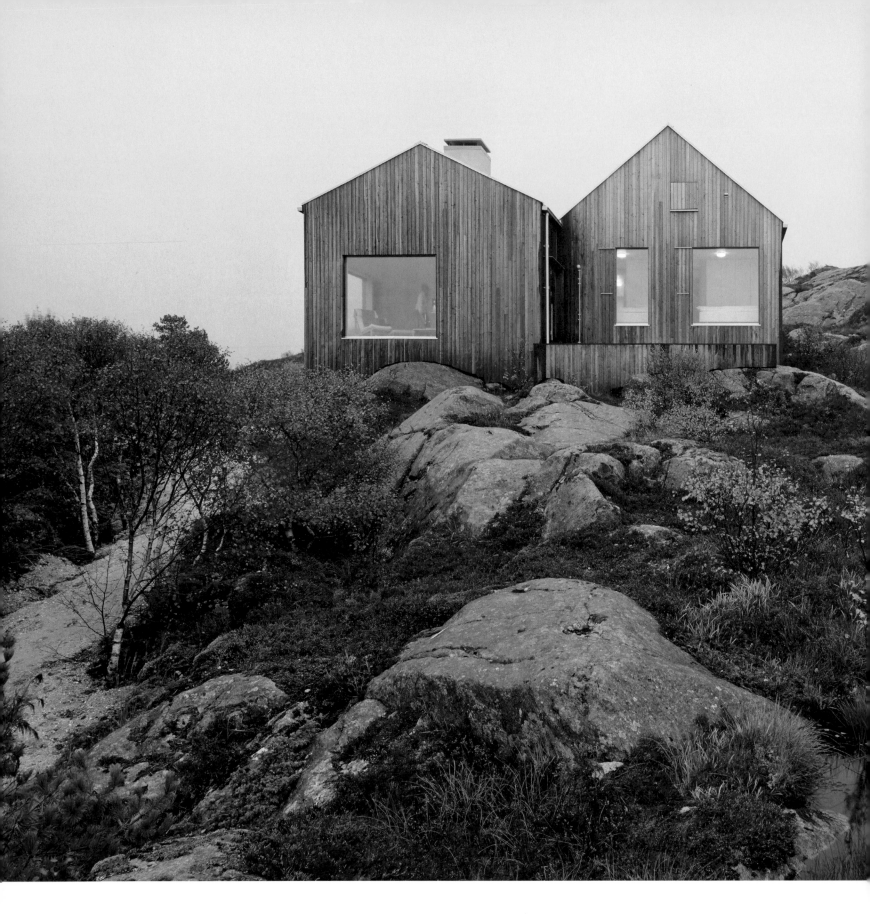

Vega Cottage

Architect/Location: **Kolman Boye Architects**
Trøndelag, Norway

Not far from the polar circle, a stoic house pays tribute to the vernacular huts found in this harsh northern landscape. The shelter learns from the traditional weathered structures, building on their strong tectonics and material vocabulary. Known for grand and wide panoramas of the Norwegian Sea and jagged mountains, the untouched and wild site welcomes the unpretentious shelter. Seemingly grown from the rocks, the dwelling engenders a unique refinement of everyday life. Large windows outline undisturbed vistas of the ocean, mountain range, and bedrock. Organized on two levels, the compact plan provides generous social spaces. The upper level holds bedrooms and family rooms, while the lower floor behaves as a gallery-like space structured around a stone hearth. The subtle wooden interior promotes tactile qualities and a patina that develops over time. Sheltered from the elements, the house offers a safe haven to quietly observe the ever-changing light over the sea.

118

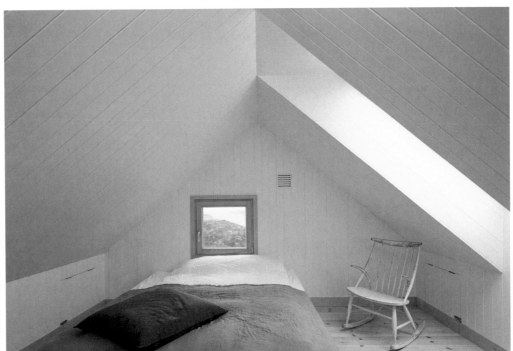
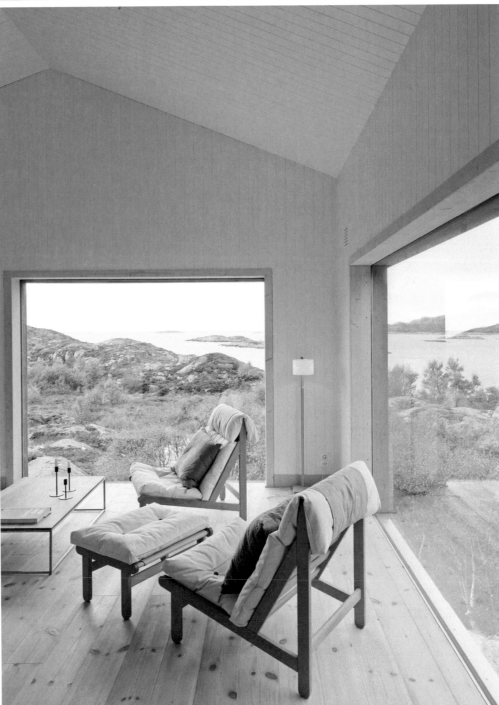

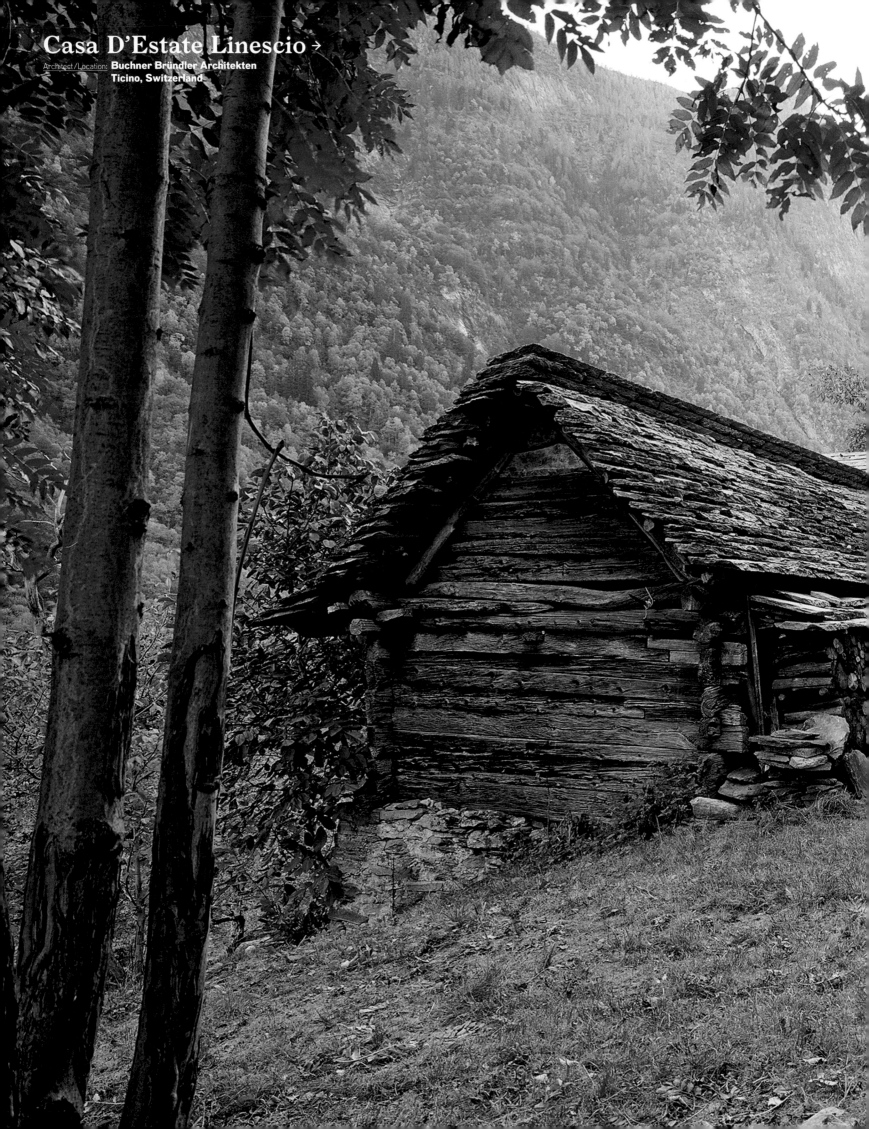

Casa D'Estate Linescio →

Architect / Location: **Buchner Bründler Architekten
Ticino, Switzerland**

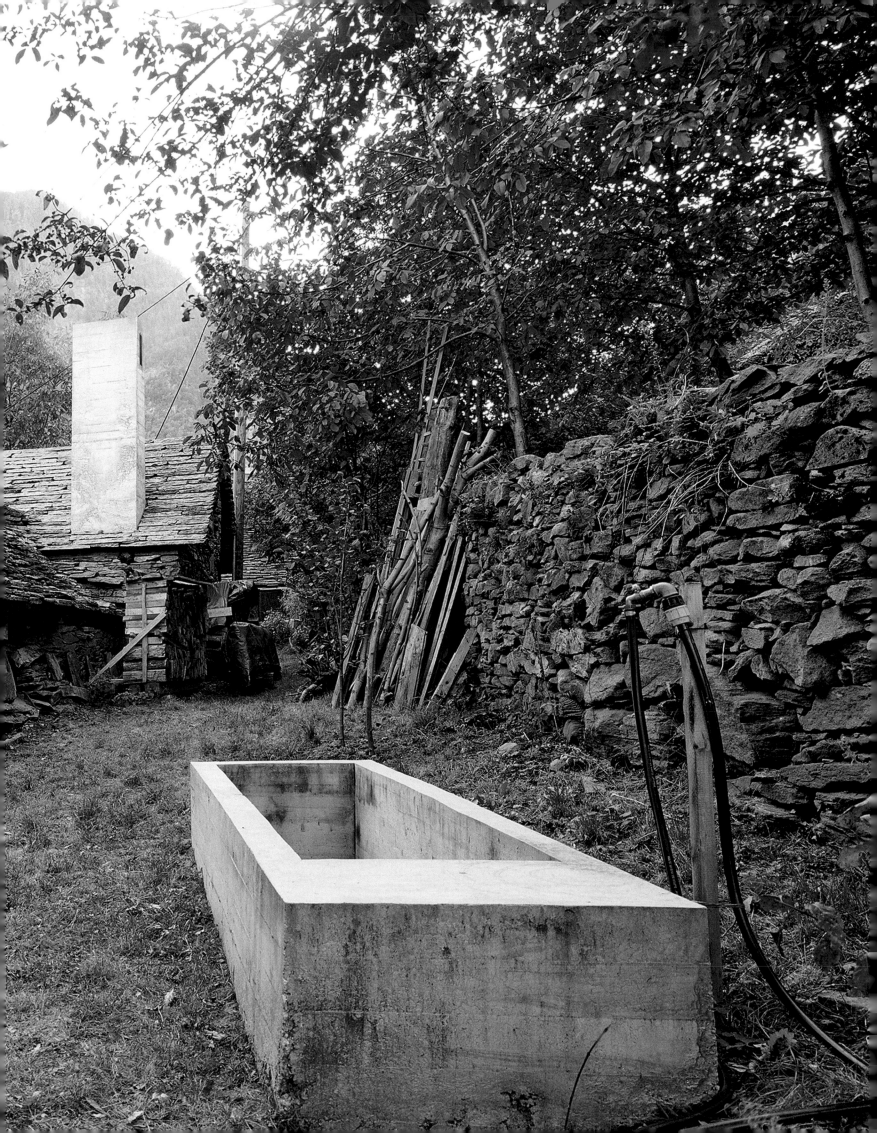

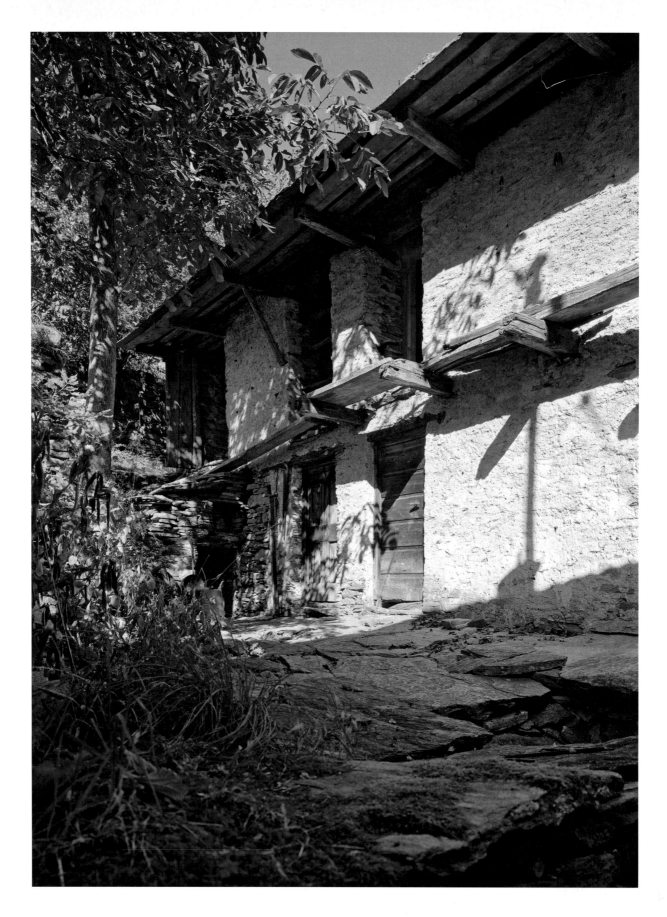

Casa D'Estate Linescio

Architect/Location: **Buchner Bründler Architekten**
Ticino, Switzerland

Located in a small village in the remote Rovana valley, a 200-year-old wood and stone building becomes an enticing summer house. The delicate and demure renovation preserves the rustic quality of the weathered original façade and stone walls. Built in a log house style, the extant structure was previously used to dry chestnuts. The simple and minimalist interior update now houses a double-height living space, sleeping niches, and a fireplace. From the exterior, the new structure stays almost entirely hidden, setting up a captivating juxtaposition between old and new elements. Sparse and atmospheric, a new kitchen and bathroom nest into the adjacent addition and connect to the extant house via a new passageway. Behind the old exterior shell, slender shuttered windows span the two-story interior to bring light and views into the cabin. Part ruin and part unexpected contemporary sanctuary, the rugged mountain cabin functions as both a lesson in local history and a stirring hideout.

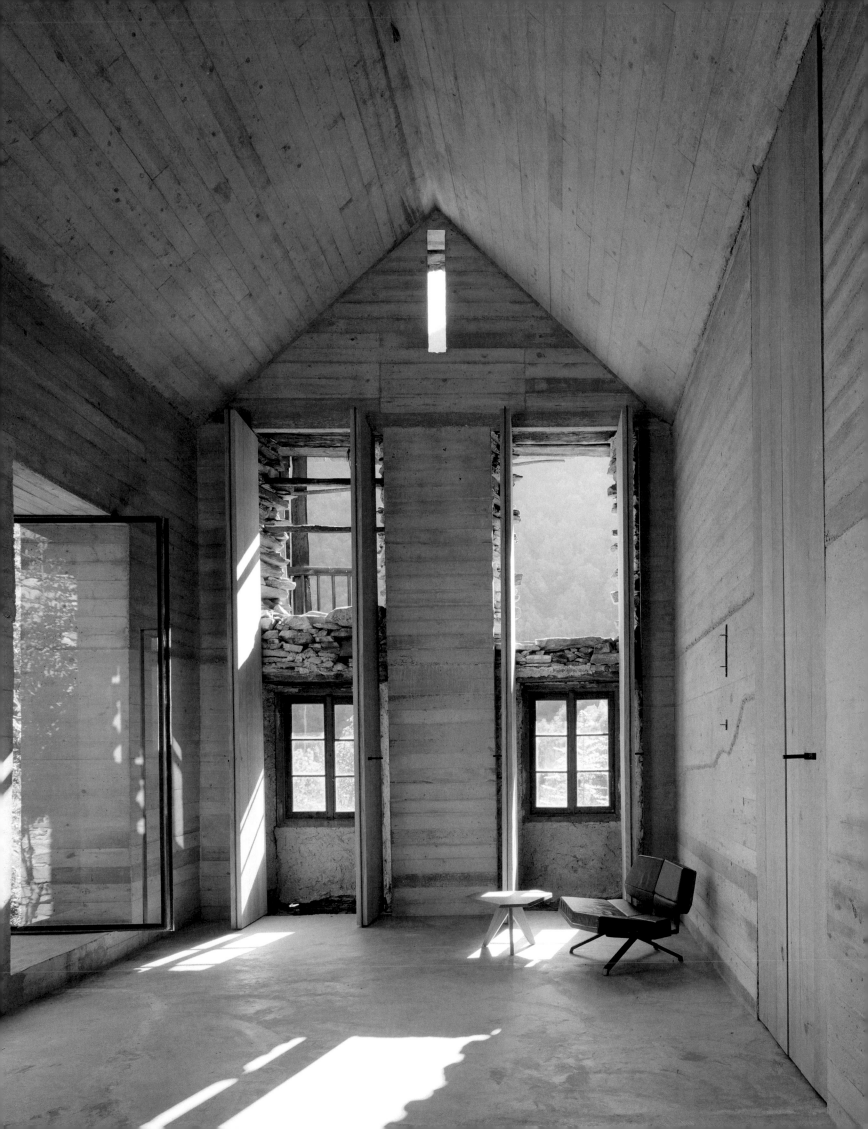

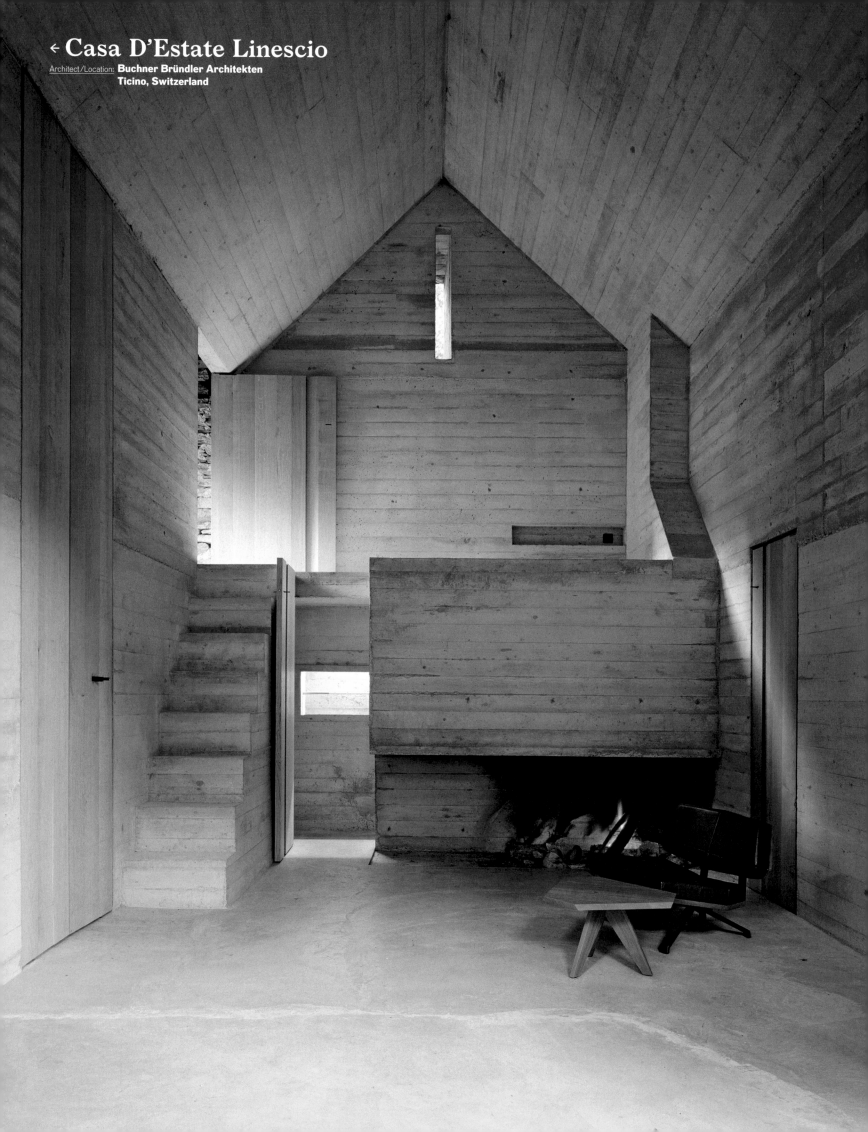

← Casa D'Estate Linescio

Architect/Location: **Buchner Bründler Architekten**
Ticino, Switzerland

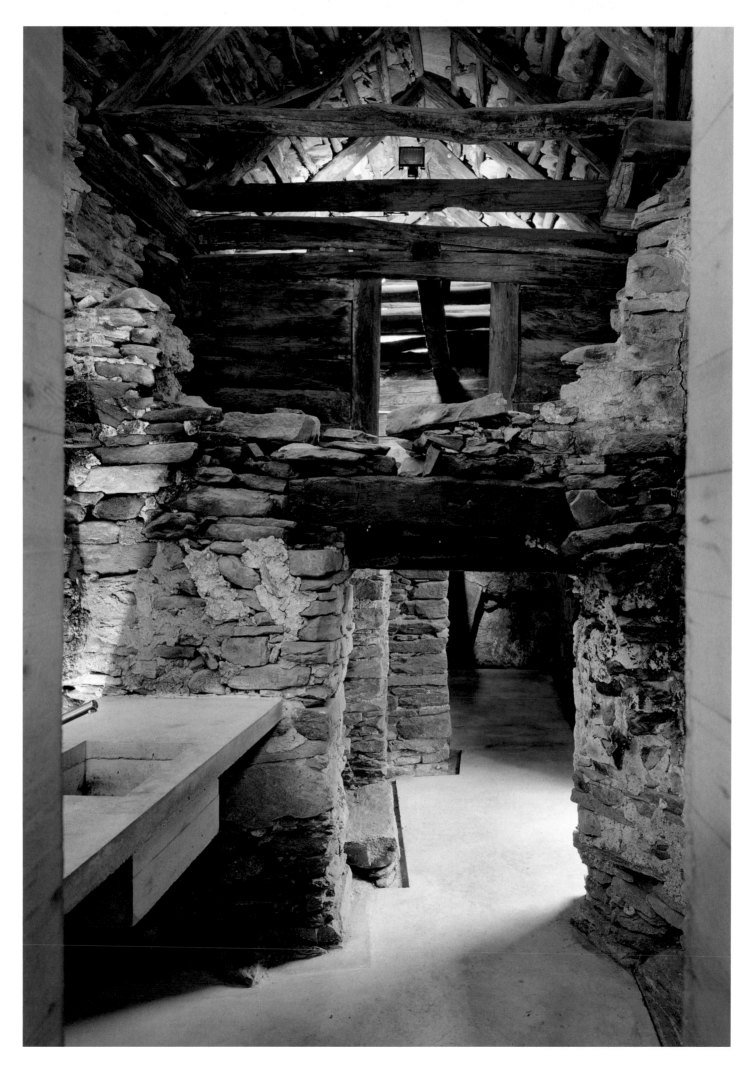

Portable House ÁPH80 →

Architect/Location: **Ábaton**
Madrid, Spain

Chapter 3

OPEN RANGE

P. 126–197

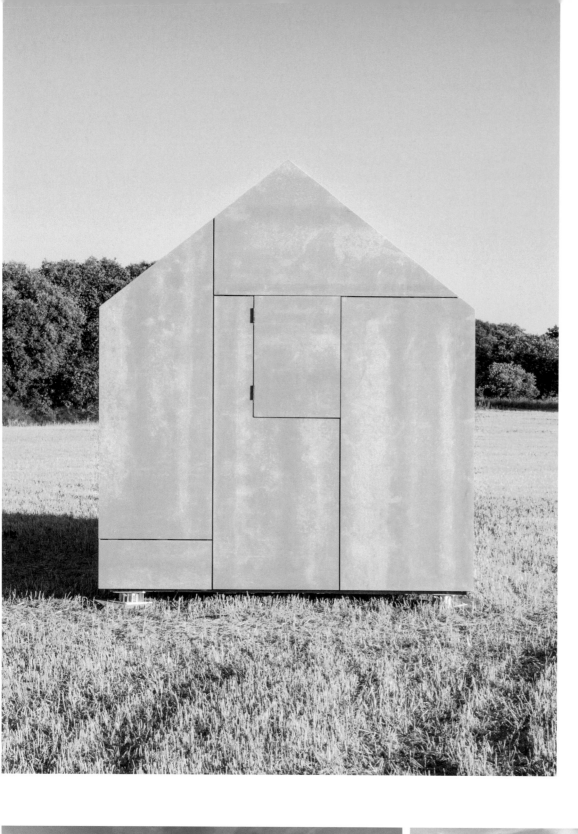

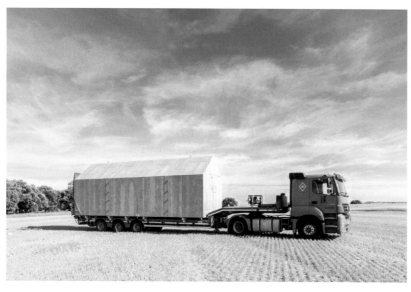
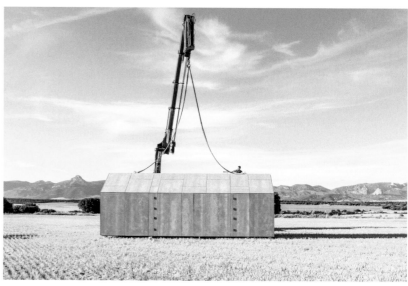

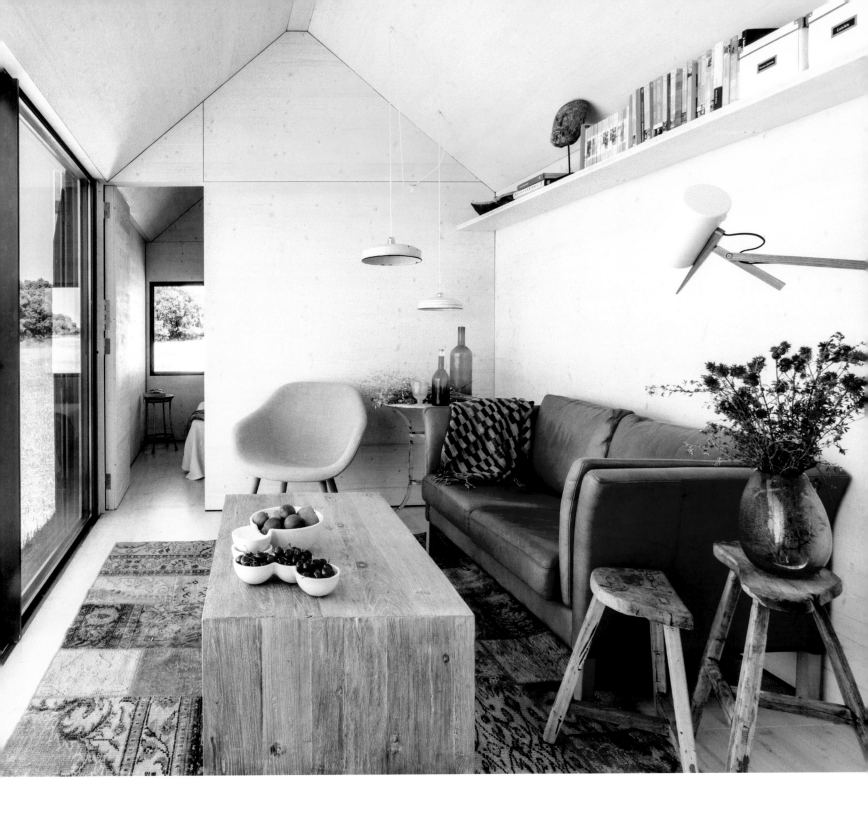

Portable House ÁPH80

Architect/Location: **Ábaton**
Madrid, Spain

Easily transported and ready to be placed anywhere, the ÁPH80 series serves as a mobile dwelling for two occupants. The wooden home, clad entirely in grey cement-board panels and built for € 21,900, generates an evolving relationship with the landscape. Depending on the current needs of its residents, the panels can swing open to reveal generous apertures or shut tight to form an impenetrable micro fortress. The archetypal but compact proportions inspire a spacious interior experience that spills into the outdoors through glass sliding doors. Simple yet sturdy, the sustainable cabin provides both comfort and environmental sensitivity. The gable roof dwelling consists of a living room/kitchen hybrid, a full bathroom, and a bedroom. Manufactured in eight weeks and assembled in a single day, the cost effective and locationally flexible cabin proves that home isn't just where the heart is, it's wherever you want it to be.

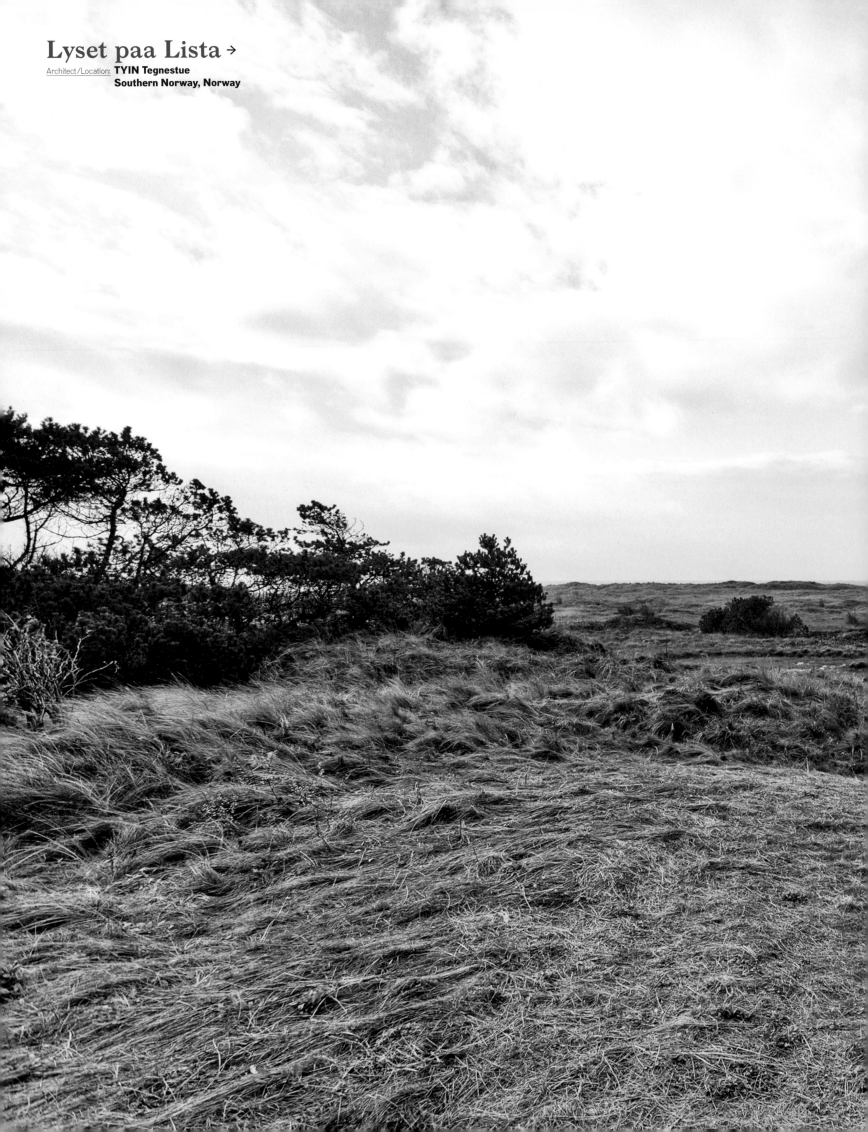

Lyset paa Lista →

Architect/Location: **TYIN Tegnestue**
Southern Norway, Norway

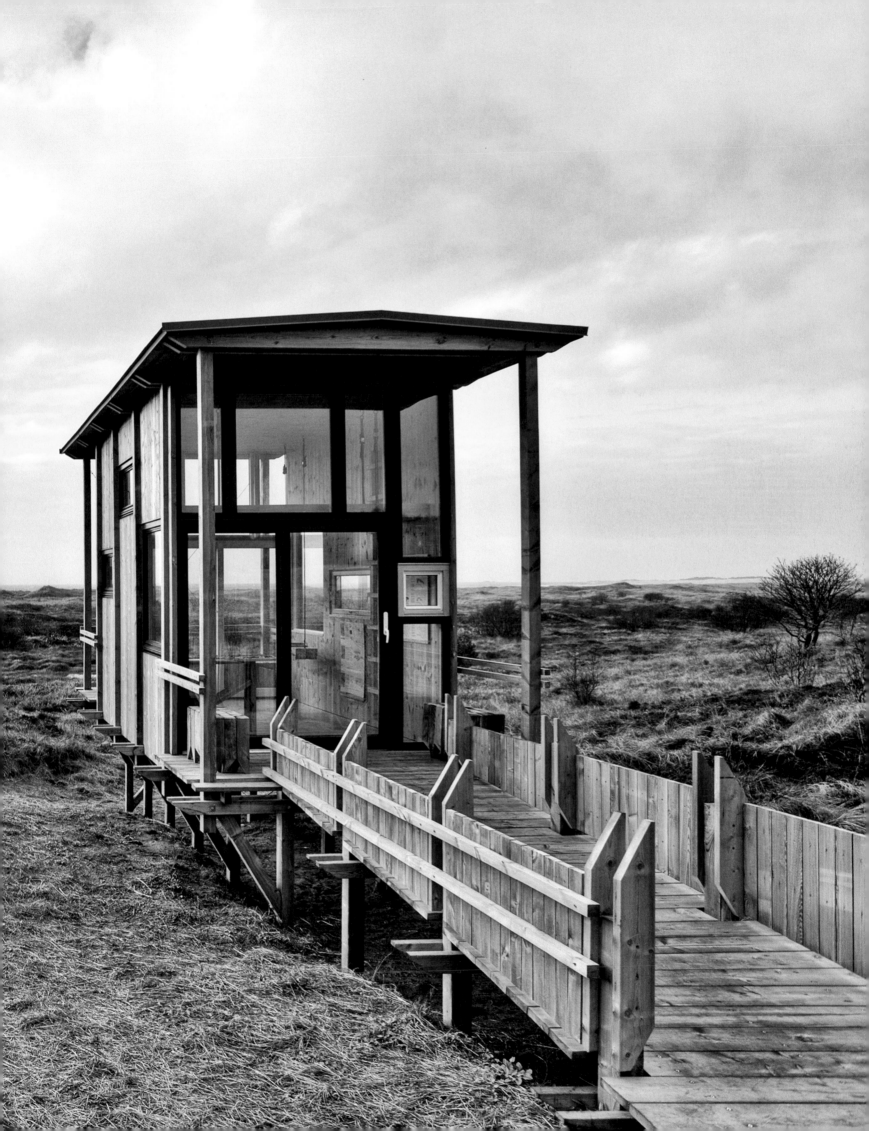

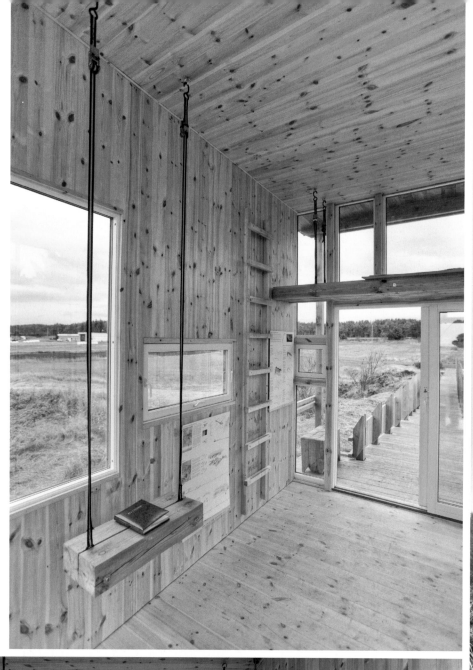

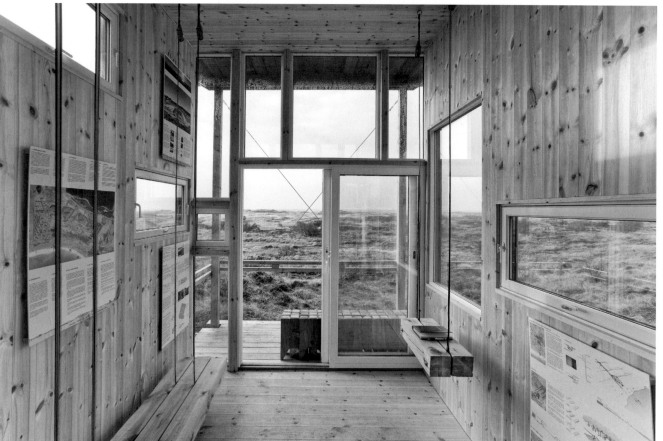

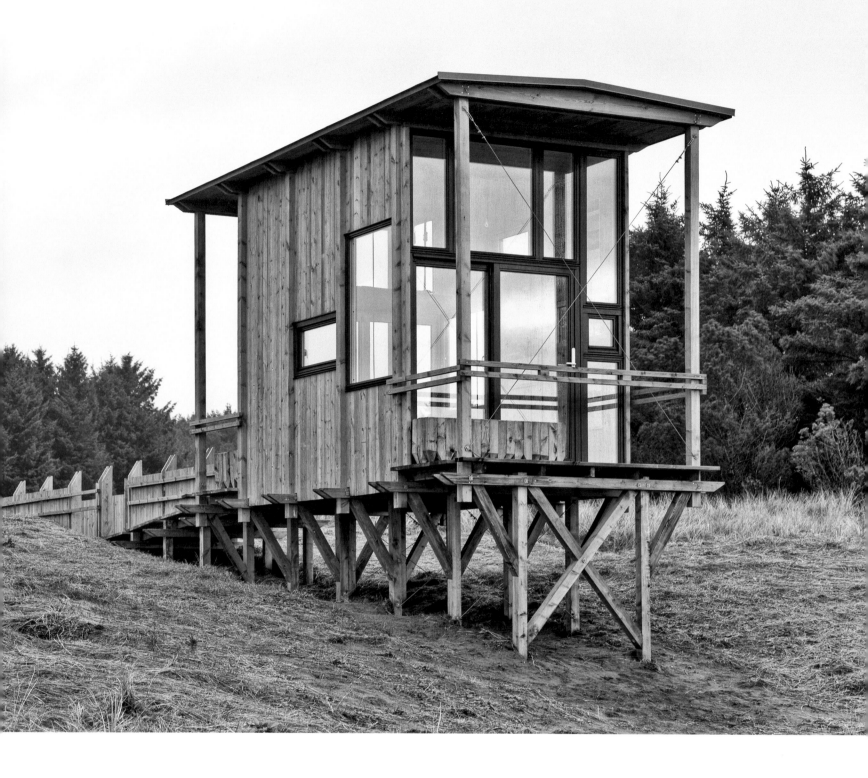

Lyset paa Lista

Architect/Location: **TYIN Tegnestue**
Southern Norway, Norway

A delicate structure in a fascinating northern landscape attempts to circumvent the migration from this rural region. The intriguing shelter showcases the site's wild beauty, hoping to draw funding back to the area. A communal effort built with the help of students from Mexico and Norway, the project's client consists of a group of 50 landowners interested in reviving local tourism. The completely reversible wooden structure contrasts against the organic sand dunes. Providing a firsthand experiential relationship to the wild, the project forms a straight line over complex and uneven terrain. A long wooden pathway ensures universal access to the small cabin found at the end of the walkway. Optimized for enjoying the ancient and emotive landscape, the cabin behaves like a seamless continuation of the path. Fondly named by the owners "The light of Lista," the enticing refuge stands as the ideal location for watching the captivating aurora borealis formations illuminate the night sky.

133

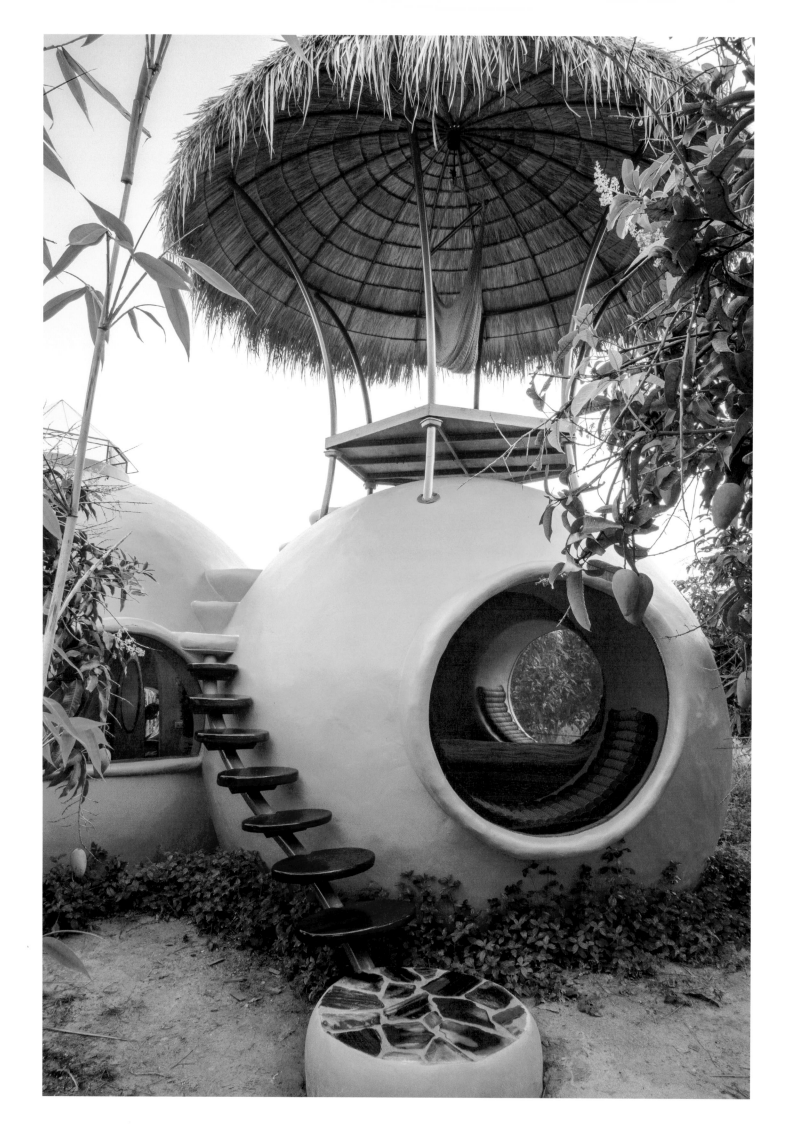

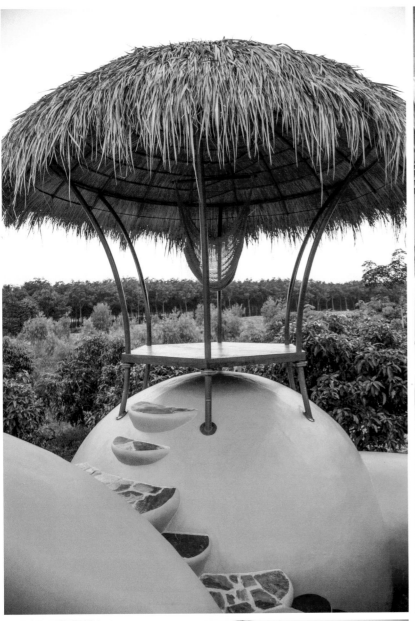

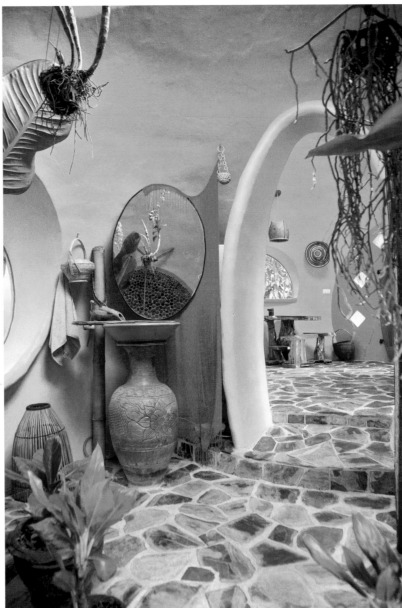

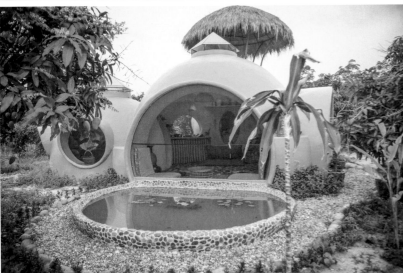

Steve's Thailand Dome Home

<u>Architect/Location:</u> **Steve Areen**
Isan, Thailand

Inspired by a friend's dome-shaped residence in a remote Thai village, this playful and imaginative dwelling built nearby combines simplicity and efficiency with a spirited and organic visual presence. The whimsical orange refuge sits amidst a large organic mango farm. A communal and low cost effort, the project was completed in only six weeks for under $6,000. Detailed with local materials, the project incorporates pottery for the bathroom sink, bamboo for the faucet, and baskets for the lights. A handmade staircase winds its way up to a rooftop patio shaded by a great palapa, perfect for lounging in the afternoons. The eccentric bungalow exudes a tropical aesthetic and the mild climate keeps the home connected to the outdoors and its refreshing breezes year round.

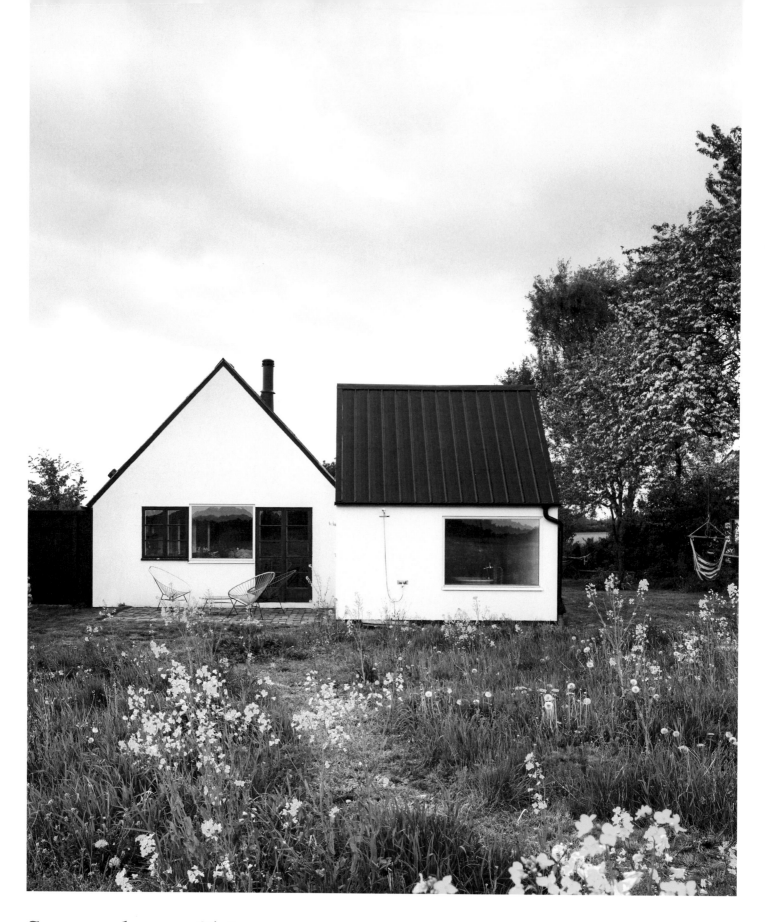

Summerhouse Skåne

Architect/Location: **LASC Studio**
Skåne, Sweden

Set in a Swedish summer vacation area, this conversion of an abandoned farmhouse rethinks notions of nostalgia and shelter by combining them with contemporary desires for space, light, and nature. While the clients were attached to the traditional and robust vernacular of the area, they also wanted to enjoy the blustery nature from indoors. The conversion re-invents the elements that give the house a sense of belonging. A pale interior palette connects to the scenery outside, enhanced by an infusion of bright colored surfaces.

These vibrant colors, reminiscent of the clients' many years in China, recall the summer days spent on the nearby beach with its bright towels and kites. Never boldly presented, the colors appear and disappear as they transition from one space to the other. Working with a restrained budget, the unpretentious summerhouse embodies a simple luxury. The retreat relates to nature through splashes of color and the meditative sound of water falling on wood.

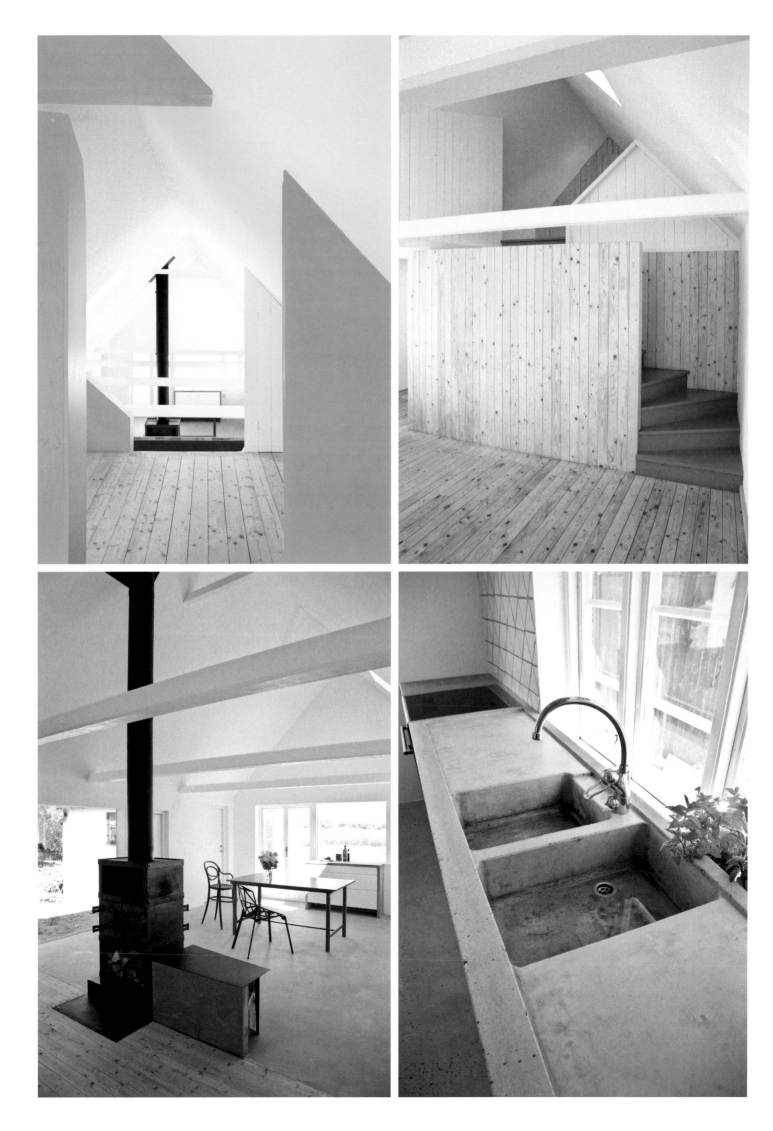

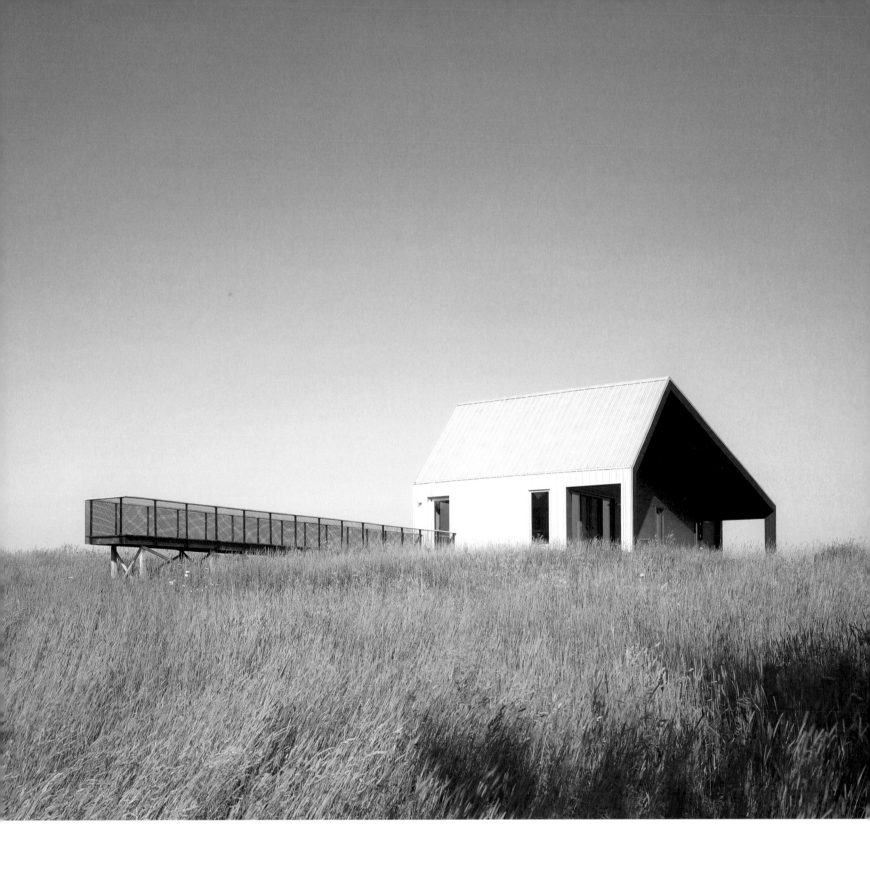

House on Limekiln Line

Architect/Location: **Studio Moffitt**
Ontario, Canada

A small off-grid house rests on a 25-acre farm lot in rural Canada. Built by local farmers, craftsmen, and family members over three consecutive summers, the house develops an intentionally modest footprint while feeling spatially expansive. The steel clad shed provides sweeping views of the agrarian landscape on which it sits. Generous decks on the east and west faces operate as threshold spaces that extend this experiential choreography from inside to out. The exterior's architectural language, informed by the local agricultural vernacular, ensures a visual coherence within the rural context. Inhabitable spaces flow into one another, culminating in an intimate sleeping area on one side and a double-height living space and loft on the other. The house, detailed with a deliberately reductive palette and abundant windows, cultivates a rejuvenating place for relaxed, seasonal observation.

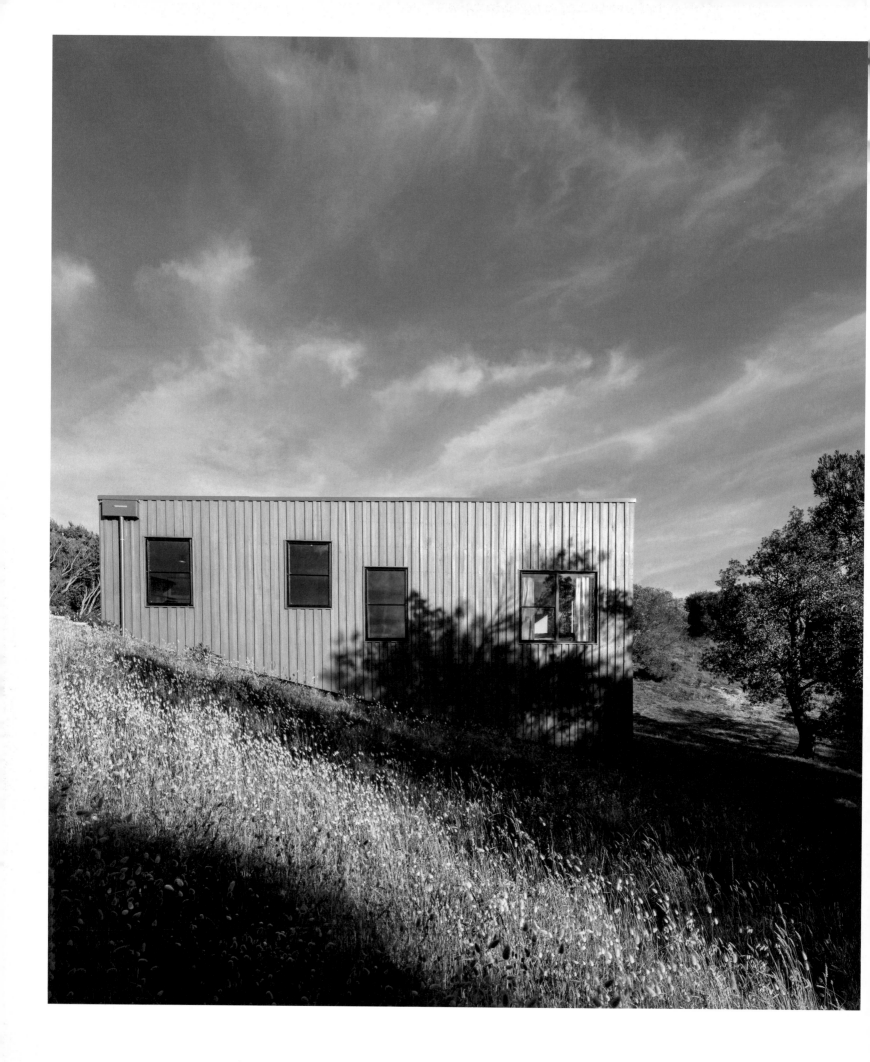

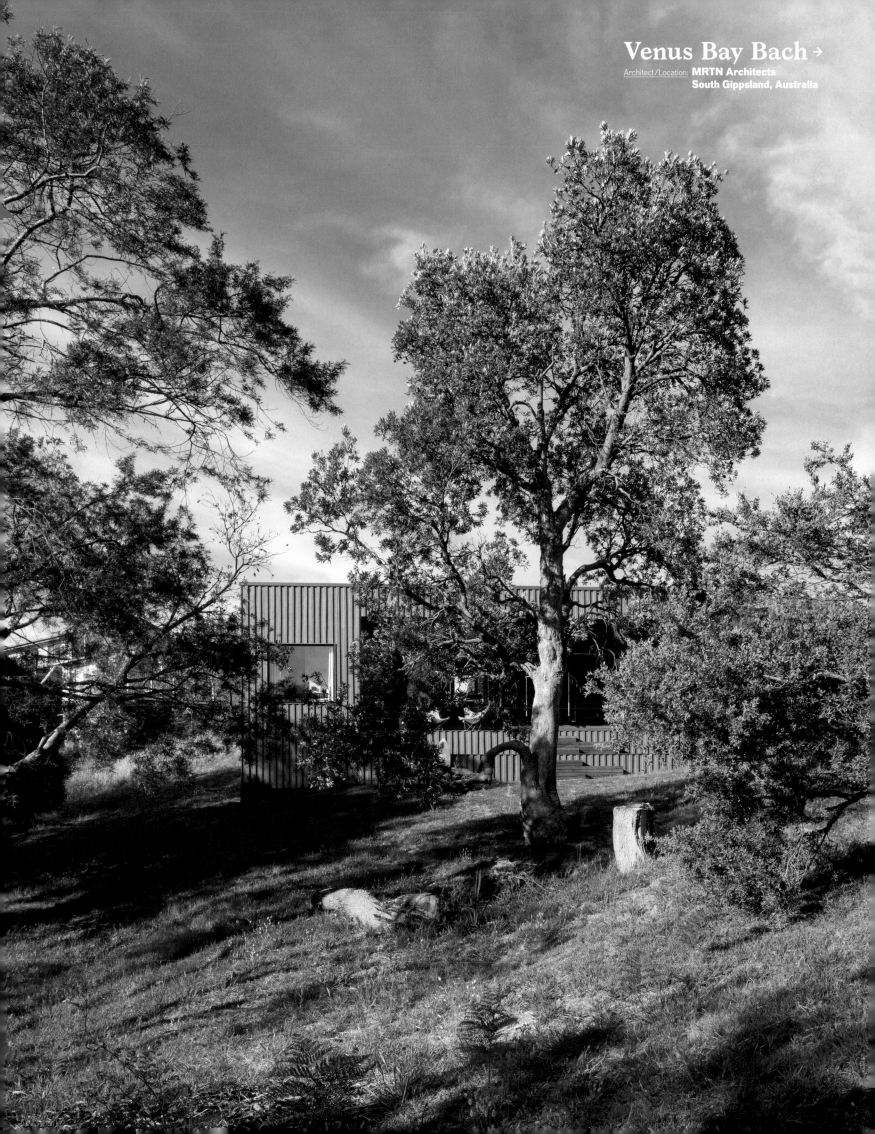

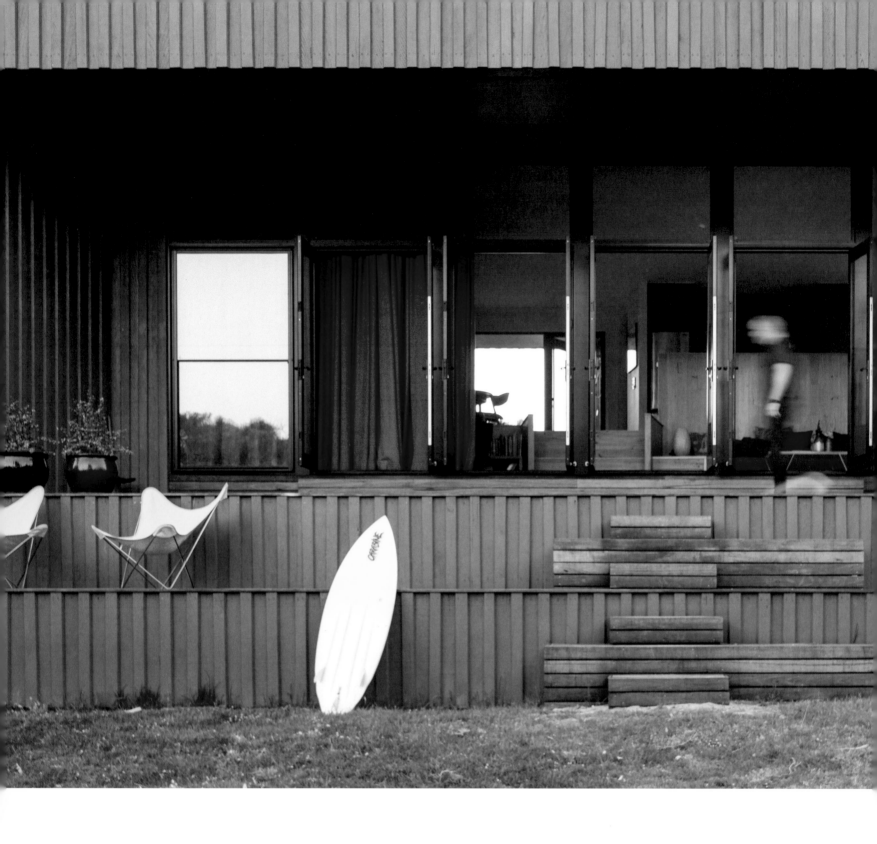

Venus Bay Bach

Architect/Location: **MRTN Architects**
South Gippsland, Australia

This cheerful vacation house resides on a grassy hillside above an exposed stretch of white sand beach. Two hours from Melbourne, the wooden dwelling capitalizes on its proximity to the rugged coast. The small four bedroom home feels much larger than its footprint. From the street, the home appears to be a low-lying volume hunkered down against the wind. Upon entry, the floor steps down with the slope of the site, revealing a generous spatial progression across the main living areas and out to the covered deck. The changes in floor levels result in higher ceilings, enhancing the views to the northeast. The covered deck, cut into the boxy mass, represents the social heart of the house. Designed as a large outdoor room, the deck stays sunny in winter and shaded in summer. This warm and protected outdoor space not only contrasts with the dark and muted palette of the exterior but also gradually cascades into the landscape, inspiring meaningful and impromptu ways to relate to nature.

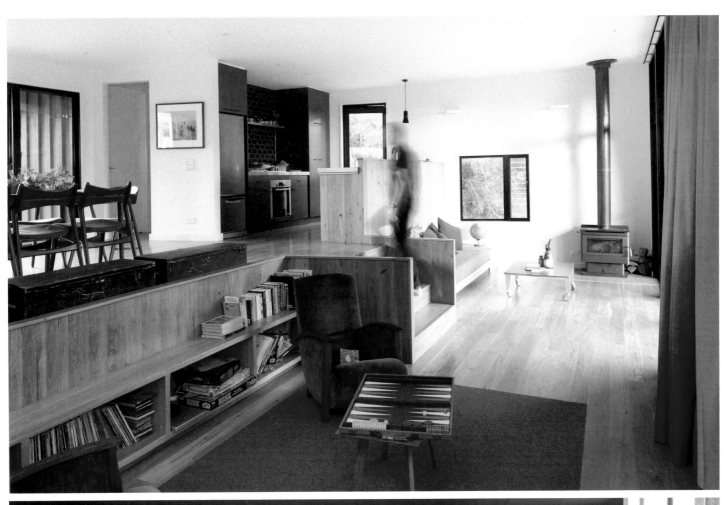

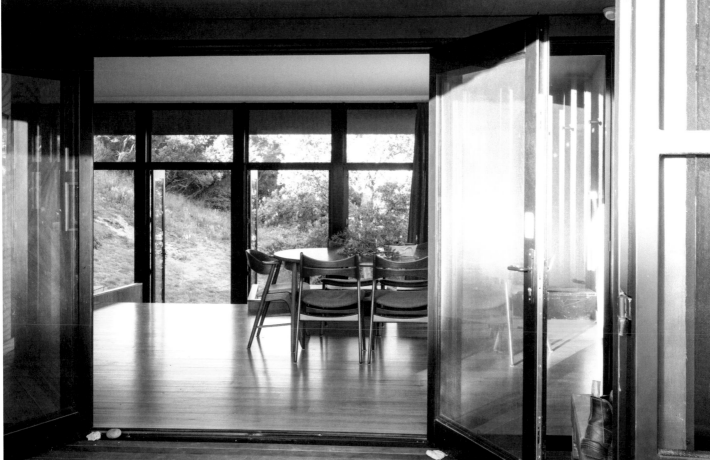

Casa Mía

Architect/Location: **Pons Estel**
Santa Fe, Argentina

This simple white home stands as a new modular housing prototype developed for a residential neighborhood in Argentina. Small but bright, the highly functional and modest dwelling transcends one's expectations. The optimized house uses a combination of recycled elements and durable industrial materials to keep costs down. With no room for the superfluous, the understated furnishings maximize the compact floor plan and promote a range of activities in each space. The white and natural wood color palette promotes a feeling of spaciousness and develops a light and airy atmosphere that extends onto an outdoor terrace. Continuous floor to ceiling windows allow visual and spatial continuity between inside and out. The linear white volume elevated off the ground exudes a timeless ambiance and a rare and authentic relationship between the industrialized, recycled, and natural worlds.

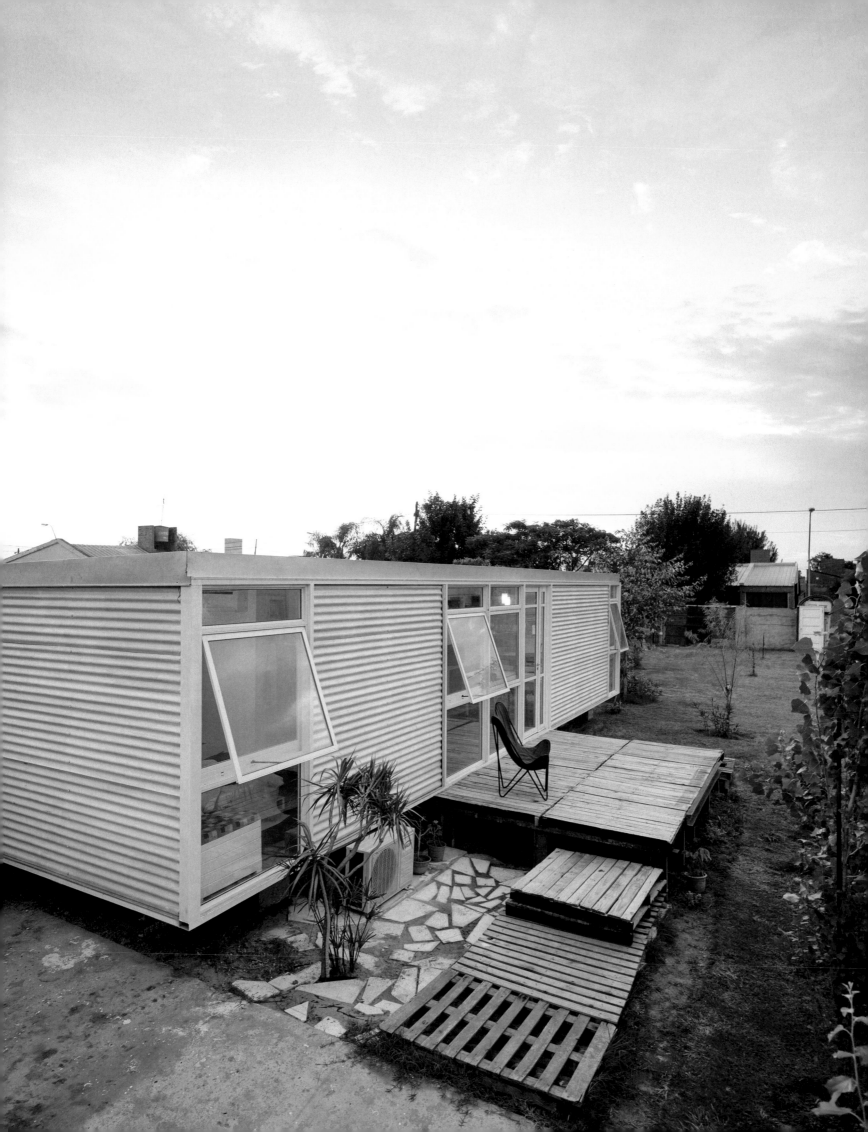

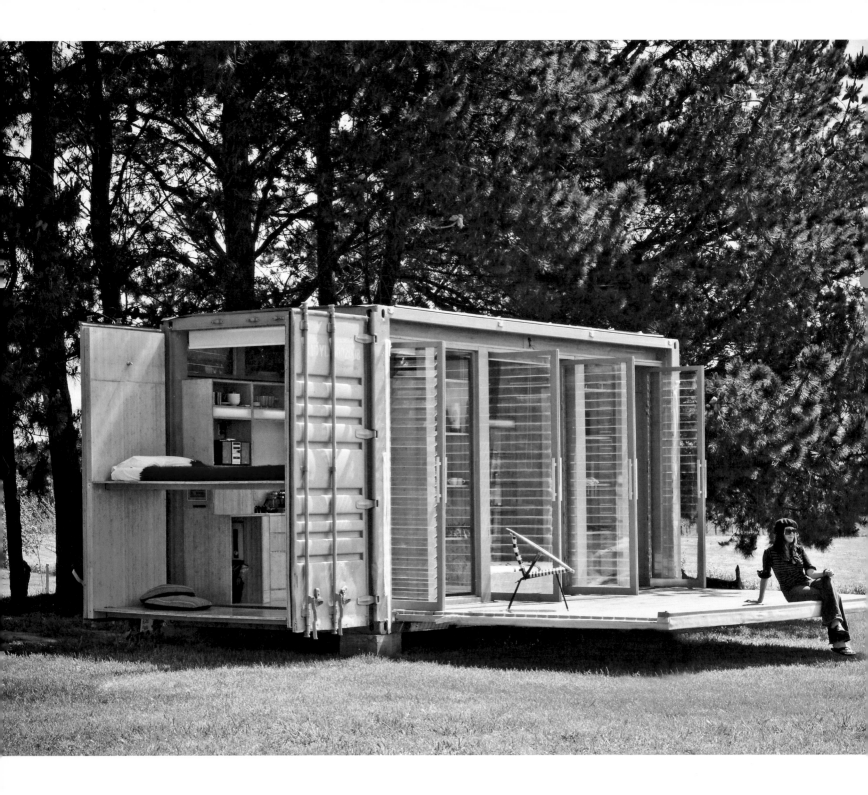

Port-a-Bach

Architect / Location: **Bonnifait + Giesen**
Matapouri Bay, New Zealand

This shipping container now acts as a playful and mobile shelter for a New Zealand family. The highly crafted, compact, and flexible living solution enables the owners to move the unit with ease. Unfolding in a matter of minutes, the closed container transforms into an airy and multipurpose 36 m² dwelling. The fold-down façade panels double as outdoor decks for the retreat and reveal operable glass doors that connect the interior to the landscape. Complete with bunk beds, an intimate living area, and a spacious bathroom, the modest but cheerful dwelling inspires an active and adaptable approach to living in and with nature. Similar to animals that carry their homes on their back, the nomadic retreat affords a unique and open-ended opportunity to find one's place within the wild again and again.

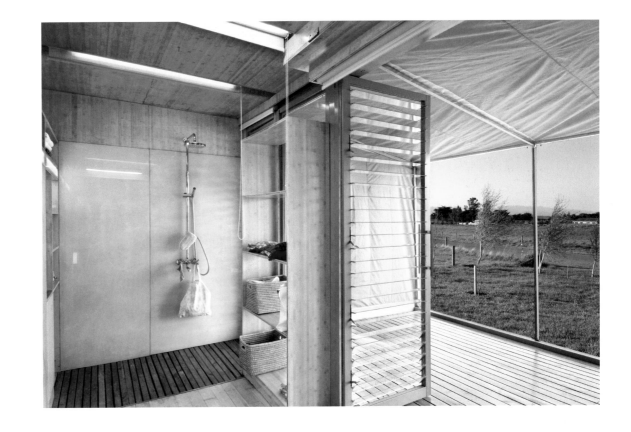

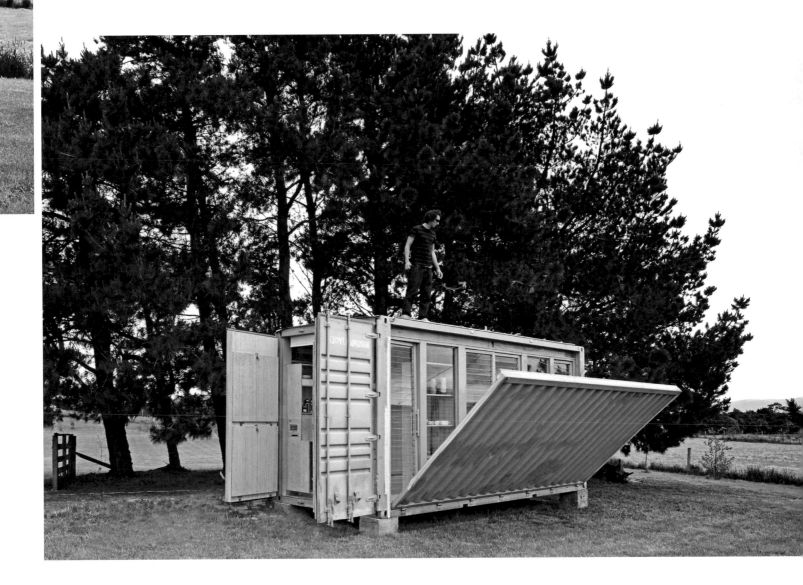

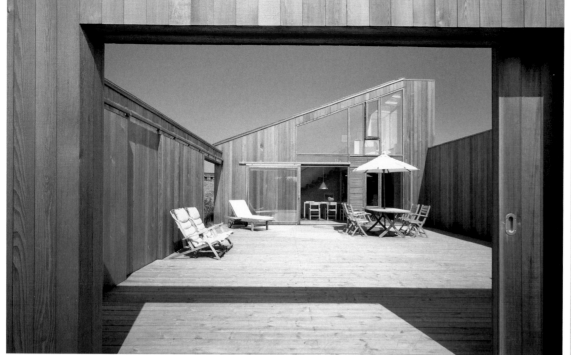

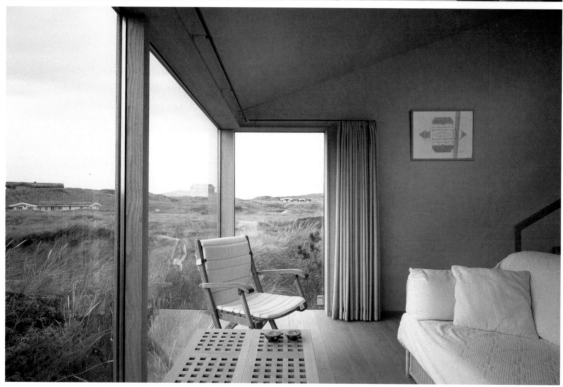

Summer House
at Kandestederne

Architect/Location: **C.F. Møller Architects**
Northern Jutland, Denmark

 This timeless summer home finds its place within nature. Set amidst a landscape characterized by a severe climate and harsh winds, the wooden residence crafts a noble space for retreat. The scenic surroundings comprise white and grayish-green softly undulating dunes, interrupted by wind blown pines. Conceived as a composition of small buildings, the house joins together around a sheltered inner courtyard. This courtyard gathers and expands the interior spaces into the outdoors. Openings on all four sides of the courtyard connect to the different areas of the house and frame moving views of the dune landscape and pinewood trees. The untreated cedar wood gradually changes color, shifting from its original reddish tint to a warm grey over the course of several seasons in the challenging climate. This final color palette harmonizes well with its blustery surroundings, bringing the house and the landscape ever closer together.

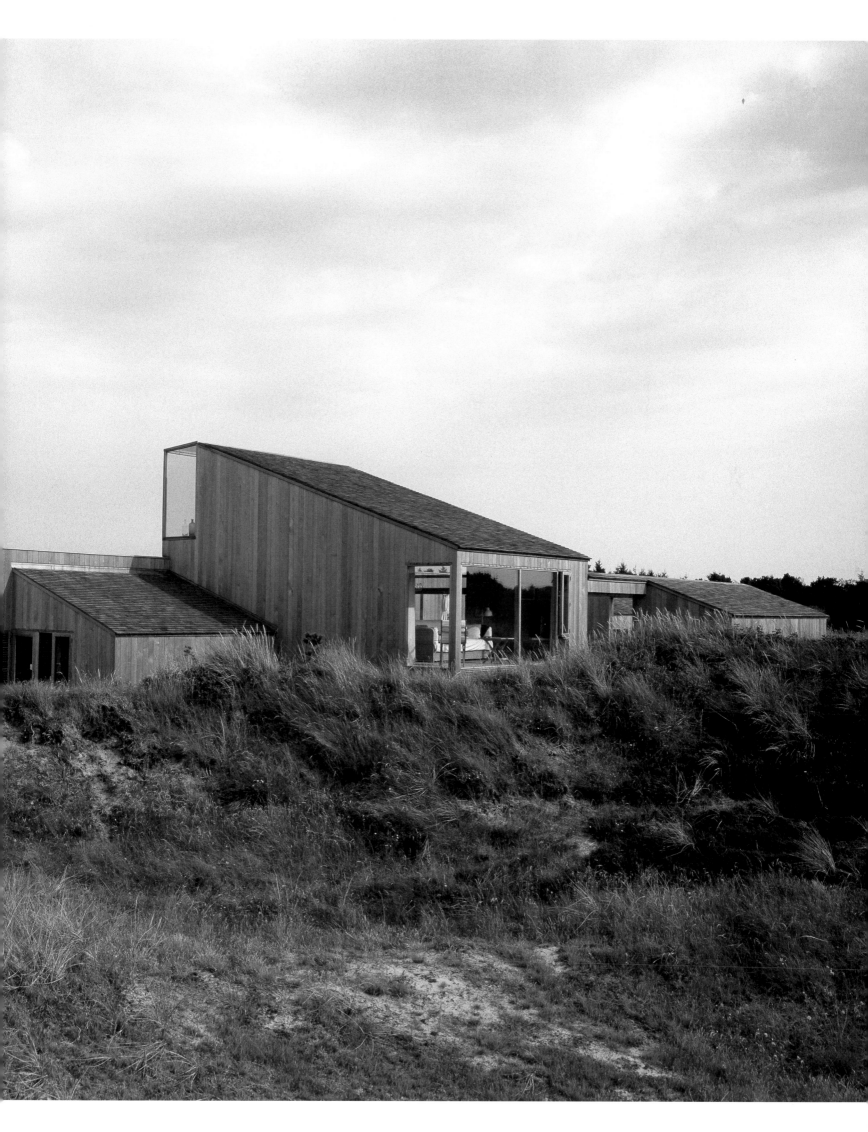

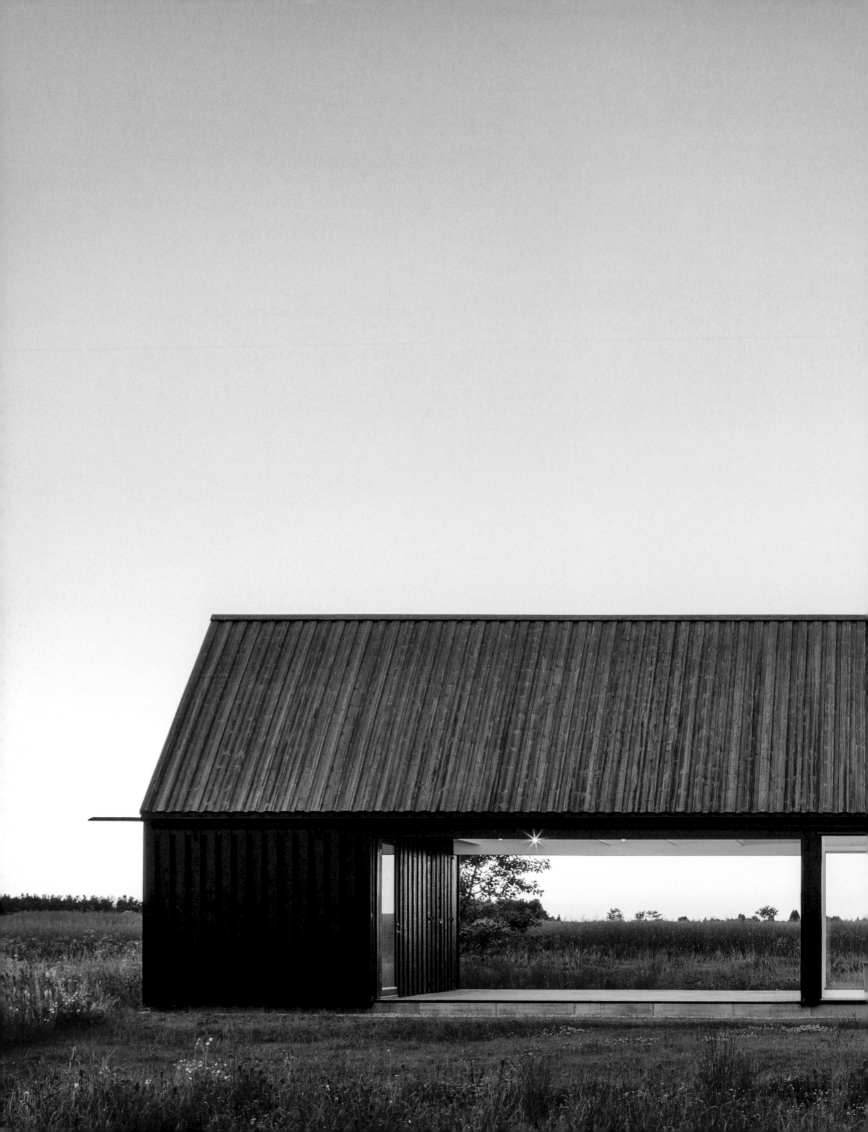

Gotland Summer House →

Architect/Location: **Enflo Arkitekter and Deve Architects**
Gotland, Sweden

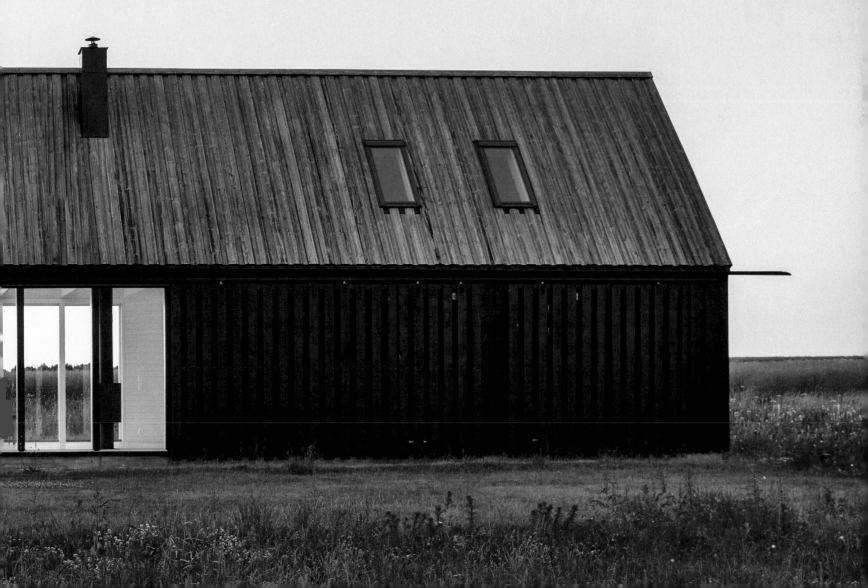

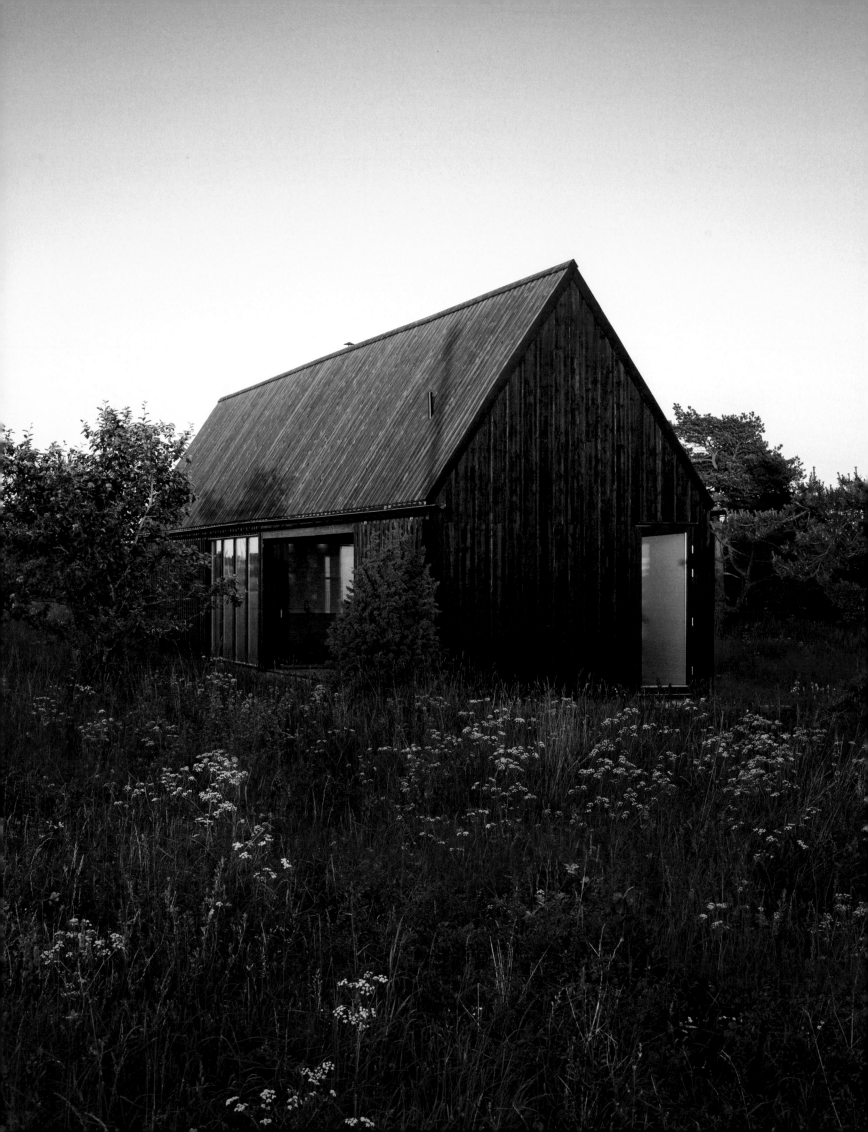

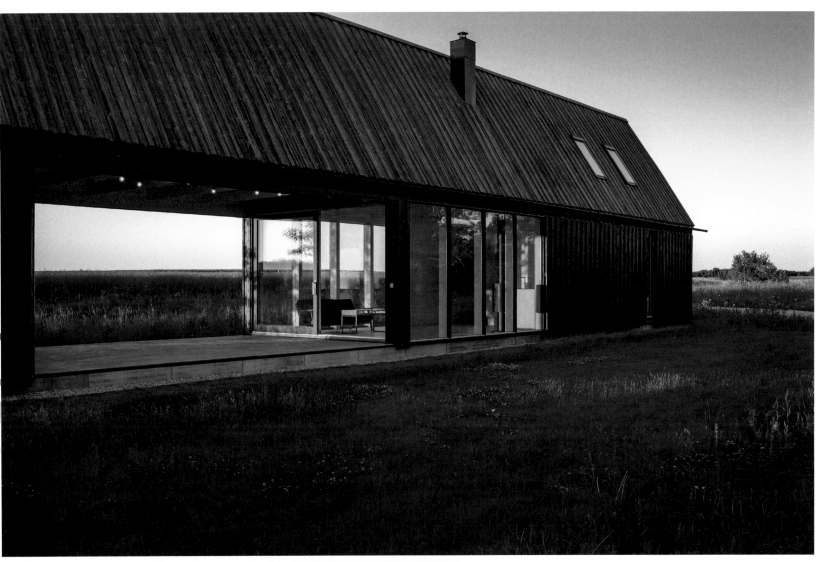

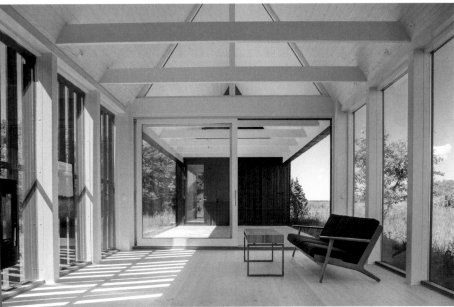

Gotland Summer House

Architect/Location: **Enflo Arkitekter and Deve Architects**
Gotland, Sweden

 A summer house for a young family scenically positions itself on a Swedish island in the Baltic Sea. Surrounded by open fields and low forests, the simple yet contemporary residence implements local building traditions. The slim volume invites light into the house and makes nature always present. A tarred pine pitched roof adds a classic reference to the sheer volume and spans across the private bedrooms and bath, the indoor and outdoor living room, and the guest room. Contrasting with the dark and mysterious exterior, the luminous interior features walls, floors, ceilings, and a kitchen made of local pine. The outdoor living room, protected under the same roof, withstands the unpredictable Swedish summer climate. Oscillating between rain, wind, and sun, exterior sliding shades shelter the open-air space from shifts in weather. As the shades open and close, the volume of the building dissolves and reappears—a tangible expression of the fleeting character of the outdoors.

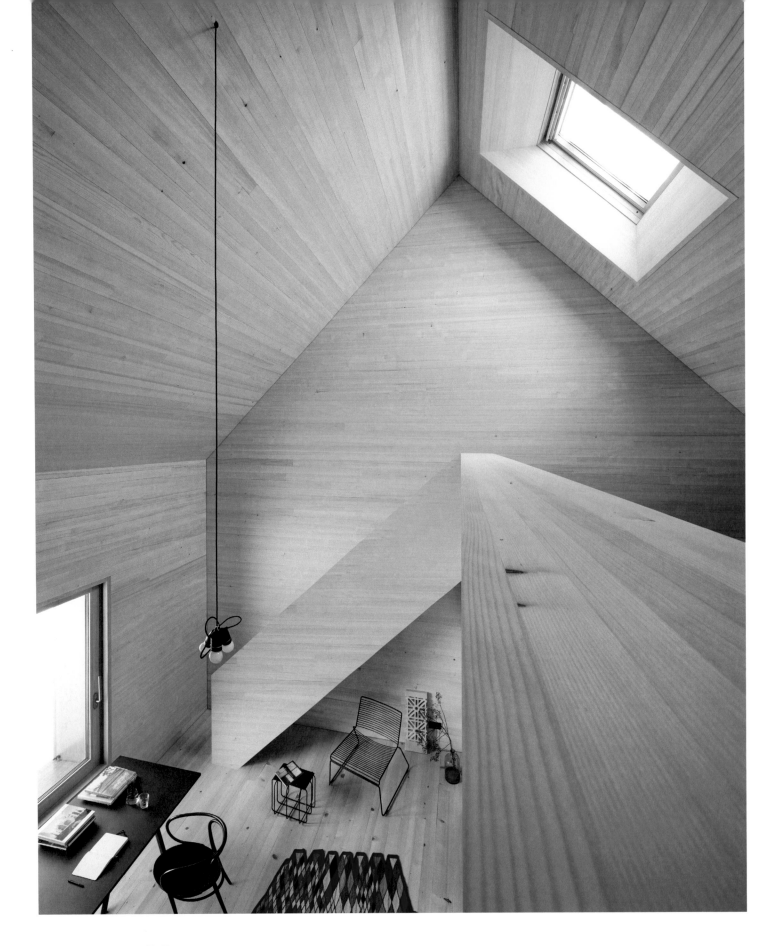

Haus am Moor

Architect/Location: **Bernardo Bader Architects**
Vorarlberg, Austria

A graceful wooden cabin resides in a scenic rural area of Austria. Made from a total of 60 locally sourced trees, the simple plan of the summer house and its clean form derive from the traditional houses of the district. The dwelling's concrete wall and ceiling structure contrast with the light tones of the interior's wooden surfaces. Warmed by a wood-burning hearth, living and dining areas occupy the largest side of the ground floor. Bedrooms and a children's playroom are located on the floor above. A home office sits on the other side of the sun deck. All spaces, whether indoor or outdoor cultivate a deep reverence for the land and encourage the occupants to take a moment to bask in nature's nuance.

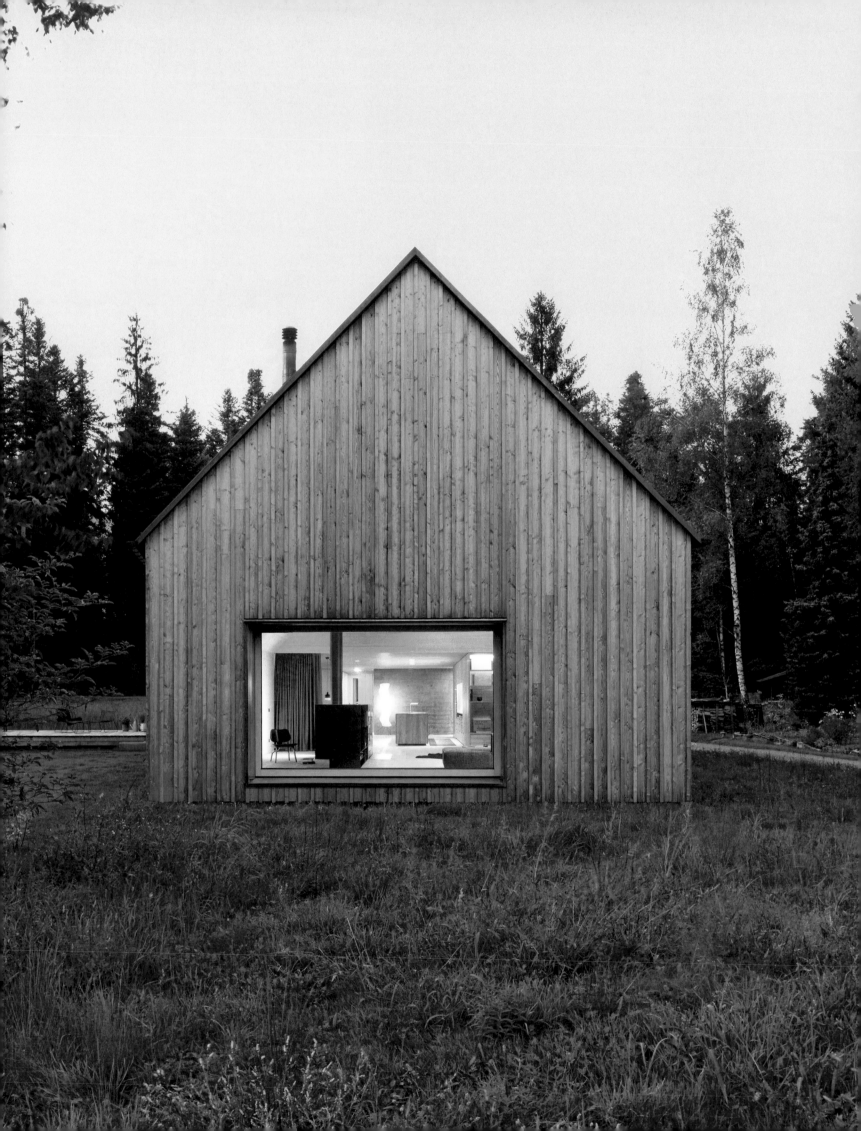

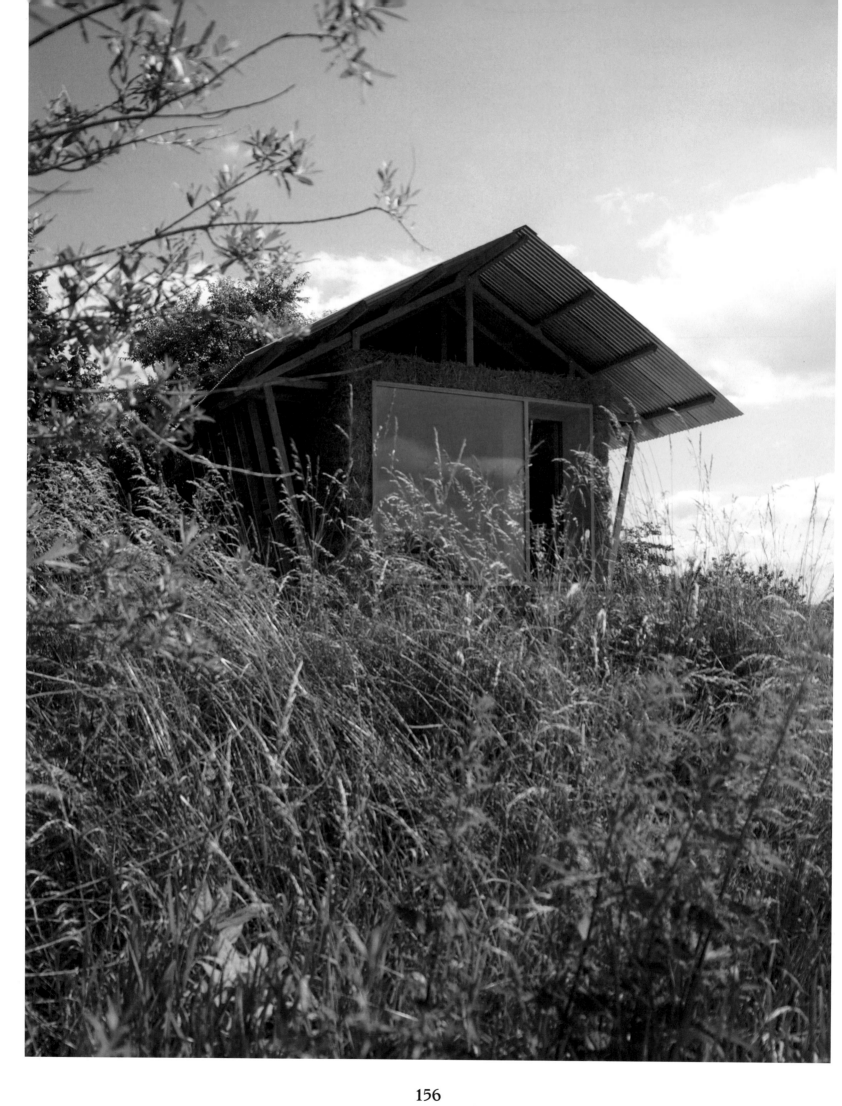

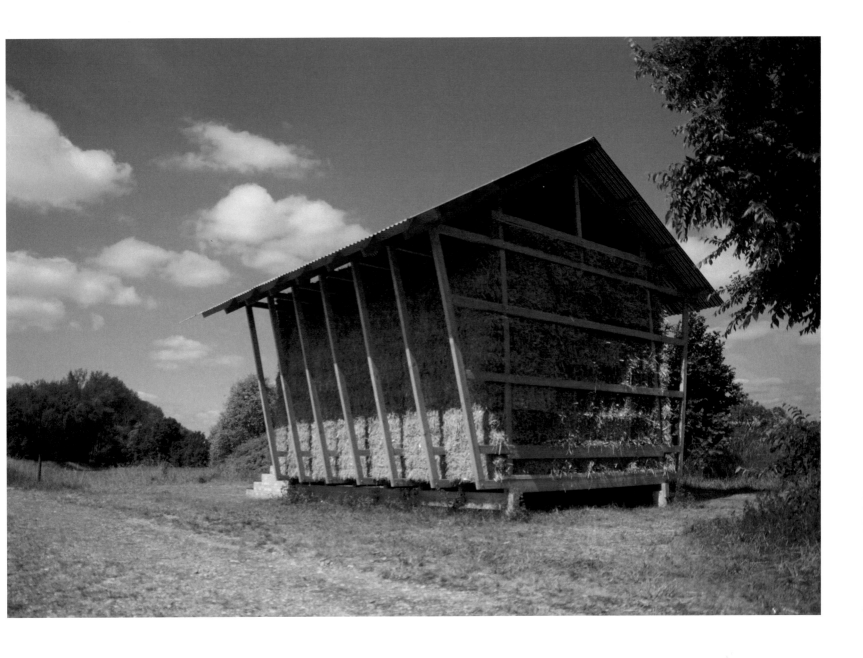

The Nest

Architect/Location: **Studio 1984**
Alsace, France

This project stands as a residential prototype developed for a sustainable housing exhibition. Built with just € 10,000, the nestlike dwelling presents a life off the grid and an architecture that minimally impacts the land. Inspired by the vernacular constructions in the area, the micro cabin's familiar shape and texture pay homage to traditional barns while capturing their discreet charm. Such a pastoral inclination dictates the choice of widely available, locally sourced materials including bales of straw and wood. The one-room shack incorporates a floor to ceiling picture window and glass entry door to admire the pastoral views of the meadow just outside. A lesson in tranquility and simplicity, the endearing pavilion offers a refreshing alternative to the hectic quality of contemporary life.

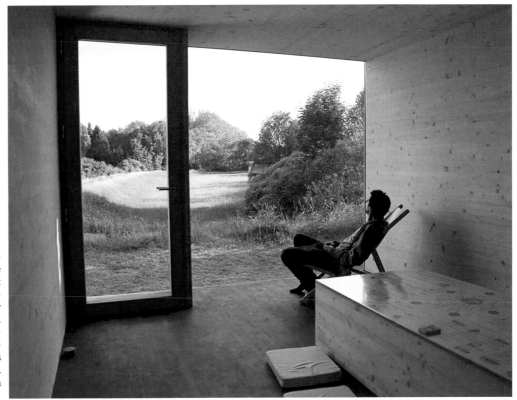

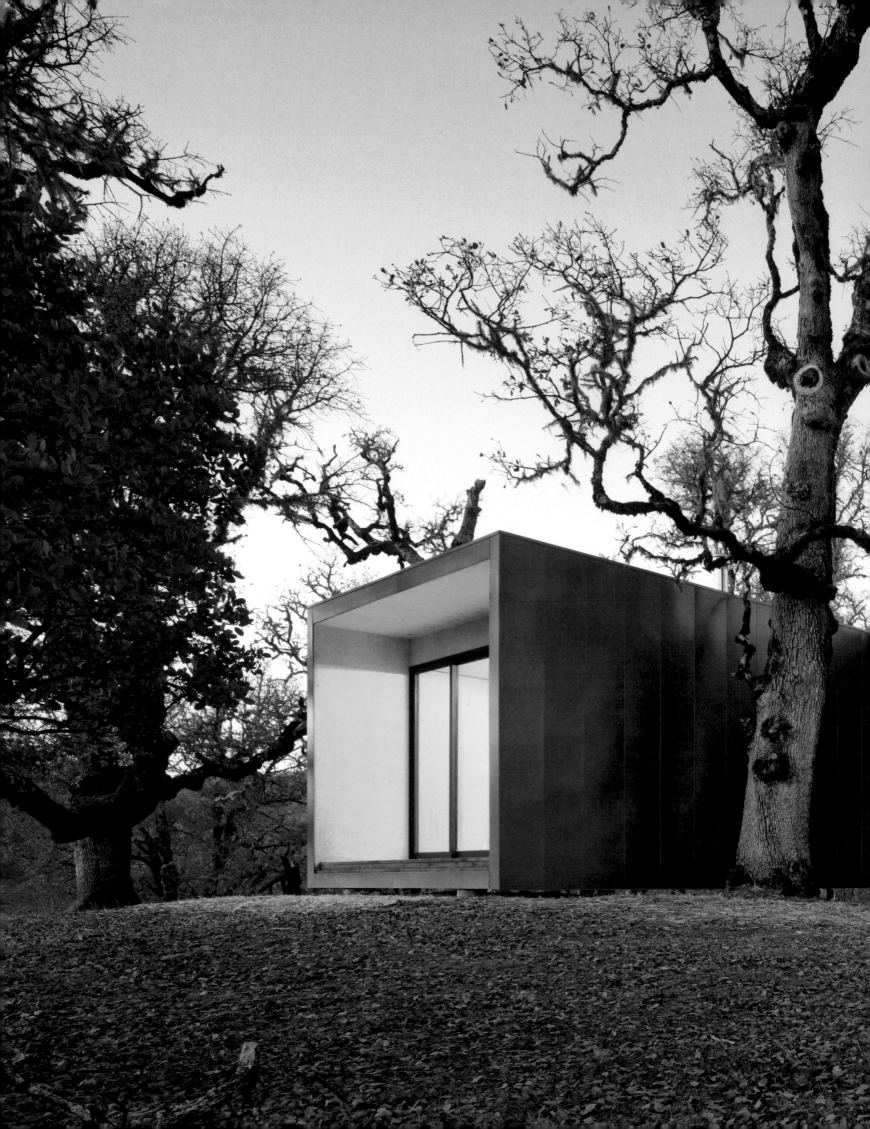

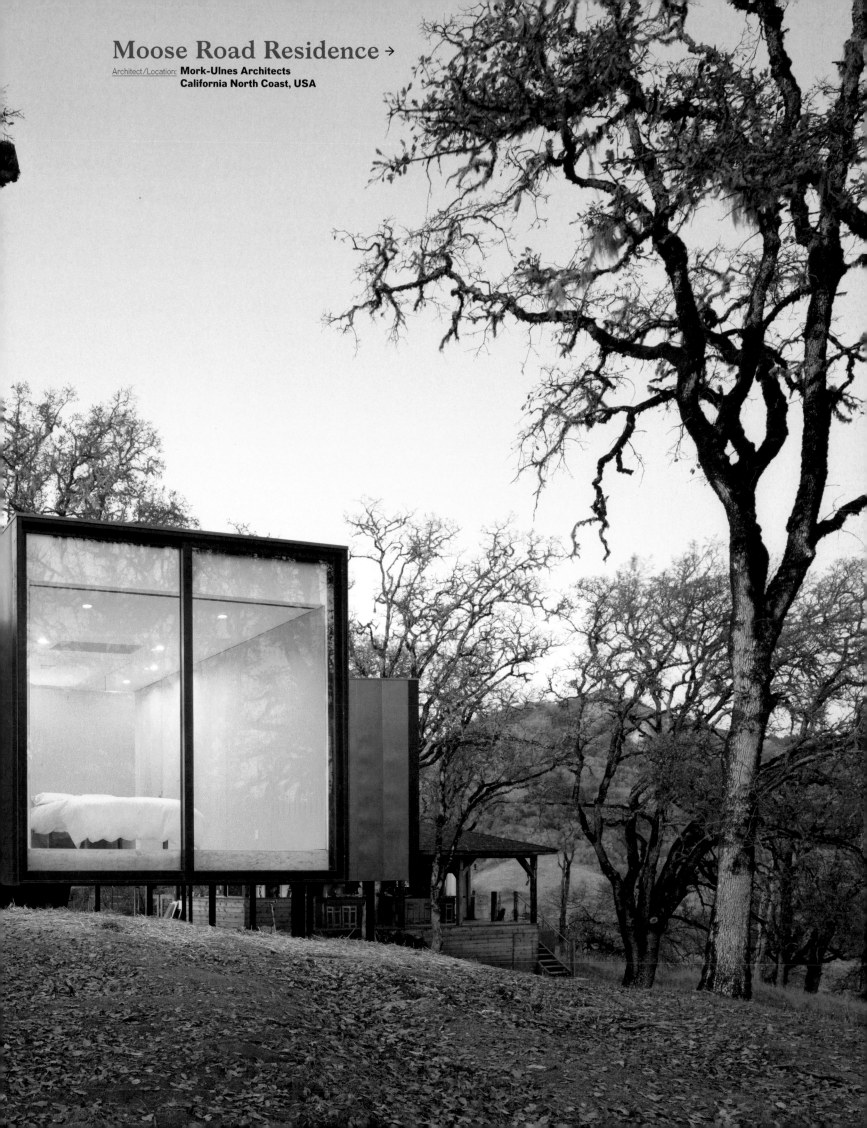

Moose Road Residence →

Architect/Location: **Mork-Ulnes Architects**
California North Coast, USA

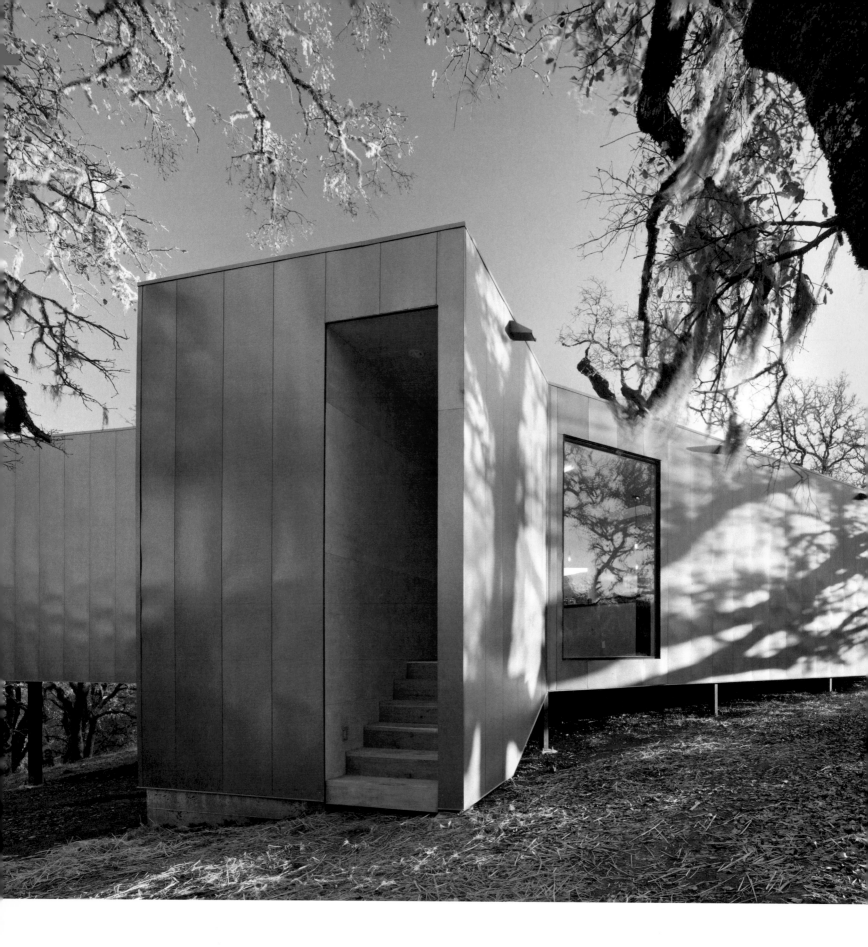

Moose Road Residence

Architect/Location: **Mork-Ulnes Architects**
California North Coast, USA

This branching house frames three separate views of three locally known land formations: a rock shaped like an eagle, a mountain ridge, and a valley brimming with vineyards below. Carefully preserving each existing oak tree on the site, the three fingers of the dwelling extend precisely in-between the existing trees to orient towards the scenic landmarks. Perched on stilts to avoid the tree roots, the compact and iconic retreat cantilevers over the pastoral grounds. A communal kitchen and living space connects the three wings of the house. From there, each more private branch reaches out towards nature, capturing intimate vistas and inviting the outside in through sliding glass doors.

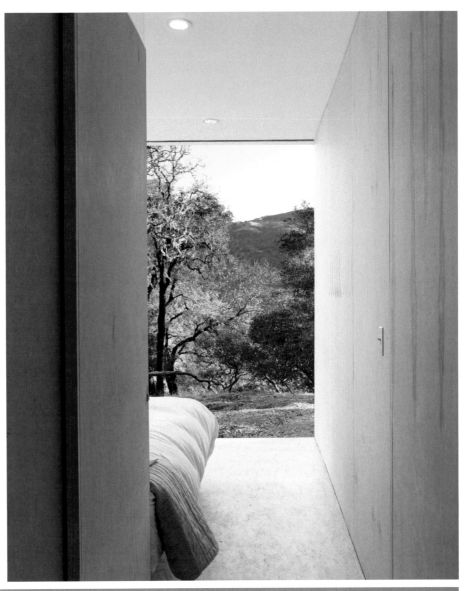

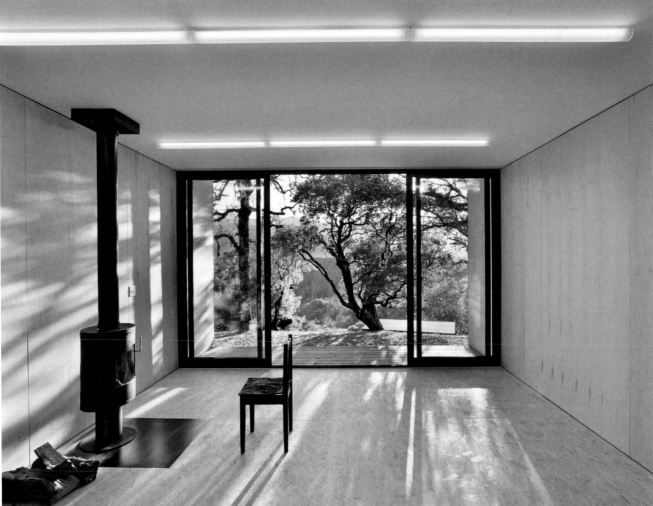

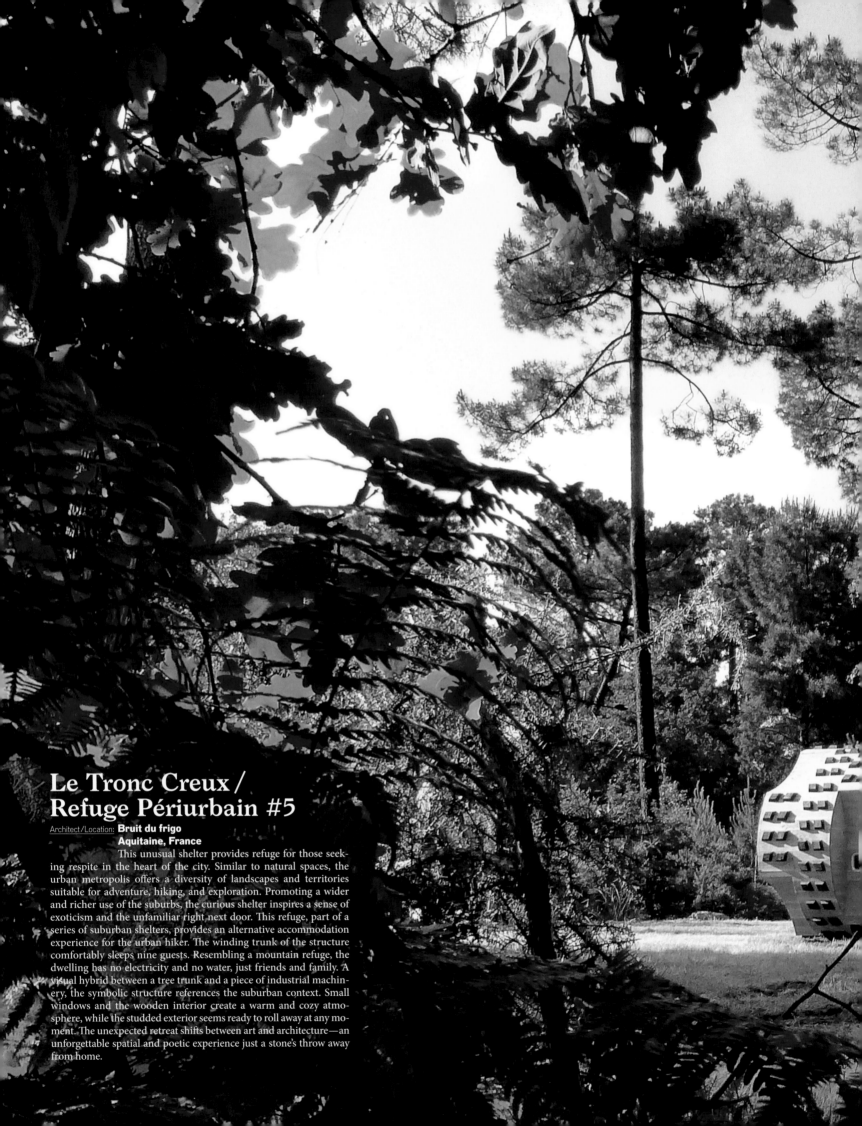

Le Tronc Creux /
Refuge Périurbain #5

Architect/Location: **Bruit du frigo**
Aquitaine, France

This unusual shelter provides refuge for those seeking respite in the heart of the city. Similar to natural spaces, the urban metropolis offers a diversity of landscapes and territories suitable for adventure, hiking, and exploration. Promoting a wider and richer use of the suburbs, the curious shelter inspires a sense of exoticism and the unfamiliar right next door. This refuge, part of a series of suburban shelters, provides an alternative accommodation experience for the urban hiker. The winding trunk of the structure comfortably sleeps nine guests. Resembling a mountain refuge, the dwelling has no electricity and no water, just friends and family. A visual hybrid between a tree trunk and a piece of industrial machinery, the symbolic structure references the suburban context. Small windows and the wooden interior create a warm and cozy atmosphere, while the studded exterior seems ready to roll away at any moment. The unexpected retreat shifts between art and architecture—an unforgettable spatial and poetic experience just a stone's throw away from home.

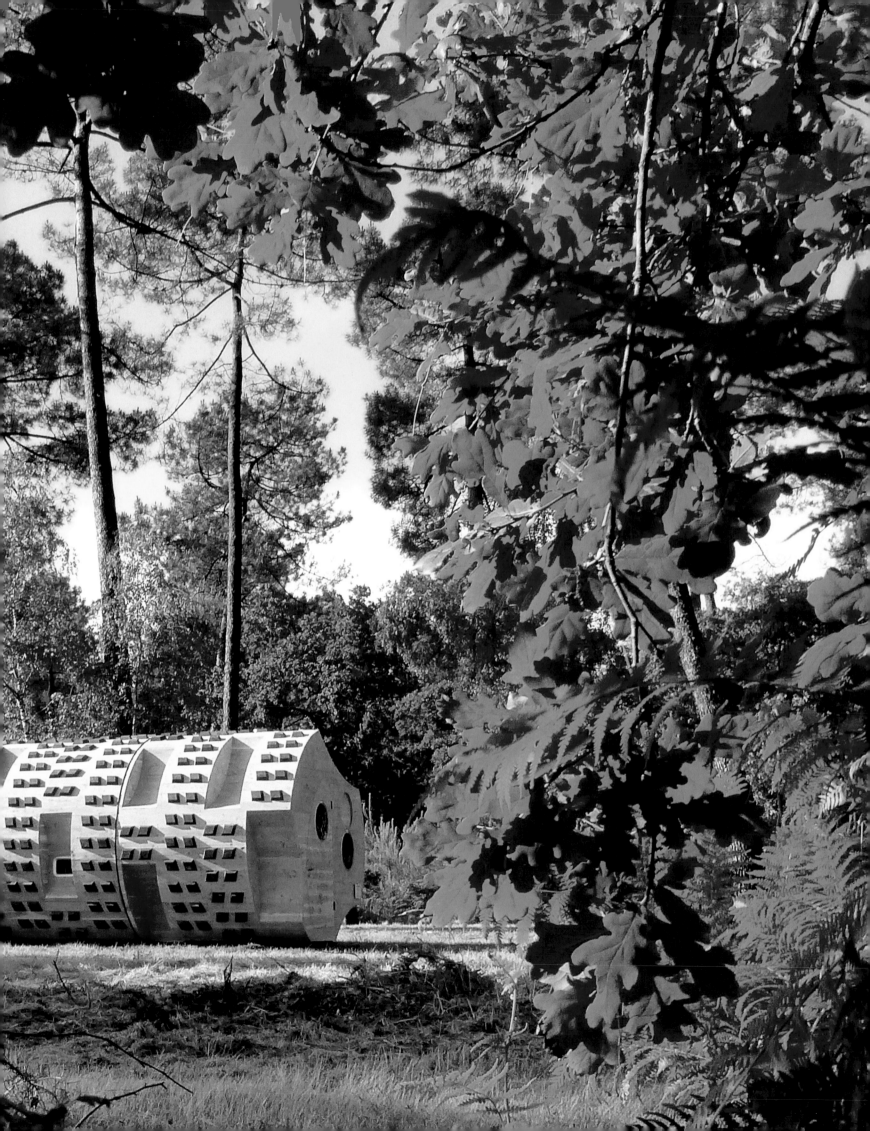

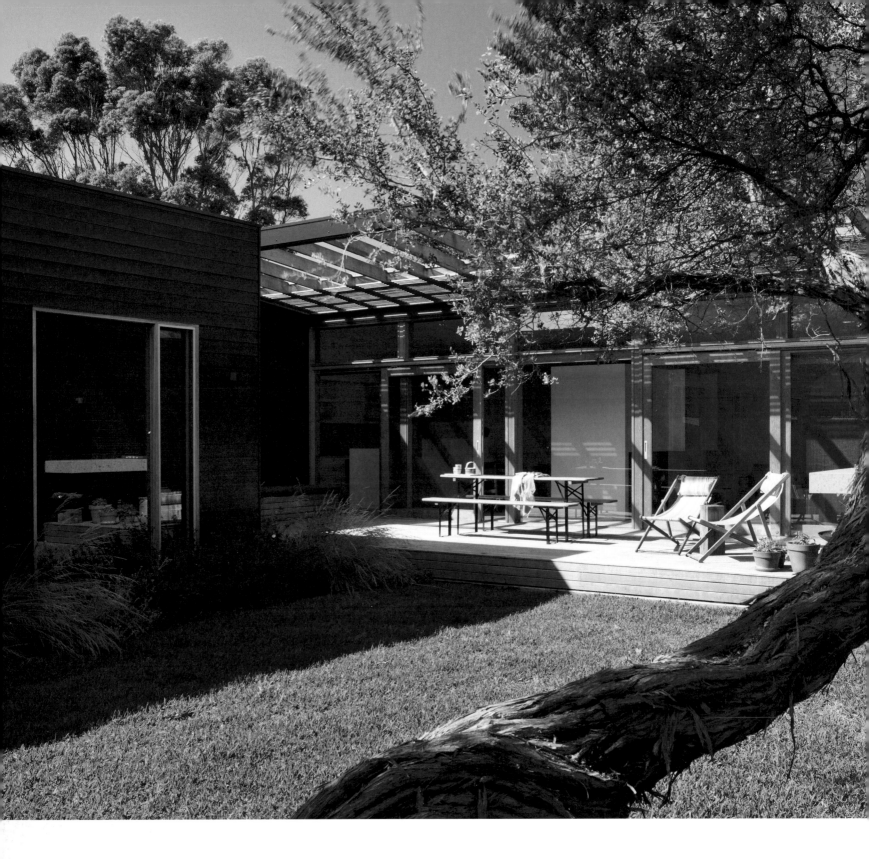

Sorrento Beach House

<u>Architect/Location:</u> **Shareen Joel Design**
Victoria, Australia

 A relaxed coastal retreat accommodates a family of four. With plenty of room for entertaining family and friends, the shared and casual beach house also includes plentiful storage for the husband and son's sailing equipment. The residence choreographs a relaxed atmosphere for taking in the ocean breezes. This appealing timber structure achieves a tasteful pragmatism without becoming overly precious. Complete with an outdoor shower, the house encourages both recreational activities and rewarding introspection along the water's edge.

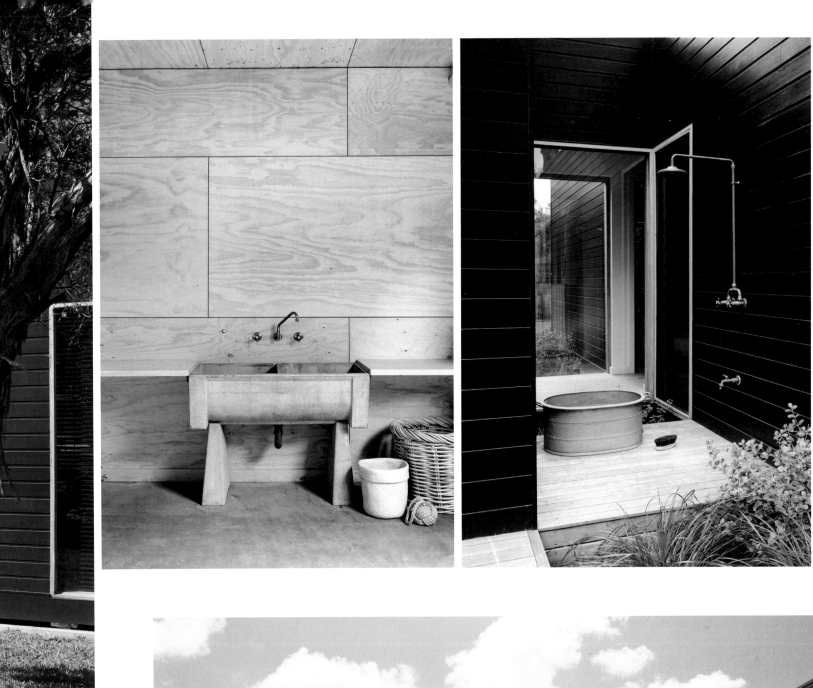

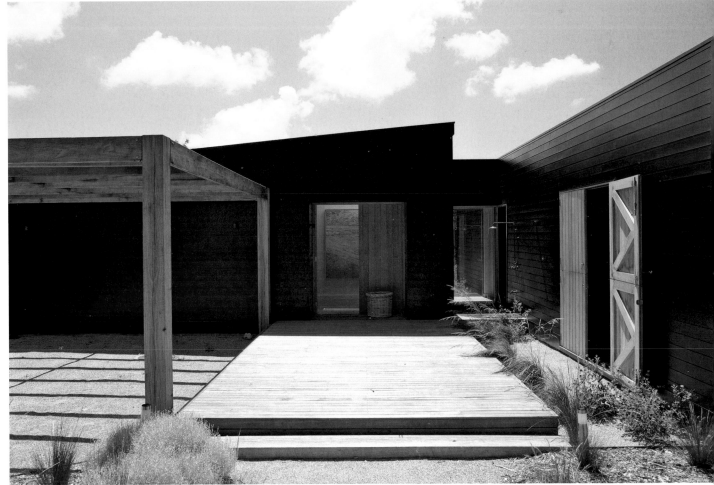

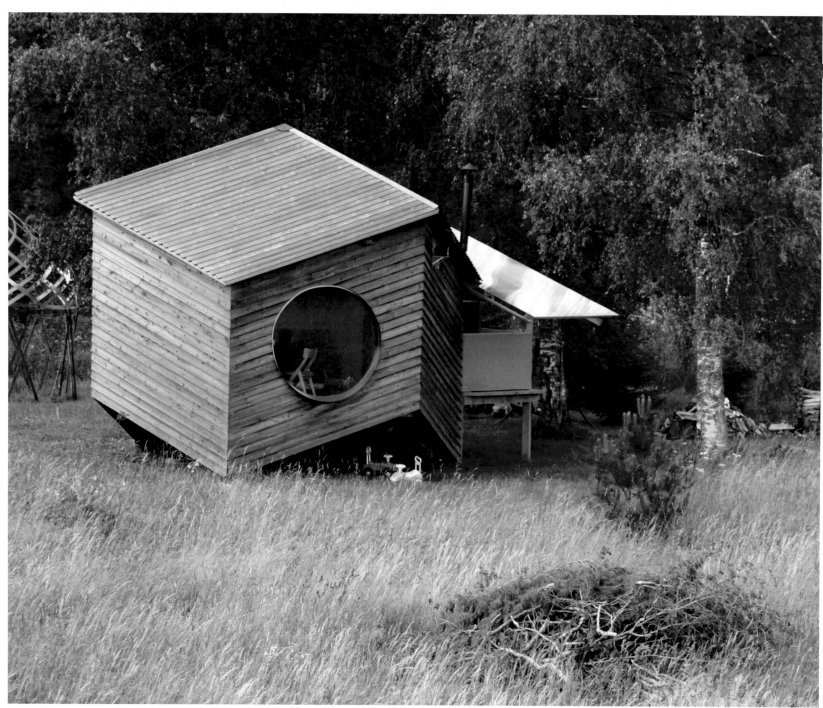

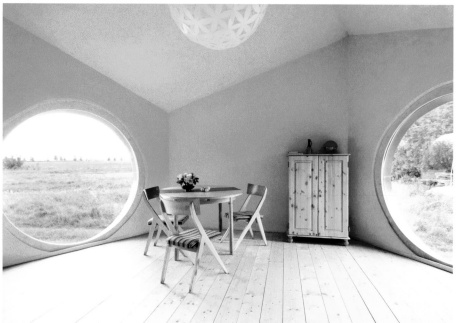

NOA Cabin

Architect/Location: **Jaanus Orgusaar**
Sõmeru, Estonia

NOA, an easily mountable sustainable dwelling, adapts to a variety of landscapes and environments. Based on the shape of a rhombic dodecahedron, the expandable unit is made from local pine, fur, and Siberian larch wood. Without the need for a ground foundation, this base geometry enables the cabin to lightly stand on three feet over the land. The stackable module's tessellations result in an appealing and personal interior realm. High, angled ceilings grant the compact floor plan a feeling of unexpected spaciousness while round windows introduce views of endless fields into the bright and cheerful interior. Simple and affordable, the durable retreat presents a timeless and adaptable approach to living. Currently in use as a summer cottage for the designer's family, a terrace for outdoor dining and socializing extends the little house into the outdoors where owls and squirrels from the forest can drop by for a visit.

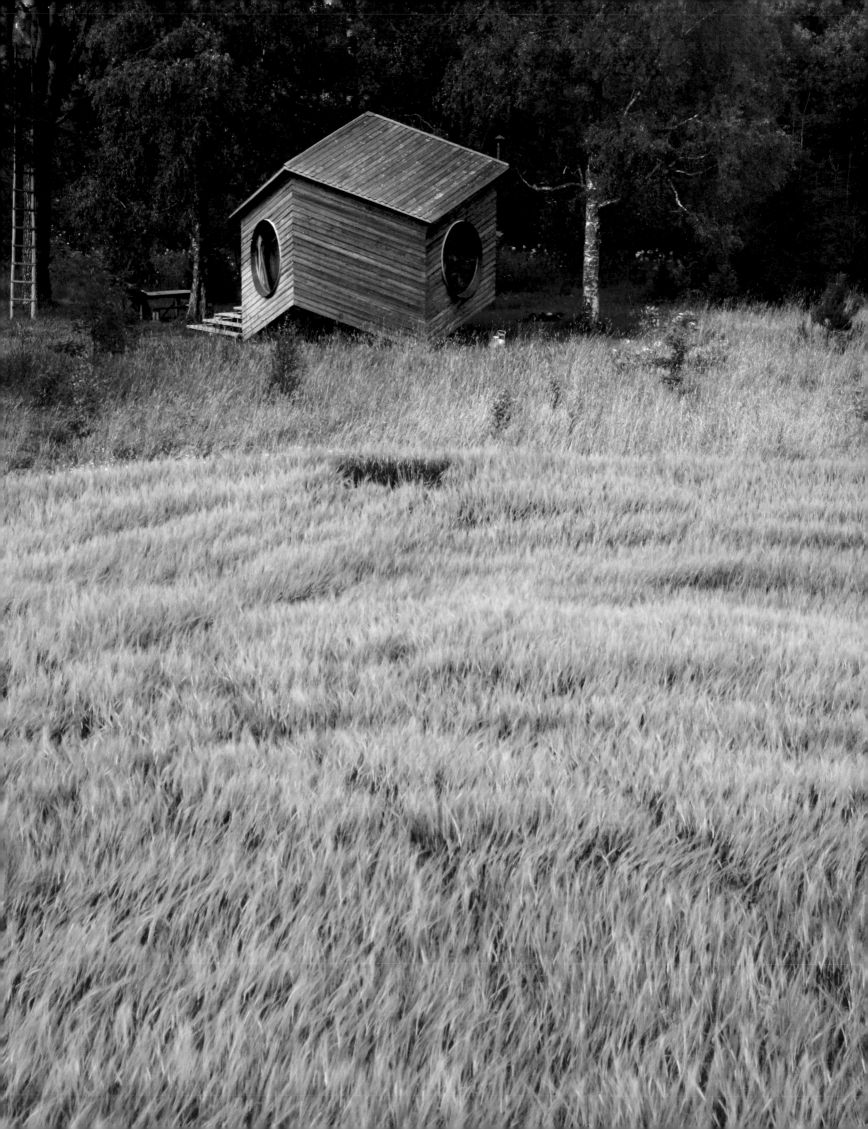

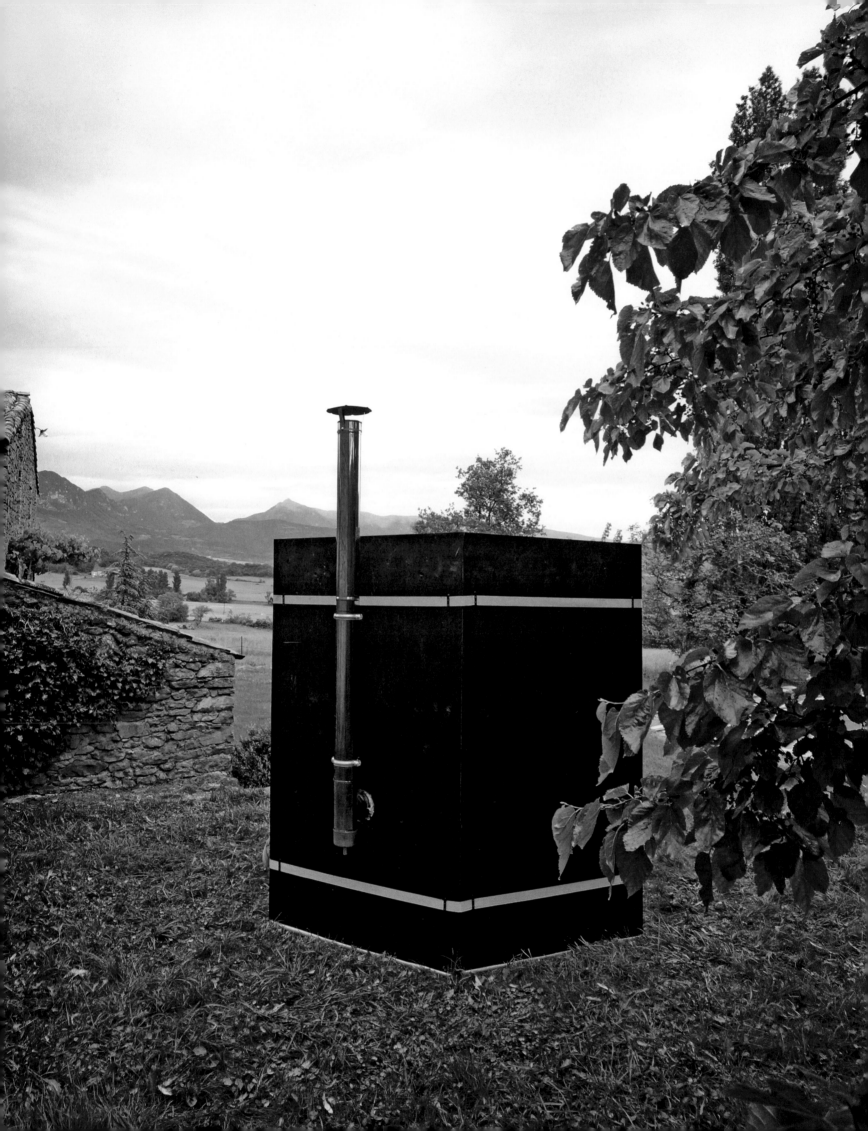

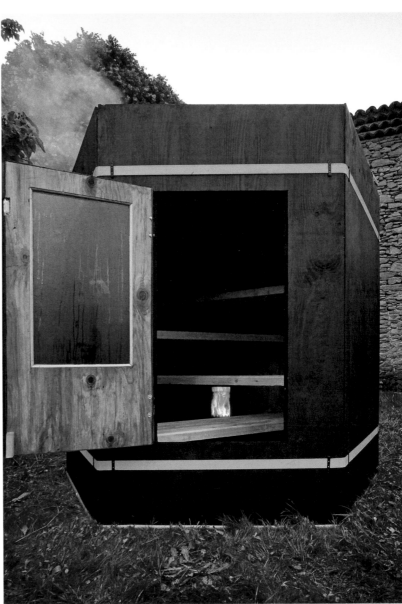

Mobile Sauna

Architect/Location: **Atelier Archiplein**
Rhône-Alpes, France

A mobile sauna combats the cold winters in the French countryside. Portable, airtight, and quickly heatable, the compact and robust structure is designed to weather the wild outdoor conditions year-round. The hexagonal form behaves like a self-sufficient and autonomous object. Contrasting with the simplicity and efficiency of the exterior, the intimate interior introduces spatial complexity through a series of stacking benches. These bird-like perches allow up to eight people to comfortably occupy the sauna, defining new view points for a sensorial and restorative temporary retreat.

169

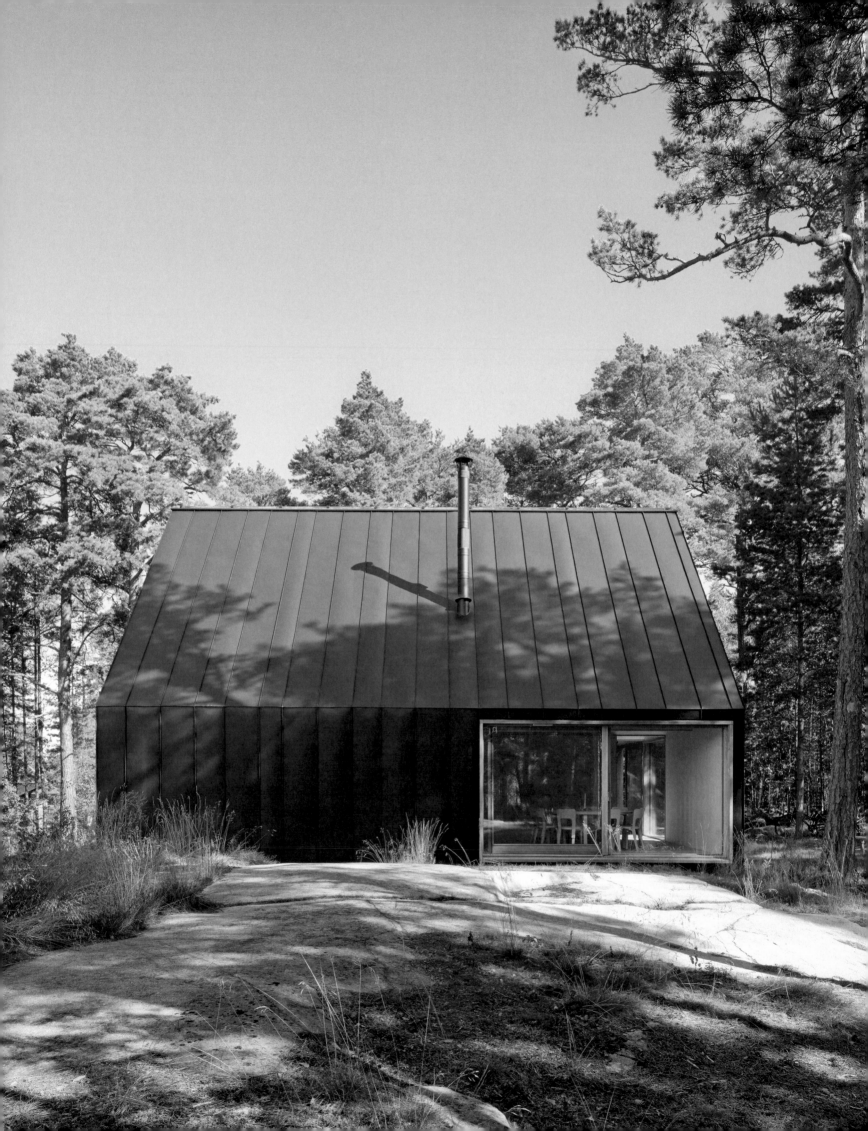

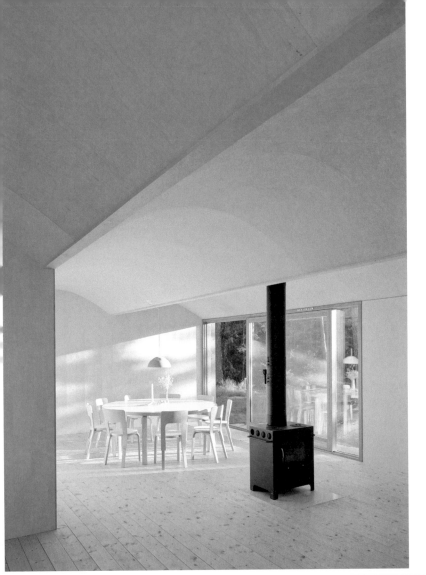

Summerhouse Husarö

Architect/Location: **Tham & Videgård Arkitekter**
Stockholm Archipelago, Sweden

 Peeking out of a forested site, a pitched roof summer house with a truncated point enjoys its elevated spot on a plateau facing the sea. The proud residence, realized on a modest budget, responds to the land's unique lighting conditions, sea views, and smooth bedrock. Divided into two levels, an open and interconnected social area makes up the ground floor and the more private bedrooms and playroom cluster above. Large sliding windows open up to the views in all directions and fill the house with sunshine. On the upper level, a long skylight underscores the verticality of the space and subtly enhances the experience of seclusion. The exterior, clad with black sheet metal, incorporates generous glazed sliding doors. This combination of glass below and solid mass above grants the house a mystical quality, as it appears to float off the ground. The elegant transition from a light wood interior to the dark metal exterior sets up a visceral and enticing relationship between inside and out.

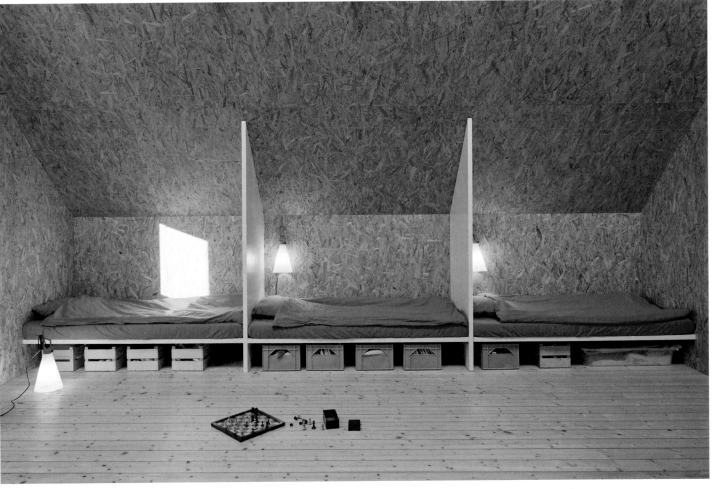

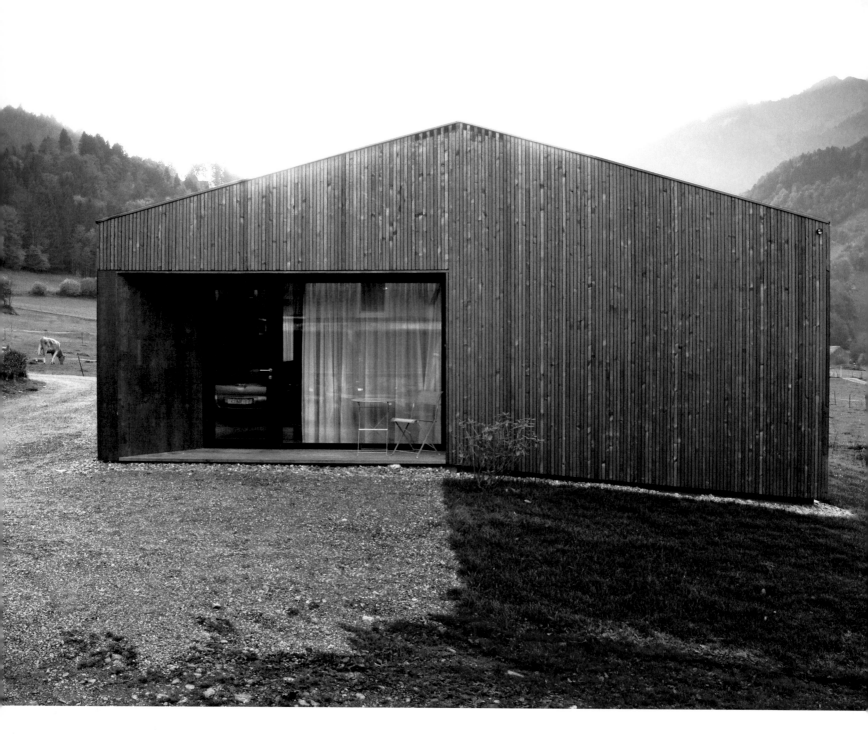

Haus für Gudrun

Architect/Location: **Sven Matt**
Bregenzerwald, Austria

Backed by majestic mountains shrouded in fog, a little house on the countryside enables the client to find her own peace, freedom, and inner nature. Built on a tight budget, the exterior's darkened spruce slats contrast with the interior's bright white fir paneling. The prefabricated, two-bedroom timber house includes a large living space with four generous openings that frame unique views of the surrounding landscape on all sides. Varying in size, position, and detailing, these openings cut deep into the four walls and each exude their own distinct character. An inset entry with a large window to the west leads to the neighboring houses while a private wooden terrace sits on the back side of the dwelling. From this terrace, the owner can reconnect with herself, her guests, and the local rabbits, deer, and foxes.

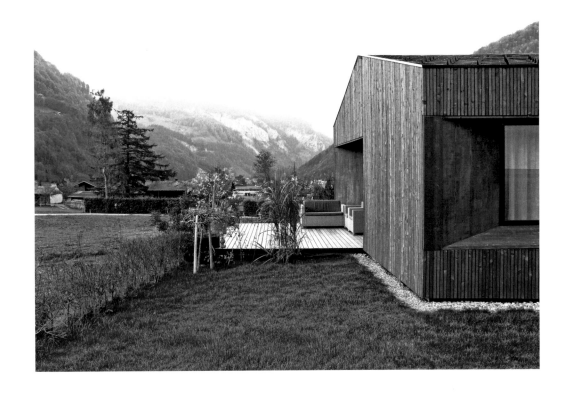

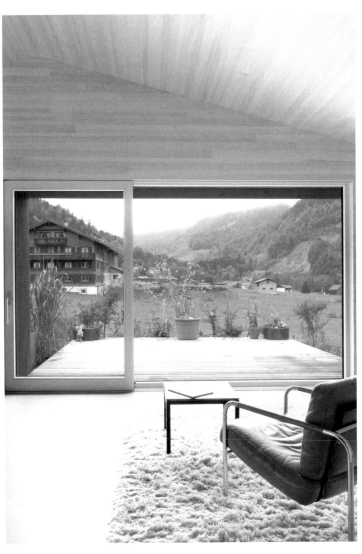

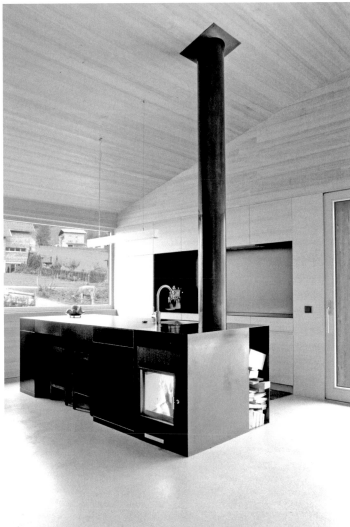

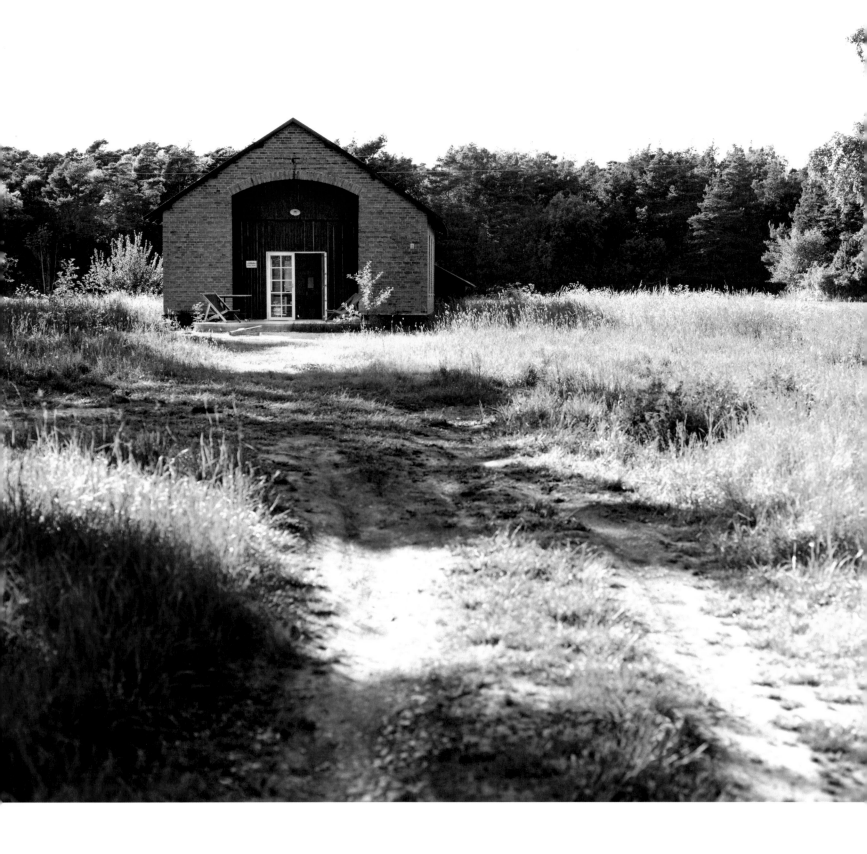

The Stables

Architect/Location: **Niklas Larsén & Fanny Nelson**
Gotland, Sweden

A 200-year-old structure previously used as a locomotive stall for a Swedish island's small railway line now serves as a charming dwelling encircled by pinewoods and wild flower fields. Durable and robust, this endearing island cottage stages a haven for year-round comfort and relaxation. The timeless renovation acts as an appealing compromise between the surrounding nature and the more modern interior. Large windows let in the colors from the lush outdoors.

A grayscale interior mixed with subtle woods form a muted backdrop for these vibrant and shifting natural hues to shine through. Featuring only local materials, the cabin introduces island-grown limestone and pine to create furniture and finishings. Gracefully balancing old and new elements, the home's rich history enshrouds it in a mythic and romantic atmosphere unmatched by its more contemporary island neighbors.

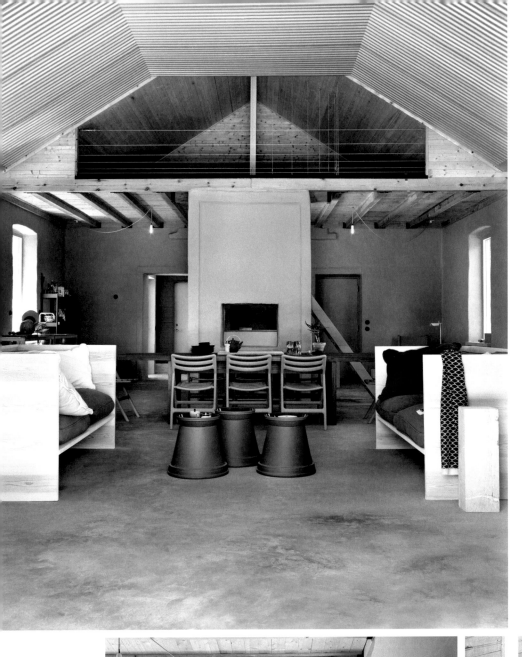

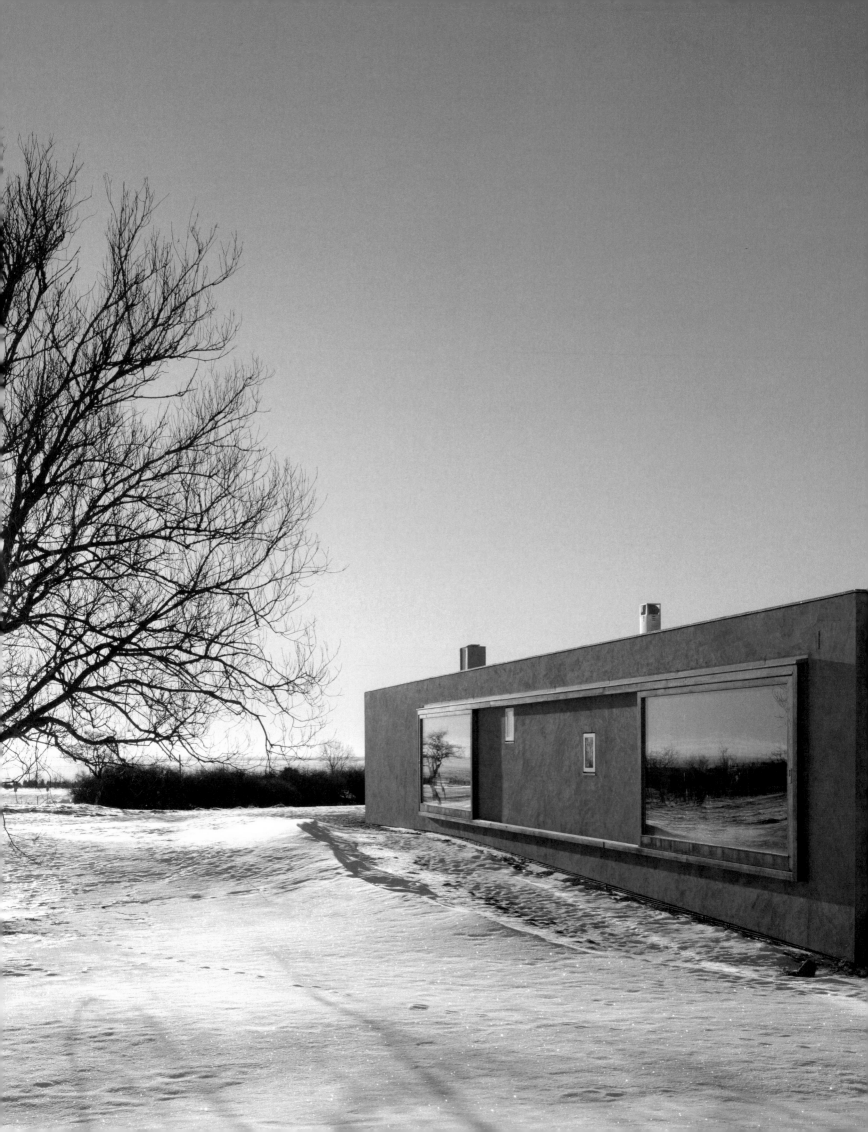

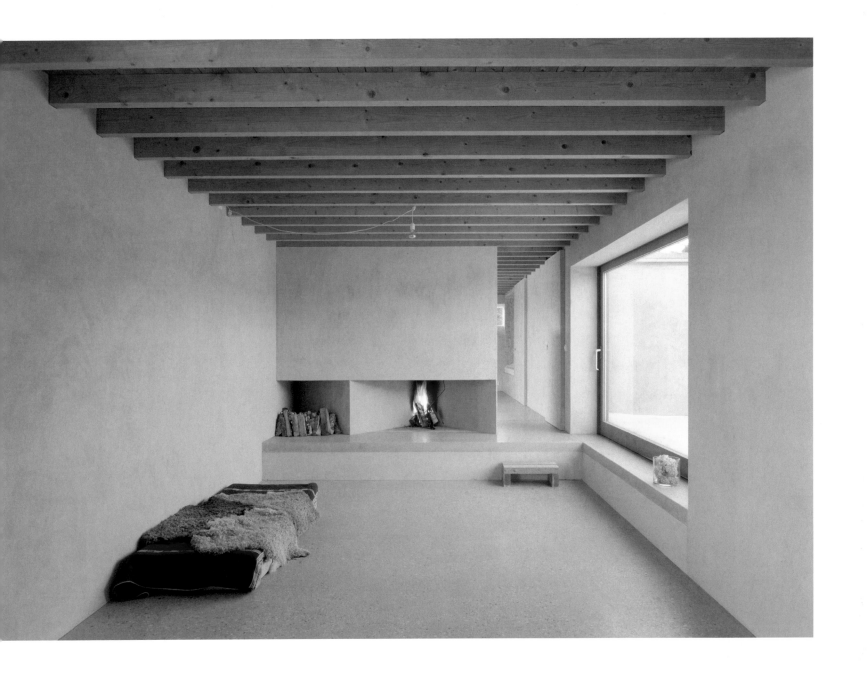

Atrium House

Architect/Location: **Tham & Videgård Arkitekter
Gotland, Sweden**

This demure vacation home takes up residence on a
Swedish island in the Baltic Sea. Built on a slight ridge, the site marks
the location of the coastline a thousand years ago—where the land
once met the sea. The masonry structure is designed for three genera-
tions: a young family with children and their grandmother. In relation
to the expansive landscape, the building seems more like a low wall
than a house. The dwelling orients around a completely enclosed atri-
um courtyard that serves as a sheltered outdoor room. Surrounded
by untouched meadows, the house features serene views of the local
grazing sheep. The home draws inspiration from the vernacular agri-
cultural architecture and the medieval wooden fortress that stands in
the center of the island. Similar to the fortress, the residence exudes a
refreshing, streamlined austerity. The narrow house compensates for
its slender footprint through broad openings, giving the interior the
character of a protective niche amidst a vast open landscape.

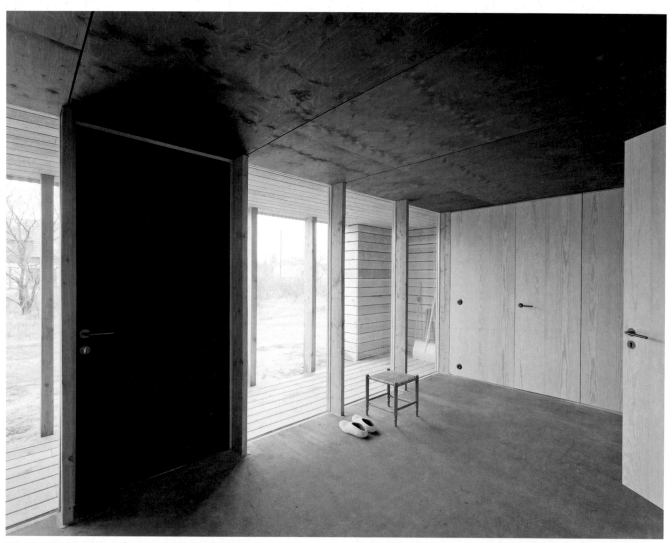

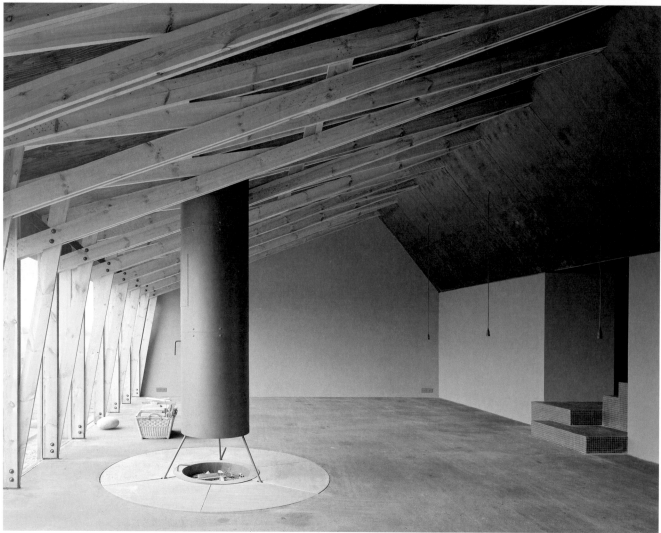

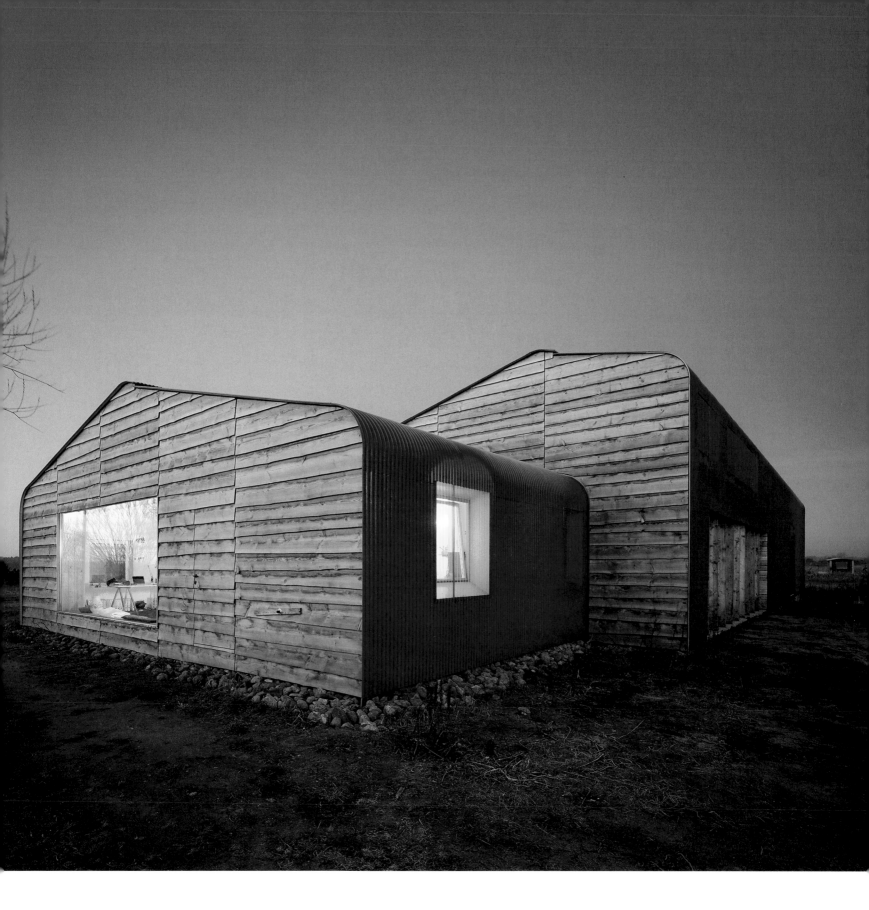

Werkhaus Schütze

Architect/Location: **Thomas Kröger Architekt**
Brandenburg, Germany

Within the calm, undulating landscape of northeast Berlin, a new workshop houses a product designer/carpenter and his work. Originally built in the 1980s, the recent renovation transforms the extant building into a functional and coherent balance of home, workshop, and showroom. The entire building, covered with a green corrugated metal skin, gently blends the house into the flat hills of the Uckermark region. Gabled ends, finished with weathered larch wood, reference the surrounding barns of the area. The centrally located showroom mediates in height and shape between the living area and the workshop, coherently relating the two together. An interplay of raw and fine materials, handmade finishes and details, and sweeping views of the land infuse both work and respite with a sense of authentic and timeless luxury.

Quincho Gorro Capucha

Architect/Location: **Grupo Talca**
Araucanía, Chile

Encircled by native forest and the formidable Villarrica volcano, a warm glowing shelter stands as a friendly beacon in the darkness. The rustic project attracts tourists to the region in both winter and summer. A place of comfort and rest, the rural sanctuary also teaches guests about the rich traditional cuisine of the area. Perhaps the structure's most iconic feature, a barbecue hood hat, reaches out of the roof to ventilate the interior and give the building's overall silhouette a more pronounced and abstract form. Clad in more than 30,000 wood shingles, the enticing refuge encourages its guests to linger and take in the awe inspiring nuances of the Chilean landscape.

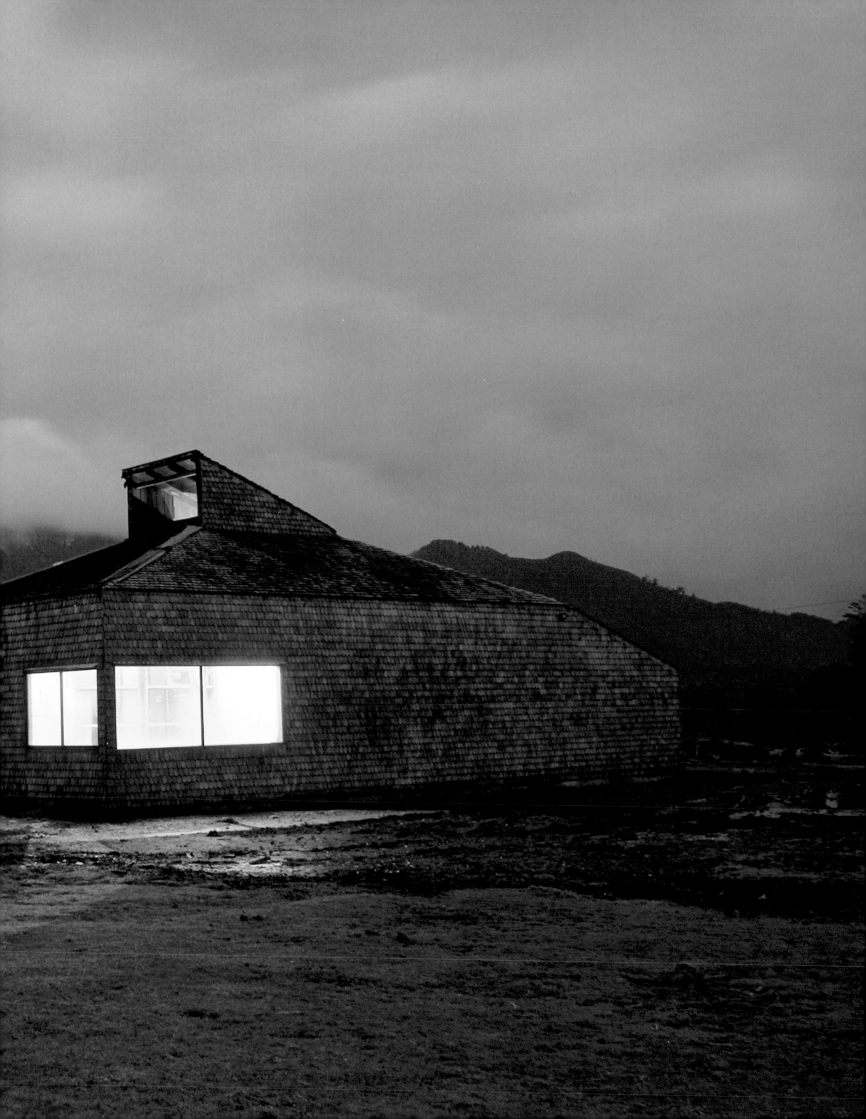

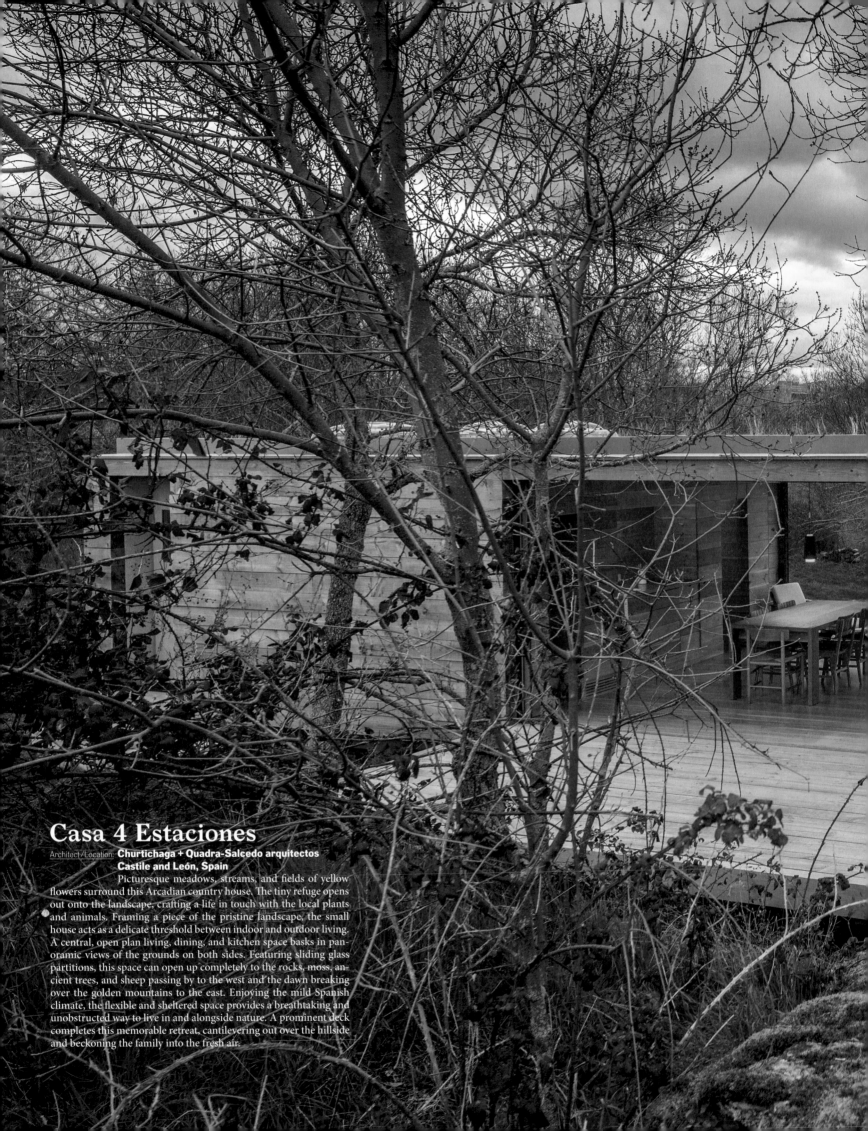

Casa 4 Estaciones

Architect/Location: **Churtichaga + Quadra-Salcedo arquitectos**
Castile and León, Spain

Picturesque meadows, streams, and fields of yellow flowers surround this Arcadian country house. The tiny refuge opens out onto the landscape, crafting a life in touch with the local plants and animals. Framing a piece of the pristine landscape, the small house acts as a delicate threshold between indoor and outdoor living. A central, open plan living, dining, and kitchen space basks in panoramic views of the grounds on both sides. Featuring sliding glass partitions, this space can open up completely to the rocks, moss, ancient trees, and sheep passing by to the west and the dawn breaking over the golden mountains to the east. Enjoying the mild Spanish climate, the flexible and sheltered space provides a breathtaking and unobstructed way to live in and alongside nature. A prominent deck completes this memorable retreat, cantilevering out over the hillside and beckoning the family into the fresh air.

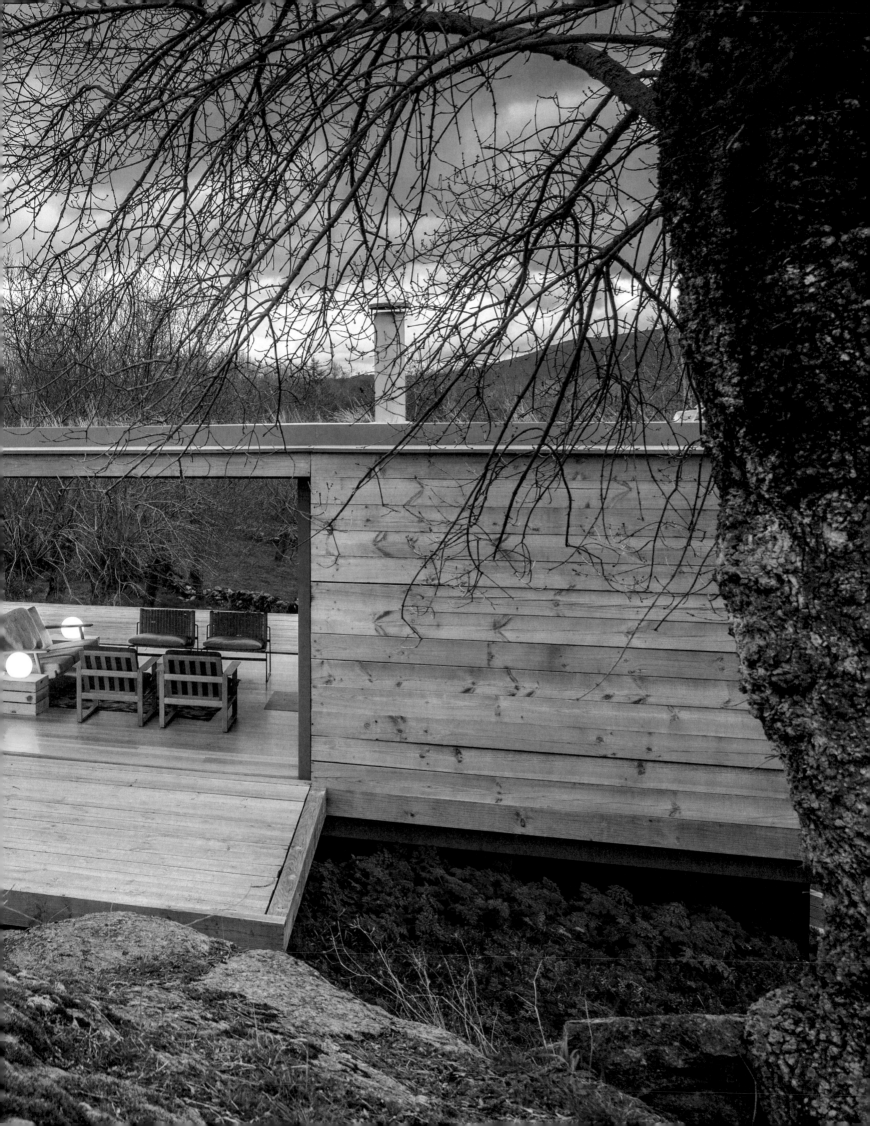

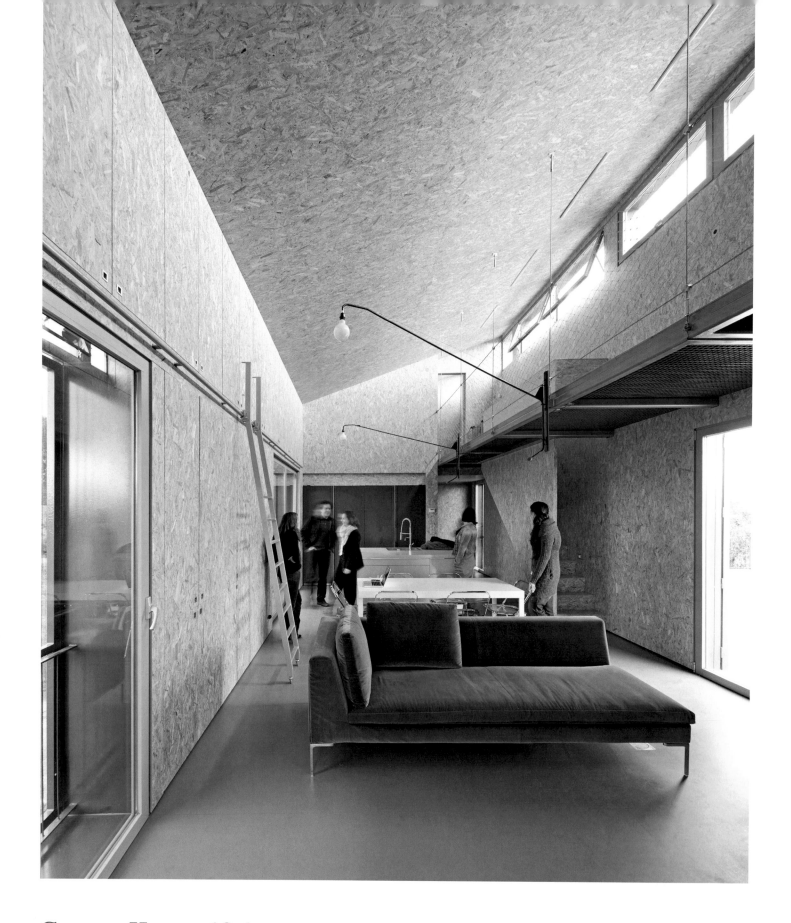

Garoza House 10.1

Architect/Location: **Herreros Arquitectos**
Ávila, Spain

A scalable and prefabricated residential prototype adapts to its users' basic and more bespoke needs. The metallic home with a sloping roof incorporates a large double-height interior space that houses all the primary social living activities. This warm interior, clad in recycled wood panels, transforms corners, mezzanines, and transition spaces into more private places for sleep and work. Outside, an expansive terrace hovering on stilts behaves like an observatory. This piece of artificial landscape strives not to modify nature but simply admire it. Integrated by contrast rather than camouflage, the galvanized steel structure remains in flux as it reflects the varied and shifting light and shadows unique to its location. The unconventional dwelling expresses a formal interest in the landscape, highlighting certain areas while protecting others. Custom designed openings bring in light, sun, ventilation, shading, or views, while never betraying from the outside what lies within.

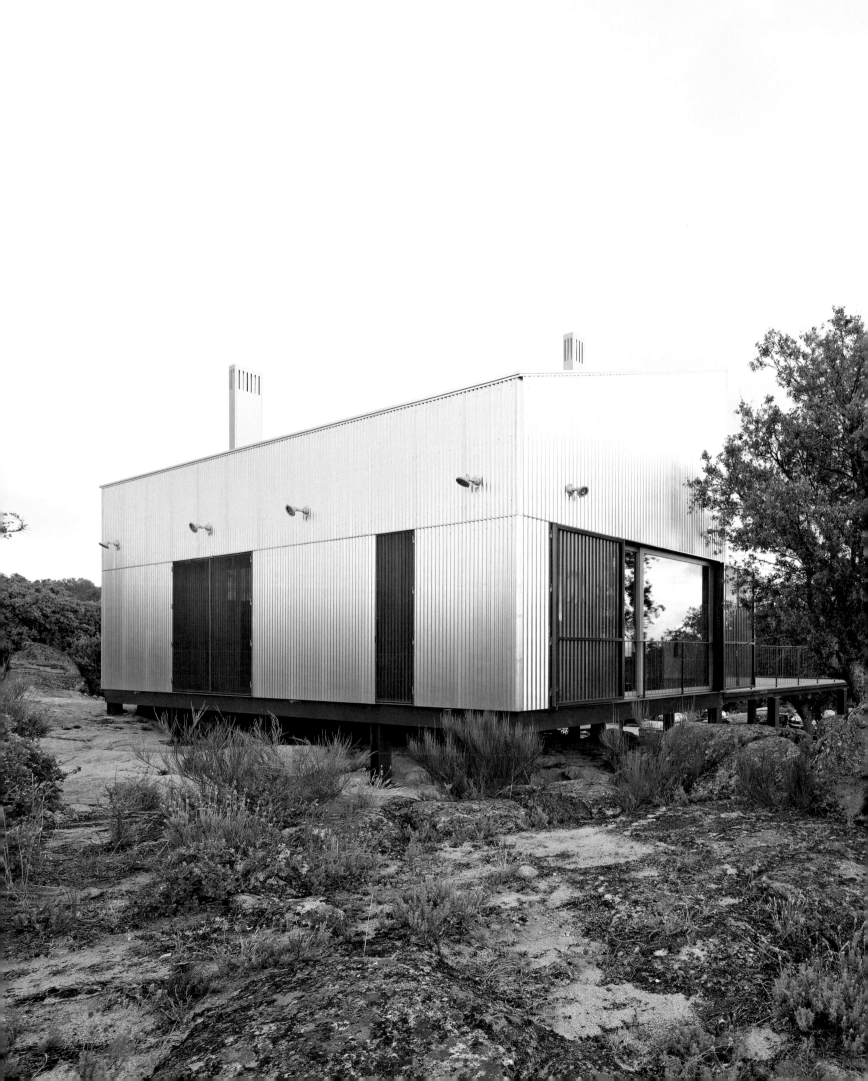

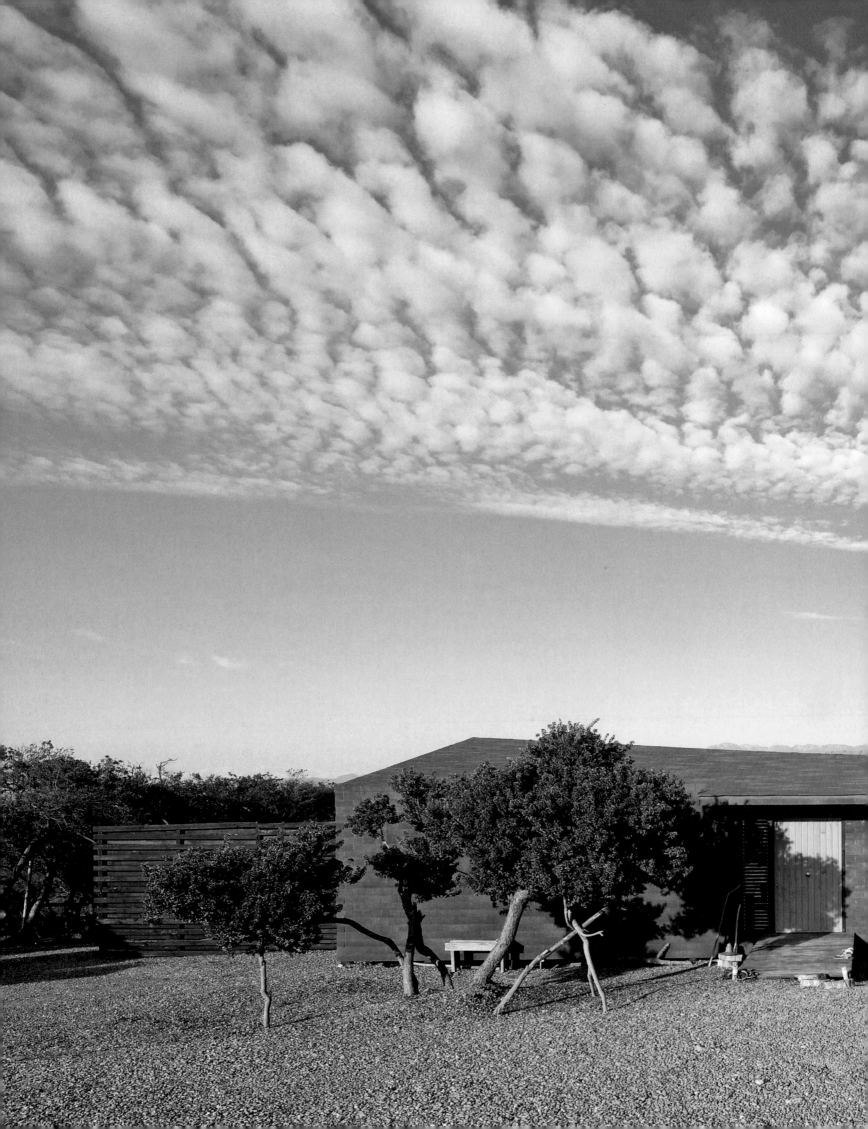

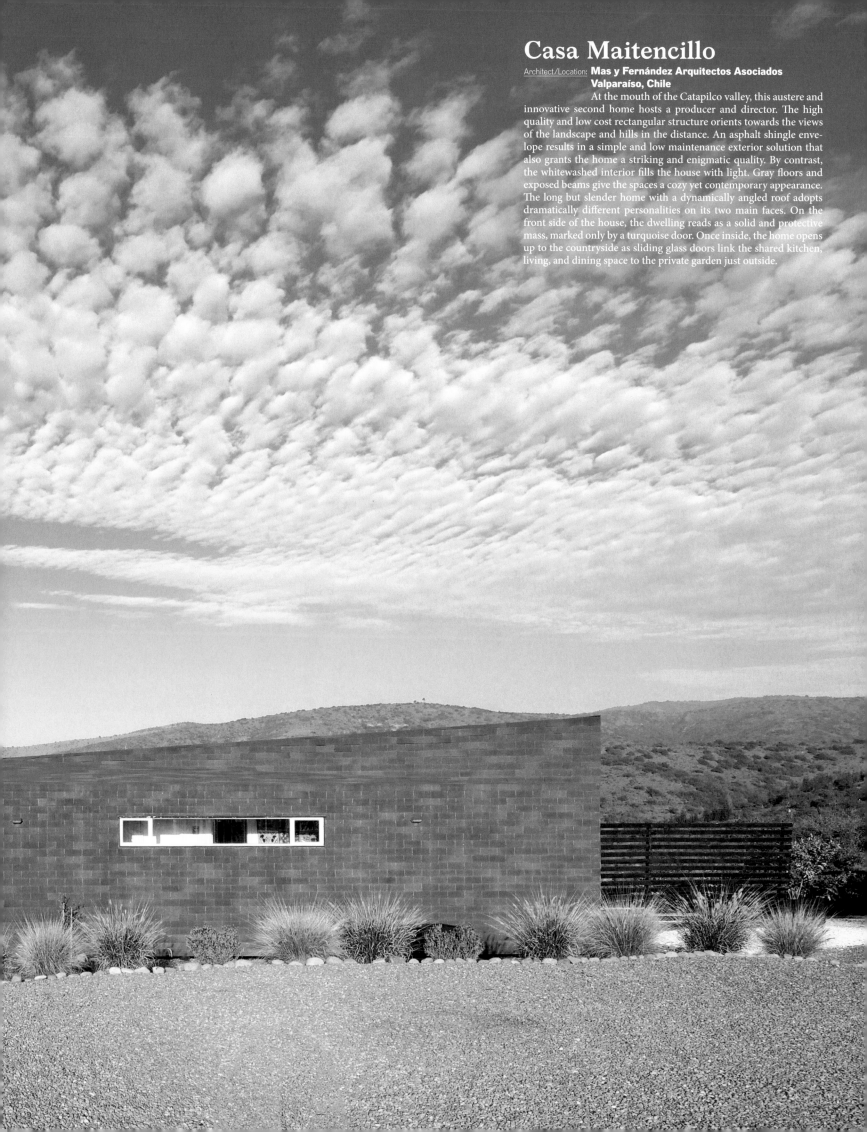

Casa Maitencillo

Architect/Location: **Mas y Fernández Arquitectos Asociados**
Valparaíso, Chile

At the mouth of the Catapilco valley, this austere and innovative second home hosts a producer and director. The high quality and low cost rectangular structure orients towards the views of the landscape and hills in the distance. An asphalt shingle envelope results in a simple and low maintenance exterior solution that also grants the home a striking and enigmatic quality. By contrast, the whitewashed interior fills the house with light. Gray floors and exposed beams give the spaces a cozy yet contemporary appearance. The long but slender home with a dynamically angled roof adopts dramatically different personalities on its two main faces. On the front side of the house, the dwelling reads as a solid and protective mass, marked only by a turquoise door. Once inside, the home opens up to the countryside as sliding glass doors link the shared kitchen, living, and dining space to the private garden just outside.

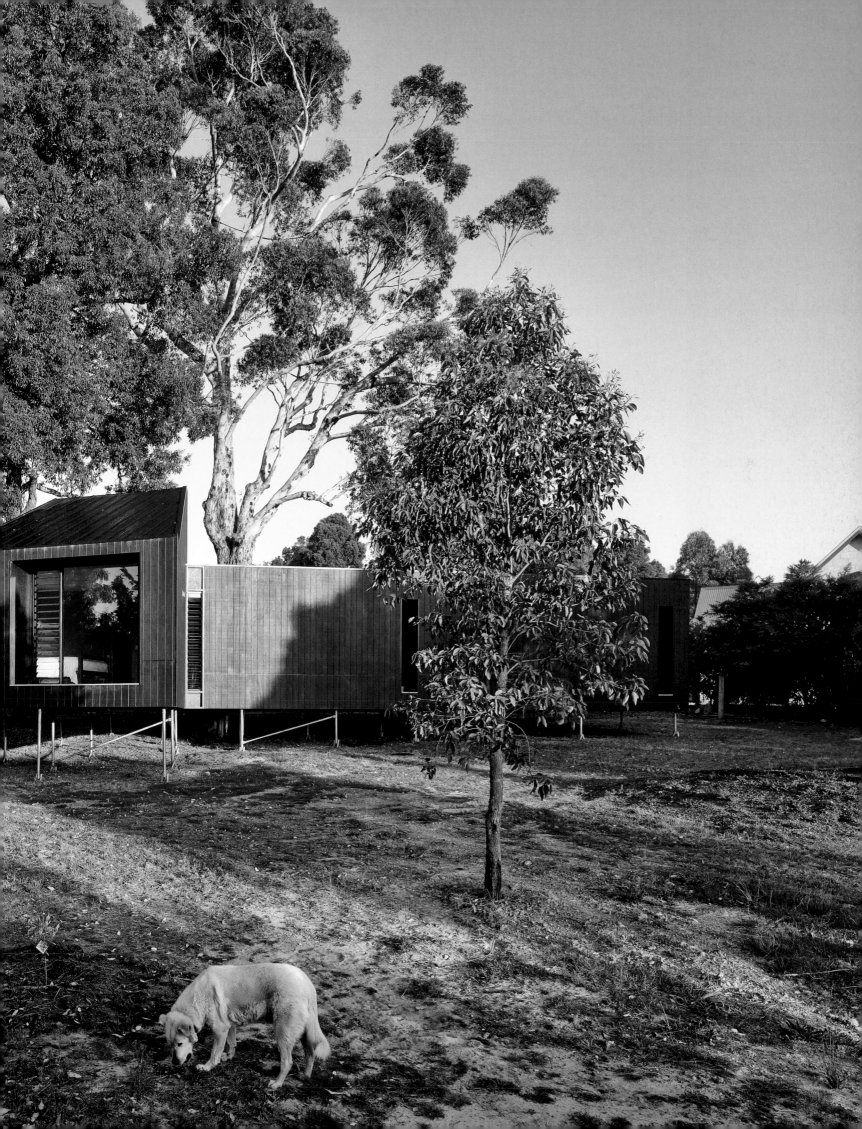

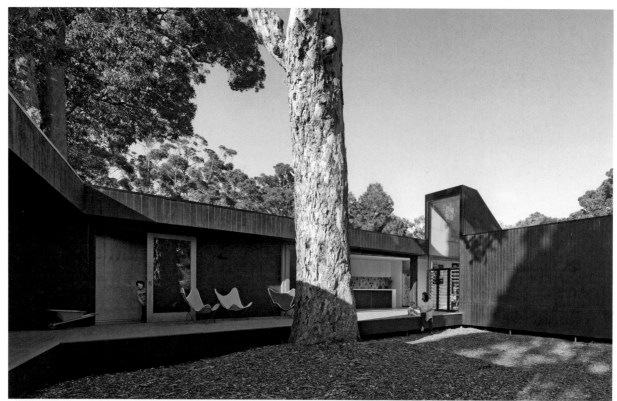

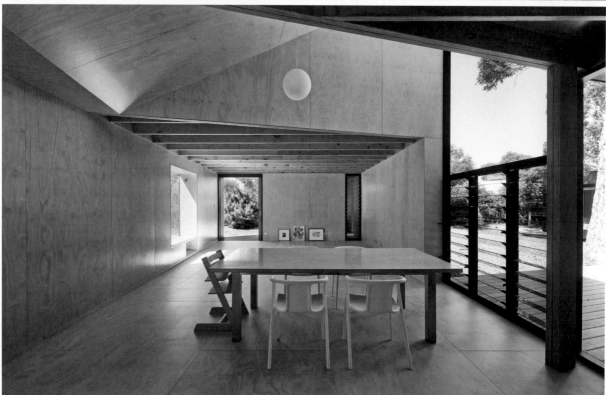

Karri Loop House

Architect/Location: **Morq architecture**
Western Australia, Australia

A dark modern residence winds its way around mature Eucalyptus trees found on-site. Shaping the layout around these majestic trees and their shady canopies, the house follows the topography of the land. The floor plan bridges in-between the tree trunks to define two open and irregularly shaped courtyards. These outdoor spaces for family life embrace the trees and the meditative landscape. Sanded pine plywood warmly envelopes the interior, creating a seamless continuous surface across walls, floors, and ceilings. The rough-sawn black-painted cladding enhances the home's abstract and somewhat mysterious appearance, while establishing a subtle connection with the texture of the neighboring trees. A tall window in the dining area and a periscope-like sloping roof in the master bedroom celebrate the presence of the trees from inside the house, staging views of both foliage and the rugged trunks aglow in the golden Australian sunlight.

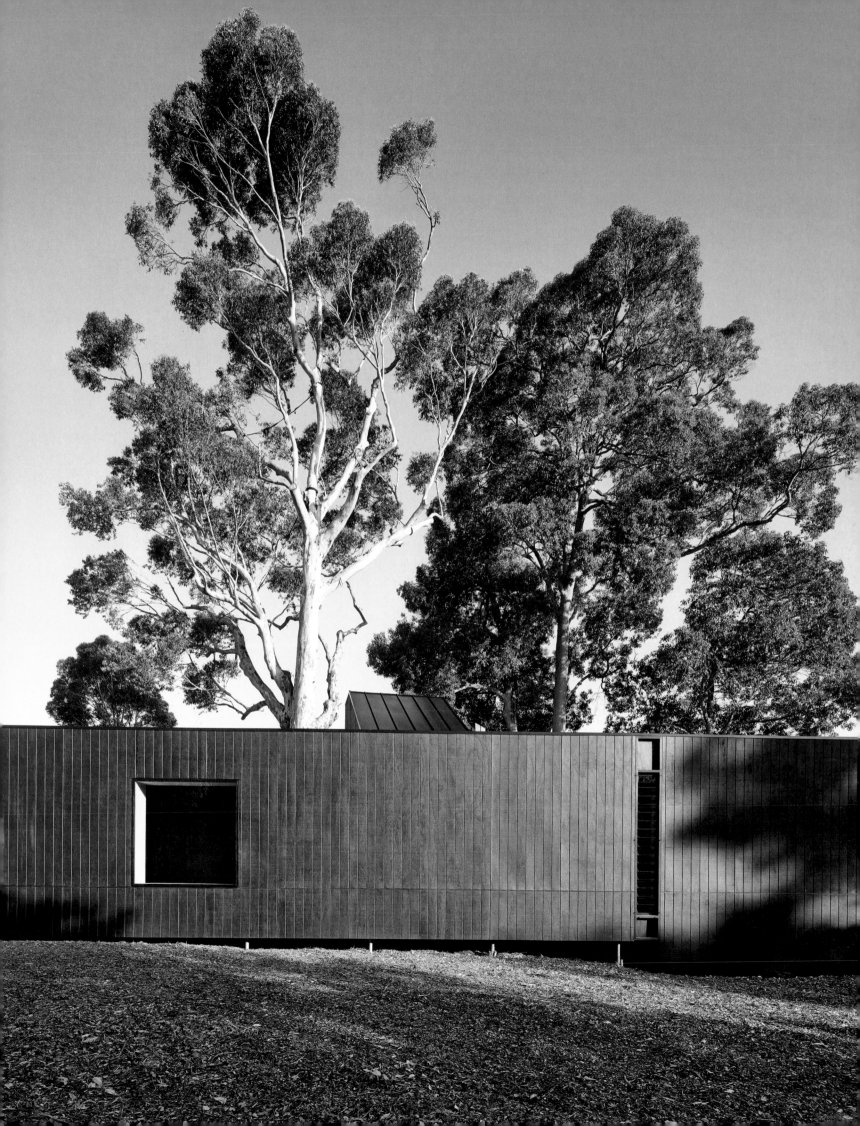

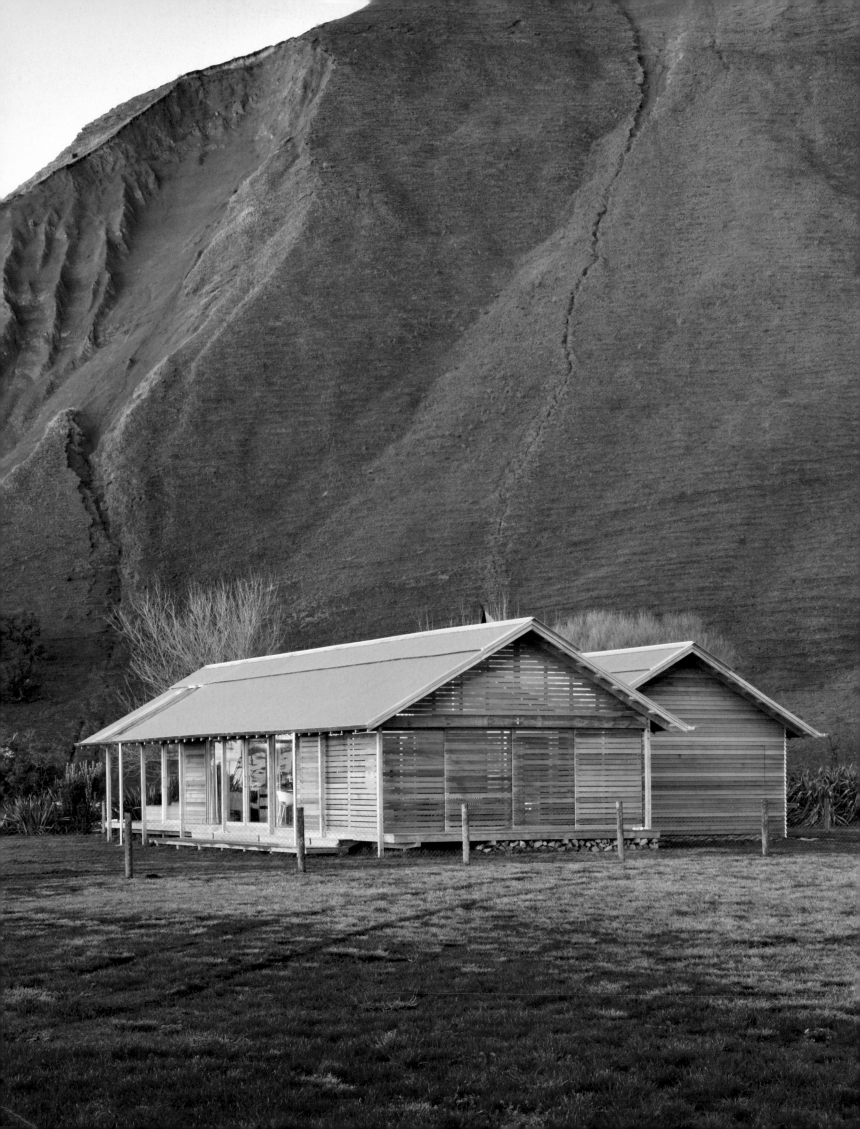

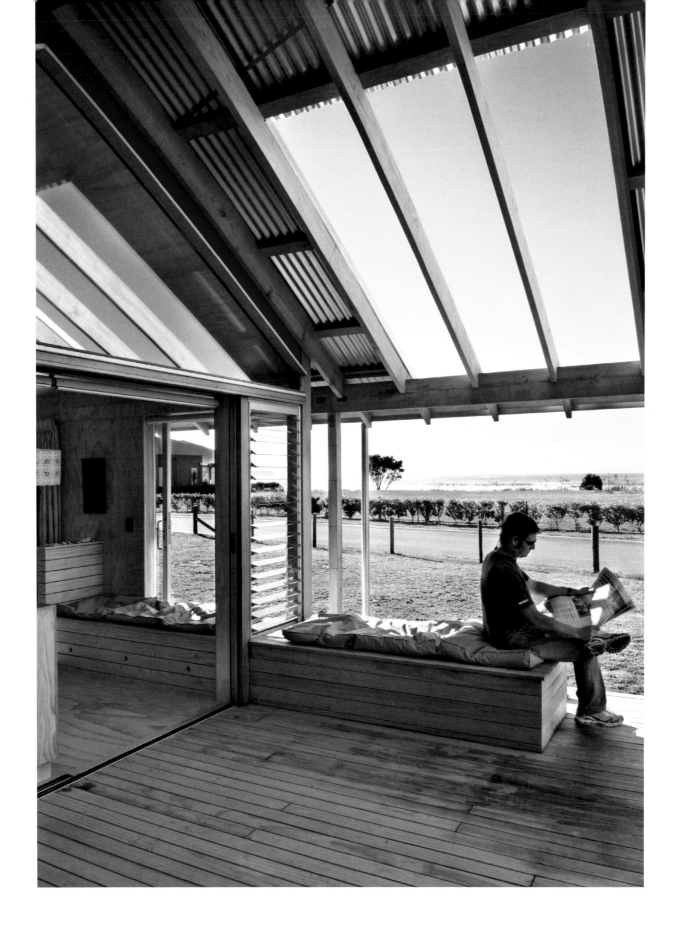

Shoal Bay Bach

Architect/Location: **Parsonson Architects**
Southern Hawkes Bay, New Zealand

A holiday retreat resides in a rugged and remote settlement surrounded by farmland. The inviting dwelling, built for a large family, provides a unique setting to enjoy the long summer holidays and entertain guests. This new residence is raised off the ground and sits beside the original wool shed, which has served the bay since the early 1900s. Comprised of two pitched roof pavilions slightly offset from one another, the residence gracefully blends into the rural landscape. One structure accommodates the bedrooms while the other holds the main living space. Decks, located at each end of the living pavilion, allow the sun to spread across the interiors throughout the day. Sliding screens form an adjustable shelter to the outdoors, integrating nature into all aspects of the house. Rugged yet welcoming, the home offers unpretentious shelter—a place to kick off one's shoes and not worry about tracking sand through the house.

193

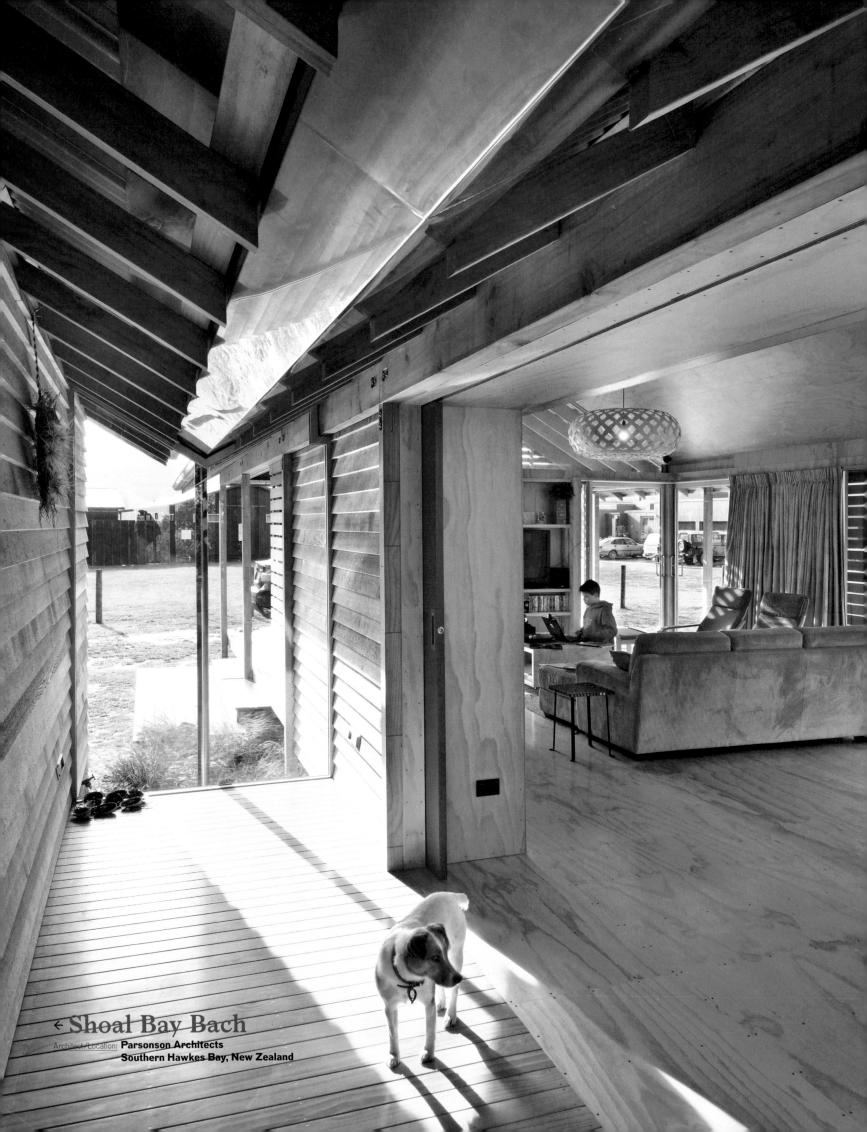

← Shoal Bay Bach

Architect/Location: **Parsonson Architects**
Southern Hawkes Bay, New Zealand

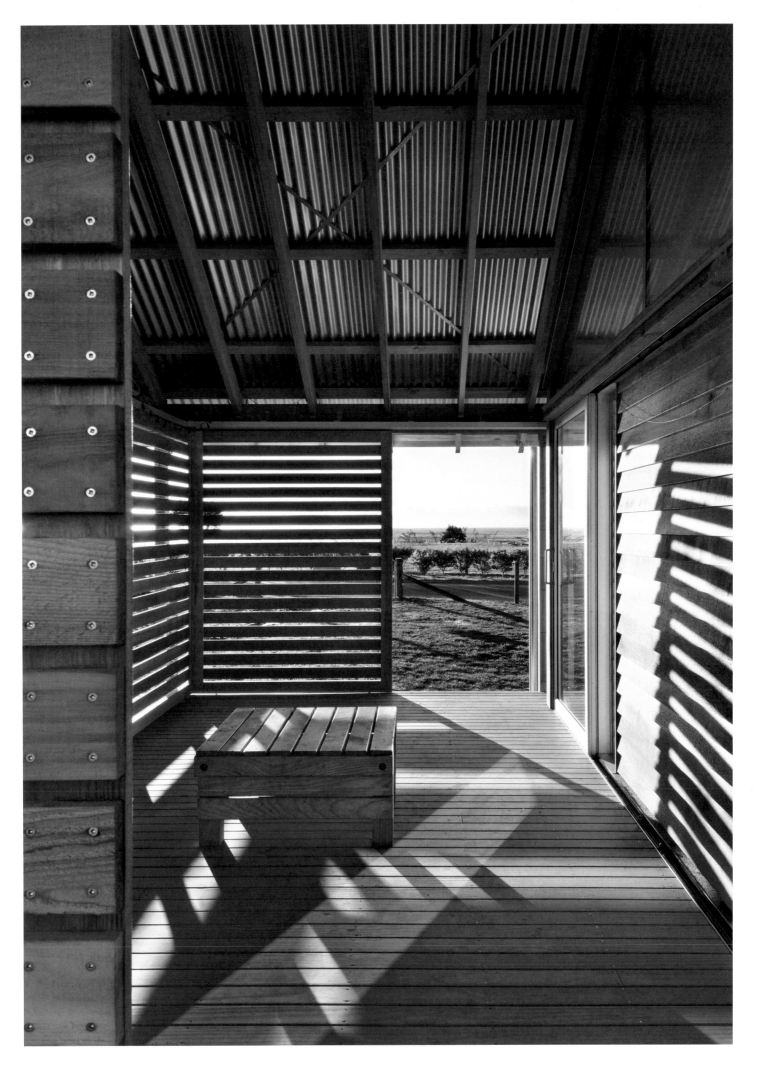

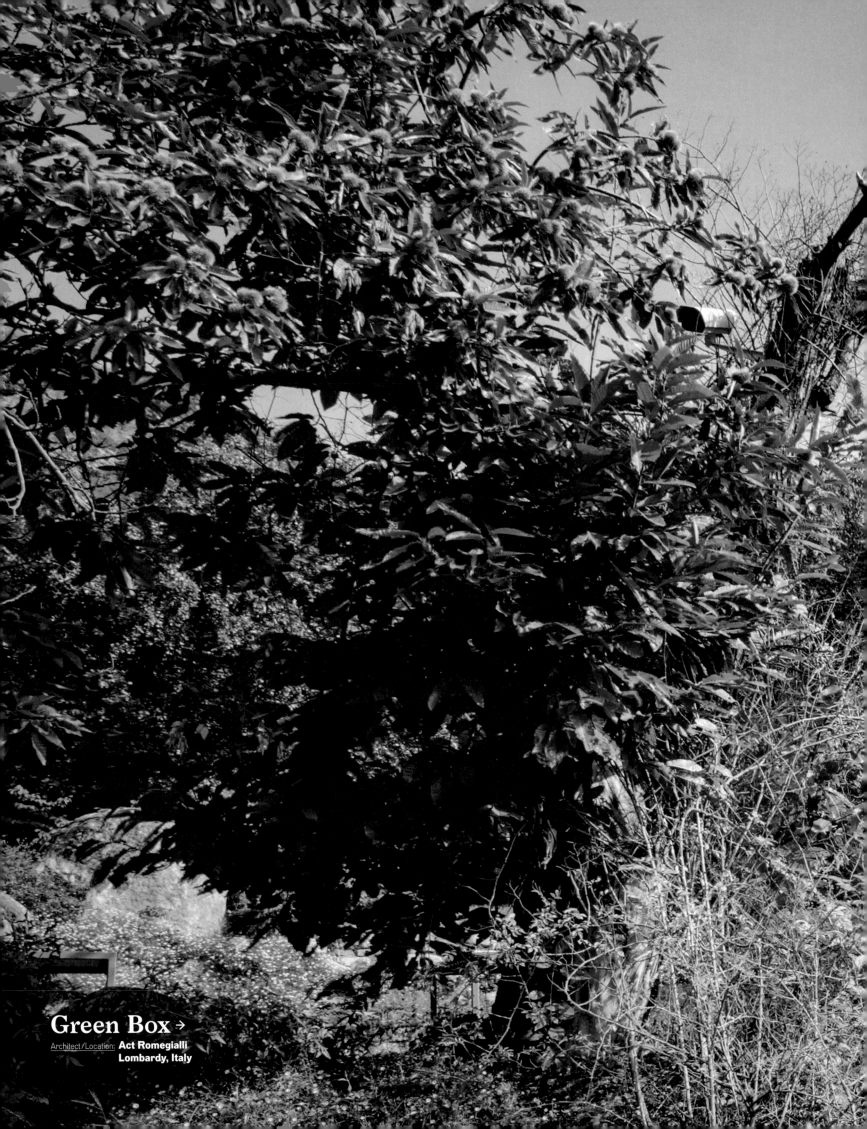

Green Box →

Architect/Location: **Act Romegialli**
Lombardy, Italy

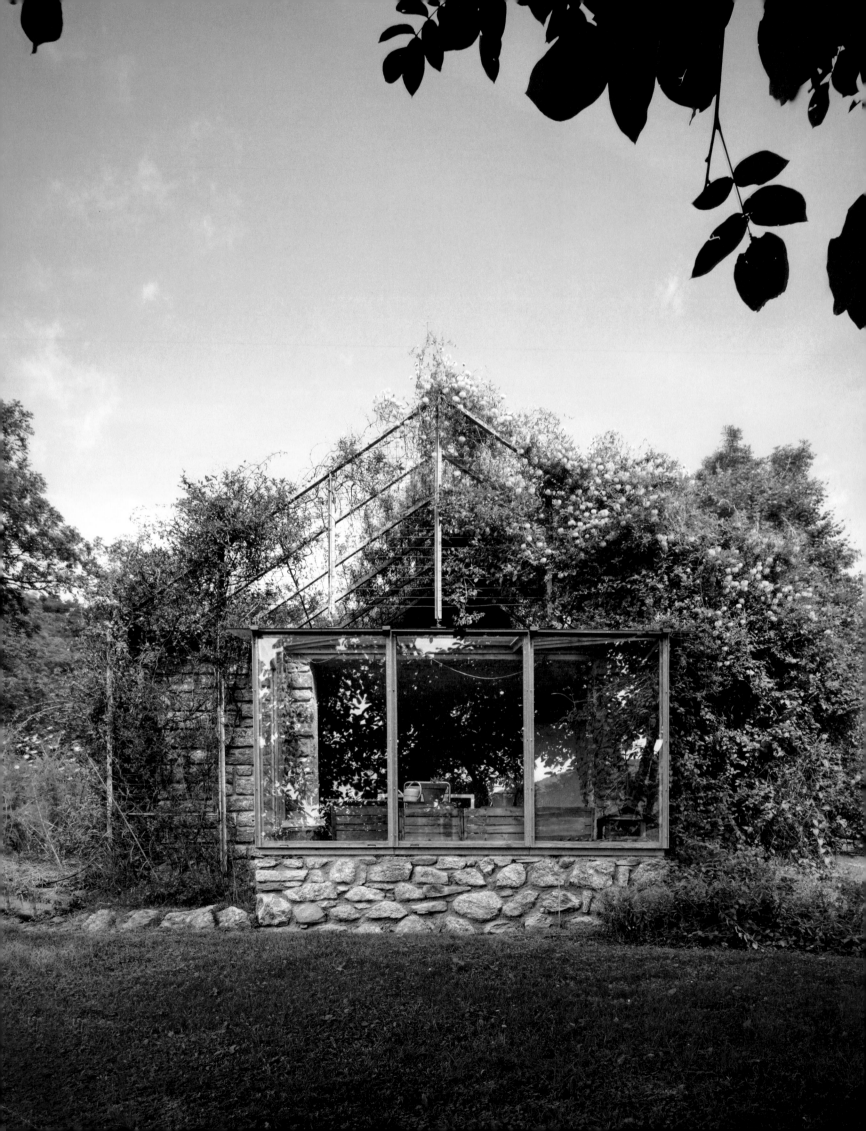

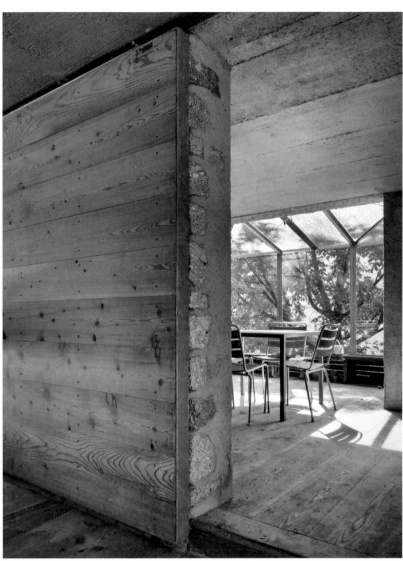

Green Box

Architect/Location: **Act Romegialli**
Lombardy, Italy

Overgrown in lush greenery, the ultimate primitive hut nestles behind a weekend house on the slopes of the Raethian Alps. The ethereal and lightweight dwelling, renovated from a small disused garage, supports a dense network of climbing vegetation that protectively shrouds the form in mystery. Large sliding doors and ample windows keep the rustically inspired interior always connected to the outdoors. As if reclaimed by nature, the delicate retreat develops a privileged lookout point for observing the changing seasons. Casting a warm glow into the wild parkland in the evenings, the modest retreat with its classic pitched roof silhouette acts as a luminous beacon shining through the leaves. The dense plants and seasonal flowers covering the exterior transform the shelter into an ever-changing extension of the wilderness.

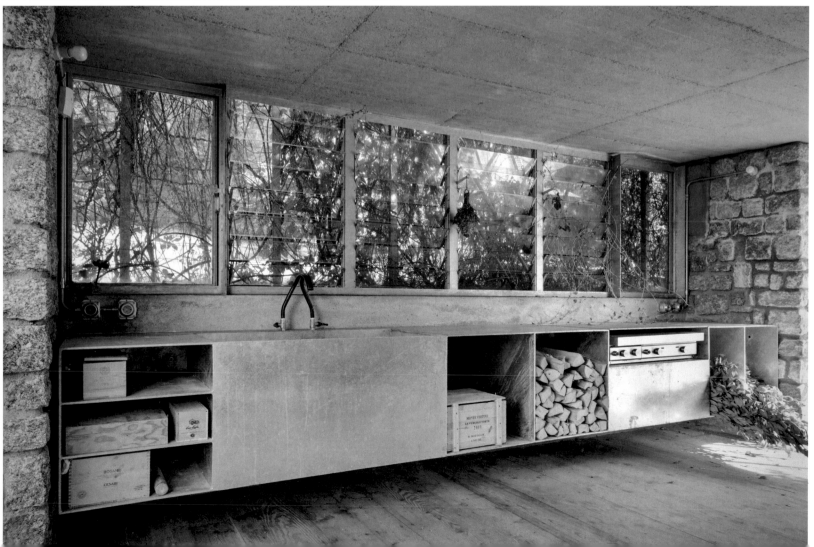

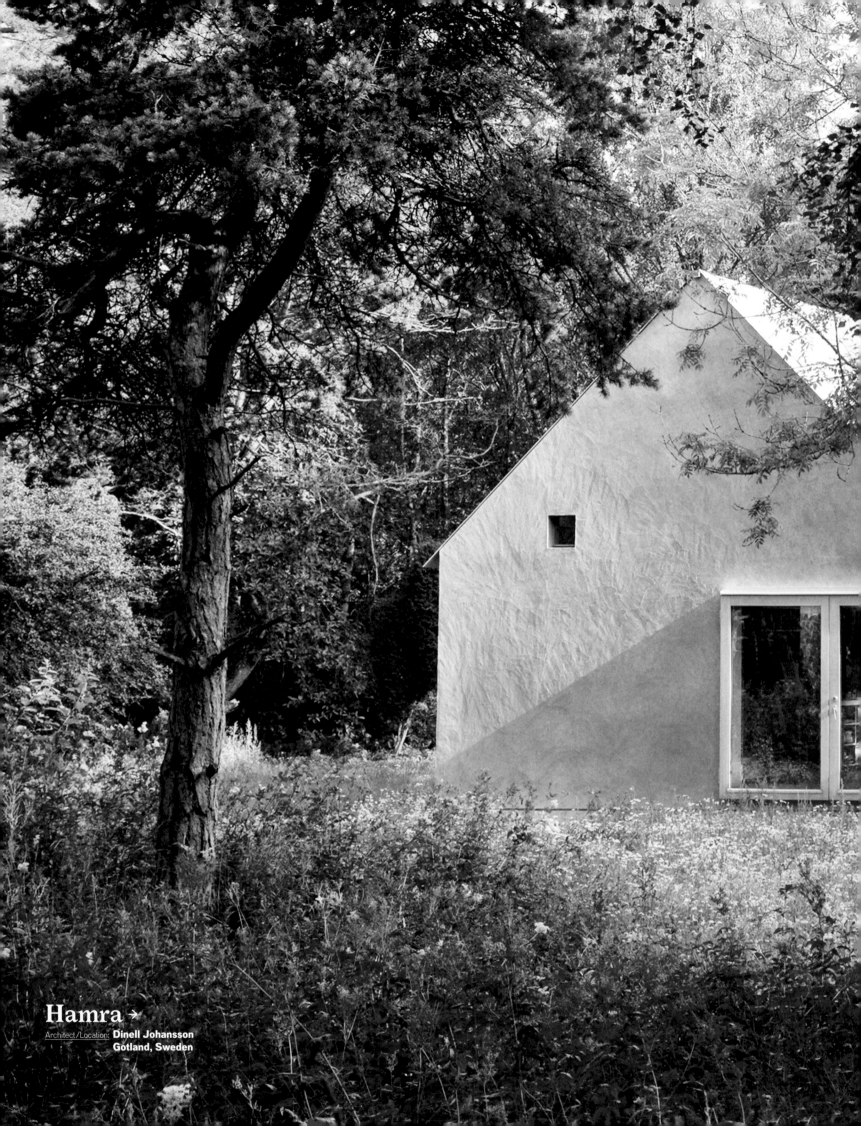

Hamra →

Architect/Location: **Dinell Johansson**
Gotland, Sweden

Hamra

Architect/Location: **Dinell Johansson**
Gotland, Sweden

Embracing the archetypal house silhouette, this simple pitched roof structure coverts an old barn into a delightful and compact summer home. The inviting interior consists of a single open, mixed-use space. Two prominent plywood volumes, stained in a rich red tone, are placed on each end of the house. These two cubes offer flexible interior and loft spaces for play and sleep. Lime green curtains, hung on each cube, add privacy to the spaces on the ground level. The bright, double-height areas between these volumes integrate a kitchen, with a concrete block for appliances and a fireplace, as well as a living and dining area. Three glazed doors and one large picture window penetrate the corrugated steel and concrete dwelling on all sides. Further illumination for the upper-level lofts comes from two generous skylights. Exceeding expectations rather than budget, what begins as a typical residential framework turns into a memorable living experience in sync with nature and family life.

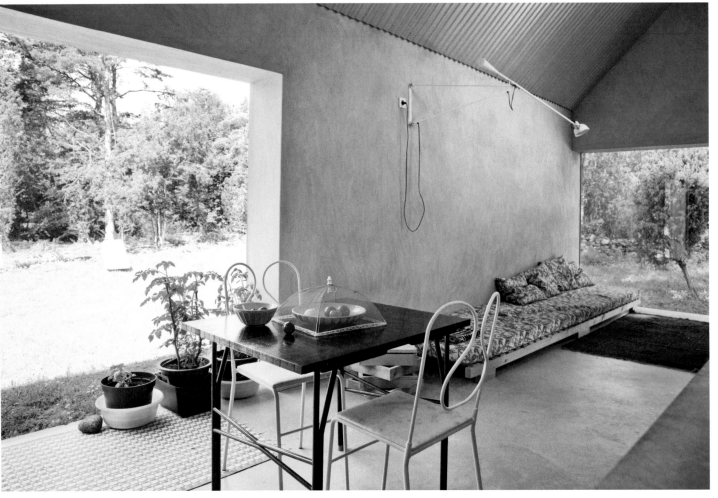

202

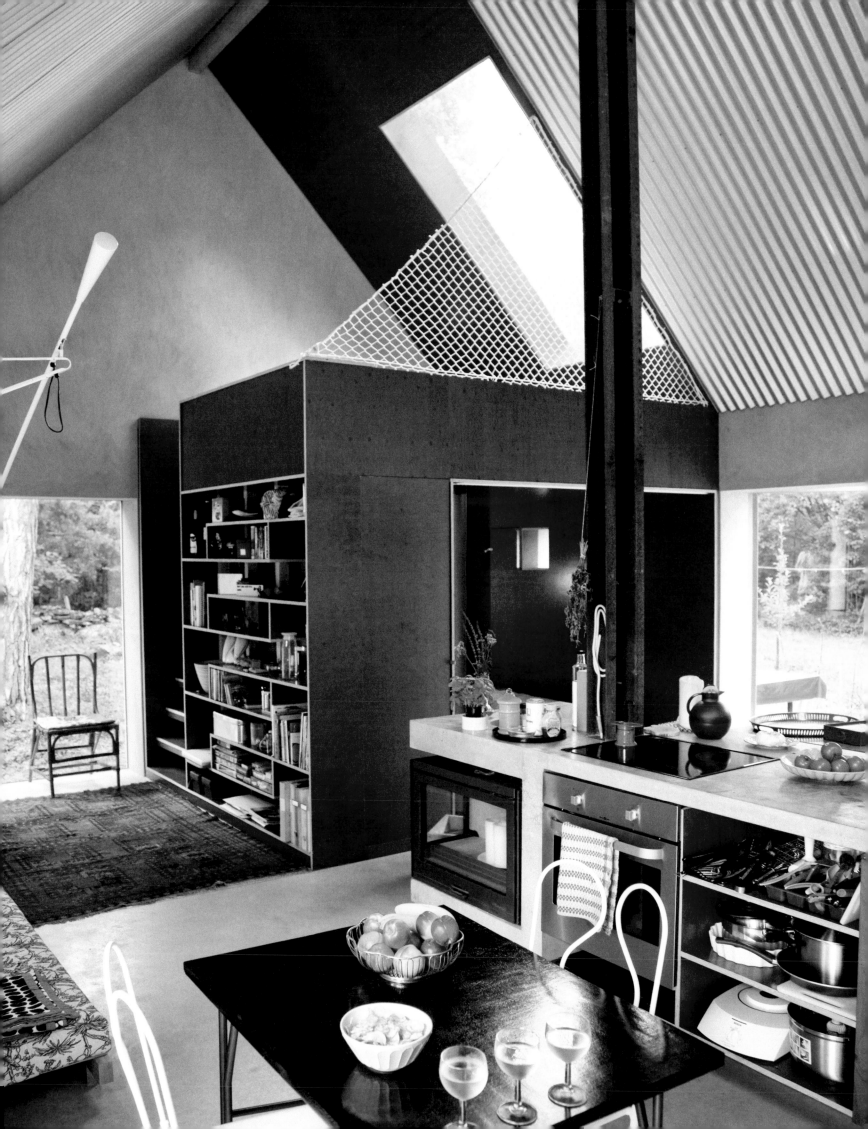

Ermitage

Architect/Location: **Septembre**
Bohuslän, Sweden

On a clearing just 50 meters from the North Sea, a two-person wooden cabin with sauna and bedroom resides on the Swedish island of Trossö. Two large windows frame the windswept and poetic landscape. With the ocean on one side and pine trees on the other, a large sliding door connecting to an outdoor deck effectively doubles the living area when open. Designed for a couple who summer on the remote island, the shelter immerses its occupants in the landscape. The retreat accentuates one's perception of the forces of nature while staying safely concealed between the trees. Raised lightly off the ground, the cabin ensures the land stays undisturbed. A pitched roof references the vernacular architecture of local fishing huts and also produces a spacious internal volume. The sauna, entered through a door at the side of the cabin, contains benches and a window looking out onto the forest. This minimal living space serves as a reminder of the all things essential—a summer day spent close to the land.

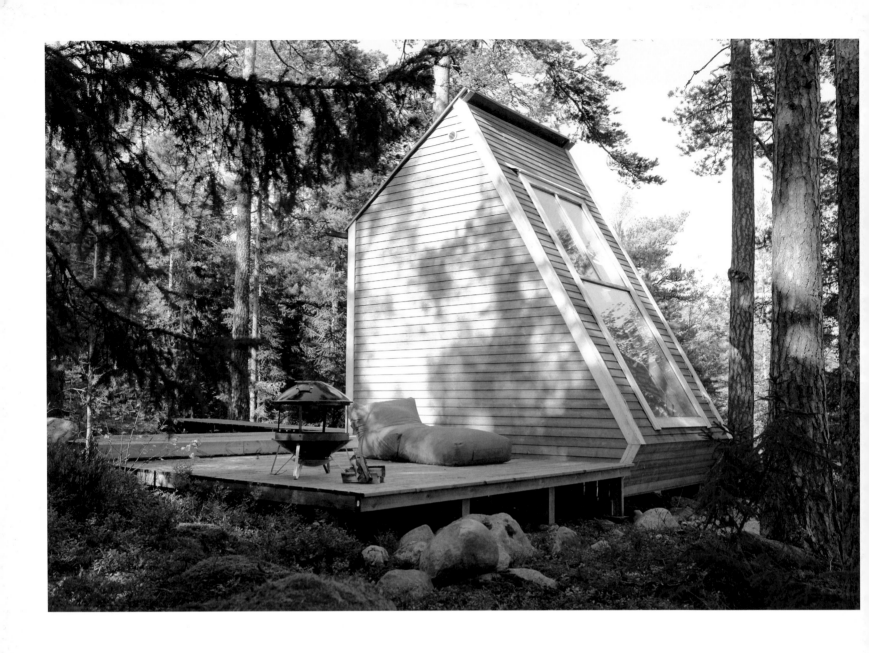

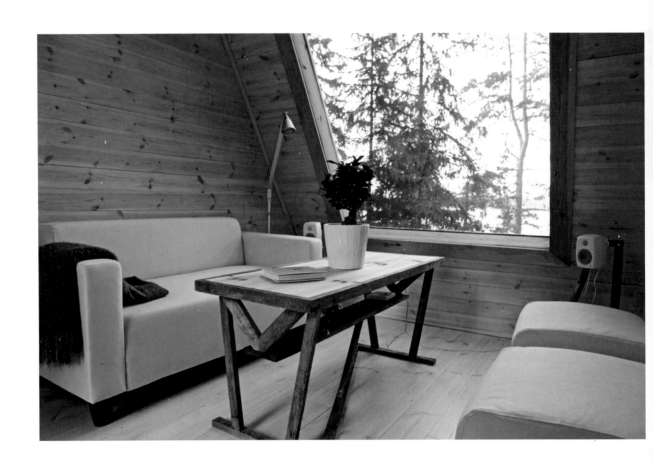

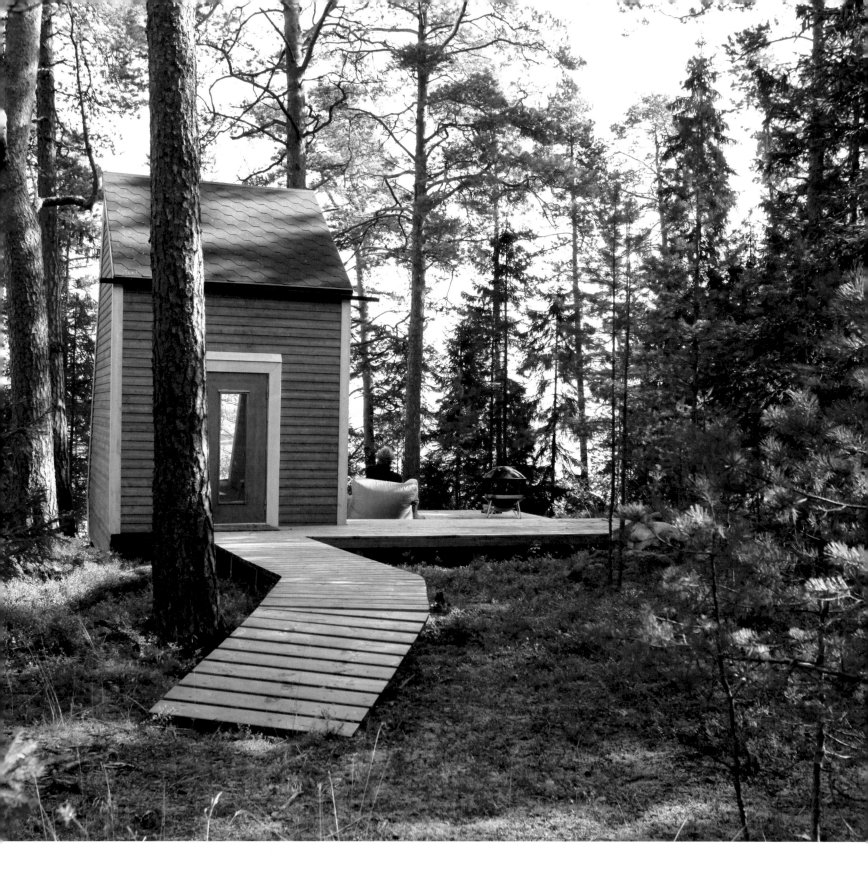

Nido

Architect/Location: **Robin Falck**
Uusimaa, Finland

Conceived and built by the owner, this micro getaway prioritizes life's simple pleasures. The angular cabin was completed in just two weeks. Named after the Italian word for "bird's nest," the shelter rises out of a lush slot of greenery. Making the most of both a tiny space and budget, this small dwelling uses local and recycled materials to stage a lasting indoor/outdoor experience. These building materials were all carried to site by hand to keep the nature untouched. The two-level dwelling accommodates a lounge area and mini kitchen on the ground floor and a sleeping loft above. An outdoor sun deck measures more than twice the width of the house and behaves as an open-air living room. The angle and size of the large window fills the compact interior with natural light. By day the window frames a striking view of the treetops and water beyond. By night, the same aperture welcomes in the starry sky.

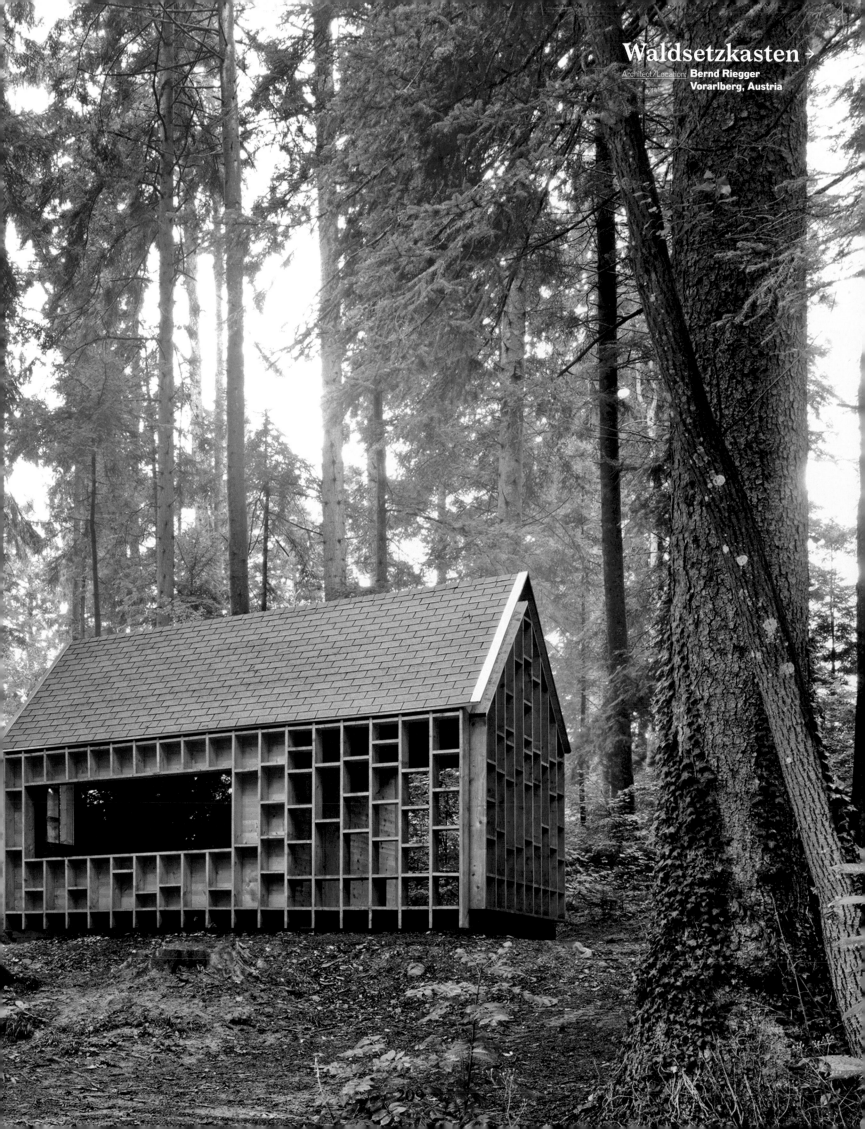

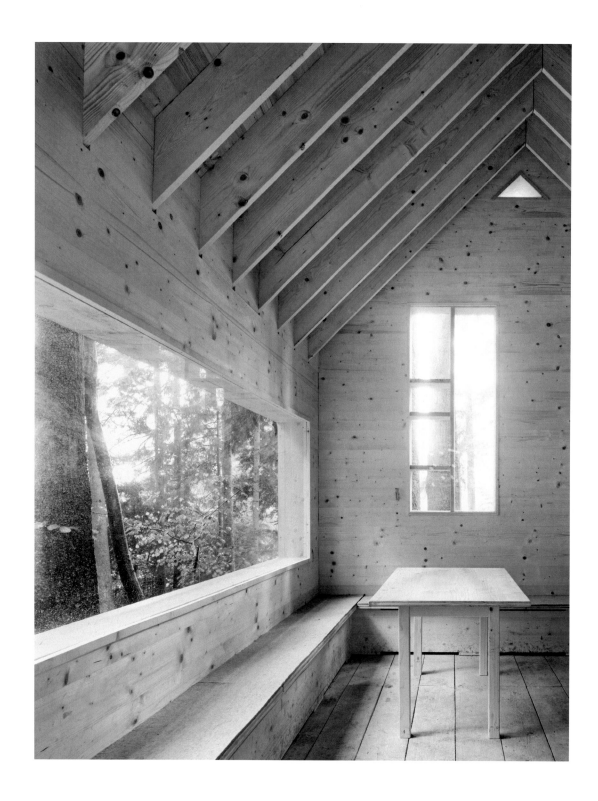

Waldsetzkasten

Architect / Location: **Bernd Riegger**
Vorarlberg, Austria

Primal and primitive, a mysterious forest hut acts as an extension of its wild surrounding. The intricate wooden structure, made from solid spruce timber, provides shelter for the children and teachers of an association promoting education in outdoor settings. Transforming the forest into an experiential playground, the protected hideout behaves as a holistic educational facility. The shelter offers a nurturing space for retreat to sojourn from poor weather and in-between intensive outdoor activity and exercise. A simple interior with a large forest view window consists of an enclosed room to warm up and share a meal as well as a covered but open-air space for basic shelter. This retreat, whose name translates to "forest display case," appears to be an open shelving unit from outside. These display areas are used by the children as places to store food for the forest animals and exhibit items collected during their nature walks. Once all shelf spaces are filled, the façade is complete.

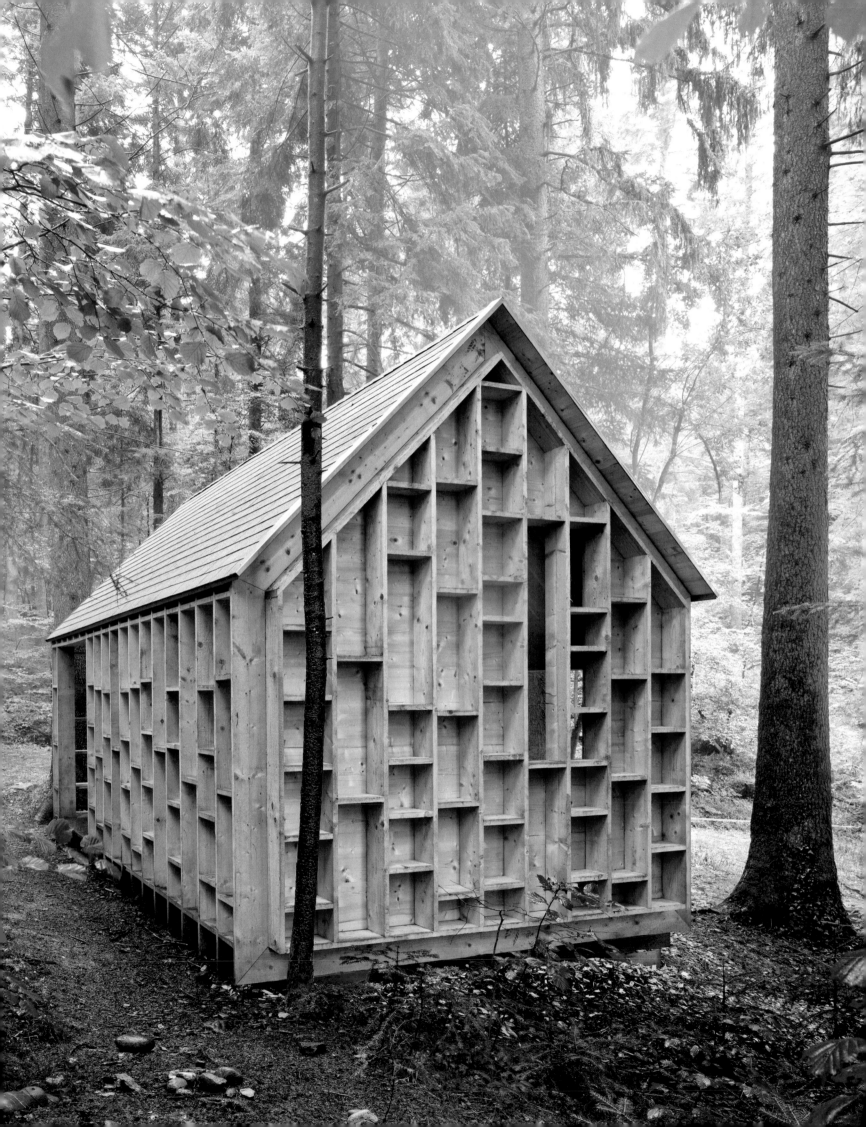

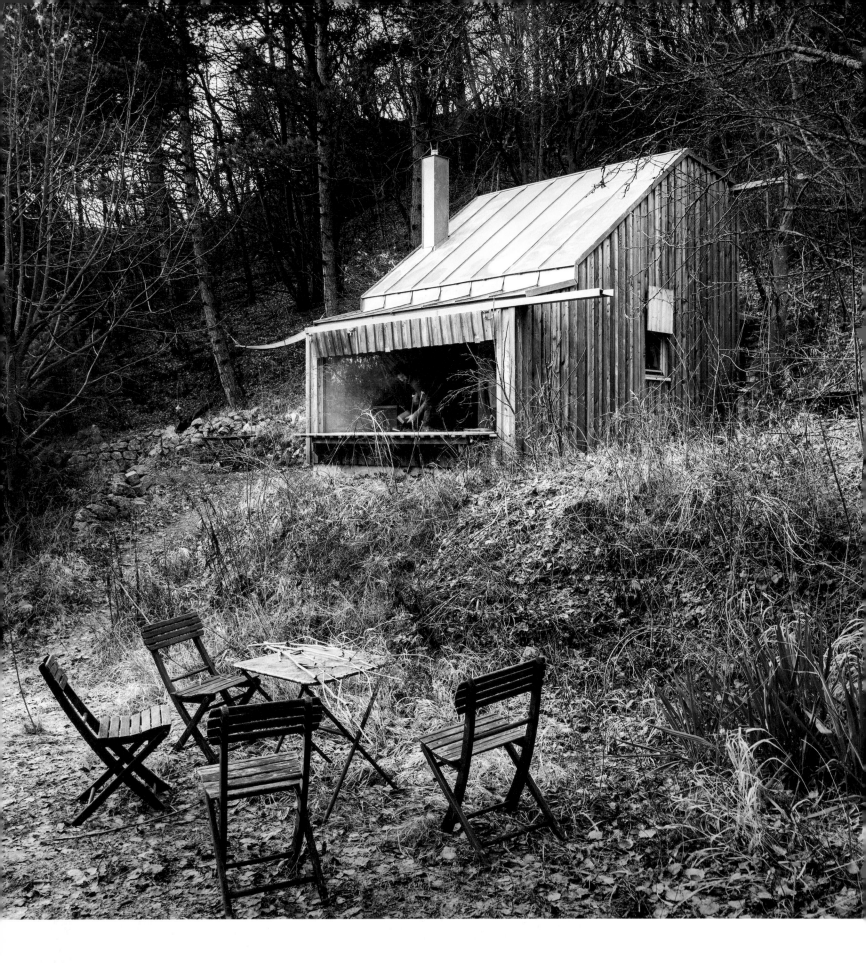

Tom's Hut

Architect/Location: **Raumhochrosen**
Lower Austria, Austria

This renovation of a classic hut in the woods serves as a thoughtful tribute to the original structure. Each side of the dwelling now enjoys a visual connection to the outdoors. Two of the widest openings at the front and the back of the hut link the updated interior to the surrounding wilderness. The use of untreated larch wood throughout naturally embeds the small shack into its forest setting. Chosen by the client as an ideal place for retirement, the calm site inspires a life of recreation and meditation. The hut consists of a place to sleep, a front room, indoor and outdoor fireplaces, and a stove for cooking and heating. With no electricity to speak of and only a single fountain for water, this charmingly rustic cabin takes its owner off the grid and back to basics.

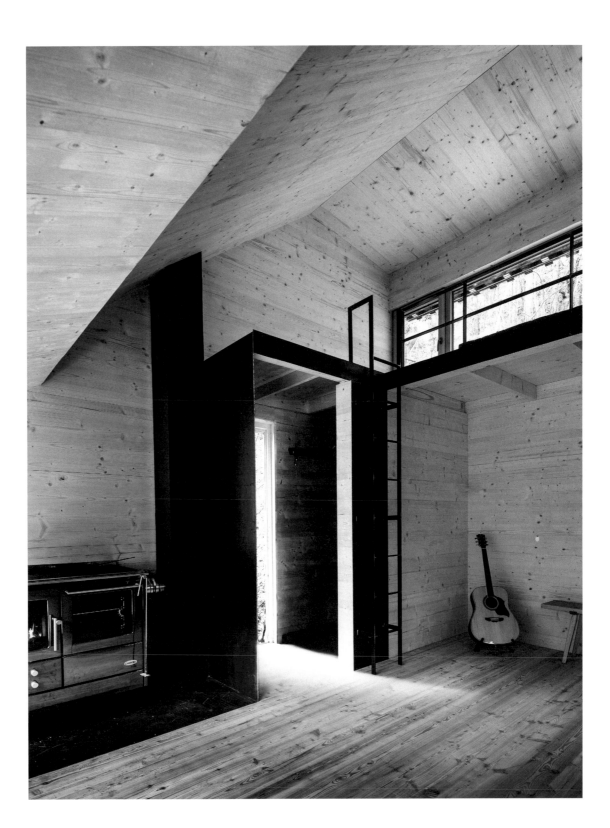

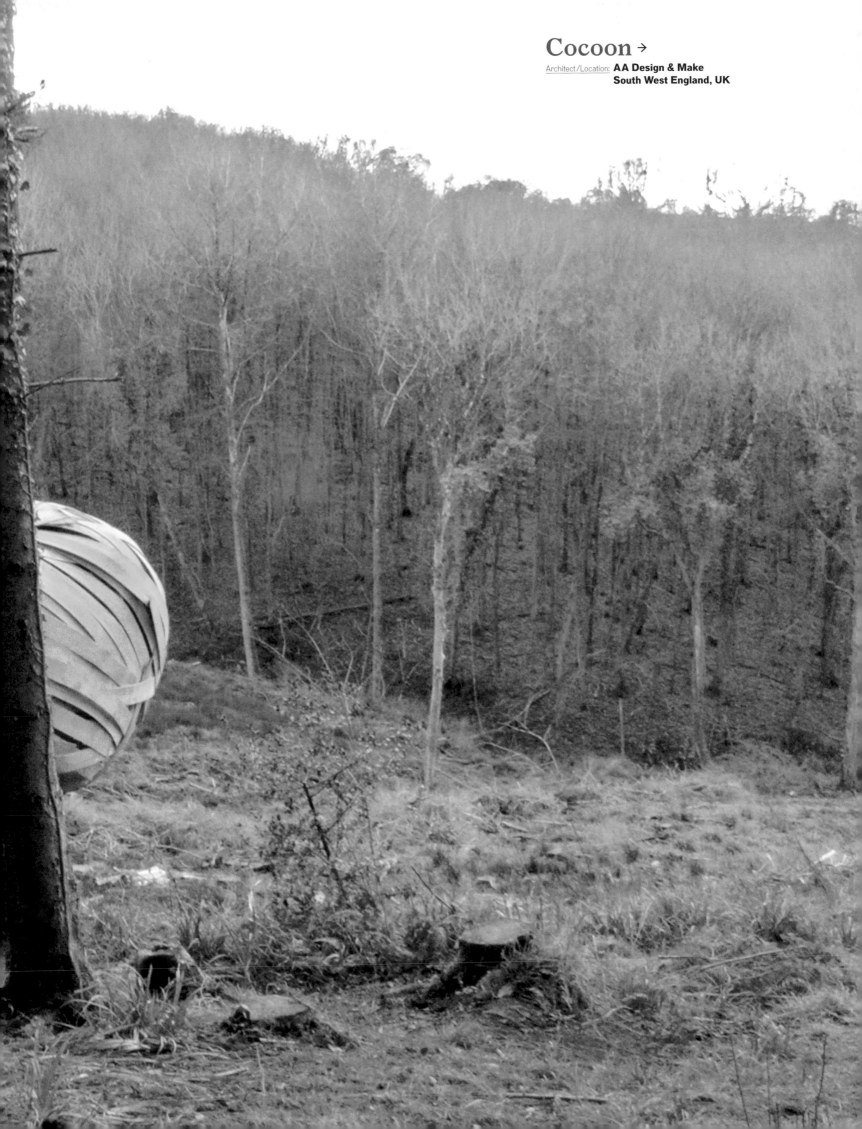

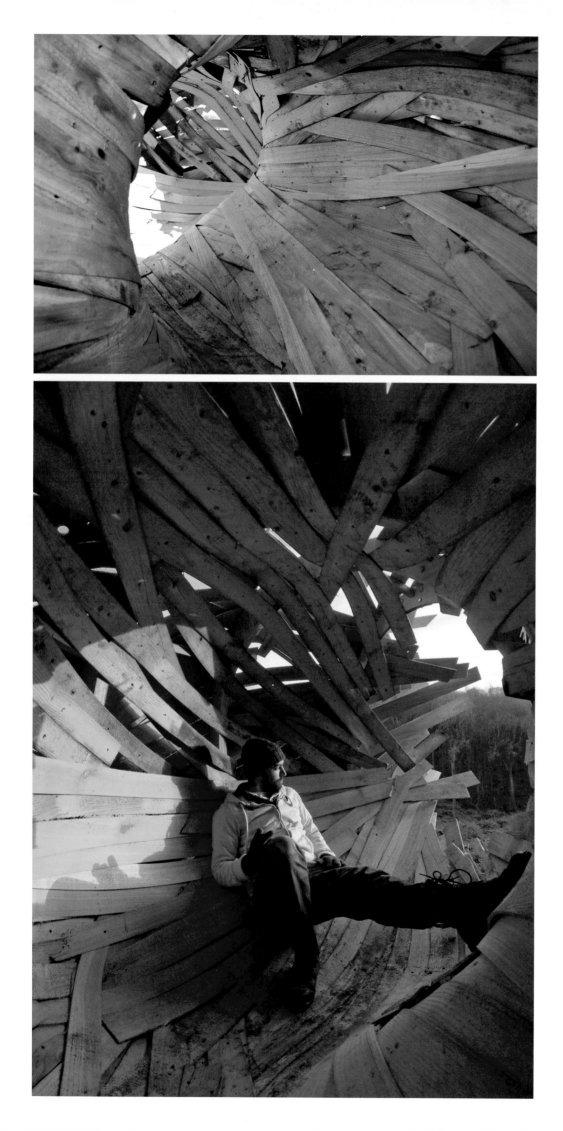
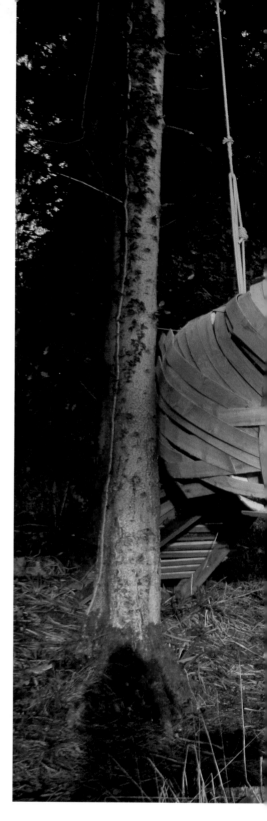

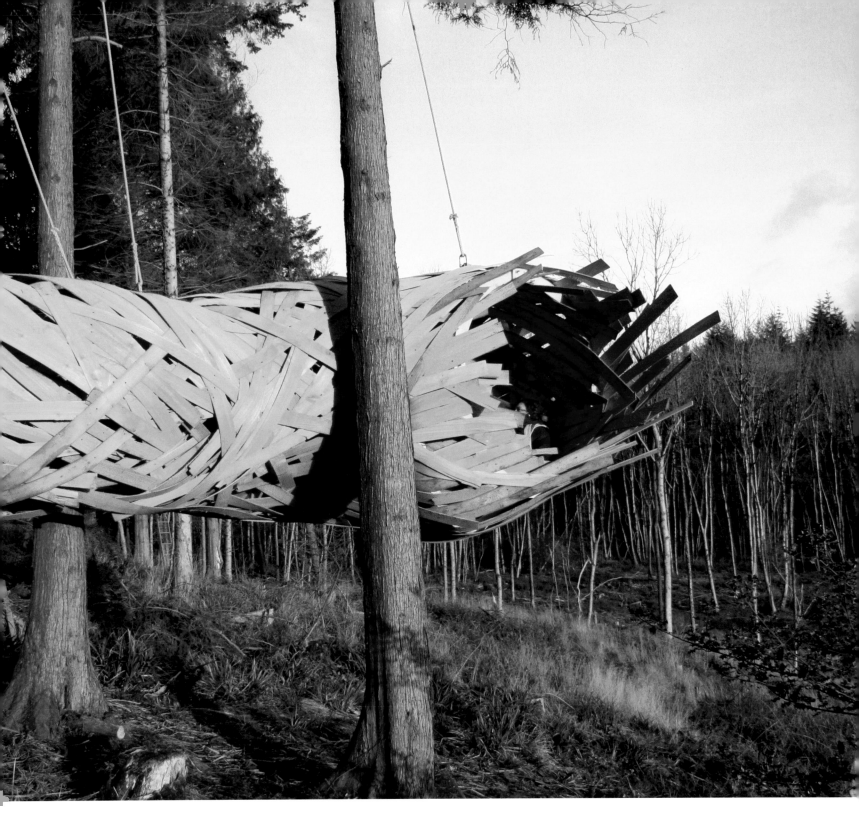

Cocoon

Architect/Location: **AA Design & Make**
South West England, UK

Woven through the trees, this inhabitable cocoon consists of a whimsical monocoque structure made from cedar strips. The prefabricated banded shelter hangs in the branches of three specially selected trees in a forest park. Exploring the relationship between natural light, material, and space, the ephemeral shelter represents a journey through the forest. The site-specific hideout invites and challenges the visitor to anticipate, imagine, explore, and discover the natural beauty of the forest from a completely new perspective. Enveloped in the fresh smell of wood, the relaxing cocoon provides an authentic, visual, and tactile experience within its undulating canyon-like form. At the fringe of a forest clearing, the imaginative sanctuary brings visitors closer to the trees and serves as the premiere vantage point to bask in the winter sunset.

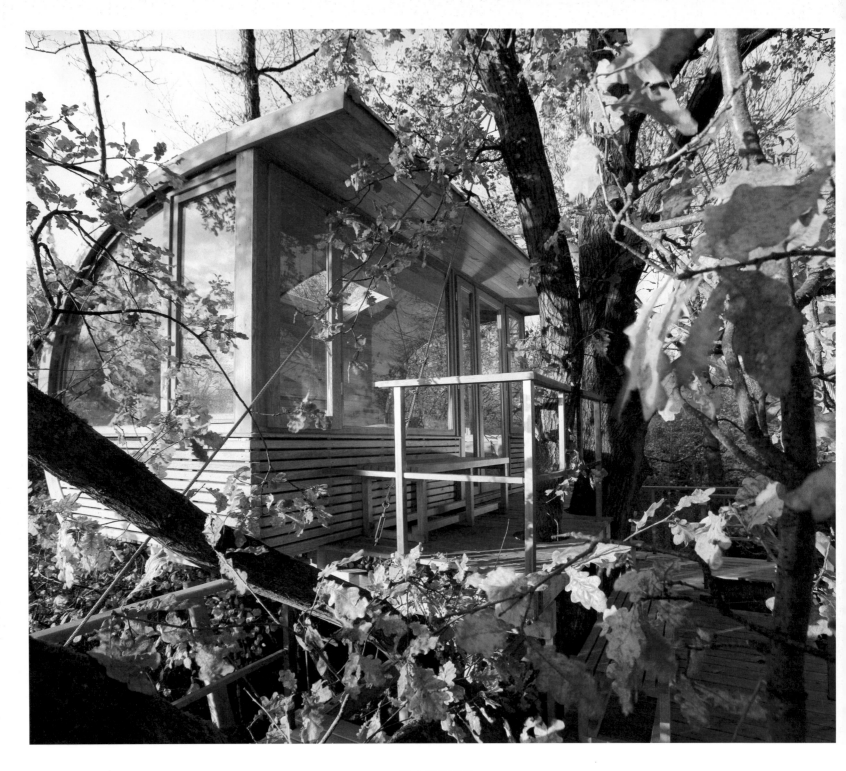

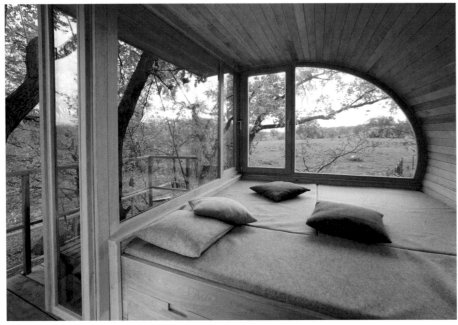

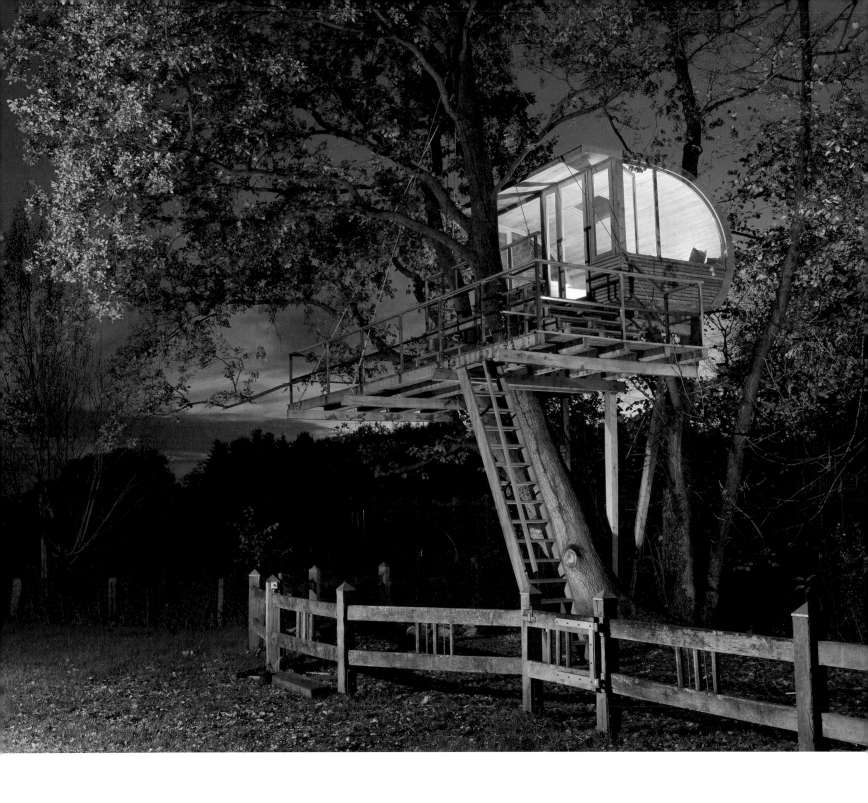

Between Alder and Oak

Architect/Location: **Baumraum**
Lower Saxony, Germany

This exceptional treehouse hovers over a scenic park-like property in Northwest Germany. Descriptively named, the treetop hideout nestles between an alder and an oak tree. The treehouse, characterized by its curved roof, features generous glazing on all sides and a large dormer window. A staircase leading up to the first terrace comfortably fits a table and a few chairs. This terrace then links to the cabin a meter higher. From this elevated perch, guests marvel at the dazzling panoramic view over the broad fields and woods. The cozy interior, furnished with a spacious sleeping area and a bench, also incorporates oak drawers for ample storage. High up in the trees, this adult manifestation of the childhood treehouse becomes the ultimate getaway for both prospect and refuge.

219

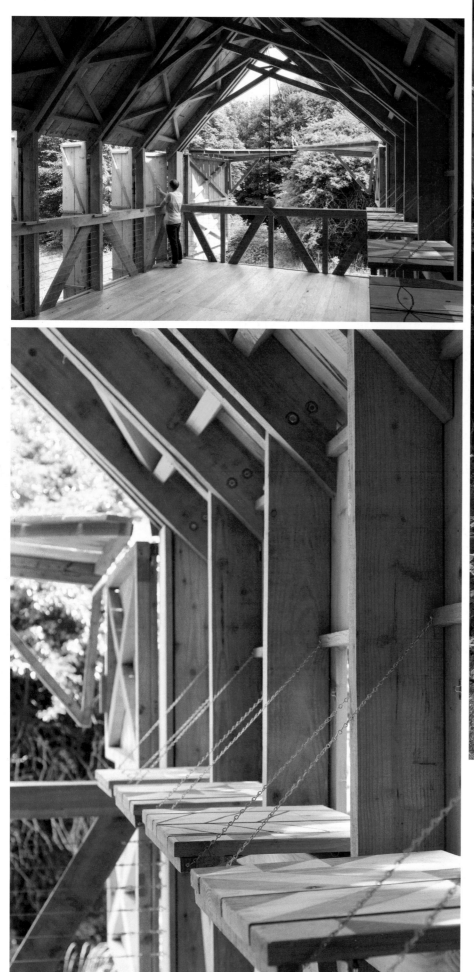

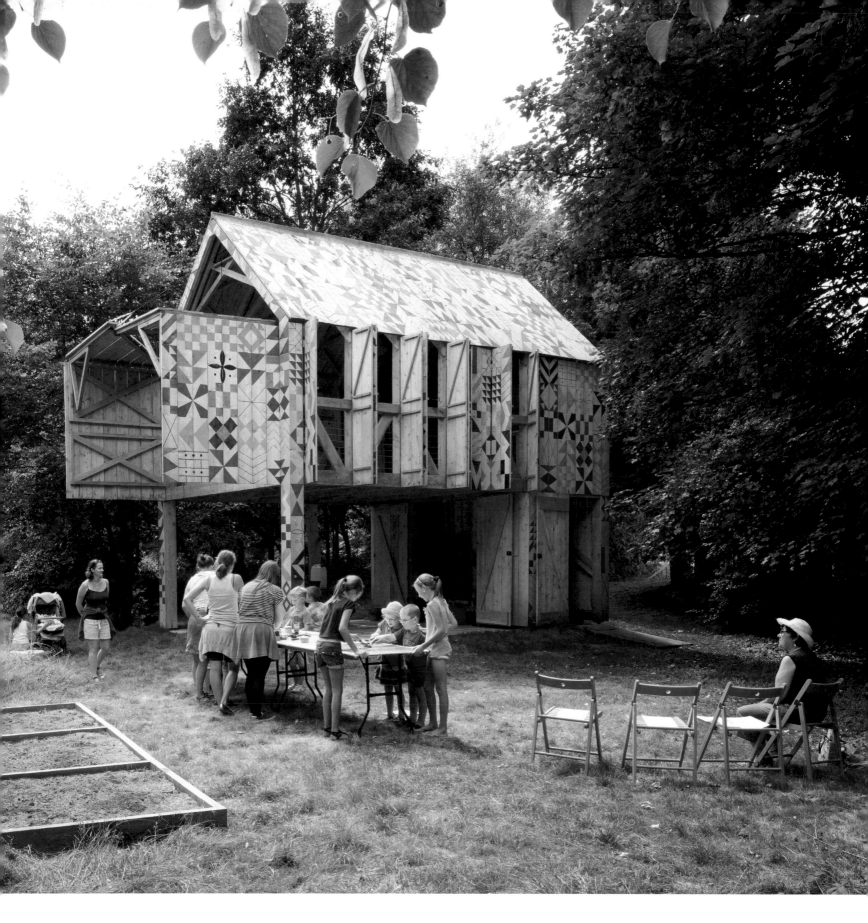

Ecology of Colour

Architect/Location: **Studio Weave**
South East England, UK

A playful cedar structure reinvigorates a neglected area, acting as a jolly custodian for the re-imagined Ecology Island in Dartford's Central Park. The multi-purpose retreat serves as a community arts studio, bird-watching hideout, and park shelter. A semi-outdoor classroom sits at ground level while an enclosed room above, with operable shutters of various sizes, encourages the indoor public events to spill out into the park. The site, a curious rural pocket within an urban context, is situated at the tip of a wild and wooded peninsula in the city center. A spirited pattern designed by graphic designers Nous Vous covers the exterior. Hand-painted by the designers and local residents, the colorful shelter features a pulley system that opens up the eastern elevation to the outdoors in one fell swoop. When open, the hideout becomes a secretive treehouse among the forest canopy—a one of a kind resource for residents to engage with the local flora and fauna.

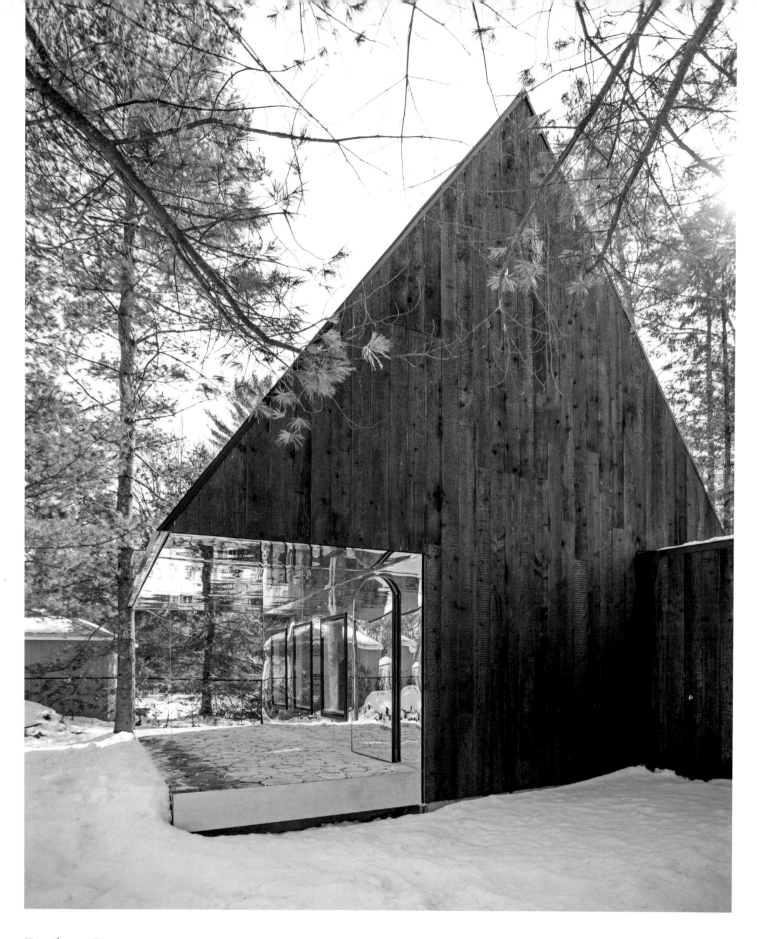

Lake Cottage

Architect/Location: **UUfie**
Ontario, Canada

In a forest of birch and spruce trees along the Kawartha Lakes, this whimsical cottage acts as a multi-use extension to a large family house. The playful retreat reinterprets life in a tree house, where nature plays an integral part in the building. Beneath the steeply pitched A-frame roof clad in charred cedar siding, a wall of mirrors disguises a built-in terrace. This protected terrace, formed out of a deep cut in the building volume, camouflages the lower level of the cabin behind a partition of forest reflections. Inside, a luminous and cozy living room connects to a dining area and sleeping loft above. Fourteen openings into the grand, double-height living room reveal glimpses of inhabited spaces, sky, and trees. Promoting a simple life amongst the tree branches, this inventive dwelling rekindles our childlike imagination.

← Lake Cottage

Architect/Location: **UUfie**
Ontario, Canada

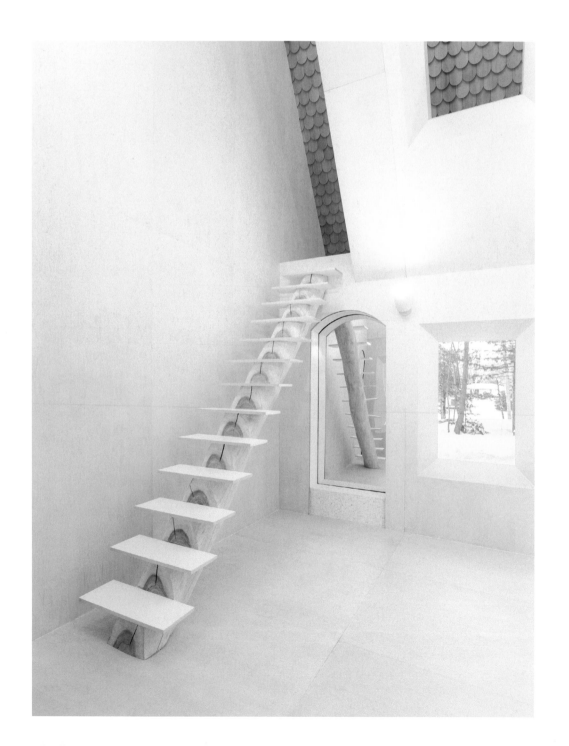

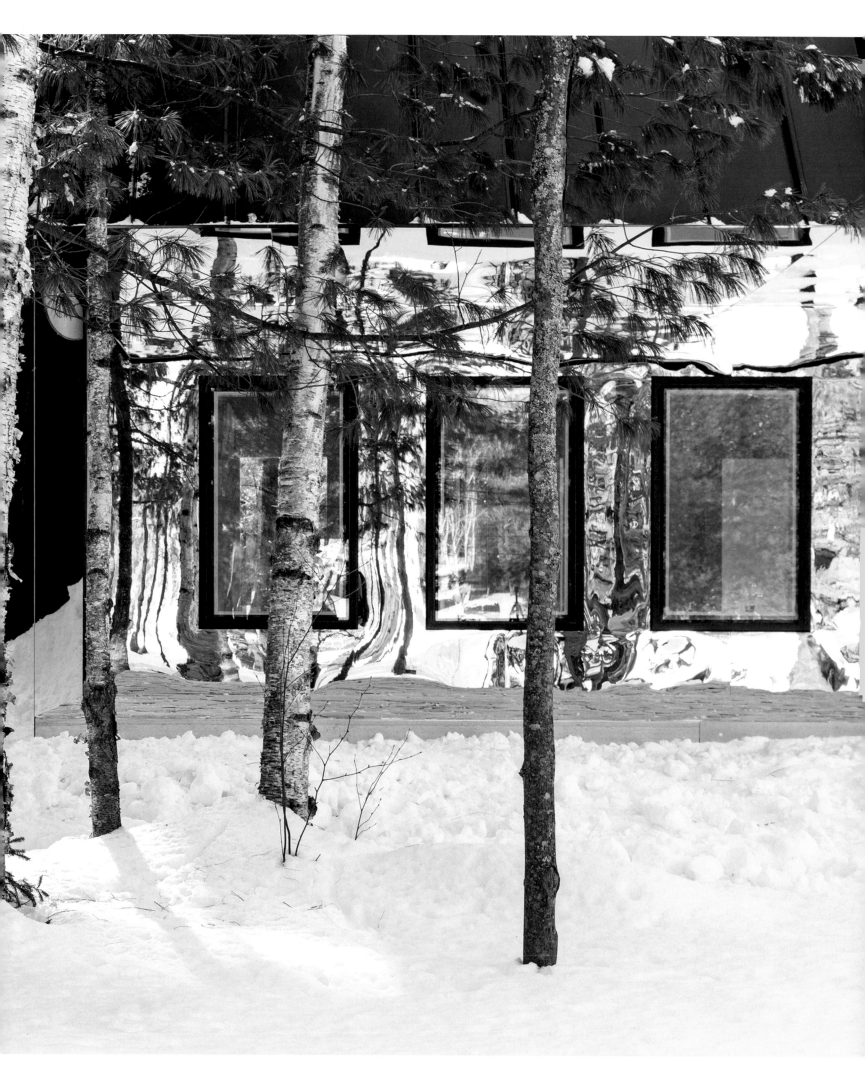

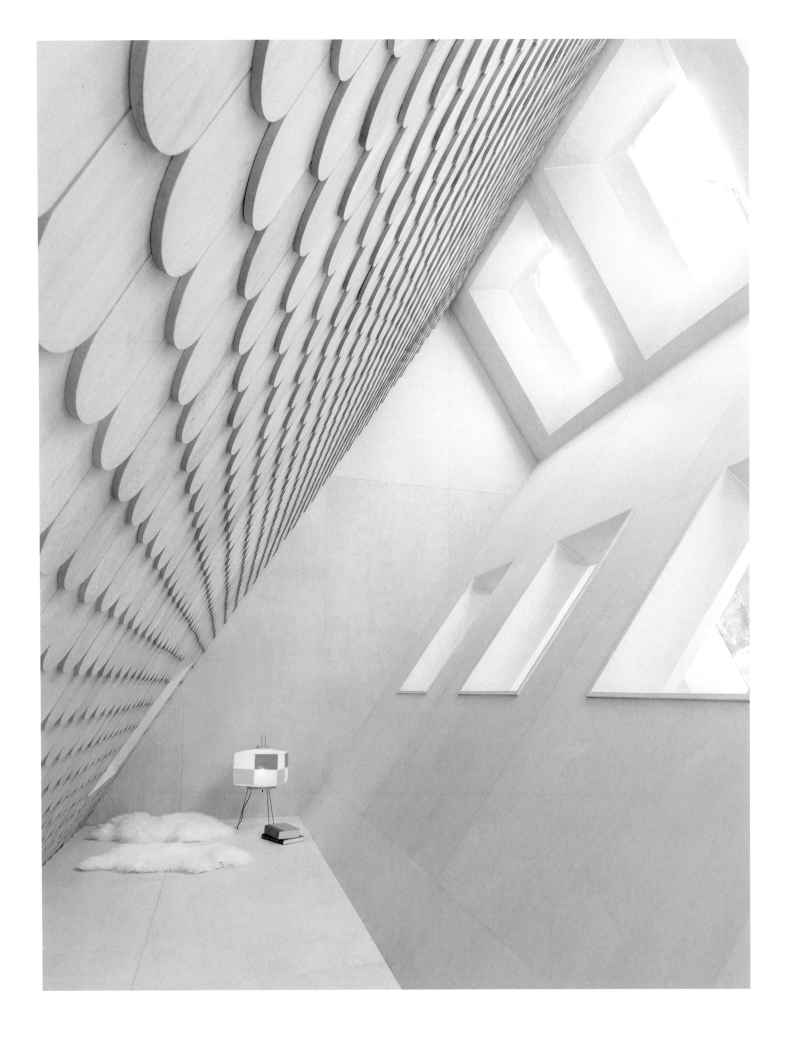

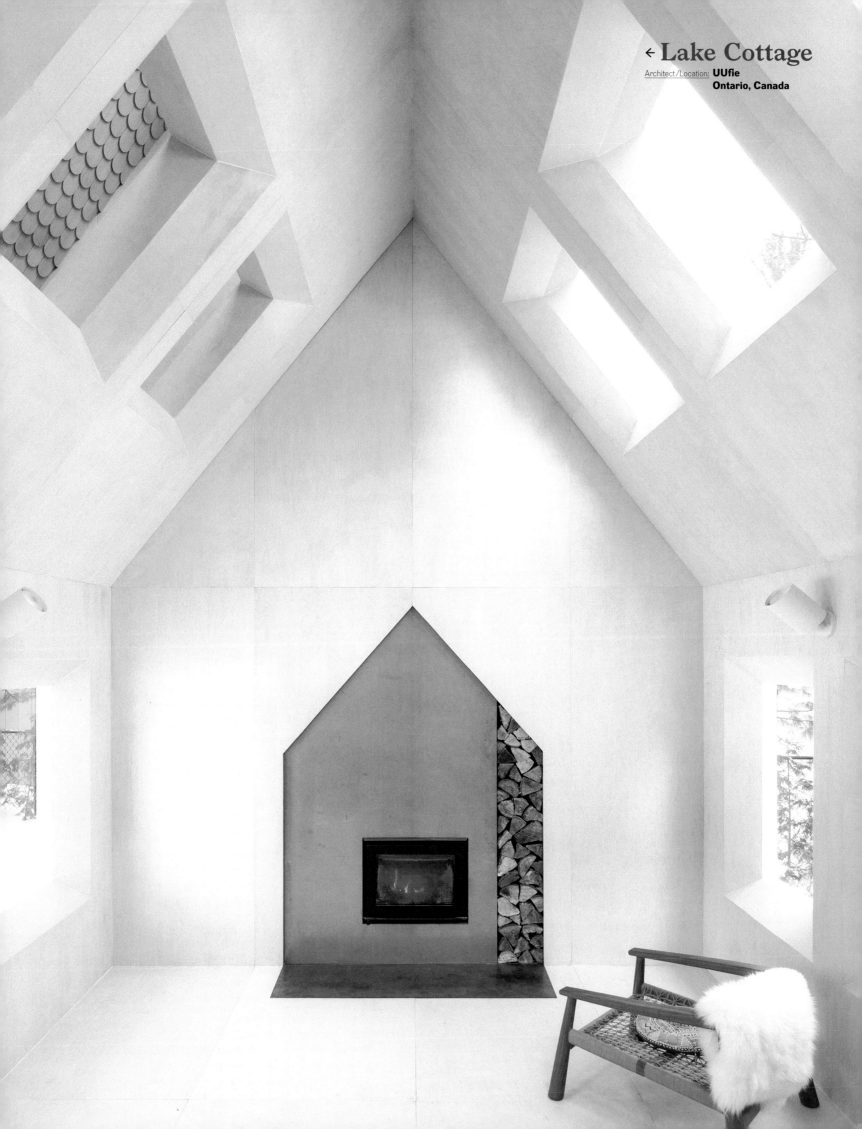

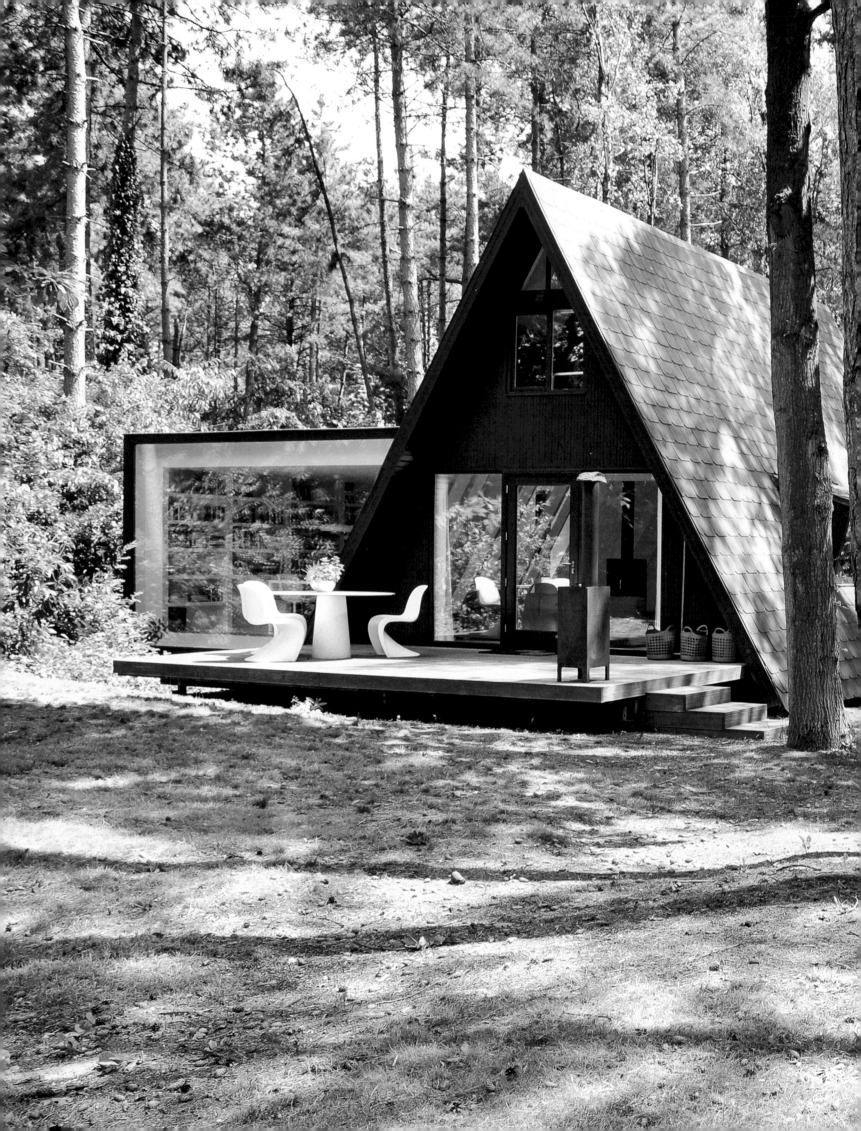

Extension vB4

Architect/Location: **dmvA Architecten**
Flemish Region, Belgium

The extension to a classic A-frame gracefully converts the traditional holiday home into a comfortable and contemporary house. Developing an iconic appearance of its own, the addition comprises a clean glass volume that intersects with and contrasts against the dark mountain retreat's original pyramid form. The modern extension holds an airy library, bathroom, and entrance. Fully glazed on both the front and back façades, the new building volume floods the cheerful interior with sunlight and panoramic views of the garden and pond. The combination of glass and wood initiates a refreshing dialogue between old and new, cosiness and openness, materiality and its details.

Tree Snake Houses →

Architect/Location: **Rebelo de Andrade**
Vila Real, Portugal

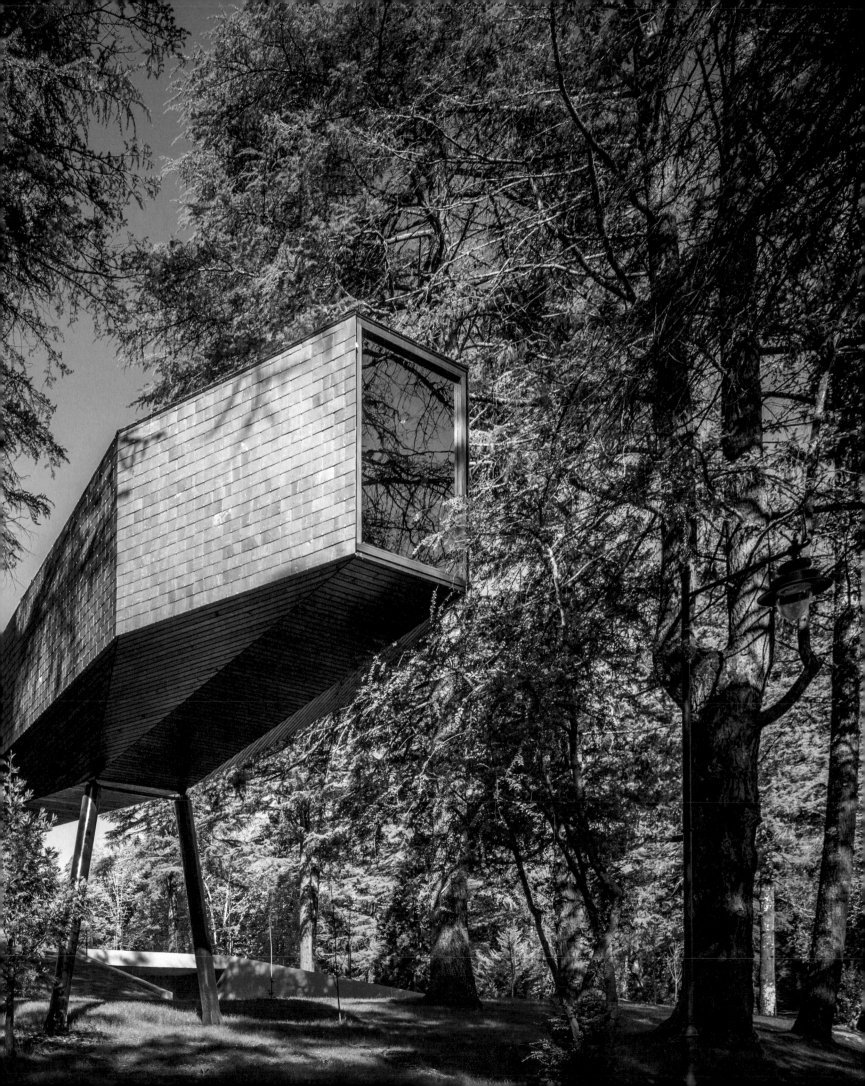

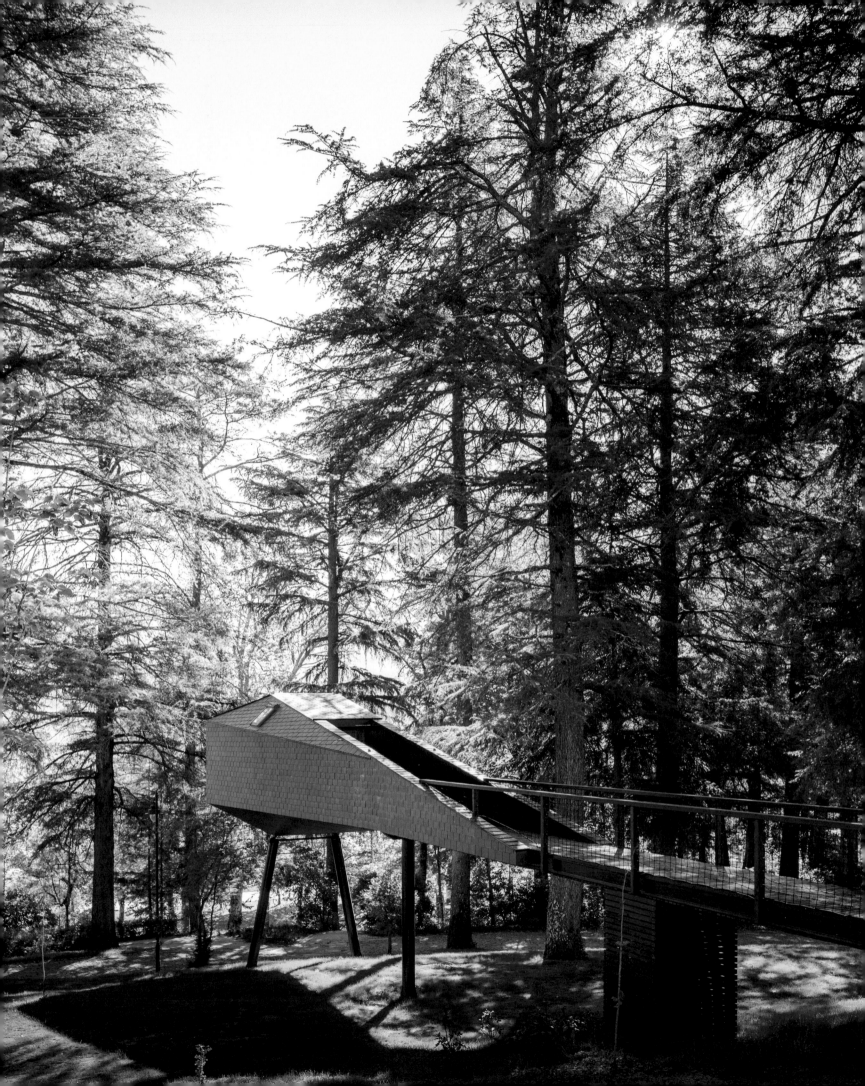

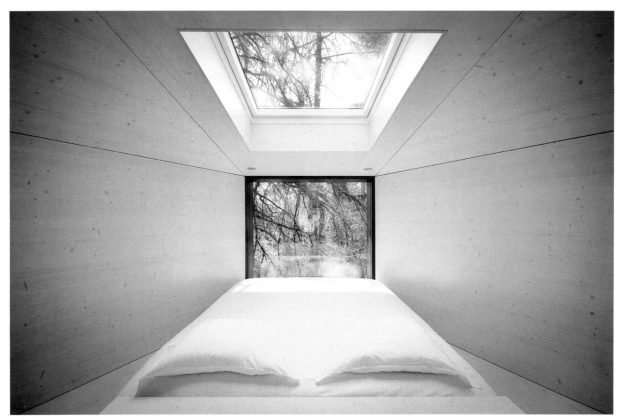

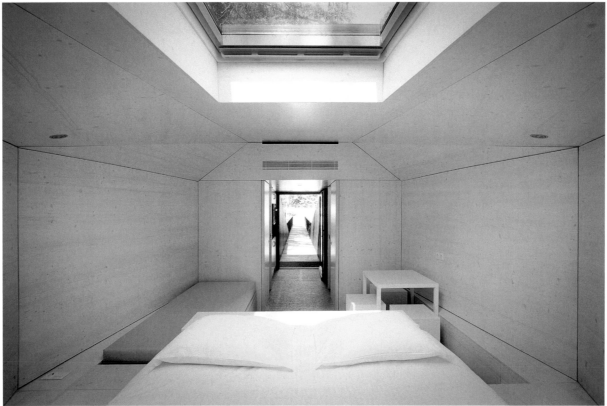

Tree Snake Houses

Architect/Location: **Rebelo de Andrade**
Vila Real, Portugal

Two twin tree houses perched on stilts jut out into a fantastic forest setting. Developed in partnership with the Modular System Company, the elevated hideouts reject the orthogonality of traditional modular construction. Like a wild snake gliding into the trees, these houses connect to the ground via lengthy elevated walkways. The dramatic transition between corridor and habitat imbues the tiny homes with a commanding visual presence. Native raw materials of slate and wood blend the structures into the landscape. With a focus on ecology, the sustainable dwellings integrate efficient insulation, heating systems, water reuse, and solar panels into the heart of the design. Inside, each dwelling consists of a peaceful studio with a small bathroom and kitchen. Adaptable to different landscapes and climates, these striking interpretations of the primitive hut channel the wild animal in all of us.

233

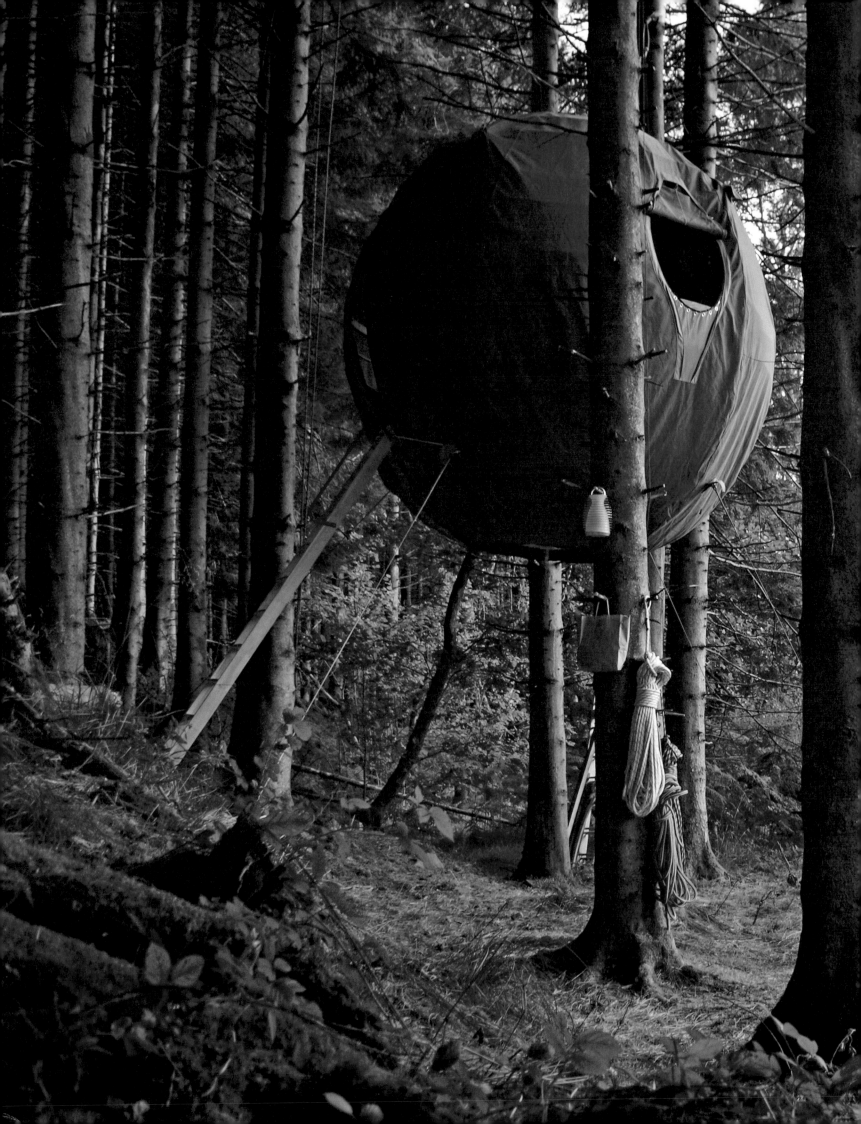

Tree Tent →

Architect/Location: **Jason Thawley**
South East England, UK

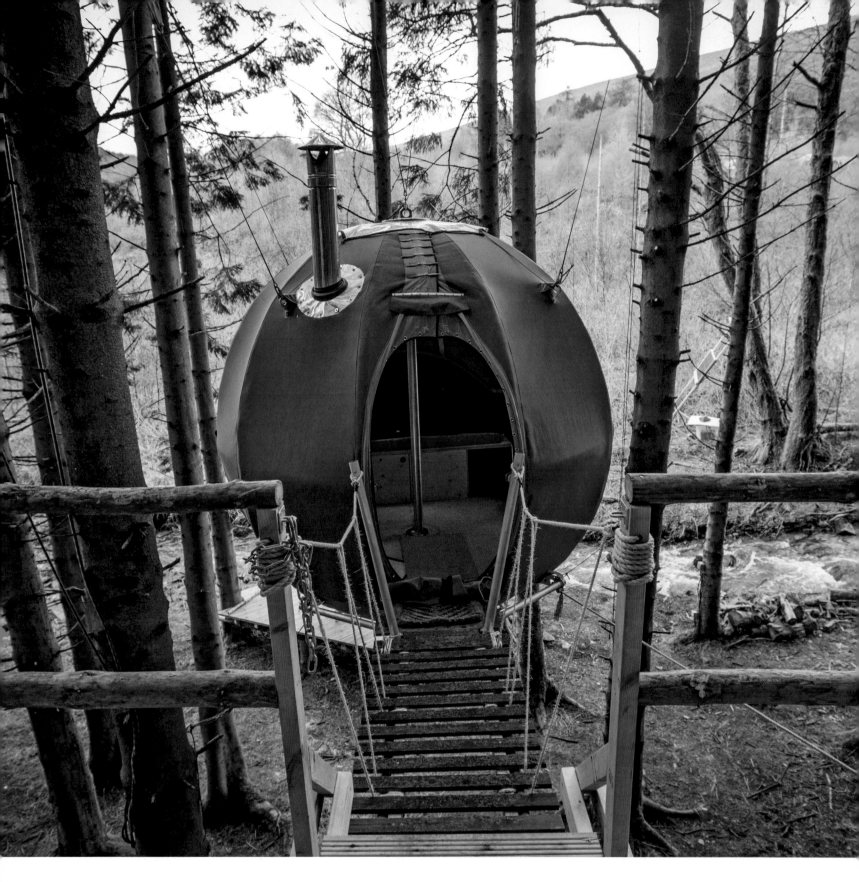

Tree Tent

Architect / Location: **Jason Thawley**
South East England, UK

A floating spherical tent hovers in the trees. This comfortable and mobile shelter delicately blends into woodland and forest settings without disrupting the fragile ecosystem. Made from recycled and natural materials, the sustainable and suspended structure can be easily assembled and transported from place to place. The modest, floating cocoon protects its guests from wildlife and the often cold, hard, and uneven ground. In spite of its elevated position, the tent stays viscerally connected to the experiential and healing aspects of nature through treetop living. Akin to an airship, the lightweight hideout takes camping off the ground and into the air.

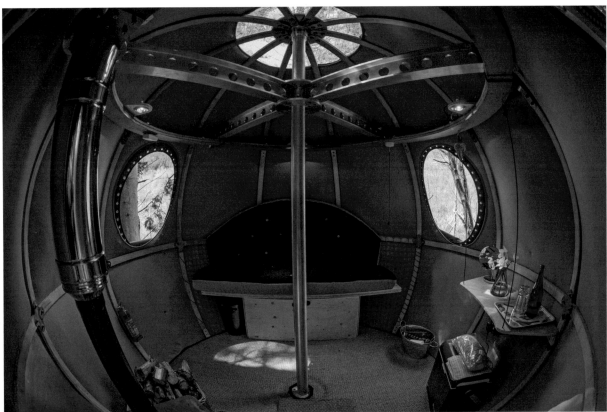
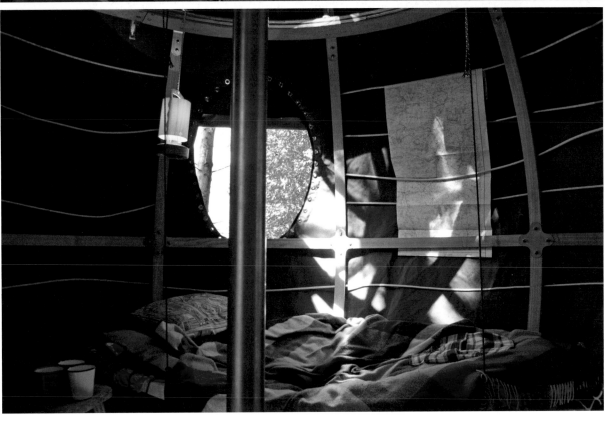

BlackWood House →
Architect/Location: **Marchi Architectes**
Normandy, France

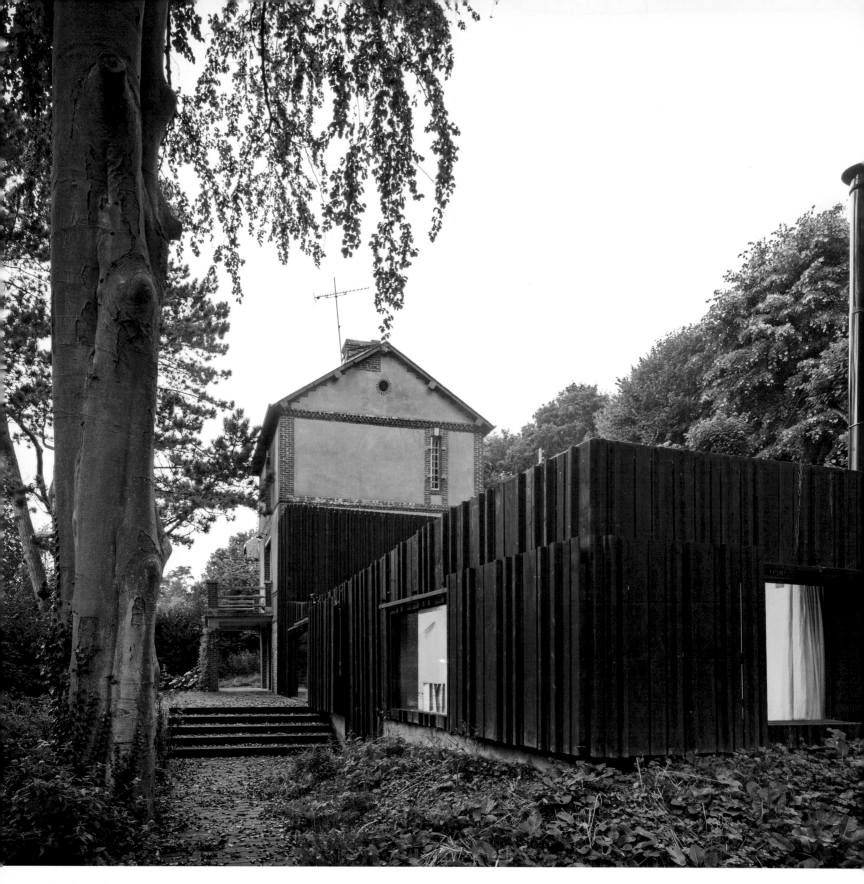

BlackWood House

Architect/Location: **Marchi Architectes**
Normandy, France

A dark and mysterious extension makes space for a more open and transparent living area while freeing up the old house for new uses. The unique added volume holds a kitchen, living room, and dining space. From the interior, wide views overlook the garden and lush landscape. In spite of its heavy appearance, the extension lightly connects to the existing house. The modest intervention, partially recessed in the topography, features black stained timber cladding which acts as a subtle camouflage against its natural backdrop. This demure color palette disguises the crisp lines of the extension, transforming the project into a fleeting shadow passing through the trees.

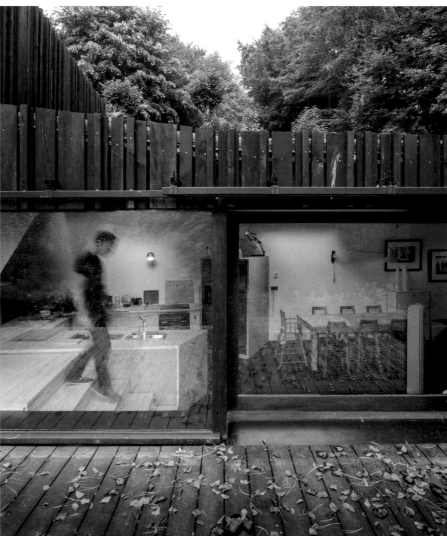
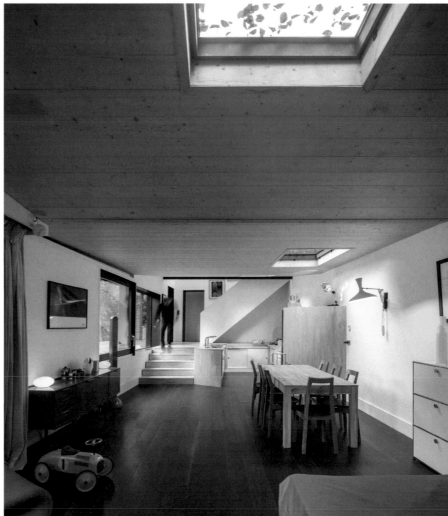

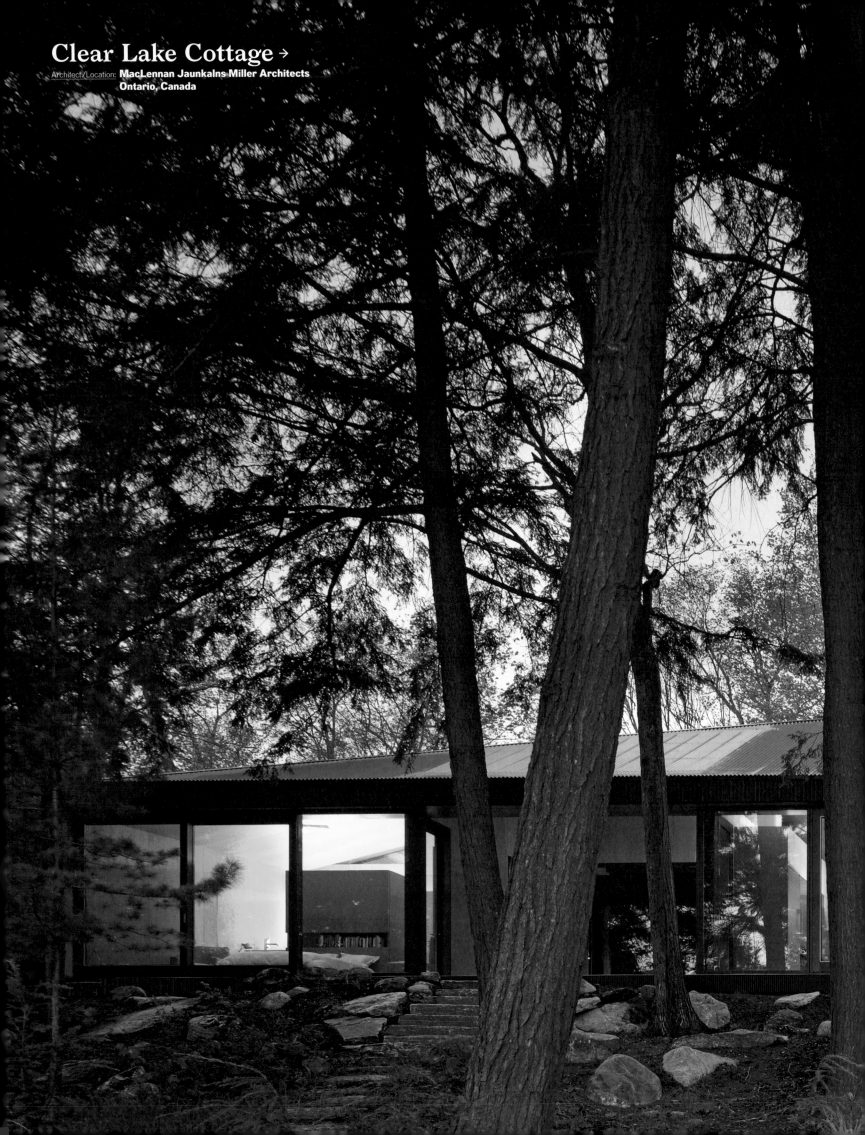

Clear Lake Cottage →

Architect/Location: **MacLennan Jaunkalns Miller Architects**
Ontario, Canada

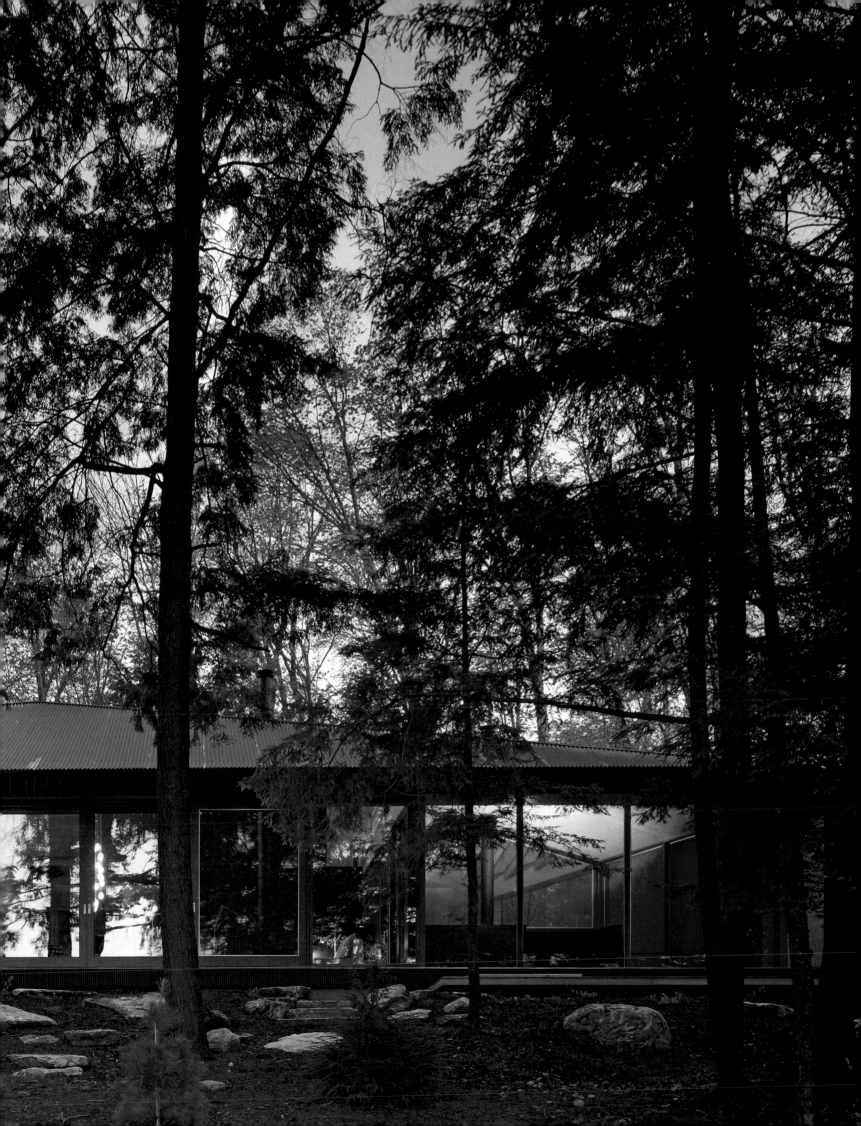

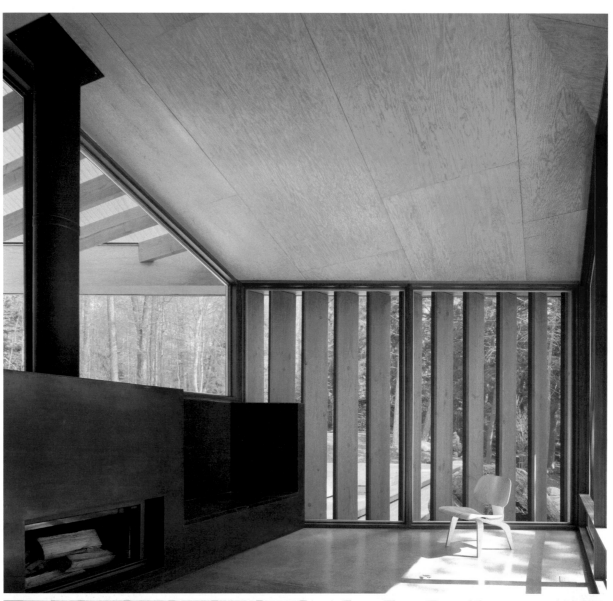

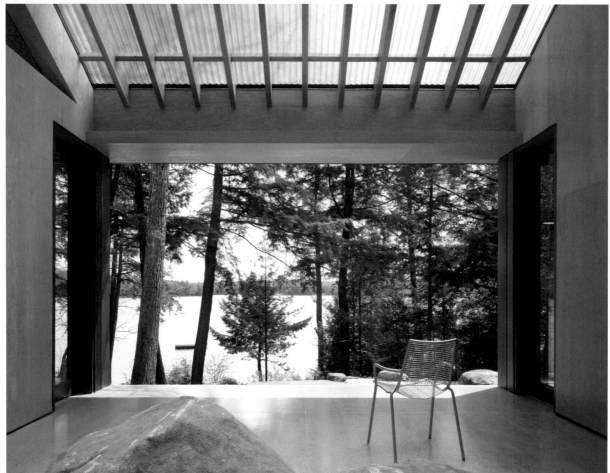

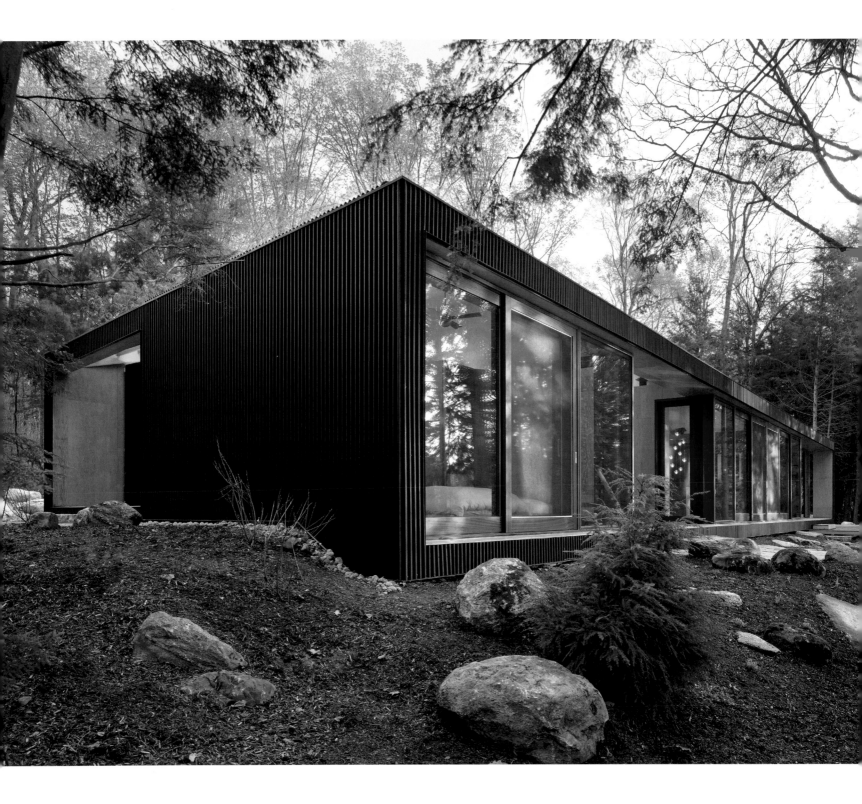

Clear Lake Cottage

Architect/Location: **MacLennan Jaunkalns Miller Architects**
Ontario, Canada

A luminous and cozy four season cottage blends with the rural character of a quiet lake community. Overlooking the placid lake, the demure building sits quietly behind trees. The house features all the benefits of modern design while connecting with the humble outdoors. A sloping peaked roof, reminiscent of a campsite structure, achieves a contemporary yet functional aesthetic. Four program masses, accented by forest and lake views, consist of a master suite, bedrooms, den, and living area with an open loft space above. The decidedly modern and streamlined form retains a raw and industrial quality. Working as a visual counterpoint to the dark exterior finish, the light plywood interior contrasts with the black façade cladding. A screened porch with a folding partition bleeds into the interior. With more than 50 percent of the glazed envelope able to open to the outdoors, the retreat encourages all worries to melt away amidst the site's tranquil breezes, fragrances, acoustics, and shadow play.

4×4 Studio

Architect/Location: **Teresa Mascaro**
São Paulo, Brazil

This working studio snuggles behind a photographer's main residence on the outskirts of São Paulo. The active workspace accommodates a desk, workbench, and shelves for digital files in a comfortable, reserved, and inspiring way. The sloping site filled with greenery influences the slender modern structure's non-invasive approach. Just 4×4 m, the concise square floor plan feels far larger than its measurements. Aligned with the height of the trees, the studio overlooks the pastoral landscape of verdant green fields. The free and inspiring work environment intersperses solid walls with floor-to-ceiling glazing, fostering both functionality and a symbiotic relationship with the outdoors.

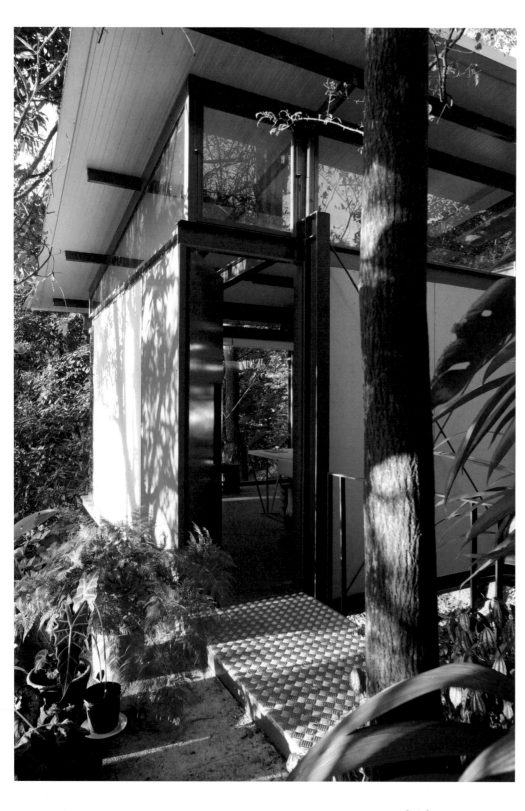

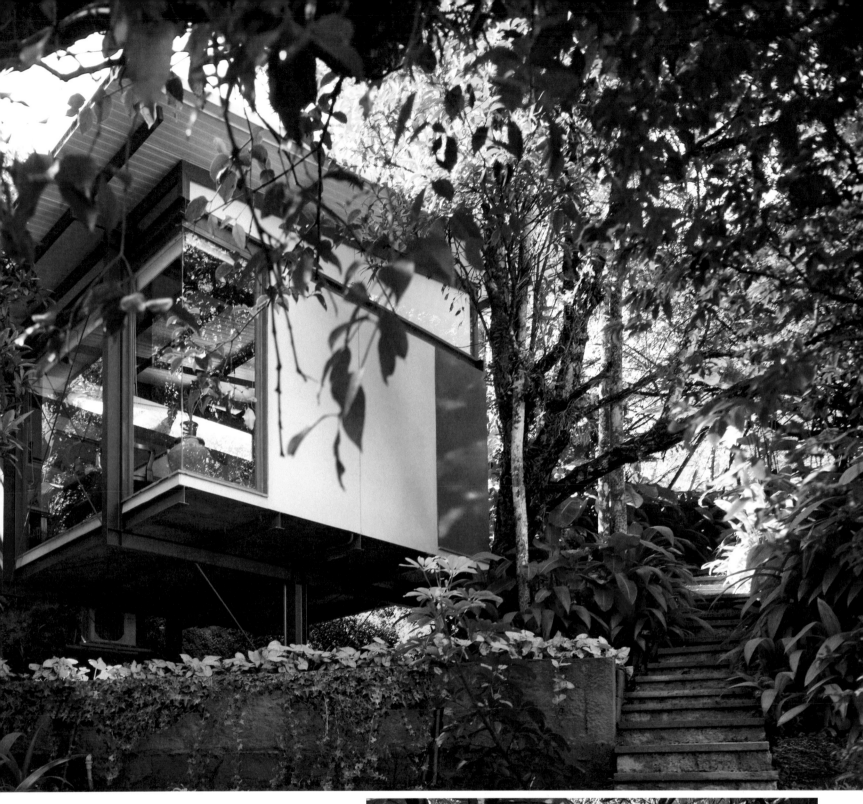

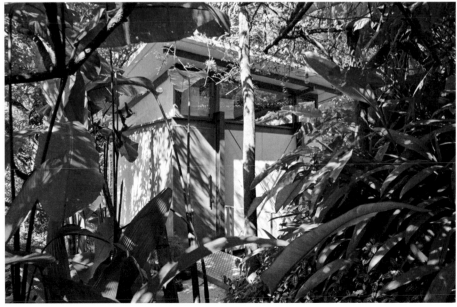

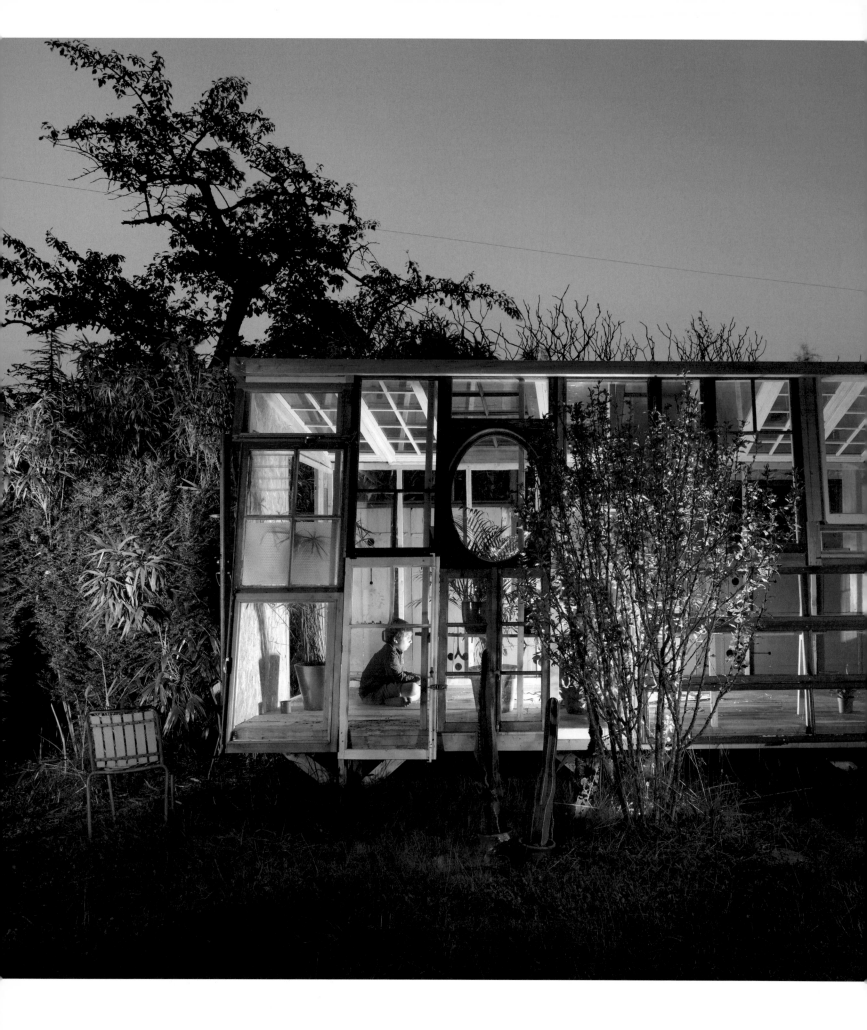

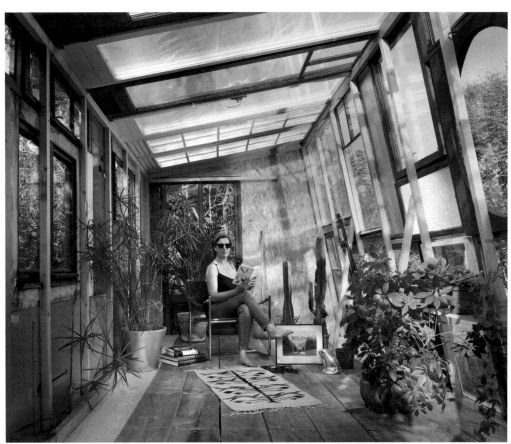

La Fabrique

Architect/Location: **Bureau A**
Geneva, Switzerland

This poetic and playful pavilion draws inspiration from comedian Buster Keaton's short film *One Week*, a story about a newly wed couple who struggles to install a kit-house on a small plot of land for their wedding gift. Built with a similar mixture of seriousness and lightness, the charming, pieced-together shelter is made out of recycled windows found on demolition sites. Designed and constructed in just a few days, the atmospheric project explores the direct relationship between dreaming and doing, pleasure and will. The nature of the pavilion resembles the emancipated miniature architecture of the follies found in classic garden culture. An architectural quilt, the enclosure of mismatched windows constructs a whimsical network of portals for reframing the world around us.

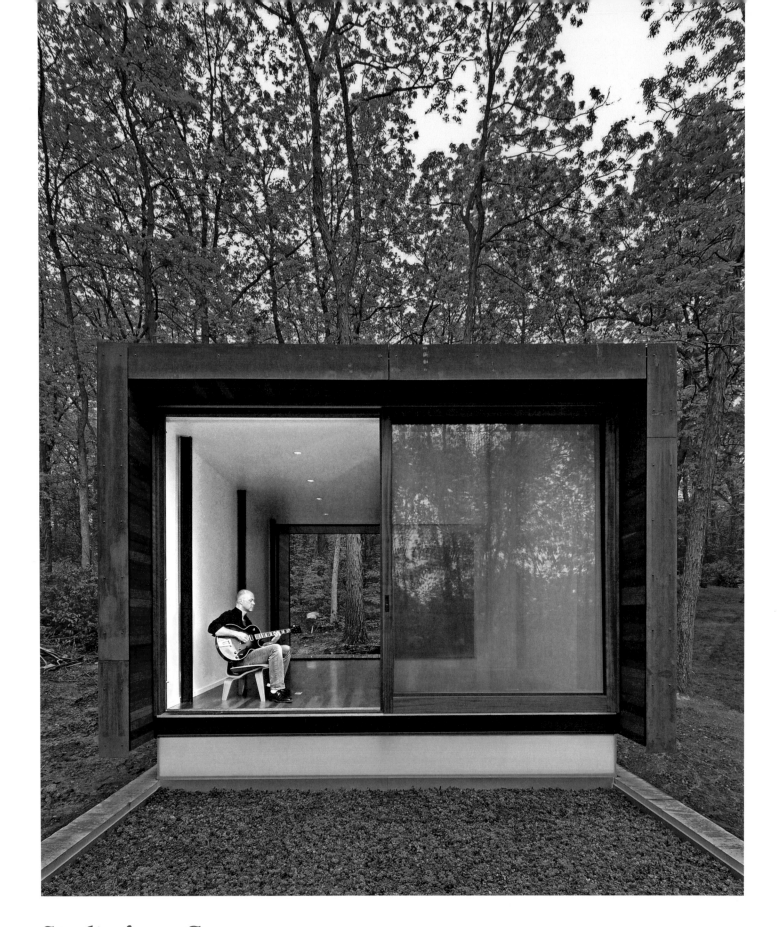

Studio for a Composer

Architect/Location: **Johnsen Schmaling Architects**
Great Lakes, USA

Snuggled into a rural hillside, this intimate retreat serves as a studio for a musician to work and reconnect with nature. The building continues the tradition of Midwestern pastoral architecture and its legacy of aesthetic sobriety, functionality, and robust craftsmanship. A concrete plinth, carved into the sloped site, supports the studio volume partially covered by a steel shroud. Glazed openings at each end of the studio frame views into the landscape and link the space to a green roof. The steel shroud, slightly lifted off the plinth, exposes a narrow clerestory that makes the studio seemingly float above its base. By night, the clerestory emits a soft glow into the dark countryside. The carefully detailed Cor-Ten steel envelope turns the building into an ever-changing canvas. Alloy imperfections, surface oils, and roller marks leave their individual traces as the material weathers, juxtaposing the building's formal restraint and evolving veneer with the untamed forest all around.

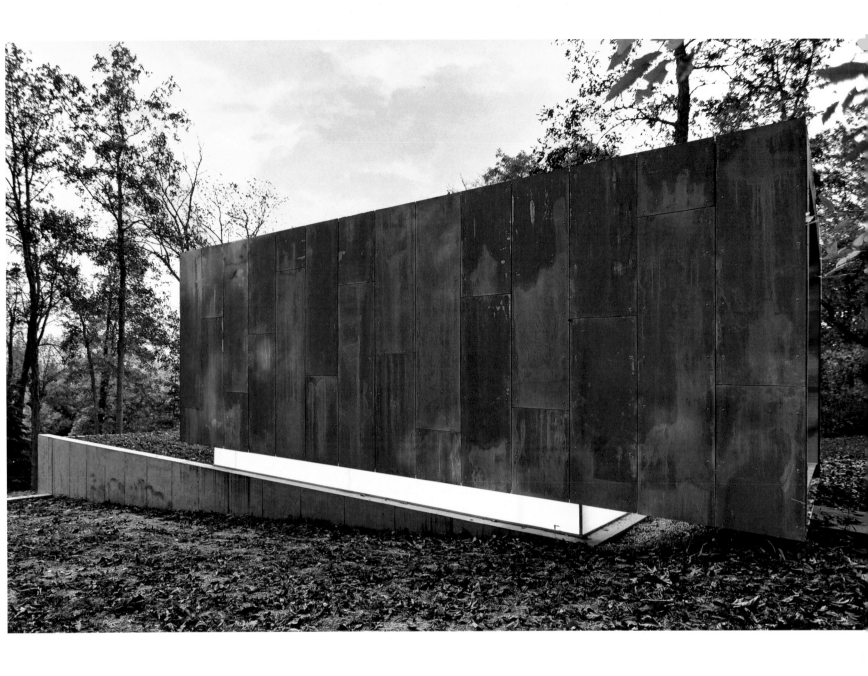

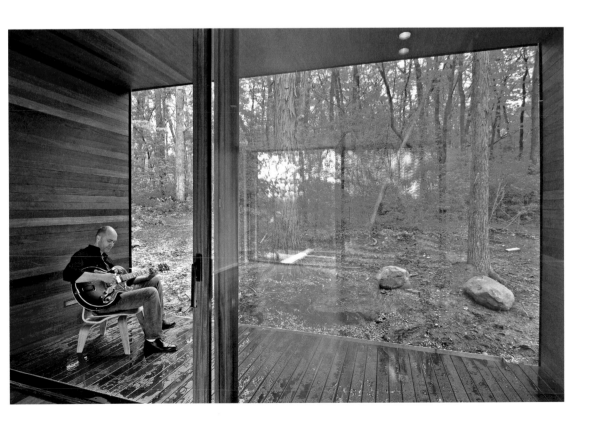

Index

Ensamble Studio
Spain
www.ensamble.info
Photo credit:
Roland Halbe
Additional credits:
DEVELOPER: Materia Inorgánica
AUTHOR OF THE PROJECT:
Antón García- Abril
COLLABORATOR ARCHITECTS:
Ensamble Studio, Ricardo Sanz,
Javier Cuesta
← P. 48–49

G

Galletti & Matter Architects
Switzerland
www.galletti-matter.ch
Photo credit:
Lionel Henriod/mc2
← P. 74–75

General Architecture
Sweden
www.generalarchitecture.se
Photo credit:
Mikael Olsson
Additional credits:
CONSTRUCTOR: Ingemar Johansson,
Rita Bygg
← P. 52–53

Giovanni Pesamosca Architetto
Italy
www.ec2.it/giovannipesamosca
Photo credit:
Flavio Pesamosca
Additional credits:
STRUCTURES:
Ingegnere Valentina Bertolutti
PLANTS:
Studio T.E.A.
CONSULTANTS:
Ingegnere Marco Pesamosca
Geometra Vittorio Di Marco
DIRECTOR OF WORK:
Geometra Roberto Palmieri
CLIENT: Luciano Vuerich
← P. 66–69

Graypants, Inc.
USA
www.graypants.com
Photo credit:
Amos Morgan Photography
Additional credits:
GRAYPANTS DESIGN TEAM: Seth Grizzle,
Jonathan Junker, Kathryn Moeller, Mike
Peterson
CONTRACTOR: Schuchart/Dow
STRUCTURAL ENGINEER: Swenson
Say Fagét
Corian Door Fabricator: R.D. Wing
← P. 20–23

Grupo Talca
Chile
www.grupotalca.cl
Photo credit:
Courtesy of Grupo Talca
Additional credits:
CONSTRUCTION: Pinohuacho Inhabitants
← P. 180–181

H

Herreros Arquitectos
Spain
www.herrerosarquitectos.com
Photo credit:
Javier Callejas
Additional credits:
PRINCIPAL: Juan Herreros
ARCHITECT IN CHARGE: Verónica Meléndez
PROJECT TEAM: Alejandro Valdivieso,
Margarita Martinez, Paula Vega
TECHNICAL ARCHITECT: Ramón Paradinas
STRUCTURAL DESIGN: Eduardo Barrón
PHOTOGRAPHY AND VIDEO:
Javier Callejas
CONSTRUCTOR: IDM Sistemas
Modulares, Modulab
← P. 184–185

J

Jaanus Orgusaar
Estonia
www.jaanusorgusaar.com
Photo credits:
Jaanus Orgusaar (166 top pic., 167),
Terje Ugandi (166 bottom pic.)
Additional credits:
PRODUCER: Woodland homes
RESELLER: www.katus.eu
← P. 166–167

Jason Thawley
United Kingdom
www.treetents.co.uk
Photo credit:
Luminair
← P. 234–237

John Robert Nilsson Arkitektkontor
Sweden
www.jrn.se
Photo credit:
Åke Eson Lindman
Additional credits:
ARCHITECTS (chief, managing and
co-workers):
John Robert Nilsson Arkitektkontor,
Robert Nilsson chief, Maria Århammar man-
aging, Niklas Singstedt, Martin Zetherström,
Vincenzo Cassotta contributory.
INTERIOR DESIGN: John Robert Nilsson
Arkitektkontor
LANDSCAPING, GARDEN:
Mikado Mark & Trädgård, Robert Forsberg
OTHER CONTRACTORS: Geo Markservice
AB, Eva Holmqvist (water/sewage), CSE
Projekt, Henrik Nilsson (construction), Itecon
AB, Eskil Stenstrand (water), Jan Fransson
Elkonsult AB, Håkan Ackland (electricity)
GLASS CONTRACTORS/SUPPLIERS:
JB GI askonsult AB, Johan Backlund, JONI
Metall & glasprojektering/CL Specialglas,
Claes Lundén
CONSTRUCTION FORM:
Shared construction
BUILDING CONTRACTOR:
Liljestrand Entreprenad
← P. 114–115

Johnsen Schmaling Architects
USA
www.johnsenschmaling.com
Photo credit:
John J. Macaulay
← P. 80–81
← P. 250–251

K

Knut Hjeltnes
Norway
www.hjeltnes.as
Photo credit:
Espen Grønli
← P. 50–51

Kolman Boye Architects
Sweden
www.kolmanboye.com
Photo credit:
Åke Eson Lindman
← P. 116–119

L

LASC studio
Denmark
www.lascstudio.com
Photo credits:
Stamers Kontor (137), Thomas Ibsen (136)
← P. 136–137

M

MacLennan Jaunkalns Miller Architects
Canada
www.mjmarchitects.com
Photo credit:
Ben Rahn, A Frame Studio
Additional credits:
STRUCTURAL: Blackwell Engineers
HVAC CONSULTANTS: V&P Enterprises
CIVIL ENGINEERS: CF Crozier and Associates
CONSTRUCTION MANAGERS:
Wilson Projects – Tim Hurley
← P. 242–245

MAPA - MAAM + STUDIOPARALELO
Brazil
www.minimod.com.br
www.mapaarq.com.uy
Photo credit:
Leonardo Finotti
Additional credits:
PARTNER ARCHITECTS:
Luciano Andrades, Matías Carballal, Rochelle
Castro, Andrés Gobba, Mauricio López,
Silvio Machado
DESIGN TEAM: Camilla Pereira, Alexis Arbelo,

Pablo Courreges, Emiliano Lago, Aldo Lanzi,
Isabella Madureira, Diego Morera, Jaqueline
Lessa, Pamela Davyt, Emiliano Ecthegaray,
Maurício Wood, Camila Thiesen, Felipe
Lessa, Guillermo Acosta, Charlotte Pericchi
STRUCTURAL SERVICES:
Valls Engenharia
MEP/ SERVICES ENGINEERING:
Studio Horizonte
AUTOMATION: Adall Home systems
FRAMING: Sistema Steel house
CLADDING: Enovare Timber cladding
GREEN ROOF: Ecotelhado
SITE: Hotel country resort – Fazenda do
Pontal
← P. 38–39

Marchi Architects
France
www.anmarchi.com
Photo credit:
Fernando Guerra
← P. 238–241

Marte.Marte Architects
Austria
www.marte-marte.com
Photo credit:
Marc Lins
← P. 94–97

Mas y Fernández Arquitectos Asociados
Chile
www.masfernandez.cl
Photo credit:
Nicolás Saieh
Additional credits:
STRUCTURE: Enrique Riobo
LANDSCAPE: María Trinidad Escudero
BUILDER: Alejandro Molina
LANS AREA: 5.226,61 m²
BUILT AREA: 177.24 m²
← P. 186–187

Morger + Dettli Architekten
Switzerland
www.morger-dettli.ch
Photo credit:
Ruedi Walti
← P. 100–101

Mork-Ulnes Architects
USA/Norway
www.morkulnes.com
Photo credit:
Bruce Damonte
Additional credits:
PROJECT DESIGN TEAM: Greg Ladigin,
Casper Mork-Ulnes, Andreas Tingulstad
CONTRACTOR: Crossgrain Co., Stephen
Ottmer
← P. 158–161

Morq architecture
Italy/Australia
www.morq.it
Photo credit:
Peter Bennetts
Additional credits:
DESIGN COLLABORATORS:
Josh Saunders, Tor Dahl, Ken Yeung,
Catherine Farrell, Clare Porter, Sally Farrah
BUILDER: Tectonics
STRUCTURES: Margaret River
Structural Engineers
LEADING CARPENTER:
Henk Van Oostenbrugge
← P. 188–191

MRTN Architects
Australia
www.mrtn.com.au
Photo credit:
Nic Granleese
← P. 140–143

Niklas Larsén & Fanny Nelson
Sweden
Photo credit:
Jonas Ingerstedt
← P. 174–175

Olson Kundig Architects
USA
www.olsonkundigarchitects.com
Photo credits:
Benjamin Benschneider (36–37),
Dwight Eschliman (34–35)
Additional credits:
PROJECT TEAM: Tom Kundig (design
principal), Chris Gerrick (project manager),
Charlie Fairchild (interior designer)
CONSULTANTS: Olson Kundig Architects
(interior design), MCE Structural Consultants
(structural engineer), Coughlin Porter Lundeen
(civil engineer), Associated Earth Sciences
(geotechnical engineer)
CONTRACTOR: Schuchart/Dow
← P. 34–37
Photo credit:
Benjamin Benschneider
Additional credits:
PROJECT TEAM: Olson Kundig Architects -
Tom Kundig, Faia (design principal),
Edward Lalonde (project manager)
CONSULTANTS: MCE Structural
Consultants (structural engineer),
Zanovic and Associates (civil engineering)
CONTRACTOR: Schuchart Dow
← P. 86–87

Panorama
Chile
www.panoramaarquitectos.com
Photo credit:
Nicolás Valdés
Additional credit:
COLABORATOR: Raul Rencoret
← P. 54–55

Parsonson Architects
New Zealand
www.p-a.co.nz
Photo credit:
Paul McCredie
← P. 192–195

Pascal Flammer
Switzerland
www.pascalflammer.com
Photo credit:
Ioana Marinescu
← P. 82–85

Pezo von Ellrichshausen
Chile
www.pezo.cl
Photo credit:
Cristobal Palma
Additional credits:
CLIENT: Christian Bourdais, Solo Houses
ARCHITECTS: Mauricio Pezo, Sofia von
Ellrichshausen
COLLABORATORS: Diogo Porto, Bernhard
Maurer, Valeria Farfan, Eleonora Bassi, Ana
Freeze
BUILDER: Ferras Prats
STRUCTURAL CONSULTANT: Jose Perez
BUILDING SERVICES: Ineco, Pablo Rived
← P. 76–79

Pons Estel
Argentina
www.estudiocuesta.com
Photo credit:
Federico Cairoli
← P. 144–145

PROARH/Davor Mateković
Croatia
www.proarh.hr
Photo credit:
Damir Fabijanić
Additional credit:
COLLABORATOR: Oskar Rajko
← P. 112–113

Raumhochrosen
Austria
www.raumhochrosen.com
Photo credit:
Albrecht Imanuel Schnabel
← P. 212–213

Rebelo de Andrade
Portugal
www.rebelodeandrade.com
Photo credits:
Ricardo Oliveira Alves (233),
Fernando Guerra (230–232)
Additional credits:
ARCHITECTS: Luís Rebelo de Andrade,
Tiago Rebelo de Andrade
COLLABORATORS: Madalena Rebelo de
Andrade, Raquel Jorge, Pedro Baptista Dias
Project Area 27,00 m²
CLIENT: Unicer
CONSTRUCTOR: Modular System
← P. 230–233

Reiulf Ramstad Arkitekter
Norway
www.reiulframstadarkitekter.no
Photo credits:
Søren Harder Nielsen, Reiulf Ramstad
Arkitekter
← P. 108–111

Rob Sweere
Netherlands
www.robsweere.com
Photo credits:
René Kristensen, Rob Sweere
Additional credit:
COMMISSIONED BY: Uummannaq Polar
Institute Ann Andreassen
← P. 32–33

Robin Falck
Finland
www.robinfalck.com
Photo credit:
Courtesy of Robin Falck
← P. 206–207

Savioz Fabrizzi Architectes
Switzerland
www.sf-ar.ch
Photo credit:
Thomas Jantscher
Additional credits:
CIVIL ENGINEER: Editec Sa, Ayent
CLIENT: Monya et Laurent Savioz
← P. 70–71
Photo credit:
Thomas Jantscher
← P. 106–107

Schjelderup Trondahl
Norway
www.sta.no
Photo credit:
Jonas Adolfsen
Additional credits:
ARCHITECTS IN CHARGE:
Stian Schjelderup, Øystein Trondahl,
Katrine Skavlan
CLIENT: Marius Ramberg, Merethe Off
CONSTRUCTOR: Larsen Bygg, Lars Arnulf
Finden
CONSULTANT: Frederiksen, Håkon
Bergsrud
INTERIOR CARPENTER: Holmestrand
Møbelsnekkeri
← P. 40–41

Scott & Scott Architects
Canada
www.scottandscott.ca
Photo credit:
Courtesy of Scott & Scott Architects
← P. 98–99

Septembre
France
www.septembrearchitecture.com
Photo credit:
Alphonse Sarthout
Additional credits:
ARCHITECTS: Lina Lagerstrom, Memia
Belkaid, Dounia Hamdouch, Sami Aloulou,
Emilia Jansson
Thanks to architect Hans Martensson
for advice in both technical, artisan, and
aesthetic questions.
← P. 204–205

Shareen Joel Design
Australia
www.marshagolemac.com
Brooke Holm (165 top pic.), Lucas Allen
(164, 165 bottom pic.)
Additional credit:
STYLING: Marsha Golemac
← P. 164–165

Simon Hjermind Jensen
Denmark
www.shjworks.dk
Photo credit:
Christian Bøcker Sørensen,
Simon Hjermind Jensen
← P. 56–57

Steve Areen
Thailand
www.steveareen.com
Photo credit:
Steve Areen
← P. 134–135

Studio 1984
France
www.studio-1984.com
Photo credit:
Courtesy of Studio 1984
← P. 156–157

Studio Moffitt
United Kingdom
www.studiomoffitt.com
Photo credits:
Shai Gil (138 top left, 139), Gabriel Li
(138 bottom pic, top right)
Additional credits:
STRUCTURAL ENGINEER: Cory Zurrell,
Blackwell Engineering
OFF-GRID CONSULTANT: Nick Treanor
BUILDER: Peter Long
← P. 138–139

Studio Weave
United Kingdom
www.studioweave.com
Photo credit:
Jim Stephenson
Additional credits:
GRAPHIC DESIGNER: Nous Vous Structure
STRUCTURAL ENGINEER: Workshop
← P. 220–221

Sven Matt
Austria
www.svenmatt.com
Photo credit:
Björn Matt
← P. 172–173

T

Teresa Mascaro
Brasil
www.cristianomascaro.com.br
Photo credit:
Cristiano Mascaro
Additional credits:
STRUCTURAL ENGINEERING: Yopanan
Rebello
FOUNDATIONS AND STRUCTURE:
Ycon Engenharia
STEELFRAME: Walltech Engenharia e
Construção
← P. 246–247

Tham & Videgård Arkitekter
Sweden
www.tvark.se
Photo credit:
Åke Eson Lindman
Additional credit:
TEAM: Bolle Tham, Martin Videgård
← P. 170–171
Photo credit:
Åke Eson Lindman
Additional credit:
TEAM: Martin Videgård (responsible archi-
tect), Bolle Tham, Maria Videgård
← P. 176–177

Thomas Kroeger Architekt
Germany
www.thomaskroeger.net
Photo credit:
Thomas Heimann
Additional credits:
ARCHITECTS: Thomas Kröger, Georg
Bosch, Urs Walter
INTERIORS AND CARPENTER WORK,
KITCHEN, FURNITURE: Gerhard Schütze
ROOF AND FACADE: Dachdecker GmbH,
Joachim Peykow
WOODEN FACADE, LOGGIA: Christoph
Steinberg
WINDOWS: Tischlerei Oliver Giese
METALWORKER: Metallbau &
Bauschlosserei Hans-Jürgen Gohr
TIMBER PILLING (FIRST FLOOR):
Fiala Parkett, Berlin
MASTIC ASPHALT (GROUND FLOOR):
Rask Brandenburg GmbH
DRYWALL INSTALLATION: Scharlau
Montagebau GbR
PAINTER: Erste Prenzlauer Maler GmbH
CARPENTER ROOF: Holzbau HoLiTa GmbH,
← P. 178–179

TYIN tegnestue Architects
Norway
www.tyintegnestue.no
Photo credit:
Pasi Aalto
← P. 130–133

U

UUfie
Canada
www.uufie.com
Photo credit:
Naho Kubota, UUfie
Additional credit:
TEAM: Irene Gardpoit, Eiri Ota
← P. 222–227

W

Wim Goes Architectuur
Belgium
www.wimgoesarchitectuur.be
Photo credits:
Kristien Daem (12–13, © VG Bild-Kunst,
Bonn 2014), Laura Bown (14–15)
Additional credits:
TEAM: Wim Goes (14–15), Anja Houbaert
STRUCTURAL ENGINEER:
Wouter Notebaert
← P. 12–15

Imprint

Hide and Seek:
The Architecture of
Cabins and Hide-Outs

This book was conceived, edited, and designed by Gestalten.

Edited by Sofia Borges, Sven Ehmann, and Robert Klanten

Preface and texts by Sofia Borges
Layout by Johanna Klein
Layout assistance by Michelle Kliem

Cover by Johanna Klein
Front cover image: Waldsetzkasten by Bernd Riegger (photo: Adolf Bereuter)
Back cover images: Stacked Cabin by Johnsen Schmaling Architects (photo: John J. Macaulay), Lyset paa Lista by TYIN Tegnestue (photo: Pasi Aalto), Lake Cottage by UUfie (photo: Naho Kubota), Refuge by Wim Goes Architectuur (photo: Laura Brown)

Typefaces: Larish Neue by Radim Peško, MinionPro by Robert Slimbach, DadaGrotesk by deValence

Proofreading by Brigette Brown

Printed by Nino Druck GmbH, Neustadt/Weinstraße
Made in Germany

Published by Gestalten, Berlin 2014
ISBN 978-3-89955-545-5

For more information, please visit www.gestalten.com.

Bibliographic information published by the Deutsche Nationalbibliothek. The Deutsche Nationalbibliothek lists this publication in the Deutsche Nationalbibliografie; detailed bibliographic data are available online at http://dnb.d-nb.de.

None of the content in this book was published in exchange for payment by commercial parties or designers; Gestalten selected all included work based solely on its artistic merit.

This book was printed on paper certified according to the standard of FSC®

Gestalten is a climate-neutral company. We collaborate with the non-profit carbon offset provider myclimate (www.myclimate.org) to neutralize the company's carbon footprint produced through our worldwide business activities by investing in projects that reduce CO_2 emissions (www.gestalten.com/myclimate).